$\frac{\text{GOD'S}}{\text{GOLD}}$

Also by Sean Kingsley

Barbarian Seas—Late Rome to Islam Shipwreck Archaeology of the Holy Land

GOD'S GOLD

A QUEST for the LOST TEMPLE TREASURES of JERUSALEM

Sean Kingsley

GOD'S GOLD. Copyright © 2007 by Sean Kingsley. All rights reserved. Printed in the United States of America. No part of this book may be used or reproduced in any manner whatsoever without written permission except in the case of brief quotations embodied in critical articles and reviews. For information, address HarperCollins Publishers, 10 East 53rd Street, New York, NY 10022.

HarperCollins books may be purchased for educational, business, or sales promotional use. For information, please write: Special Markets Department, HarperCollins Publishers, 10 East 53rd Street, New York, NY 10022.

FIRST EDITION

Designed by Emily Cavett Taff

Library of Congress Cataloging-in-Publication Data is available upon request.

ISBN: 978-0-06-085400-3 ISBN-10: 0-06-085400-6

07 08 09 10 11 ID/RRD 10 9 8 7 6 5 4 3 2 1

TO MY FAMILY PAST AND PRESENT, lost in the concentration camps of Nazi Europe, reborn on the streets of London.

CONTENTS

	Introduction	ix
	Acknowledgments	xiii
	Abbreviations	xv
ROO	ТS	
1.	River of Gold	3
2.	Awakenings	8
3.	Ghosts of Israel Past	,13
4.	Exodus and Exile	17
5.	Herod's Treasure Chest	28
ISRAI	EL—LAND OF GOD	
6.	Dark Secrets in the Vatican	39
7.	Temple Prophecies	45
8.	Volcano of Hate	50
9.	Keeping the Faith?	59
10.	Benjamin of Tudela	66
11.	The Philosopher's Folly	70
12.	Dead Sea Treasures	77
13.	Castles in the Air	84
TEMP	LE TREASURE	
14.	Divine Light—the Menorah	IOI

11.	Divine Light the Menorali	101
15.	Hunting Graven Images	109
16.	The Tree of Life	117

- VII -

Contents

	Bread of Heaven	123
18.	Trumpeting Messages	130
REVO	LUTION	
19.	City of Unbrotherly Love	137
20.	Turning the Screw	144
21.	Death of a Temple	149
22.	Flavian Spin	153
IMPE	RIAL ROME	
23.	Walking with God	165
24.	A Word from the Sponsors	174
25.	Aliens in Rome	178
26.	Of Circuses and Artichokes	185
27.	The Triumphal Way	190
28.	A Day at the Circus Maximus	197
29.	A Temple for Peace	205
VAND	DAL CARTHAGE	
30.	Jewish Gold, Barbarian Loot	213
	Heresy and Holocaust	227
31.	Tieresy and Tiolocaust	221
31. 32.	Keeping the Faith	221
32. 33.	Keeping the Faith	230 235
32. 33.	Keeping the Faith In a Vandal Palace	230 235
32. 33. CONS	Keeping the Faith In a Vandal Palace STANTINOPLE—NEW RO	230 235 ME
32. 33. CONS 34.	Keeping the Faith In a Vandal Palace STANTINOPLE—NEW RO Treasures Recycled	230 235 ME 249
32. 33. CONS 34. 35. 36.	Keeping the Faith In a Vandal Palace STANTINOPLE—NEW RO Treasures Recycled Hunting Hippodromes	230 235 ME 249 259
32. 33. CONS 34. 35. 36.	Keeping the Faith In a Vandal Palace STANTINOPLE—NEW RO Treasures Recycled Hunting Hippodromes Imperial War Games	230 235 ME 249 259
32. 33. CONS 34. 35. 36. THE I	Keeping the Faith In a Vandal Palace STANTINOPLE—NEW RO Treasures Recycled Hunting Hippodromes Imperial War Games HOLY LAND	230 235 ME 249 259 265
32. 33. CONS 34. 35. 36. THE I 37.	Keeping the Faith In a Vandal Palace STANTINOPLE—NEW RO Treasures Recycled Hunting Hippodromes Imperial War Games HOLY LAND Sanctuary of the Christians	230 235 PME 249 259 265 279
32. 33. CONS 34. 35. 36. THE I 37. 38. 39.	Keeping the Faith In a Vandal Palace STANTINOPLE—NEW RO Treasures Recycled Hunting Hippodromes Imperial War Games HOLY LAND Sanctuary of the Christians Desert City of Saints	230 235 ME 249 259 265 279 289

INTRODUCTION

On the summit of the Sacred Way in the Forum of Rome, an infamous monument conceals brutal memories and an eternal secret. Passage through the Arch of Titus is today blocked by request of the government of Israel and by order of the Italian prime minister to heal an ancient wrong. Rome built the arch to commemorate its destruction of Israel in AD 70, which witnessed the death of over 600,000 Jews during the First Jewish Revolt of AD 66–70. The last dignitaries said to have formally walked through were Benito Mussolini and Adolf Hitler. Today tour guides give visiting Jews permission to spit on the arch's walls and so condemn what it stands for.

A relief on the southern wall of the arch immortalizes one of the most pivotal moments in history. Fifteen men can be seen parading through the streets of Rome in a triumph celebrated in AD 71 by the emperor Vespasian and his son, Titus, who, a year before, had crushed Israel and the First Jewish Revolt. On their shoulders Roman soldiers carry the broken dreams of the Jewish nation, the gold menorah (candelabrum), a pair of silver trumpets, and the gold and gem-studded Table of the Divine Presence ransacked from the Temple in Jerusalem—intimate instruments of communication between God and man.

While the Arch of Titus is a popular monument today, the fate of the Temple treasure of Jerusalem has slipped through the cracks of modern exploration. Western consciousness hungers for ancient treasure. Hundreds of books, TV documentaries, and Hollywood movies

— IX —

Introduction

have trawled lands and seas for the Ark of the Covenant, the Holy Grail, Noah's Ark, and Atlantis.

Yet the Temple treasure remains the most valuable and attainable of all these iconic objects and themes. Most of these alluring subjects are fascinating but, in reality, no more than the stuff of myth and legend. The Holy Grail was an invention of medieval literature. And the Ark of the Covenant was regrettably destroyed in 586 BC, when King Nebuchadnezzar of Babylon torched the First Temple of Jerusalem. So it no longer exists to be discovered. This leaves the candelabrum, Table of the Divine Presence, and trumpets of truth immortalized on the Arch of Titus as the greatest treasure to have survived Bible times.

But so far they have remained beyond the grasp of man. Various characters have pursued the Temple treasure. From 1909 to 1911, in Jerusalem the philosopher Valter Juvelius and Captain Montague Parker dug around the Temple walls and even illegally within the Dome of the Rock mosque in search of an anticipated \$200 million windfall. The 4 trillion francs that the parish priest Bérenger Saunière was inaccurately credited with having discovered in rural Rennes-le-Château in southern France around 1885 was said to have been Temple treasure hidden by a Merovingian king. And after translating the Copper Scroll found in Cave 3 near Qumran in Israel, Dr. John Allegro led a failed expedition to the Dead Sea from 1960 to 1963 in search of God's gold. All of these theories proved hollow. The revelation of the Temple treasure's true hiding place today, and the story of how it ended up there, is my quest.

If the real Temple treasure has remained elusive until now, Hollywood has recently glossed over fact. In 2004, Nicolas Cage played a guardian of Jerusalem's vanished secrets, Ben Gates, in *National Treasure*. This action-packed adventure crossed the globe in search of King Solomon's gold, and using crypts, codes, and maps at the end exposed a \$10 billion treasure deep beneath Trinity Church on the corner of Wall Street and Broadway in New York. All extremely exciting and entertaining, but only make-believe: you'd be hard pushed to explain how the statues of Egyptian pharaohs, mummy coffins, and papyrus scrolls

— x –

Introduction

from the great library at Alexandria uncovered by Ben Gates ended up in a Jewish temple.

When most people think of treasure, their eyes light up and they are overcome by what Freud called the dreamlike "oceanic" feeling. Certainly the three central objects depicted on the Arch of Titus are priceless artistic masterpieces worth billions at auction. Money, however, is not what makes the Temple treasure so intriguing to me. I'm happy to borrow the closing lines of Ben Gates in *National Treasure*, who promises to donate his discoveries to the Smithsonian, the Louvre, and Cairo Museum because "there's thousands of years of world history down there and it belongs to the world and everyone in it." For me archaeology has always been about knowledge rather than possession.

God's Gold, the first physical quest for the Temple treasures of Jerusalem immortalized on the Arch of Titus, brings the history of these awesome icons back to the world. So little is known about their antiquity, artistry, symbolism, and, most crucially, their fate down the centuries. Did the Romans melt them down to swell the imperial coffers? Did the swirling winds of change—barbarians, Vandals, Byzantines, Persians, and Islam—destroy them? Or could they have survived into the modern era? To address these questions I have circled the Mediterranean twice since 1991 and time-traveled across six hundred years of history.

Along the way I confronted a host of ancient ghosts from famous emperors and politicians to theologians and general troublemakers. Although the quest incorporates rich texts and archaeological remains, the testimonies of two brilliant minds have contributed enormously to the cause. The first is Flavius Josephus, a Jewish priest of royal descent born in Jerusalem in AD 37. Josephus started the First Jewish Revolt as commander of the Jewish forces in the Galilee, but ended it as military adviser to the Roman emperor. For swapping sides and turning imperial informer, he remains vilified in many religious and political circles. Yet he was a realist who knew the game was up for his fellow revolutionaries. The iron fist of Rome could not be resisted.

After Vespasian's victory, Josephus set about memorializing the complete history of biblical Israel in *Antiquities of the Jews* and the *Jewish*

— XI —

Introduction

War. Both are rich mines of knowledge tapping incredible stories—fascinating and harrowing—about the social, military, and religious history of Palestine from the days of the Exodus from Egypt into the AD 70s.

My second major source spun his literary magic centuries later. Born in the late fifth century AD, Procopius of Caesarea in Palestine lived until around AD 562. His was a world of profound change, and he witnessed firsthand the end of classical antiquity and rise of the Byzantine "orientalist" era. As the court historian of the emperor Justinian (AD 527–565), in his *History of the Wars* Procopius wrote lively accounts of the empire's battles with Goths, Vandals, and Persians, and in *Buildings* he chronicled Justinian's colossal building program across the Mediterranean. Despite his formal position at court, however, in private the historian detested the emperor's immoral behavior and anarchic style of rule, and in the dark hours he penned a clandestine, venomous book. *The Secret History* lifted the lid on myriad scandals in embarrassing detail and, miraculously, still exists.

We don't know what Josephus or Procopius looked like. No portraits survive, only their words. Both historians are far less well known than the fifth-century BC word spinners Herodotus and Thucydides, but deserve equal billing as preeminent historical voices. I hope the reader will appreciate their fine attention to fact, yet their love of a good yarn as well.

God's Gold is a quest for truth. I have no political or religious ax to grind, no preconceived ideology to push. I write this as an objective archaeologist, historian, and humanist, not as a theologian. The reader will not encounter fanciful crypts and codes; more often than not the truth is more staggering than any fiction. Even the dramatized account of the destruction of Jerusalem in AD 70, described in chapter 1, "River of Gold," derives from factual detail in Flavius Josephus's *Jewish War.* (The only artistic license surrounds the export of the Temple treasures from the port of Caesarea.) This is no fairyland. All of the crazy, harrowing, and tragicomic events described in this book actually happened.

> Dr. Sean A. Kingsley London 2007

– XII —

ACKNOWLEDGMENTS

Like many of the most exhilarating moments in my life, the seeds of this book go back to my work as a marine archaeologist along the shores of the ancient harbor of Dor in Israel. For falling asleep in our archaeological lab one stormy day in 1991, shrouded in the Jerusalem Post, and for unwittingly revealing a letter on its pages about the Temple treasure of Jerusalem, I am grateful to Kurt Raveh for the seeds of this quest.

Numerous scholars have generously given various forms of academic advice during my quest: Géza Alföldy, Rupert Chapman III, Amanda Claridge, Frank Clover, Shimon Dar, Ken Dark, Jerome Eisenberg, Stefania Fogagnolo, Shimon Gibson, Richard Hodges, Dalu Jones, Paolo Liverani, Jodi Magness, Eilat Mazar, Peter Clayton, and David Stacey. For other forms of information, thanks to Shuli Davidovich at the Israel Embassy, London; Philippe Van Nedervelde of E-Spaces; and to Gershon Salomon in Jerusalem. The template of the map used in this book was provided by Vince Gaffney and Henry Buglass from the Institute of Archaeology and Antiquity, the University of Birmingham.

Eric McFadden and Italo Vecchi of the Classical Numismatic Group Inc. patiently answered endless questions about Roman coins and modern value equivalents. From Jerusalem, Ibrahim Raï (Abou George) carefully drove me into the West Bank and shared a fright for the cause.

Due to its politically and religiously controversial subject matter, this book was written under a veil of secrecy. For the necessary smoke screens, I offer apologies to all of the above.

— XIII —

Acknowledgments

At HarperCollins I am especially indebted to my editor, Claire Wachtel, for her guidance and faith in the book; special thanks also are extended to Lauretta Charlton, David Koral, and Muriel Jorgensen, for her hawk-eyed copyediting. Vivienne Schuster at Curtis Brown and George Lucas at InkWell Management have been beacons of support, enthusiasm, and advice. Special thanks are due to Josie Lloyd and Emlyn Rees for their ambassadorial generosity, and to Mark Merrony for reading and commenting on the text and for his friendship and encouragement. Dorothy King has also been generous and wise with her advice and support.

As ever, the highs and lows of writing are shouldered by family, and for their understanding, interest, and belief, endless thanks to Andrew and Sally. However, the star of this production is Madeleine Kingsley, a veritable Old Testament matriarch with unrivaled energy and passion, who read and advised on the manuscript with boundless enthusiasm despite huge pressures on her time. She is a source of constant inspiration. This book is for her and the family and roots she lost during the brutality of World War II.

Permissions to reproduce ancient sources have been kindly granted by Elizabeth Jeffreys (*The Chronicle of John Malalas*); Cyril Mango (*The Chronicle of Theophanes Confessor*); John Moorhead (*Victor of Vita*); and the Loeb Classical Library of Harvard University Press (*Ammianus Marcellinus III*, translated by J. C. Rolfe; Cicero X, translated by C. Macdonald; Pliny: *Natural History IV*, translated by H. Rackham; *Pliny: Natural History X*, translated by D. E. Eicholz; *Procopius of Caesarea: Buildings*, translated by H. B. Dewing). Very special thanks to Sebastian Brock for permission to reproduce from his unpublished translation of *The Khuzistan Chronicle*.

Full reference to these titles is provided in the select bibliography.

Every effort has been made to obtain reproduction permission for all titles in copyright cited in this book. The author and publisher will include any omission in subsequent reprints.

ABBREVIATIONS

AJ: Josephus, Antiquities of the JewsHVP: Victor of Vita, History of the Vandal

Persecution

JW: Josephus, Jewish War

Legends of the Jews: L. Ginzberg, Legends of the Jews, I-IV

On Moses: Philo of Alexandria, *Questions and Answers in Exodus*

Pro Flacco: Cicero X

Secret History: Procopius, The Secret History

Wars: Procopius, History of the Wars

- xv -

ROOTS

RIVER OF GOLD

I

Yet there was no small quantity of the riches that had been in that city [Jerusalem] still found among its ruins, a great deal of which the Romans dug up . . . the gold and the silver, and the rest of that most precious furniture which the Jews had, and which the owners had treasured up underground, against the uncertain fortunes of war . . . as for the leaders of the captives, Simon and John, with the other 700 men, whom he [Titus] had selected as being eminently tall and handsome of body, he gave order that they should be soon carried to Italy, as resolving to produce them in his triumph.

(JW 7.114-118)

Jerusalem was lost, its ashes returned to the soil that gave birth to the holiest city on earth an eternity ago. The end of the world was nigh just as the omens of impending doom had foretold. For months, strange portents had petrified the High Priests. A sword-shaped star hung over the great Jewish Temple; across Israel, chariots cavorted past the setting sun and armed battalions hurtled through the clouds. During the festival of Passover a sacrificial cow inexplicably gave birth to a lamb in the Temple court, surely the work of the devil. And finally the eastern gate of the Temple's inner court, crafted of bronze and so monumental that twenty men could hardly move it, opened of its own accord in the middle of the night. Terrified High Priests swore they heard the voice of God proclaim, "We are departing hence." The day was September 26

- 3 ---

Sean Kingsley

in the year 70, and Rome had just crushed the last drop of life out of the First Jewish Revolt of Israel.

Battleground Jerusalem was hell on earth, an inferno of blood, smoke, and tears. With typical Roman efficiency imperial troops razed the city. Fire consumed the Temple, one of the great wonders of the world. The holiest place on earth, where Abraham had prepared to sacrifice his son Isaac to the Lord, was an inferno. The graceful architecture of the 500-foot-long precinct—the largest religious forum of classical antiquity—was one immense fireball.

Satanic flames danced across stores of holy oil used in animal sacrifice, shooting columns of fire and thick plumes of smoke high into the night's sky. The air reeked with the stench of burning flesh. Some Jewish zealots had been put to flight, while the bodies of other Jewish revolutionaries lay piled across the altar steps of the Temple's Holy of Holies. As the corpses burned, the cedar roof crumbled and the goldplated ceiling crashed onto the elegant marble paving below, entombing the holy warriors.

All across the upper city, once home to the rich and famous of Jerusalem, fortunes were going up in smoke. Villas as opulent as any gracing the Bay of Naples, playground of Rome's aristocrats, fell to Titus's ruthless soldiers. No one had ever dared lock horns with the empire so brazenly. The result would be death and destruction.

Amid a landscape of Armageddon, the groans of hundreds of crucified Jews cut the night. Wooden crosses lined the streets as far as the eye could see. Roman soldiers maliciously taunted dying Jews with wine and beer; others downed food in front of famished prisoners who had not touched a morsel in days. The noose of the siege had strangled the city, and starvation alone would cause 11,000 deaths inside beleaguered Jerusalem. Jews over seventeen years old were chained together in readiness for the long march south to Egypt's desert, where forced labor awaited them in the imperial gold and granite mines; Jews under seventeen were simply sold into slavery.

And yet these were the fortunate minority: 1.1 million Jews were allegedly killed across Israel during the First Jewish Revolt. A further

- 4 ---

GOD'S GOLD

97,000 prisoners became fodder for gladiatorial games in the Roman provinces, butchered by sword or wild beast in the name of entertainment. Perhaps these "performers" would have preferred crucifixion rather than death in a distant land in front of a crowd of foreigners baying for blood in alien tongues they could not fathom. All across the Temple Mount, Roman troops flushed out the revolutionaries hiding in dunghills and the rat-infested underground passages honeycombing the Temple complex.

At the end of one of the bloodiest and most savage battles of history, Rome was getting high on the spoils of war. Rumors abounded that the Temple was stuffed with the most fabulous and rarest treasures in the world. Jews trying to desert the front line and escape Jerusalem had taken to swallowing gold coins in a desperate attempt to conceal their surviving valuables from the enemy. But following a tip-off, Romans soldiers and their Arabian and Syrian mercenaries had reveled in slicing open and disemboweling Jewish deserters. Even though Titus expressly forbade this barbarism, 2,000 Jews were dissected on one night alone. The hunger for war booty was intoxicating.

But this was just loose change. The vision of the Temple, plated throughout with gold, had inspired the Roman soldiers during ferocious battles. They rightly assumed its secret storerooms overflowed with wealth, and they were thrilled to find vast money chests, piles of garments, and other valuables within the treasury chambers. Since the Temple was a sanctuary both holy and fortified, many High Priests and aristocrats had transferred their own personal wealth to this supposedly secure repository over the months. Now as fire consumed the dry cedar timbers, the precious wall plating melted into a river of gold at the soldiers' feet.

While low-ranking Roman soldiers dreamed of a little plunder to soften the blows of a weary battle campaign and to impress their wives and families back home, their generals were privately negotiating a highly delicate deal to secure the greatest sacred treasure known to man. Inside the Jewish sanctuary lay items of immeasurable wealth and religious value, the very symbols of state passed down from generation to generation and locked away in the Temple's secret places.

— <u>5</u> —

Sean Kingsley

The High Priests knew they were cornered like rats in a sinking ship—nowhere to go other than into Roman chains or through the gates of heaven. So it did not take long for Titus to cut a deal with the priest Jesus, son of Thebuthi, who, in return for a royal pardon, handed over the wall of the sanctuary two candelabrums, along with tables, bowls, and platters, all crafted of solid gold. Next Jesus gave up the exquisitely woven veils that divided the Holy of Holies from the impure outside world, alongside the High Priests' belongings, precious stones, and many other religious objects used in public worship. Once taken prisoner, Phineas—the Temple treasurer—also disclosed purple and scarlet tunics and girdles worn by the priests, a mass of cinnamon, cassia, and other spices, as well as a mountain of treasures and sacred ornaments. Suddenly Titus and his father, the emperor Vespasian, were rich beyond their wildest dreams.

While Titus and his troops mopped up Jerusalem and jostled and joked about marching south to relax amid the luxuries of the great port city of Alexandria—with its baths, brothels, and fine wines from the shores of Lake Mareotis—the harbor of Sebastos at Caesarea witnessed an altogether different scene. A crack unit of two hundred army officers sped to Israel's chief port under a veil of secrecy. In the dead of night they slipped into the city by the back gate near the amphitheater and followed the shadows down to the shore. Only eighty years old, King Herod's harbor had been built from 22 to 10 BC to honor the emperor Augustus and as a port of call for Egyptian grain destined for Rome. With its streets of temples, vaulted warehouses, fountains, latrines, and inns, Sebastos was a bastion of *romanitas*—Rome away from home.

At the far tip of the breakwater, a fleet of warships was moored menacingly by the inner harbor. Rapidly and without ceremony, rugged officers lugged heavy straw baskets deep into the ships' holds—the Temple treasure of Jerusalem—as the remainder of the troops sealed off the area. After an hour of toil, the operation ceased as abruptly as it had started. The air was calm and windless; waves softly caressed the shore.

GOD'S GOLD

Suddenly, a procession of three priests swinging gold incense censers, accompanied by six generals, descended from the darkness of the Temple of Augustus and Rome fronting the port along the quay and carefully stepped up the gangway of the largest warship. "Lift anchor," barked a general clad in bronze breastplates embossed with the personification of the smiling goddess of victory, Victoria.

The ship's captain acknowledged the order by shining a bronze oillamp overboard. For a split second the pitch-black night was pierced, silhouetting a white-robed figure with a long priestly beard, clutching close to his chest a seven-pronged golden candelabrum. The spoils from the Temple of Jerusalem, razed not a week before, were on their way to Rome.

AWAKENINGS

A fierce storm ripped along the coast of Israel as I stood on the beach at the ancient port of Dor in May 1991. Just eight miles to the south, the ghostly outline and blinking lights of the power station at Caesarea hulked among the sea mist, close to the spot where King Herod's lighthouse once welcomed sea-battered sailors home to port. The howling wind and swirling sand threatened to take my head off. Cafés rushed to secure their shutters and villagers of the Carmel took to the roofs to escape rising rainwater. Even hardy Arab fishermen, who had spent all their lives on the moody Mediterranean Sea, dragged their boats high onto beaches and battened down their hatches. As they savored thick, muddy coffee from within a ruined Ottoman house they nodded wisely. This was one of the great storms that ravage this quiet backwater of the eastern Mediterranean once or twice a generation.

The storm meant bad news for me. After the First Gulf War ended following Saddam Hussein's invasion into oil-rich Kuwait, I had packed my snorkel, wet suit, and underwater camera to work as a marine archaeologist in Israel. I had cofounded the Dor Maritime Archaeology Project to explore ancient shipwrecks in the waters of Dor, a city of Canaanite origin perched on a rocky promontory midway between Caesarea and Haifa. This ancient port city is a well-kept secret hidden among a breathtaking landscape. Its tantalizing waters conceal myriad unanswered secrets about the ancient maritime world. The concoction

- 8 -

2

GOD'S GOLD

of rich history, archaeology, and outstanding natural beauty is magical; in a place like this you awake each morning tingling with excitement at the endless promise of a new day.

For several weeks I had dived the ancient sea-lanes, spending more time underwater than on land, scouring a seabed choked with ton upon ton of sand blankets that it would take lifetimes to remove by hand or even with the help of powerful airlifts, underwater vacuum cleaners. The underwater visibility was astonishingly clear but revealed only a desert of sand and shell. Frustrated, my project codirector and diving partner, Kurt Raveh, and I yearned to learn what lay beneath. Day after day we lived in hope of finding the preserved timbers of a Phoenician or Roman ship peering out of the sediments.

With growing impatience we watched the storm wreak havoc. I killed time in our laboratory, drawing the few fragments of Roman terra-cotta wine jars discovered so far. This was a long way to come for a bag of broken crockery, a very small return for a gamble in life at a time when my peers were climbing corporate ladders and socializing with fine foods and wines. Fidgeting over lost time, I pulled the back page off the *Jerusalem Post* Kurt had been reading before he fell into deep slumber on the office sofa.

While chilling spring winds made me shiver and dream of English fish and chips drenched in salt and vinegar, a small headline tucked away on the back page caught my attention. Israel's minister of culture had sent a formal letter to the Vatican demanding return of the Temple treasure looted from Jerusalem in AD 70. The Eternal City stood accused of deliberately imprisoning this national birthright deep in its dusty, centuries-old storerooms.

To my scientific mind, any idea that this treasure might have survived 2,000 years sounded frankly ludicrous—at least at first. After all, war and greed have robbed mankind of so many great artistic wonders of classical antiquity. The original Greek bronze statues fashioned by the master craftsmen Myron, Pheidias, and Polykleitos were largely melted down in antiquity. Where are the 120,000 talents of gold and silver, the enormous chests stuffed with jewels

Sean Kingsley

and gold that Alexander the Great looted from Persepolis in Iran in 330 BC? What happened to these spoils after they were carried away on 10,000 mules and 5,000 camels, according to the ancient writers Diodorus Siculus and Plutarch? The once fabulously wealthy interiors of the Greeks' treasuries, *thesauroi*, uncovered at the oracles of Delphi, Olympia, and Gela are all barren today. Why should Jerusalem's loot be any different?

The storm waves still pounded the shore and lightning illuminated pewter gray skies—plenty of time for a little mental excavation and welcome distraction. From my years of studying classical civilizations, a distant bell rang in my head as I recalled a historical reference to this very treasure being showcased by the emperor Vespasian in a triumph in Rome following the bloody subjugation of Palestine. Pen in mouth I pulled a dog-eared copy of Flavius Josephus's *Jewish War* from the dusty lab shelf.

Some of the detail that Josephus describes, particularly statistics, has to be taken with plenty of pinches of salt. But as Kurt snored and fishermen played cards in ruined shacks along the shore, I read how in AD 71 looted silver, gold, and ivory ran along the streets of Rome like a river of wealth. Pageants on floats up to four stories high reenacted the bloody siege of Jerusalem, with the Temple on fire and ships clashing in sea battles. Meanwhile, humiliated Jewish military leaders were dragged in chains in front of the triumphant emperor and son.

According to Josephus, the most impressive moment was the passing of the Temple spoils: a heavy golden table and a seven-branched golden candelabrum (menorah). As the triumph reached its conclusion at the Temple of Jupiter Capitolinus, a silence gripped the crowd as Simon, son of Giora and commander of the Jewish revolt, was executed in the Forum.

Amazingly, Josephus explicitly tells us that once the excitement of the triumph died down:

Vespasian decided to erect a temple of Peace. This was very speedily completed and in a style surpassing all human concep-

GOD'S GOLD

tion. For, besides having prodigious resources of wealth on which to draw he also embellished it with ancient masterpieces of painting and sculpture; indeed, into that shrine were accumulated and stored all objects for the sight of which men had once wandered over the whole world, eager to see them individually while they lay in various countries. Here, too, he laid up the vessels of gold from the temple of the Jews, on which he prided himself. (*JW* 7.158–161)

This revelation made my senses tingle. A wave of adrenaline shot through my body. Could this report be historically accurate, or was it the kind of hyperbole of which Josephus is so often guilty? Did the holy treasures of Herod's Temple find a home in the Eternal City? If so, were they eventually melted down for liquid capital? If not, what was their fate during the fifth-century Gothic and Vandal invasions? Could they even still survive today?

The very idea was exhilarating. If true, the implications for humanity were enormous. Not only would this treasure be worth a king's ransom of hundreds of millions of dollars, but as the symbolic insignia of a people lost and found—Judaism and the modern state of Israel—the political implications were highly sensitive, even dangerous.

The following day the skies cleared and the sea ceased to swirl. We dived eagerly and found that ten-foot-deep sand blankets covering the seabed had been blasted away by the force of a thousand sea horses in a single storm, exposing parts of Dor's ancient harbor floor never before seen by the human eye.

Throughout those heady spring and summer days we found twelve shipwrecks along a 260-foot-long stretch of seabed—the richest concentration in the eastern Mediterranean—recovering a fifth-century BC Greek war helmet, Roman bronze bowls, and, gratifyingly, the noble timbers of those elusive Late Roman wooden hulls. I got my hands on more ancient pottery than I could ever have wished for. To my corporate friends this may have looked like old garbage, but to me it was living history, a vast jigsaw puzzle that had important historical stories to tell. In those days I wouldn't have swapped my museum of broken

— II —

Sean Kingsley

pots for a case of champagne. As I lived through the most invigorating time of my life, recording the archaeology, participating in television documentaries, and writing articles, the riddle of Titus, Josephus, and the case of the missing Jewish treasure was relegated to a back drawer of my mind for ten long years—stored away germinating, but never erased from memory. 3

GHOSTS OF ISRAEL PAST

Strange how past memories resurface when you least expect. By 2001 I had swapped my face mask and wet suit for reading glasses and a smart suit to edit *Minerva*, the International Review of Ancient Art and Archaeology. Fighting crowds to work in London's West End was a very long way from those heady days of shipwreck exploration in Israel.

Each morning I would ritually savor my first cup of life-sustaining coffee while scanning the latest newspaper clippings for ancient ruins making the news. As a familiar time traveler into antiquity, most of the stories that found their way into the papers were old news to me; hot discoveries were rare. However, I was always alert for an exception to the rule that might give us a scoop over the magazine competition.

One memorable day in August 2001 I spluttered on my coffee, and my eyes nearly popped out of my head as I read a story publicizing the opening of the Blood and Sand in the Colosseum exhibition in Rome. The Amphitheatrum Flavium, as it was originally called, was one of the engineering wonders of classical antiquity, a four-story entertainment facility started by the emperor Vespasian in AD 72 and finished by his son, the emperor Titus, in AD 80. When complete, the Colosseum boasted eighty entrances, was 620 feet long, 158 feet high, seated fifty thousand people, and was by far the largest amphitheater of the Roman Empire. The noise and atmosphere generated by this stone theater of death must have been terrifying, unlike any of today's comparatively

- 13 -

tame entertainment facilities, even Madison Square Garden on a world championship boxing night.

To the side of the Colosseum's main entrance is a massive marble lintel that once spanned a major passageway. Until very recently it lay idly on the ground, neglected by the 3 million visitors passing by each year. Ancient relics like these simply litter Rome. However, this turned out to be no ordinary stone. Since 1813 historians have been familiar with a Latin inscription running across its front surface referring to a restoration of the Colosseum sponsored by Rufius Caecina Felix Lampadius in AD 443–444, interesting and useful in its own right for working out the complex surgery that this monument has been subjected to over the decades.

Far more compelling, though, are a series of sixty-seven small holes studded across the lintel's surface, half an inch deep, that originally pegged in position bronze letters from a far earlier inscription. Once Lampadius decided to reuse this piece of architecture, the original bronze letters were melted down. So today all that remain are the empty holes from this earlier "phantom" inscription.

On that stifling summer's day in August 2001, in an office down Old Bond Street, I was intrigued to read how Professor Géza Alföldy from the University of Heidelberg, an expert in so-called ghost epigraphy, had reconstructed three lost lines of Latin beneath the fifth-century inscription:

IMP(ERATOR) T(ITUS) CAES(AR) VESPASIANVS VG(VSTVS) Amphitheatrvm Novvm Ex Manvbis Fieri IVSSIT

The importance of this inscription, dating to AD 79, far exceeds the massive weight of the lintel, and can be translated as:

The Emperor Titus Caesar Vespasian Augustus ordered the new amphitheater to be made from the (proceeds from the sale of the) spoils.

GOD'S GOLD

Titus never served as a general before going to war in Judea where he earned his spurs, so the *manubiae* (spoils) can only have been those plundered from the Temple of Jerusalem in AD 70.

The looting of Jerusalem must have had a huge impact on Rome's economy. The holy Temple was a massive gold mine. This lintel, a living piece of history that has endured the centuries, was clear confirmation that Josephus had been reporting fact all along. Jerusalem's treasures did make it to Rome, impacting powerfully on the everyday landscape not only of the pagan city of antiquity but also the contemporary skyline.

The success of Vespasian and Titus over the First Jewish Revolt of Israel had brought the empire spoils beyond its wildest dreams, exceeding the exploits of all of Rome's celebrated rulers. Just how much of Flavian Rome was built from Jewish blood money? Josephus leaves us in no doubt of the enormity of the windfall:

So glutted with plunder were the troops, one and all, that throughout Syria the standard of gold was depreciated to half its former value. (JW 6.317)

The cities and towns of the Near East were simply saturated with Temple gold and, as the Colosseum's phantom inscription verifies, Vespasian's slice of the bounty was easily sufficient to sponsor the grandest entertainment facility the ancient world had ever boasted. Recent estimates put the cost of the Colosseum's foundations alone at \$55.6 million of today's money (excluding labor, drainage, and any superstructure). The end product must have been closer to \$195 million. The enormity of the Temple treasure was also sufficient to bankroll the foundations of the entire Flavian dynasty (AD 69–96) from Vespasian to Domitian. The economic windfall of the looting of the Temple in Jerusalem is estimated to have brought the treasury of Rome an immense fifty tons of gold and silver.

As I grappled with this exciting revelation, I recalled the shores of Dor and the ferocious storm of May 1991. Now intrigue had been replaced by scientific curiosity. When I contacted Professor Alföldy to congratulate him on his discovery and confirm a few details, his reply

- 15 -

Sean Kingsley

was modest but telling: "Now we know what happened with this immense booty."

By the end of the same week I had completed and submitted a short article in *Minerva* titled "The Roman Siege of Jerusalem and Fate of the Spoils of War." Once again I was consumed by curiosity, not so much amazement and awe at the scale of the treasures as a resolute determination to know precisely what happened to the mighty gold candelabrum, the Table of the Divine Presence, and the silver trumpets looted from Jerusalem—one of the greatest and most important lost treasures of history. My mind was in turmoil. I couldn't sleep. I would have liked to close the offices of *Minerva* then and there to head straight to Jerusalem and Rome in search of answers. But reality bit and magazine deadlines pressed.

Intrigue had turned into an obsession. Already I found myself processing the lost Temple treasure story through a critical series of scientific filters. Why did Rome destroy King Herod's Temple in Jerusalem in AD 70? Was it done deliberately or just as an unavoidable by-product of war? If the Jewish loot really made it to Rome, did it survive the decline and fall of the Roman Empire in the fifth century? When did the gold candelabrum—symbol of a displaced civilization—finally disappear from the pages of history?

With so many unanswered questions, I pledged to unravel the truth about one of the most important, yet neglected, stories of history. During the next four years I would circle the Mediterranean twice on this quest, visiting four of the greatest cities of antiquity—Jerusalem, Rome, Carthage, and Constantinople—clarifying some questions, burying others as red herrings, and uncovering a web of facts more startling than any work of fiction. The journey drew me to dangerous places and people that reminded me of the archaeological proverb: treasure is trouble. 4

EXODUS AND EXILE

Inspired in 2001 by the revelations of the Colosseum's phantom inscription, I itched to jump on a plane and head for the Eternal City. Just as all roads led to Rome 2,000 years ago, so the threads of the Temple treasure now seemed to converge there. Preliminary research flagged Rome as the crucial link in the disappearance of the Jewish spoils—the Temple of Peace seemed to be the last place where they were spotted in public. Or so I thought at the time.

But for now I would have to resist the lure of Rome. First, I needed to separate fact from fiction amid the epic story of the empire's destruction of Israel in AD 70. At the moment the quest felt abstract: I was hunting down a monumental treasure without having clearly unraveled why Rome had attacked Israel in AD 66 and how the war unfolded.

If I was going to track down the Temple treasure of Jerusalem successfully, I needed to evaluate its physical, spiritual, and monetary value to the Roman Empire and the Jews of ancient Israel. Without creating an historical, political, and psychological profile, the spoils would lack context. Imagine investigating a murder scene without dusting for fingerprints or taking samples for DNA analysis. You would have no forensic evidence—case closed. My attitude toward the Temple treasure was exactly the same.

I needed to turn the clock back to the moment when the Temple fell, to reconstruct the final weeks of the siege and assess Titus's rationale for razing Jerusalem. Had he plotted with his father, the emperor

— I7 —

Sean Kingsley

Vespasian, to deliberately burn down the Temple so they could stuff the imperial coffers with Jewish blood money? If so, perhaps they liquidated all of the treasure. After the great fire of Rome in AD 64, the Eternal City was certainly an eyesore badly in need of a face-lift. Did the Temple treasure pay for these renovations?

In art and literature the image of the Temple treasure of Jerusalem has assumed legendary status. Steven Spielberg and George Lucas famously presented the Ark of the Covenant as an omnipotent force of divine power in *Raiders of the Lost Ark*, capable of wiping out Nazi units at the lift of a lid. In this profile the movie moguls were deeply inspired by the ark's biblical military prowess against enemies of the Israelites. More recently, *National Treasure* saw Nicolas Cage successfully hunt down Solomon's treasure beneath the sewers of New York.

A few books have flirted with the theme of Jerusalem's Temple treasure but, astonishingly, without defining its character. Rennes-le-Château in southern France has long been a stomping ground for conspiracy theorists wondering how the local parish priest, Bérenger Saunière, got his hands on vast riches around 1885. But books such as Guy Patton and Robin Mackness's Sacred Treasure, Secret Power: The True History of the Web of Gold (2000) make no attempt to define the treasure they seek. How can you hope to find, let alone understand, such a treasure on this basis? Elsewhere, the eccentric spiritual leader of the Parker Expedition to Jerusalem in 1909-1911, Valter H. Juvelius, anticipated discovering riches beyond his wildest dreams beneath the Temple Mount: a \$200 million treasure hidden away when King Nebuchadnezzar conquered Jerusalem and destroyed Solomon's Temple in 586 BC. Following nocturnal probing of the Dome of the Rock, local rumor ran wild with speculation that the Crown and Ring of Solomon, the Ark of the Covenant, and the Sword of Muhammed had all been plundered. They hadn't. But what artistic wonders did the Temple really conceal in AD 70?

Truth is a rare commodity in the zealous world of treasure hunting, where the fertility of the human mind finds the perfect playground. This is a field where clairvoyants are known to swing rings over maps

to locate shipwrecked treasure and where virtually any method is employed in the pursuit of glory. Far from being restricted to Western greed, treasure hunting was already common in nineteenth-century Palestine. Writing in *Pictured Palestine* in 1891, James Neil colorfully described a common tendency to hide wealth in the ground in an Ottoman world where banks and security of property were unavailable:

All that is not turned into jewellery and worn by the women on their persons is hidden in the ground. . . . The owner of such buried treasure, until at his last gasp, will seldom if ever reveal the secret hiding-place even to his wife, and therefore when he dies suddenly or among strangers, his secret dies with him. Hence the country, through thousands of years, has come to be honeycombed with hidden treasures. In consequence of this, there has arisen a class of men who, like gamblers, abandoning their proper calling, and often neglecting their families, spend almost their whole life in wandering about to seek out buried property. . . .

One class of treasure-hunters are called *Sahiri*, or "Necromancers." Their method of procedure is to seek out certain nervous and highly-sensitive individuals, who are credited with the faculty of perceiving objects concealed under ground, or in any other place of hiding.

In *Domestic Life in Palestine* (1862), Mary Eliza Rogers explained how the medium was coerced to pronounce:

But the faculty is only active when raised by the influence of necromantic ceremonies, which are understood by the professional treasure-seeker. He properly prepares the medium, and calls into full activity the visionary power; then, in obedience to his command, the hiding-places of treasures are said to be minutely described. On being restored to the normal state, the medium does not remember any of the revelations which may have been made. The practice of this art is considered *haram*, that is, "unlawful," and is carried on secretly. . . . Those people of whom I made enquiries on the subject spoke with fear and trembling, and mysteriously whispered their explanations.

- 19 -

Just what riches these speculators hunted down in the soils of Palestine will never be known. In reality, however, the various methods initiated to track down the Temple treasure of Jerusalem have turned up nothing more to date than old horseshoes. To seek the Temple spoils or to write about their effects on later history, without determining what these treasures actually consisted of, is to construct a house of straw.

U nraveling the mystery of the Temple treasure of Jerusalem hinges on two points in time, historical periods that could not be more culturally different. The first is the biblical story of the Exodus, when proto-Israelite groups wandered in the wilderness of Sinai around the end of the thirteenth century BC before establishing a Jewish homeland in Israel. The second fixed point dates to AD 81, when the Arch of Titus was built on the summit of the Sacred Way in Rome's Forum. The scene depicted in its remarkable wall relief is the equivalent of a detailed photograph of its age. Some form of table is carried at shoulder height on wooden poles; two cylindrical trumpets with flaring mouths are tied to its frontal plane. Behind, a seven-branched candelabrum is marched conspicuously through an archway. But what connects these two moments in time, the first from the dawn of organized religion, the second associated with the peak of pagan worship and the zenith of Roman civilization?

The answer is God's detailed instructions to Moses about the formation and doctrine of Judaism in the biblical book of Exodus. Here the first record of the dominant symbols of the Jewish faith are plucked out of the thin air to become constant beacons of faith for the next 3,500 years. If you want to try to fathom the composition of the Temple treasure of Jerusalem in AD 70, you have to focus on the Arch of Titus. But to set the spoils depicted in an accurate context, you must start with Exodus. Only in this way is it possible to determine whether the Arch of Titus menorah, table, and trumpets were original heirlooms passed down the centuries or products of the Roman era.

In the book of Exodus, the central tenets of First and Second Temple Judaism (tenth century BC to late first century AD)—sacrificial

worship based around a single "temple," commandments, and objects of worship—emerge in fully developed form. The language used is precise, leaving no room for error. For instance, two one-year-old lambs must be sacrificed daily, one in the morning and one in the evening, offered with one-tenth of choice flour mixed with one-fourth beaten oil and one-fourth of wine (Exodus 29:38–46). During his lengthy dialogue with God on Mount Sinai, Moses was bombarded with information—the prophet must have possessed a fine memory.

Exodus 25:1-9 instructs:

The Lord said to Moses . . . Tell the Israelites to take for me an offering; from all whose hearts prompt them to give you shall receive the offering for me. . . . And have them make me a sanctuary, so that I may dwell among them. In accordance with all that I show you concerning the pattern of the tabernacle and all its furniture, so you shall make it.

Even though the Tabernacle was only a glorified portable reed tent inspired by Late Bronze Age architecture-essentially little more physically than those gracing Bedouin camps today-from the very beginning it was furnished with fine art and precious metals. The Ark of the Covenant, for instance, was decorated with two gold cherubim with spread wings (Exodus 25:18-20), and the Court of the Tabernacle contained twenty pillars and twenty bases of bronze to the south, covered with silver bands and beads (Exodus 27:10-11). The sanctuary also featured a bronze basin and washstand to maintain the cleanliness of Aaron and his priestly sons. A central feature of early Judaism, ritual purity, is also embedded within the religion from the very beginning: "They shall wash their hands and their feet, so that they may not die: it shall be a perpetual ordinance for them, for him and his descendants throughout their generations" (Exodus 30:21). The dazzling array of mikvaot-ritual cleansing pools-surrounding the ancient site of Qumran on the shore of the western Dead Sea, not to mention those scattered behind the Temple Mount today, attest to the longevity of this religious observance.

- 21 -

Equally remarkable were the demands for priestly clothing passed down to Moses, which offer a startling insight into the wealth associated with the central Jewish sanctuary throughout the ages. These were lavishly decorated, making the High Priests literally shine in the presence of God:

You shall make a breastplate of judgment, in skilled work . . . of gold, of blue and purple and crimson yarns, and of fine twisted linen. . . . You shall set in it four rows of stones. A row of carnelian, chrysolite, and emerald shall be the first row; and the second row a turquoise, a sapphire, and a moonstone; and the third row a jacinth, an agate, and an amethyst; and the fourth row a beryl, an onyx, and a jasper; they shall be set in gold filigree. There shall be twelve stones with names corresponding to the names of the sons of Israel. . . . You shall make for the breastplate chains of pure gold, twisted like cords. . . . So Aaron shall bear the names of the sons of Israel in the breastplate of judgment on his heart when he goes into the holy place, for a continual remembrance before the Lord. (Exodus 28:15–29)

From the elaborate essence of Exodus, the word of God offered vast opportunities for architectural and artistic embellishment over time. If you accept the Bible verbatim, the tenth century BC witnessed a watershed in building and an economic boom for the fledg-ling nation of Israel. At this time, "Judah and Israel were as numerous as the sand by the sea; they ate and drank and were happy. Solomon was sovereign over all the kingdoms from the Euphrates to the land of the Philistines, even to the border of Egypt" (1 Kings 4:20–21). With his mighty 40,000 stalls of horses for his chariots and 12,000 horsemen, this wisest of ruler was lord of all he surveyed.

The First Temple built by King Solomon was one of the wonders of the age. Enormous financial resources were invested in the new sanctuary and political alliances exploited to turn a dream into reality. King Hiram of Tyre arranged for Lebanese cedars to be floated down the Mediterranean Sea to Israel in return for annual tribute of 20,000 cors of wheat and 20 cors of fine oil (1 Kings 5:23–25). Solomon sent shifts

- 22 -

of 10,000 people into Lebanon each month to speed up the construction business, and dispatched 70,000 laborers and 80,000 stonecutters into the hill country of Judea.

The Bible describes Solomon's Temple as 60 cubits long and 20 cubits wide (100 x 33 feet), with a timber inner sanctuary overlaid with pure gold. Much of the cedar wood was sculpted with cherubim, palm trees, gourds, and open flowers, while the floor of the inner and outer rooms was again overlaid with gold. The entrance door to the inner sanctuary repeated the same decorative scheme, but this time the artwork was overlaid with gold (1 Kings 6:2–20, 29–32). The Temple sounds as if it must have been a major drain on regional gold resources, mined in the legendary land of Ophir—probably either Ethiopia or Yemen:

Solomon overlaid the inside of the house with pure gold, then he drew chains of gold across, in front of the inner sanctuary, and overlaid it with gold. Next he overlaid the whole house with gold, in order that the whole house might be perfect. (1 Kings 6:21–22)

Mirroring the Tabernacle sanctuary of the wilderness, the king also housed two monumental gilt-veneered olive wood cherubim within the inner sanctuary, each 16 feet wide (1 Kings 6:23–28). The bronzes adorning the Temple were equally staggering. Hiram the bronze-worker of the tribe of Naphtali, resident in Tyre, was commissioned to cast two bronze pillars in the Temple vestibule known as Jachin and Boaz. Each was 30 feet high and 20 feet wide. Two vast bronze capitals capped each pillar, each 8.2 feet high and decorated with 200 bronze pomegranates (1 Kings 7:15–22). Next Hiram crafted the "cast sea," essentially a 16foot-wide cauldron that could hold the equivalent of 2,000 baths, with a brim shaped like the flower of a lily standing on twelve cast oxen (1 Kings 7:23–26). This was accompanied by ten bronze basins, each capable of holding the equivalent of forty baths (1 Kings 7:38). Finally, the master craftsman modeled ten bronze stands decorated with lions, oxen, and cherubim, each standing on four bronze wheels (1 Kings

- 23 -

7:27-37). To these artistic masterpieces were added the treasures of King David.

King Solomon was one of the most celebrated characters of history, a powerful ruler of proverbial wisdom and a master builder. For these reasons he has become a victim of his own success, with popular perception immediately linking images of the Temple treasure to this man. Such a view, however, has to surmount two major pitfalls. First, extensive archaeological exploration conducted across Jerusalem and the surrounding hills has failed to produce one iota of evidence for a ruler called Solomon or, more worryingly, for monumental tenth-century BC building operations. If Jerusalem was really inhabited at this time, then the very meager pottery unearthed proves it can only have been a small, rural village and hardly the epicenter of a magnificent United Monarchy. This image is completely at loggerheads with the Bible's elaborate description of major urban development.

Second, and equally conclusive, the Bible paints a vivid canvas of severe political and cultural disruption in sixth-century BC Jerusalem, when Israel was dismantled. As Israel was ransacked by the generals of King Nebuchadnezzar of Babylon, the superpower of the day, the religious symbols of Judaism were deliberately destroyed—at least according to the main biblical tradition. Thus, 2 Kings (24:13–15) emphatically narrates Nebuchadnezzar

carried off all the treasures of the house of the Lord, and the treasures of the king's house; he cut in pieces all the vessels of gold in the temple of the Lord, which King Solomon of Israel had made. . . . He carried away all Jerusalem, all the officials, all the warriors, ten thousand captives, all the artisans and the smiths; no one remained except the poorest people of the land.

The plunder of the wealth of Jerusalem's Temple, it is safe to say, was comprehensive.

As emphatic as the reports relating to the timing and effects of these events seem to be, later testimony clouds the matter. For some deliber-

- 24 -

ate reason the Bible crosses wires to contradict itself over the fate of the Temple treasure. Rather than having it completely destroyed and melted down for reuse in Babylon, Ezra (1:7–11) announces a completely different set of circumstances whereby, in 538 BC, King Cyrus of Persia handed the exiled Jews their freedom and returned the Temple treasures:

King Cyrus himself brought out the vessels of the house of the Lord that Nebuchadnezzar had carried away from Jerusalem and placed them in the house of his gods. King Cyrus of Persia had them released into the charge of Mithredath the treasurer, who counted them out to Sheshbazzar the prince of Judah. And this was the inventory: gold basins, 30; silver basins, 1,000; knives, 29; gold bowls, 30; other silver bowls, 410; other vessels, 1,000; the to-tal of the gold and silver vessels was 5,400. All these Sheshbazzar brought up, when the exiles were brought up from Babylonia to Jerusalem.

Written at least one hundred years later than the book of Kings, Ezra is a case of wishful thinking, clever political propaganda designed to give Israel the noble epic history it deserved. Over time even this version of repatriation was replaced by vividly overimaginative Late Roman and medieval legends that sought to emphasize the survival myth of Solomon's treasure. One source supposes that the vessels were entrusted to the prophet Jeremiah, under whose protection the Ark of the Covenant, the altar of incense, and the "holy tent" were carried by an angel to Mount Sinai. There, Jeremiah concealed the vessels in a large cave. Another medieval tradition places Solomon's Temple treasure under a stone next to the grave of Daniel (of lion's den fame) at Shushan in Persia. Legend states that anyone trying to remove the stone fell dead; people digging near the spot were crushed by a storm, or so the story goes.

The tale of the concealment and preservation of the Temple vessels during the exile into Babylon became increasingly embellished and dramatic down the centuries. One intriguing legend preserved among a

— 25 —

wealth of medieval folklore vividly portrays the fantastic dimensions to which the story had swollen. As a unique document of messianic hope and projection, it deserves quoting at length:

Even the temple vessels not concealed by Jeremiah were prevented from falling into the hands of the enemy; the gates of the Temple sank into the earth, and other parts and utensils were hidden in a tower at Baghdad by the Levite Shimur and his friends. Among these utensils was the seven-branched candlestick of pure gold, every branch set with 26 pearls . . . and 200 stones of inestimable worth. Furthermore, the tower at Baghdad was the hidingplace for 77 golden tables, and for the gold with which the walls of the Temple had been clothed within and without. The tables had been taken from Paradise by Solomon, and in brilliance they outshine the sun and the moon, while the gold from the walls excelled in amount and worth all the gold that had existed from the creation of the world until the destruction of the Temple.

The jewels, pearls, gold, and silver, and precious gems, which David and Solomon had intended for the Temple, were discovered by the scribe Hilkiah, and he delivered them to the angel Shamshiel, who in turn deposited the treasure in Borsippa. The sacred musical instruments [trumpets] were taken charge of and hidden by Baruch and Zedekiah until the advent of the Messiah, who will reveal all treasures. In his time a stream will break forth from under the place of the Holy of Holies, and flow through the lands of the Euphrates, and, as it flows, it will uncover all the treasures buried in the earth. (*Legends of the Jews* IV.321)

Here, in fully romanticized form, the description of the gold candelabrum departs from the concise biblical version to stud the artefact with all manner of precious stones. The original narrative is now overlain with glorious fantasy to evoke a dreamlike myth of hope for the communities of the Diaspora, tenuously peering back through the mists of time for a bridge to Temple days that might offer comfort amid the religious persecutions of contemporary medieval life.

Such rich folklore is fascinating in its own right, important documentation revealing the psychological condition of medieval Jewry. Yet

- 26 -

it is also undoubtedly fantasy with no historical bearing on the true movements of Solomon's Temple treasure. At no point does the Old Testament pretend that the major vessels of faith—the menorah, Showbread Table, and trumpets—were returned to Jerusalem in the reign of King Cyrus of Persia. On balance, every shred of evidence dovetails to suggest that if it really ever existed, the treasures of the First Temple went up in a puff of smoke during the sixth-century BC destruction of Jerusalem. So when and in what context did the treasures of Herod's Temple emerge?

HEROD'S TREASURE CHEST

5

To define the unique character of the Temple treasure plundered by Rome in AD 70, and crassly paraded along its streets a year later, we must leave behind the murky world of Iron Age Palestine. Sifting through the texts, one specific event emerges as a defining moment that dictated its composition. In the second century BC the borders of Palestine were creaking against the pressures of a regional power struggle. Palestine was a geographical jewel, a land and sea bridge linking Egypt and the Far East with the northern Mediterranean. Control Palestine and you controlled the entire eastern Mediterranean basin and the world beyond—lucrative caravan routes heading into Arabia and over the horizon to the Indies. Not without reason, in 1799 Napoleon Bonaparte's chief of staff still dubbed Palestine "the key to the East."

Just before the mid-second century BC, Egypt and Syria were at loggerheads over Israel, and the ruling elite of Judea exploited the hostile political circumstances to try to bring about internal regime change. At the same time as the Syrian overlord Antiochus IV was quarreling with Ptolemy VI of Egypt over control of greater Syria, in Jerusalem the High Priest Onias III cast the sons of Tobias, political enemies, from the city gates. Aware of the territorial squabble between Egypt and Syria, the sons of Tobias fled to Antiochus and petitioned the king to appoint them his client rulers, a policy that suited his intention of Hellenizing all of Syria.

Antiochus was spoiling for a fight and eagerly exploited this op-

- 28 -

portunity to attack Jerusalem with a mighty force, which triggered a blood bath against Ptolemy's supporters in 169 BC. Writing some two hundred years after the event, Josephus confirmed that the king "also spoiled the temple, and put a stop to the constant practice of offering a daily sacrifice of explation for three years and six months" (JW 1.34).

The sons of Tobias proved to be naive political pawns and had no clue that they were being exploited as dispensable puppets in a more brutal realpolitik. In any event, the schemers' dreams backfired. Rather than support his Jewish "allies," in December 167 BC Antiochus forced the Jews to dissolve their laws, defiled the Temple by ordering sacrifices to pigs, and forbade circumcision. The seditious sons of Tobias thus paid dearly for presuming the wider war for world domination cared a fig about religious sensitivities.

In Antiquities of the Jews, Josephus explained Antiochus's megalomania as inspired by pure greed, and described the looting in detail. The king backstabbed the sons of Tobias,

on account of the riches that lay in the temple; but, led by his covetous inclination (for he saw that there was in it a great deal of gold, and many ornaments that had been dedicated to it of very great value), and in order to plunder its wealth, he ventured to break the league he had made. So he left the temple bare, and took away the golden candlesticks, and the golden altar [of incense], and table [of showbread], and the altar [of burnt offering]; and did not abstain from even the veils, which were made of fine linen and scarlet. He also emptied it of its secret treasures, and left nothing at all remaining; and by this means cast the Jews into great lamentation. (*AJ* 12.249–250)

Not for the first time in history the Jews proved convenient scapegoats, on this occasion taking the backlash for Antiochus's impotence in failing to outmaneuver Ptolemy VI of Egypt. The Syrian king proceeded to burn the Lower City of Jerusalem, torch the sacred books of Jewish law, and strangle circumcised children. The bodies of murdered sons were hung around the necks of crucified fathers and 10,000 men were enslaved (AJ 12.251–56). Here was Jerusalem's Kristallnacht,

- 29 -

2,100 years before the Nazis ethnically cleansed the streets of Germany's Jewish minority.

The bloody actions of Antiochus guaranteed that no Temple treasures survived in Jerusalem after the year 167 BC. The Bible reinforces the historical reality of this event with complementary written evidence that the gold candelabrum, Table of the Divine Presence, and all other treasures were seized and taken to Syria (1 Maccabees 1:21–24; 2 Maccabees 5:16).

Following three years of religious persecution, Jerusalem was recaptured by the Maccabean dynasty, a family of priestly descent from Modi'in in the outskirts of the Holy City. After Matthias defeated Antiochus and expelled the Syrian, his son, Judah Maccabee, returned Israel to Temple worship:

He then got the temple under his power, and cleansed the whole place, and walled it round about, and made new vessels for sacred ministrations, and brought them into the temple, because the former vessels had been profaned. He also built another altar, and began to offer the sacrifices. (JW 1.39)

The Bible confirms the creation of "new Holy vessels" and dates the rededication to 25 Kislev 164 BC. Soon after, Judah rebuilt the Temple sanctuary and consecrated the courts (1 Maccabees 4:48–49). In memory of this famous victory, the Maccabees "decorated the front of the temple with golden crowns and small shields" (1 Maccabees 4:57). Yet in an ironic twist of fate, Josephus hints that Judah's success was supported by an alliance with a new political power whose voice was starting to rumble across the Mediterranean Sea: the Romans. At the very moment when Israel was refounded and the Temple rededicated, the seeds of its eventual demise were sown.

The ferocity of Antiochus IV Epiphanes ensured that any Temple spoils plundered by Titus from the Temple in AD 70 must postdate 164 BC. Between these two chronological stepping stones, the Temple of Jerusalem experienced a golden age. As the central religious institu-

- 30 -

tion of Judaism, it received a level of patronage unparalleled in preceding centuries. We will never know exactly what Titus and his generals found sparkling within the treasure chests of the Temple Mount. No inventory survives and I doubt that anyone outside the inner circle of High Priests really knew exactly what wealth the Temple had amassed.

Over the centuries, kings, generals, and the ordinary farmer alike offered donations varying from the magnificent to the humble. And as history ebbed and flowed, passing despots and greedy rulers seized parts of the national wealth of the Jews. From time to time ancient writers illuminated this complex tapestry, giving a flavor of the river of gold lying within the sanctuary in the first century AD.

The central vessels of worship were certainly safe and sound in 63 BC, when Pompey the Great and his entourage invaded Jerusalem on the pretense of resolving the civil war between two brothers of the ruling Jewish Hasmonean dynasty, Hyrcanus and Aristobulus. There, they "went into the temple itself, whither it was not lawful for any to enter but the high priest, and saw what was reposited therein, the candlestick with its lamps, and the table, and the pouring vessels, and the censers, all made entirely of gold, as also a great quantity of spices heaped together, with 2,000 talents of sacred money" (JW 1.152).

Back in Rome, Pompey undoubtedly boasted about how he had demonstrated Rome's greatness over the god of the Jews by violating the Holy of Holies. So when Crassus was later appointed governor of Judea, he took the opportunity in 51 BC to remove the Temple gold and 2,000 talents untouched by Pompey to cover the costs of a military expedition against the Parthians.

Only in its final century of its existence did the Temple of Jerusalem become one of the greatest wonders of antiquity. Eager to cement a reputation as one of the supreme leaders of the Mediterranean world, during his rule from 37 to 34 BC, King Herod was obsessed with ambitious building projects. With his network of royal palaces at Caesarea, Herodium, Jericho, and Machaerus, the king established a reputation as a man of immense wealth and style. By building the world's first deepwater artificial port, and naming it Sebastos, the

31 -

Greek for Augustus, the king proved the depth of his allegiance to his Roman masters. Herod was the perfect client king for safeguarding the economic and political interests of the empire. And to appease the local population, around 20 BC he initiated the most ambitious building plan in the entire Near East—the redesign and rebuilding of the great Temple of Jerusalem.

The Temple would be Herod's crowning glory, a perpetual memorial of his omnipotence. Even though it is this Temple, generally referred to as the Second Temple (although more accurately a third sanctuary after those of Solomon and Zerubbabel), that went on to inspire generations of world religions, politicians, artists, and poets, not one contemporary artistic representation of the site survives. From the air, at least, the scale of the Temple Mount on which the sanctuary stood can still be marveled at. Measuring 1,590 by 1,030 feet, the area of five football fields, it was twice the size of the emperor Trajan's Forum in Rome. Today, however, the ground plan of Herod's Temple has been utterly annihilated.

Fortunately, various ancient writers recorded the basic form of the sanctuary in detail, to which archaeology has added a few physical features. Herod essentially started from scratch, removing the foundations of the former Temple and superimposing a new edifice measuring 165 feet long and 200 feet high. Single blocks of masonry weighed up to five tons, and an exceptional stone built into the western wall of the Temple Mount measures a staggering 40 feet in length and weighs about 300 tons.

Just as no expense was spared on the architecture of the Temple, its lavish decoration pushed the boundaries of extravagance and taste. While most of the building complex was built of white limestone and marble, an ever-exuberant display of precious metal increased the closer you got to the central Holy of Holies. The nine gates of the Lower Court, for example—donated by Alexander, the father of Tiberius Julius Alexander (governor of Judea from AD 46 to 48, and later a Roman commander in the First Jewish Revolt, although himself a Jew)—were covered with gold and silver sheet, as were their doorjambs and lintels.

- 32 -

Josephus explicitly states that the outer face of the Temple "wanted nothing that was likely to surprise either men's minds or their eyes," being covered all over with heavy gold plate. At sunrise, the Temple reflected the fiery splendor of the sun, blinding onlookers. From a distance the golden facade was said to resemble a snowcapped mountain. To cap this spectacle, King Herod bolted an enormous golden eagle above the entrance gate.

According to the Mishnah (the earliest postbiblical codification of Jewish oral law, written c. AD 200), the entire Holy of Holies, the most sacred part of the Temple, was overlain with gold except for the rear side of the doors, and its inner door was crafted of Corinthian bronze. Above the twelve steps leading up to its entrance hung the famous golden vine sculpture with clusters of grapes as tall as men. Over the decades individuals donated additional golden leaves, berries, or even clusters. Eventually it became so heavy that it took three hundred priests to lift it for cleaning. Another artistic masterpiece displayed was a silver and gold copy of a crown worn by the High Priest Joshua son of Jehozadak after the return from Babylonian exile. The original crown, presumably looted by Antiochus in 164 BC, symbolized his divine appointment as architect of a new Temple and role as God's mouthpiece on earth (Zechariah 6:11–13).

The wealth of the Temple that fell into Rome's hands in AD 70, as summarized by Josephus, included an extraordinary array of precious materials and objects. Alongside entire golden walls and doors were High Priests' clothing, including golden bells signifying thunder and pomegranates worn on garment fringes symbolizing lightning. The High Priests' breast girdles were embroidered with five rows of gold, purple, scarlet, and blue thread, onto which were sewn gold buttons enclosing large gems (sardius, topaz, emerald, carbuncle, jasper, sapphire, agate, amethyst, ligure, onyx, beryl, chrysolite), each engraved with a name of one of the twelve tribes of Israel. The High Priest also sported a golden crown engraved with the name of God, which was worn once a year when he entered the most sacred part of the Temple. The Mishnah also refers to chambers beneath the Court of the Israelites at the

- 33 -

entrance to the inner Temple complex, where the Levite servants stored harps, lyres, cymbals, and other musical instruments.

The daily administration of the Temple was a labyrinthine business, whose inner workings largely remain a mystery. This was not simply a house of worship but, in many ways, a world of its own with unique quirks of operation, not dissimilar to Vatican City today. Independent offices existed for rinsing the hides and innards of holy materials and for their salting. A small army of priestly bureaucrats ran this holy "city." Petahiah (renowned for his knowledge of seventy languages, presumably allowing him to converse with Jewish pilgrims from the four corners of the world) supervised bird offerings, and the House of Garmu looked after the baking of the showbread.

Temple economics was an imprecise science rotating around two streams of revenue. Every Jew in Israel and the Diaspora annually contributed half a shekel taxation. Donations comprised a second major source of income. The daily contributions were processed in underground chambers plummeting to depths of sixty-five feet. The Mishnah refers to "shofar" chests kept in the sanctuary and inscribed in Aramaic "new shekels" (for current year Temple tax) and "old shekels" (for people who belatedly paid for the previous year). Other chests were incised for the relevant donations: "bird offerings," "frankincense," "gold for the Mercy seat," and "for freewill offerings." This cash was collected three times a year, half a month before the festivals of Passover, Pentecost, and Sukkoth.

Beyond the annual Temple tax, it is impossible to estimate the value of further arbitrary offerings. People harboring secrets and private fears, for instance, offered secret gifts, whose proceeds went to the poor. Equally enigmatic in AD 70 would have been the contents of the Chamber of Utensils, donations assessed every thirty days and either used in Temple upkeep or sold with revenue going to the sanctuary. None of this patronage was constant. Other than noting the general prosperity of the period, which would have made the Temple a national bank of Israel, it would be grossly misleading to attempt any calculation of that wealth.

Alongside donations made by the local Jewish citizens of Judea, rulers contributed artwork to the Temple as political tribute. King Herod had spoils captured by Israel's wars with "the barbarous nations" mounted all around the Temple complex. Sosius, the Roman governor of Syria, who in 37 BC helped Herod capture Jerusalem from Antigonos, the last ruler of the Hasmonean dynasty, also donated gold to the Temple, including a crown (JW 1.357). There is every reason to expect that this pattern of royal political patronage was mirrored by vast unknown riches, such as the precious cauldrons, dishes, tables, and pouring vessels donated by the Roman emperor Augustus and his wife (JW 5.562).

Herod Agrippa, grandson of Herod the Great, spent much of his youth in Rome, where he paid the price for supporting Caligula's imperial power struggle. Although the emperor Tiberius imprisoned Agrippa for his duplicity, when head of the empire Caligula subsequently appointed him puppet king of Israel from AD 37 to 44. At this time Agrippa also contributed to the splendors of the Temple:

And for the golden chain which had been given him by Caius [the Emperor Caligula], of equal weight with that iron chain wherewith his royal hands had been bound [in prison], he hung it up within the limits of the temple, over the treasury, that it might be a memorial of the severe fate he had lain under . . . that it might be a demonstration how the greatest prosperity may have a fall, and that God sometimes raises what is fallen down; for this chain thus dedicated, afforded a document, to all men, that king Agrippa had been once bound in a chain for a small cause, but recovered his former dignity again. (*AJ* 19.294–295)

The issue of what Rome encountered in the Temple in AD 70 is complicated even further by increased instances of deliberate plunder in the first century AD, as the jaws of Rome closed more tightly around Israel's neck. In 4 BC Sabinus seized the Temple treasury by force (JW2.50) and, as the fifth procurator of Judea from AD 26 to 36, Pontius Pilate later diverted sacred moneys to build aqueducts (JW 2.175), no doubt including the arches still standing north of Caesarea. Gessius Flo-

- 35 -

rus, Roman procurator of Judea in AD 65 and described as "eager to obtain the treasures of God," later extracted seventeen talents in the name of the emperor (JW 2.293), allegedly to make up for arrears of tribute, but really to stoke up war with the Jewish state.

Such "withdrawals" generated a slow simmering hatred across Israel for Roman institutions. By dipping into the Temple funds, however, Rome was merely duplicating its behavior elsewhere in the provinces. But in assuming Jerusalem's Temple was simply a place of worship, Roman policy would backfire disastrously. To Judaism, the Temple was the spiritual core of Israel's state religion.

But it wasn't just the Romans who plundered the Temple in the first centuries BC and AD. Once Jew took up sword against Jew inside Jerusalem during the First Revolt of AD 66–70, the various splinter factions deemed the Temple treasury acceptable prey because it contained wealth donated by groups whose authority they refused to recognize. After looting most of the upper-class houses of Jerusalem around AD 69, John of Gischala "betook himself to sacrilege, and melted down many of the sacred utensils, which had been given to the temple, including the vessels donated by the Emperor Augustus" (JW 5.562). By ignoring the greater Roman threat, and immersing themselves in constant internal bickering and battling, the Jews were courting catastrophe and bringing the destruction of the Temple and its treasures closer by the day.

ISRAEL— Land of god

DARK SECRETS IN THE VATICAN

6

Jerusalem was not just an essential crime scene to pick up a treasure trail of DNA disseminated after the destruction of the Temple in AD 70. I had a parallel reason to get to the Holy City as soon as possible. As it turned out, I was not alone in questioning whether the key to the Temple treasure conundrum lay in Rome. Since the mid-1990s a heated political wrangle has been simmering between the Vatican and Israel, which accuses the papacy of imprisoning the treasure looted by Titus in AD 70. Israel is insistent that the spoils have remained in Rome uninterrupted for two thousand years and, not surprisingly, covets the repatriation of its birthright to put right an ancient wrong.

Both right-wing factions, such as the Temple Mount and Land of Israel Faithful Movement, and Israeli politicians are committed to recovering the lost sacred vessels and, not least, to benefiting from their transferable divine powers. This war of words boiled over in 1996, when Israel's minister of religion, Shimon Shetreet, presented the Vatican with historical research, allegedly compiled at the University of Florence, which apparently left no shred of doubt that the gold candelabrum and other treasures still languished in Rome. Shetreet claimed to possess statements from former popes confirming that the Catholic Church holds these objects. An official inquiry leading to the return of the sacred vessels was demanded.

Then, in 1999, Moshe Katzav, president of Israel, formally asked Cardinal Angelo Sudano, prime minister of the Vatican, to prepare a list

of all the Temple treasures and Judaica in his possession. Israel's chief rabbis, Yehuda Metzger and Shlomo Amar, joined the battle lines in January 2004 by requesting permission from Pope John Paul II to search the Vatican storerooms. The Israeli newspaper *Maariv* reported that the rabbis planned to buy back the gold candelabrum. All of these formal petitions fell on deaf papal ears.

The case for the repatriation of the Temple treasure from the Vatican is also vehemently championed by the Temple Mount and Land of Israel Faithful Movement. The ultimate goal of this extreme Zionist organization is to establish a Third Temple in Jerusalem over the ground space of the historical Solomonic and Herodian Houses of God, today occupied by the Muslim Dome of the Rock and Haram al-Sharif (Noble Sanctuary). The Movement boldly asserts that Israel has "very clear evidence" that the Vatican continues to imprison the two-thousandyear-old Temple treasure, "making this an undeniable fact." A newsletter released by the movement in 2003 summarizes the argument thus:

The information regarding the taking of the Menorah and the holy vessels to Rome and later, when the Roman Empire became Christian, being placed in the basement of the Vatican, has been passed down from generation to generation of the Jewish people. During the exile the holy Menorah and vessels remained at the focus of the memory of the Jewish people. Their dream was that one day soon they would recover them from the Vatican and return them to Jerusalem. This would be a sign of the beginning of the rebuilding of the Temple in Jerusalem and the redemption of the people of the land of Israel.

The fact that the Vatican holds these holy Temple vessels has been very well known since 70 CE. Many Jews traveled to the Vatican when they could do so to look for them and to see them. Some of the travelers testified that they had personally seen the golden Menorah and the vessels in the basements of the Vatican. Some priests have even confirmed this fact....

Israel is now living in the prophetic end-times of redemption, that the Temple of the God of Israel is soon to be rebuilt in Jerusalem, and that the golden Menorah from the Second Temple

and the other vessels will soon be returned to Jerusalem to be used in the Third, end-time Temple. . . . This should move the heart of everyone in the world.

Further expectation and curiosity have been aroused by Steven Fine, professor of Judaic Studies at the University of Cincinnati. Although the University of Florence denied any connection with research pinpointing the Temple treasure in the Vatican, he contributed further tantalizing ammunition. An unpublished inscription on a mosaic in a chapel of Saint John Lateran, Rome, and dated to 1291, reads: "Titus and Vespasian had this ark and the candelabrum and . . . the four columns here present taken from the Jews in Jerusalem and brought to Rome." Legend has it that Pope Pius XII (1939–1958) even showed the gold menorah to Isaac Herzog, chief rabbi of Israel, but refused to return it.

My own research confirmed the existence of a rich vein of tradition placing the Temple treasure in Rome uninterrupted from the Late Roman period onward. By the nineteenth century the Eternal City's Jewish ghetto believed that Early Christian soldiers threw the sevenbranched candelabrum into the River Tiber, whose bed miraculously turned bronze from Rome to Ostia. The Jewish community even petitioned Pope Benedict XIV (1740–1758) for permission to excavate the Tiber and recover the menorah, a request denied. Hence, diverse threads woven at disparate times have created a zealous climate of hope and anticipation.

Without personally having access to the "undeniable facts" serving as Israel's accusations against the Vatican, I intended to tread very cautiously among this war of words and to accept nothing as the gospel truth. In my own scientific work I had met many brilliant biblical scholars with elaborate theories born of passion and emotion, but these were often straw houses lacking secure foundations. My own interest in the Temple treasure of Jerusalem had no religious or political agenda. As a humanist and "man of science," I was committed simply to historical integrity, to exposing the truth in whatever shape it might take.

The Vatican and its museums are renowned for their secret archives,

— 4I —

winding storerooms that contain endless shelves of ancient masterpieces. Like earth's oceans, nobody really knows exactly what's down there and, of course, Dan Brown's *The Da Vinci Code* has recently added great weight to conspiracy theories swirling around the papal residency. Could the Temple treasure really be languishing in those vaults? Simply discounting the idea out of hand wasn't an option: a Catholic priest even claims he once saw several Temple relics in a vault buried four stories under the West Wing.

If any of the great treasure of Jerusalem lies beneath the Vatican's holy facade, then word of its presence ought to be inked into the Secret Archive. But excavating this evidence would be a Herculean task. Although the Papal collection currently meanders along seven and a half miles of bookshelves in the Tower of the Winds, an astronomical observatory built in 1578, the archive's contents today owe much to chance survival and random removal and relocation.

There is no doubt that great wonders and mysteries lurk under lock and key. Even the Tower of the Winds' staff has no knowledge of some documents residing behind a heavy door at the end of a corridor on the lower floor. It is always closed, and its key never leaves the side of the chief prefect. Behind it are stored the Vatican's most sensitive and precious documents: for instance, Greek letters exchanged between the popes and emperors of Byzantium discussing the protection of the Crusaders in 1146 and the last letter sent to the pope by Mary Queen of Scots a few days before she fell under the ax of Queen Elizabeth I in 1587.

If word of the Temple treasure of Jerusalem truly lies amid these tantalizing documents, we have to assume that it—or a facsimile—has survived undisturbed for at least seventeen hundred years. Are such ancient scrolls even capable of long-term survival amid Rome's microclimate? Probably not. In the Hall of the Parchments alone, thousands of documents have been turned purple by a violet-colored fungus that scientists have failed to contain.

In all honesty, the tumultuous history of the Secret Archives makes survival extremely unlikely, especially for documents covering the first

- 42 -

two hundred years of the Temple treasure's presence in Rome. In AD 303, Eusebius Pamphilus, bishop of Caesarea in Palestine and the father of Church history, recorded how in the reign of Diocletian: "I saw with my own eyes the places of [Christian] worship thrown down from top to bottom, to the very foundations, and the inspired holy scriptures committed to the flames in the middle of the public square" (*History of the Church* 8.2.1). Rome's Early Christian archive went up in smoke. Nothing survived for monks to make copies from. The crucial documentation covering the nine centuries after the reign of Constantine the Great are also irretrievably gone, and the earliest surviving entry, register Number 1, dates to the papacy of John VIII in AD 872–882.

At this time, and in a bizarre quirk of fate, the papal archive was stored in the Patriarchum on the Palatine Hill, alongside a castle-fortress that abutted the Arch of Titus. Because this Roman arch depicted some of the holy treasures of Jerusalem looted by Titus, including the mighty gold candelabrum, the ninth-century building was known as Turris Cartularia, the Tower of the Seven Lamps. The safety of the archive was entrusted to the Frangipani family, who were also in charge of the public granaries. However, in the course of endemic fighting between Rome's noble families, the archive vanished. So, in its current form the bulk of the archive dates from 1612, when it was reestablished by Pope Paul V Borghese. Preservation of word of the Temple treasure within the Secret Archive, confirming its current existence within the Vatican, is beyond a million-to-one chance.

What about the treasure itself, though, within Vatican City, as argued passionately by various high-powered Israeli politicians? In England I spent six tortuous weeks politely harassing the Israeli embassy to reveal its sources. Although they contacted universities, the Israel Antiquities Authority, and various political offices, no one could locate the original documentation or "undeniable facts." In the face of my immense frustration, the embassy's press secretary did finally provide me with a hollow answer: "If anyone knows the Vatican does."

No doubt the embassy tried its best on my behalf, but no one was going to go on the record about this sensitive issue. The official line

- 43 ---

claimed that the historical documentation had gone missing when Prime Minister Ariel Sharon dissolved the corrupt Ministry of Religion for financial irregularities in 2004. Its duties had been carved up between various other ministries, such as the Department of Culture and Ministry of Education, with some interests "falling between the cracks," or so I was informed. It sounded to me as if someone was plastering over those cracks. A whitewash was in progress, but why?

Next I pursued the Vatican, although I suspected that a portcullis of silence would swiftly fall. If they did have the Temple treasure they surely wouldn't come clean; if they didn't, why waste time answering disrespectful questions? In the end, my communication with Dr. Paolo Liverani, curator of classical antiquities in the Vatican Museums, made the Vatican's formal position crystal clear: "In later times there is not the smallest evidence that any part of the treasure of the Temple arrived in Rome and I do not think that the Vatican has any interest to hide the Menorah or any other part of the booty of Titus."

With various doors slammed in my face, but with Israel's "undeniable facts" still beyond my grasp, I had one card left to play. Uncomfortable as I was talking to a group that wanted to eject Islam from the Temple Mount and replace it with a third Jewish Temple, I was optimistic that the director of the Temple Mount and Land of Israel Faithful Movement, Gershon Salomon, would be more forthcoming with fact. If there was any validity to Israel's allegations against the Vatican, the truth would out. 7

TEMPLE PROPHECIES

Throughout its history Jerusalem has always been the focus of extreme Middle Eastern politics—bomb scares, street skirmishes, and murder are daily occurrences. Israeli politics is wild and spontaneous; people suck the marrow out of every hour of every day as if it might be their last. You certainly know you're alive when you visit the Holy Land.

The morning I flew to Israel in April 2005 to meet the director of the Temple Mount Faithful, the Middle East was once again in uproar. Three fourteen-year-old Palestinians had been caught red-handed smuggling weapons in Gaza and were shot dead by the Israel Defense Force. Gazan militia responded in the usual biblical fashion—an eye for an eye, tooth for a tooth—by pumping eighty mortars and Qasam rockets into the Jewish settlement of Gush Katif. The same day, extreme right-wing Jews from the Revava movement marched on the Temple Mount to demonstrate against its "occupation" by Arabs. Some 8,000 police were drafted in to patrol the entrances to the site for three days. The extremists failed to break in. Instead, thousands of Palestinians, including the leader of the West Bank's Hamas cell, Hassan Yousef, flooded the Mount to create a human shield.

Meanwhile, dozens of right-wingers, opponents of the Gaza disengagement plan, burned tires along Tel Aviv's Ayalon Highway, chained the gates of seventeen Tel Aviv schools, and hung signs on their railings reading JEWS DO NOT EXPEL JEWS. Should the Israeli withdrawal go ahead, they threatened to paralyze the country with civil disorder.

- 45 -

Jew fighting Jew is a familiar theme stretching back to the First Jewish Revolt of AD 66–70, a historical event that effectively killed the House of Israel and lost the Temple treasure to Rome. The cliché that history repeats is a deadly truth in the embattled Middle East. Lessons are not learned.

Elsewhere, a bored Jordanian workman repairing the bulging eastern wall of the Temple Mount of Jerusalem was accused of defacing this UNESCO World Heritage Site by incising the word *Allah* into the masonry. At the Hawara checkpoint outside Nablus, a fifteen-year-old Palestinian suicide bomber was arrested as he tried to take out as many Israeli soldiers as possible. His long woolen overcoat concealing five homemade pipe bombs, worn in temperatures of 86 degrees Fahrenheit, gave his deadly plot away. To travel from the UK to Israel is a complete metamorphosis, a culture shock that sees inertia replaced by thunderous passion.

Jerusalem's Temple Mount is a place of extremes. With its tranquil landscaped gardens, breathtaking blue-tiled Dome of the Rock mosque, and endless fountains and soothing water features, it is extremely beautiful. When you escape the winding alleys of the Arab souk surrounding the Temple Mount, and pop out of the oriental bustle into the open spaces where the Jewish temples of Solomon and Herod once stood, the air somehow appears cleaner, saturated with spirituality. The accumulation of history on the Temple Mount deeply enhances the sense otherworldliness.

However, the holiest place on earth is also one of the deadliest, a seething volcano of hatred that emits tremors that erupt down the centuries. Over the past four thousand years, 118 conflicts have been fought in Jerusalem. It only takes a minor provocation for all hell to break loose. Witness the Tunnel Riots of September 1996, when the government of Benjamin Natanyahu opened an ancient tunnel complex leading beneath the Western Wall. Fierce fighting kicked off, with the deaths of seventy Palestinians and seventeen Israeli soldiers. In 2000, Ariel Sharon's politically insensitive visit to Temple Mount triggered the second Palestinian intifada. With good reason Meron Benvenisti, the former

deputy mayor of Jerusalem, calls the rival Jewish and Muslim claims to the Temple Mount "a time bomb . . . of apocalyptic dimensions."

In recent years this bomb has started to tick increasingly loudly. One of the fundamental reasons why extremist right-wing Jewish organizations like the Temple Mount Faithful have pressured Vatican City into releasing the Temple treasures looted by Titus in AD 70 is to prepare for the pending liberation of the Mount from Arab occupation and for the rebuilding of a Third Temple. According to Rabbi Yisrael Ariel, a paratrooper who helped free Jerusalem during the Six-Day War of 1967, and founder of the Temple Institute, "The State of Israel can only be one thing—a State with a Temple at its center. . . . All of today's troubles originate in the sin of abandoning the Temple Mount and the site of the Holy Temple."

Such right-wing Jews are convinced that we are living in "endtime" that will witness a new Jewish Temple emerge on the Temple Mount. Signs of long-held biblical prophesies shine all around us, typified by the bizarre case of the red heifer. During the Exodus from Egypt and the First and Second Temple periods, anybody entering the Tabernacle or Temple had to be ritually clean. Most purity was ensured through immersion in ritual water baths called *mikvaot*, still visible to this day clustered around the southern entrance to the Temple. However, people who had come into contact with dead bodies were more seriously contaminated, especially priests performing funerals. In such instances, cleansing revolved around the ashes of an unblemished red heifer sacrificed on the Mount of Olives.

The Bible describes how God commanded Moses and Aaron to manage such ritual:

Speak to the people of Israel, that they bring you a red heifer without spot, which has no blemish, and upon which never came yoke; And you shall give it to Eleazar the priest, that he may bring it forth outside the camp, and one shall slay it before his face; And Eleazar the priest shall take of its blood with his finger, and sprinkle of its blood directly before the Tent of Meeting seven times; And one shall burn the heifer in his sight; its skin, and its

- 47 -

flesh, and its blood, with its dung, shall he burn; And the priest shall take cedar wood, and hyssop, and scarlet, and cast it into the midst of the burning of the heifer. (Numbers 19:2–6)

From the time of the first establishment of a proto-Temple, the Tabernacle, in the wilderness of Sinai, through to Herod's construction of a Second Temple in the late first century AD, nine red heifers were allegedly born. The tenth, so tradition promises, will appear during the end-time heralding the Third Temple. Yet following the destruction of the Second Temple in AD 70, no such beasts have been born for the past 1,900 years. By stark contrast, however, since 1997 a rash of appropriately pure heifers have been born: one called Melody at Kfar Menachem in northern Israel; one in the religious youth village of Kfar Hasidim near Haifa; and others on the Texas ranch of a member of the Temple Mount and Land of Israel Faithful Movement. Where extremist right-wing Jews have welcomed these signs with unbridled excitement, secular Israel is highly concerned. Various sources have recommended that Melody be shot. To the liberal Haaretz newspaper, "The potential harm from this heifer is far greater than the destructive properties of a terrorist bomb."

Further minor miracles continue to herald the fast approach of the prophetic end-time in Jerusalem. Thus, on July 18, 2002, the Western "Wailing" Wall of Herod's Temple inexplicably started to weep, a sign from God. A section of masonry fifty feet high became wet. As foreseen in the book of Joel, water flowing from the hill of the house of God will signal the redemption of the people of Israel:

And it shall come to pass on that day, that the mountains shall drop sweet wine, and the hills shall flow with milk, and all the streams of Judah shall flow with waters, and a fountain shall issue from the house of the Lord, and shall water the valley of Shittim. Egypt shall be a desolation, and Edom shall be a desolate wilderness, for the violence done against the people of Judah, because they have shed innocent blood in their land. But Judah shall remain for ever, and Jerusalem from generation to generation. (Joel 3:18–20)

- 48 —

The attitude of the Temple Mount Faithful cannot simply be dismissed as the ramblings of a lunatic minority. In the sensitive world of Temple Mount politics, it takes very little to shatter the fragile peace. Nevertheless, plans continue apace to prepare for the end-time. Since 1998 the Temple Mount Faithful have been preparing to lay the cornerstone for the Third Temple. These stones were cut by the Allafy family, immigrants to Israel from Iraq (the ancient Babylon of Jewish exile after the destruction of the First Temple by Nebuchadnezzar in 586 BC), and, coincidentally, one of the largest workers of stones in modern Israel. The Allafys believe they are descendants of the original Temple builders, thus fated to build the Third Temple. For them, an historical circle is closing today.

Three cornerstones of the Third Temple have already been marched to the Temple Mount. Fortunately, Israeli authorities barred their movement beyond the gates, so these insensitive political objects now sit in Jerusalem's City of David. Meanwhile, in 2004 the Passover animal sacrifice was resumed on the Mount of Olives in sight of the Holy of Holies. Since Israel reopened the Temple Mount to the non-Muslim world in August 2003, five thousand Israelis have visited the site every month. Because Jews are forbidden from treading the hallowed ground of the Holy of Holies, even after the Temple's destruction in AD 70, Israel's right wing interprets this trend as evidence of a fast-moving Third Temple culture.

In the modern political climate of this apocalyptic end-time, the resurfacing of the Temple treasure would create an unparalleled level of frenzy leading to appalling conflict, as Jew and Muslim fight over the sacred spaces of the Holy City. Monetary and historical value aside, this is the core reason why the quest for the Temple treasure of Jerusalem is so central and dangerous to contemporary Middle Eastern politics.

VOLCANO OF HATE

8

Spiritual and historic heart of the world, Jerusalem is also one crazy fairground ride. Ever thrilling, the Western Wall and Temple Mount are a stressful environment. The high-level security, political baggage, and fanatical emotions stoking this religious volcano leave one feeling edgy and disoriented. But in early April 2005, before heading into the center of modern Jerusalem to discuss Jewish treasure in the Vatican with the Temple Mount Faithful, I had no alternative but to face the most "peaceful battleground" on earth. Once again, the Temple Mount had been dragged into the Arab-Israeli peace process, only this time the argument felt personal: the archaeology of the Temple Mount itself was on trial.

Between October 1999 and January 2000 the Islamic trust charged with overseeing the site, the Waqf, dug a massive hole 165 feet long, 82 feet wide and 40 feet deep into the southeastern corner near "Solomon's Stables." Although the architecture aboveground is the work of the Crusaders and Knights Templar, its subterranean hall of thirteen vaults and eighty-eight piers is ancient, an original design of King Herod to create an inclining entrance leading onto the Temple Mount from the southern triple Hulda Gate complex. The term Solomon's Stables is wishful thinking based on the reference in 1 Kings 4:26 to the wise ruler's 40,000 stalls of horses for his chariots and 12,000 horsemen. Over the centuries the legend stuck.

The latest wounds inflicted on the Mount annexed both Solomon's

- 50 ---

Stables and the eastern Hulda Gate into a new mosque extending over one and a half acres, with a ten-thousand-person capacity, making the structure the largest mosque in Israel. In all, an estimated 65,000 square feet of the ancient Temple Mount's surface has been ripped up and paved over.

This development is highly provocative from any viewpoint. In 1967 Moshe Dayan infamously handed back the Temple Mount's keys to Jordan at the end of the Six-Day War to prevent military escalation and greater bloodshed with the Arab world. So today the site is legally controlled by the Islamic Waqf. Traditionally, however, the Waqf has respected the Mount's sacred status to both Judaism and Christianity, as well as to Islam. The large-scale building operations have now shattered this spirit of accommodation.

Virtually nothing is known about the archaeology of the Temple Mount, so any building work carried out without recording ancient deposits is a major lost opportunity to contribute to global cultural knowledge. That ancient remains were destroyed is undeniable—but exactly what is lost remains contentious. Israeli police claim that an arched water channel dating to the time of King Herod was willfully destroyed (although other sources claiming a medieval date are more realistic) and according to an Arab Waqf worker, stones with decorations and inscriptions were deliberately recut to destroy religious marks, including ancient Hebrew texts.

Israeli intelligence believes the Waqf has cleaned out ten giant subterranean cisterns on the Mount with the intention of filling them with water from Mecca's holy Zamzam Spring. Zamzam is a major pilgrimage station in the Hajj, holy to Muslims as the traditional site of the ancient well where Hagar and Ishmael rested after being banished from the home of Abraham and Sarah (Genesis 21:9–20). This action would elevate Jerusalem's sanctity within Islam, making al-Aqsa as important as the Great Mosque in Mecca. The entire project is thus seen as a political Arab ploy to deny Israeli claims to a Jewish Temple Mount.

Far more archaeologically destructive, however, was the dumping of 1,500 tons of soil extracted from the Mount across Jerusalem, most

- 51 -

prominently in the Kidron Valley east of the city walls, but also in the municipal city dump of El Azariah. The Waqf claims it has nothing to hide: the disturbed soil was mere fill lacking archaeological value. Conversely, elements of Israeli society accuse the Islamic clerics of de-Judaizing the Temple Mount and deliberately Islamicizing it.

Clearly passions for these extremist positions run very high. I wanted to examine both sides of the argument. My fact-finding mission to the Temple Mount would attempt to flush out any destructive signs of major ancient cultural heritage. I also planned to speak to Dr. Eilat Mazar of the Hebrew University, an outspoken opponent of the development works and a high-profile member of Israel's Committee for the Prevention of Destruction of Antiquities on the Temple Mount.

As I walked through the Jewish Quarter of Jerusalem in April 2005, I was struck by the city's extremes as a junction for the ancient and modern worlds. The ancient Jewish quarter of 2,000 years ago is today the center of global Jewish identity. Hasidic Jews traded kabbalistic blessings in the guise of red wool bracelets for hard cash. The Pinchas Sapir Jewish Heritage Center and Women's Torah Institute straddle the ruined homes of Roman Jerusalem's High Priests, rejuvenated as museums, and stores peddling Judaica, trinkets, cups, and T-shirts announced DON'T WORRY BE JEWISH and JERUSALEM, JUST DO IT. A fresh desert breeze rolled in from the southern Judean Desert.

The Western Wall looks dry today; no signs of weeping. A cherrypicker crane, however, is parked on the sacred ground with its operator examining the wall and cheekily peering over its summit at what his Muslim brethren are up to. Bar mitzvah boys are proudly carried aloft on fathers' shoulders. A grandpa tells his wide-eyed grandson, "This is the center of the world." Past and present converge. The western outer wall of King Herod's magnificent Jewish Temple dwarfs the plastic chairs and a diverse Israeli society. A crooked old man in traditional black Jewish garb retreats backward from the wall, bending down as he moves to touch the sacred ground and run his fingers down his chest in blessing. Another elderly man exits walking sideways for some eso-

- 52 -

teric reason. A Russian girl dolled up in a pink leather belt and matching lipstick wafts by. Jewish soup kitchens ring the Western Wall.

As in antiquity, women and men are divided into different sections for worship along the Western Wall. So the women peer over a wooden screen and emit immensely shrill screams, a celebratory cacophony that seems more appropriate company for the tribal boiling of a Westerner in a remote African jungle. They throw silver glitter into the air, which twinkles like fairy dust in the midday sun—messages from God. White doves glide along the summit of the Temple Mount, offering peace to Jew and Muslim alike if they wish to seize it.

At the checkpoint leading up to the Temple Mount, the police have a pressing security issue to tackle: confiscating Bibles. A white-haired English gentleman with a well-polished middle-class accent is quizzed about his brown book. "Is this a Bible," he is asked. An emphatic no is the response. Much police huddling and discussion ensues. "Are you sure this isn't a Bible?" reiterates the main security guard. The confused Englishman nods an affirmative. More huddling and finally the chief guard is summoned to referee the stalemate. "If this isn't a Bible, what is it then?" he challenges. "Well, if you must know," replies the innocent abroad, "it's a history book about cannibalism at sea." The black humor of this ludicrous situation is lost on the guards. All they know is that they must temporarily confiscate Bibles to prevent Christians praying publicly on the Temple Mount and potentially inciting religious conflict.

I enter the Morocco Gate where, according to Muslim tradition, Mohammed harnessed al-Barak, his trusty horse, when he flew into Jerusalem. To my left, well-manicured gardens conceal the 70,000 Muslim *shahid* (dead holy warriors) of the twelfth-century Crusades. The Mount today is seemingly completely free of Roman architecture. The smell of strong Turkish coffee wafts through the air from the Old City, home to 15,000 Arabs and 5,000 Jews.

If you didn't know the extremely dark history of the Temple Mount, you could be forgiven for judging this place an oasis of peace. In reality, the site has been a production line of hatred, death, and destruction over

- 53 -

the millennia. A spent bullet from the 1967 Six-Day War lies at my feet. Yet tranquillity reigns today. The northern quarter, where Titus finally broke through the mighty Antonia Tower fortress to set alight the cloisters of the Second Jewish Temple, is now a garden of olive and cypress trees and exotic fountains. A teacher shrieks at her pupils along the eastern wall, where hundreds of Arab kids sit within the vaulted classes of the "Al Aqsa Sec. Religious School—1901 Est."

But I was not on the Temple Mount for tourism. Instead, I was searching for traces of destruction that would confirm or refute Israel's claims of an ongoing cultural intifada on the site. Was Israel presenting a balanced case or was Sheikh Ikrima Sabri, chief Muslim administrator of the Mount, correct when he recently stated that "The Temple Mount was never there. . . . There is not one bit of proof to establish that. We do not recognize that the Jews have any right to the wall or to one inch of the sanctuary. . . . Jews are greedy to control our mosque. . . . If they even try to, it will be the end of Israel." If simple building work can inspire such a tongue lashing, what would be the repercussions of the reappearance of the Temple treasure?

The signs did not look good for Sheikh Sabri. A bulldozer was parked immediately outside the entrance to the Dome of the Rock mosque. Something unusual was clearly going on. Traces of massive earth-moving activities quickly became obvious. Olive tree gardens had been filled with freshly relocated earth and, on closer examination, revealed a high density of Roman, Islamic, and Crusader pottery, undeniable proof of a first-century BC to first-century AD presence on the Temple Mount.

No pottery has ever been published from the Temple Mount, yet here was tons of the stuff beneath my feet—an archaeologist's dream. Sheikh Sabri had been speaking nonsense. With such a collection of potsherds, archaeologists can spin wonders and tease fresh and important historical data from silent soils.

Nearby, what can only be described as a breaker's yard had been shoddily assembled. On one side stood piles of ancient stone masonry, and on the other newly cut blocks of stone "repackaged" for reuse in

- 54 -

modern structures on the Mount. While I had no problem with the Waqf developing the site to accommodate growing numbers of Muslim worshippers and wasn't partisan about the politics involved, the level of destruction coupled with a lack of documentation of this vital site's ancient remains was seriously disturbing.

Imagine if developers cut chunks out of Rome's imperial Forum and threw out the cultural debris without sieving the soils or recording what lay in the exposed trenches. The Eternal City would be in uproar, no doubt the pope would protest, and the collective archaeological community would denounce these sacrilegious activities. In historical terms, the Temple Mount is without doubt more important than Rome's Forum. But this is Jerusalem, where passions run high and politics pervade. Very few outsiders are willing to stick their neck out and be seen to be anti-Islamic. To me, however, this is not just a political matter but, actually, an ethical debate about protecting the past.

If the Waqf had nothing to hide, I couldn't help wonder why it had off-loaded three hundred truckloads of soil and debris under cover of night. Why had important ceramic remains been concealed under olive groves and, most grievously, how could it explain and justify the recutting of ancient masonry without specialist archaeological supervision? Ancient inscriptions may well have been erased.

G reat destruction had without any doubt already been perpetrated on the Temple Mount. To discuss the scale of the problem, and the political fallout, I had arranged to meet Dr. Eilat Mazar of the Hebrew University, a very high-profile, outspoken critic of the Waqf's building activities. On the way to the City of David, where she was currently excavating Iron Age remains, I exited the Temple Mount by the northern Katemin Gate, desperate for a refreshing drink. But all I could find along the shadowy market alleyway approaching the holiest site on earth was a bewildering array of children's toys. Not dolls and action men, as you might naively expect—appropriate for kids of all faiths—but a vast armory of plastic guns and weapons: imitations of "Swat Police," "Power," "Space," and "Tommy" pistols; curved scimi-

55

tars and straight-edged Crusader plastic swords; even sets of guns, face masks, and mustaches. In this way new generations of religious hatred are born a hairbreadth away from the holiest place on earth.

As crowds of Muslims pushed their way onto their Haram al-Sharif, a Hasidic Jew stopped in the narrow entrance to the ancient Temple Mount and started to pray, bending sharply at the waist. Had the world gone crazy? Were both Muslims and Jews hell-bent on stoking up further bloodshed and hatred? An Arab boy looked at me, pointed, and smirked. I asked him whether the Hasids do this a lot. "Yeah," he replied, "they're head cases."

Clambering down the Ophel hillside, I found Dr. Mazar sorting ancient pottery in her laboratory on the edge of the City of David. The vast pit of her excavation was hidden from prying eyes by a tall screen, security guards, and a fearsome Alsatian dog. Only back in London would I discover why such secrecy shrouded her dig: Dr. Mazar claimed to have discovered the biblical palace of King David, no less.

Eilat Mazar has both a professional and an emotional vested interest in the problems of the Temple Mount. Her grandfather, Professor Benjamin Mazar, excavated at the southern foot of the site for ten years, and from him she inherited the digging bug and also the far more serious responsibility of his publication backlog. To her credit, both scientific and popular articles and books have now started to flow. When complete, her work will comprise the most important body of scientific information about the history and archaeology of the Mount.

An outspoken critic of the Islamic Waqf's clearance operations and the Israel Antiquities Authority's weakness over the scandal, she is nevertheless a balanced archaeologist. Rather than ignore all cultural evidence other than the Jewish remains from the periods of King Solomon and Herod, her books, such as *The Complete Guide to the Temple Mount Excavations*, cover all antiquity from the tenth century BC to the Ottoman period, with equal balance and without historical bias.

As the Muslims were called to prayer from a nearby minaret, Dr. Mazar emphasized that the Waqf's development work breaks the law

- 56 -

because the Haram al-Sharif is subject to Israel's legal system. She considers the physical damage perpetrated to be extreme. Although it would be far too politically insensitive for her as a Jew to monitor the archaeological destruction personally, the Committee for the Prevention of Destruction of Antiquities on the Temple Mount has used an eye in the sky—aerial photography—to observe the changes over the past five years. The camera reveals trenches cut up to forty-two feet deep into the ancient Mount.

"Ancient structures have been greatly damaged," she confirmed. "We calculate that 20,000 tons of ancient fill have been dumped outside, of which we are trying to save about 5 percent. The majority is lost forever among the modern rubbish of the Azariah garbage dumps." Literally hundreds of trucks unloaded their ancient cargoes into these places and who knows what has been lost. For Mazar, the Temple Mount is a sealed box stuffed with ancient archaeological riches. "The percentage of probability for finding treasure is very high," she argued. "There is no reason why inscriptions shouldn't be preserved deep among the ruins."

Surely both sides would have learned from these mistakes now that the scale of the destruction is widely known. But no. "The Waqf couldn't care less," bemoaned Dr. Mazar. "It doesn't even care about its own Islamic heritage. The goal is religious fundamentalism, and archaeology is absolutely not going to stop them on their way. The Arabs believe they can twist and rewrite history and that a mosque has existed here since the time of Adam and Eve. Their actions are deliberately provocative, a very extreme fundamentalist Islamic approach. Similarly, the Israel Antiquities Authority has to fulfill Israeli law, but it doesn't due to political pressure from the prime minister. This is a boomerang issue." It was a dilemma that Dr. Mazar was sure would come back to haunt Israel.

The ever-swirling politics make objectivity difficult. Even though I found Eilat Mazar's tone harsh, I sympathized with her frustration born of deep love for all the archaeology of the Temple Mount area. Her words continued to ring in my ears while I plodded back up the hillside

- 57 -

of the City of David: the Temple Mount is the most fantastic site in the world, yet so many scholars won't debate its cultural fate because politics monstrously overshadows all else. Why is UNESCO so impotent in this matter, I wondered, as I set off to confront a worldview that made the archaeological battle for the Mount sound like child's play. Gershon Salomon, director of the Temple Mount and Land of Israel Faithful Movement, awaited me in central Jerusalem. KEEPING THE FAITH?

9

Jerusalem is an ultramodern city in an ancient, battered, and bruised skin. Inspired economically and culturally by its big brother, the United States, Israel swiftly embraced the consumer revolution in the late 1980s. Away from the winding medieval alleys of the Old City bazaar, many of Jerusalem's bars are as hip as those found in Soho. Its youth are more conscious of changing fashions than down-dressing London and, in terms of overall quality and value for money, from breads and salads to seafood, its restaurants put the UK to shame. Israelis love complaining, and skimping on portions or stale servings will buy you an earful of abuse.

The Temple Mount Faithful occupy offices tucked away behind Jerusalem's busiest commercial district. Almost all of the trade around Yafo Street is local these days, and has been since tourists stopped visiting once the Second Intifada kicked off in 1999 and suicide bombers targeted pizza and falafel restaurants. Even local Israelis watch their backs when they go out. As a friend explained, every time you put on a coat, hat, and lipstick, you prepare for a game of Russian roulette: Who will bite the bullet today?

Gershon Salomon's office occupies an old British Mandate-period town house, not unlike a Roman villa with a main corridor and two side wings flanking an open courtyard. Overgrown vegetation droops down the sides of a run-down building, which has seen better days. There is no nameplate, no hint of end-time plans being hatched behind

- 59 -

a closed door. I knocked on a ground-floor door to be greeted by a bemused student who had never heard of the Temple Mount Faithful and was quite sure they didn't operate from his building.

This meeting has taken enormous patience to set up. An endless stream of messages on answerphones, flying faxes, and e-mails seemed to be for nothing. Crestfallen, I left the building's grounds and was about to give up the chase when a dark blue Cadillac parked in the shadows flashed its lights at me. I was being watched. Inside sat the director of the Temple Mount Faithful, Gershon Salomon, cautiously vetting me from a vantage point of quick escape should the need arise. Clearly I passed the test and wasn't considered an immediate threat. Within five minutes I found myself seated in the sanctuary of a rather scruffy office.

Back home in England I had steeled myself to dislike Mr. Salomon. I had no sympathy with a political mind-set obsessed with ridding the Haram al-Sharif (Judaism's Temple Mount) of Islam and seeing God establish a Third Temple on the Mount. I couldn't see how it could work peacefully and firmly believed that this was a political problem, not to be resolved through direct religious channels. The way the Faithful went about their business also disturbed me. Publicly dragging cornerstones for a new Temple to the edge of the Old City, and searching out unblemished red heifers to revive Temple ritual based on sacrifice, isn't a very subtle way of negotiating your business. However, having been firmly shown the door by the Vatican and Israel's politicians, I was relying on Gershon Salomon to give up the golden key to unlock the "undeniable facts" proving the Temple treasure of Jerusalem to be imprisoned in Rome's Vatican City. To uncover these facts I was prepared to sup with the devil.

To my great surprise I ended up rather liking Mr. Salomon. Contrary to the image of the man I had envisaged—someone who was loud, self-opinionated, and arrogant—he neither dressed nor spoke like a fanatic. Perhaps it was the way he hobbled with a cane after surviving a life-threatening military skirmish as a youngster, or the glimpse of a broken man, weary from a lifetime battling for a cause he believed in

— 60 —

heart and soul. Gershon spoke eloquent words with passion and without ego. His eyes shone like an evangelical prophet as he outlined dreams of the Promised Land he hoped to create.

Gershon Salomon established the Temple Mount Faithful movement immediately after the Six-Day War of 1967 with the objective of returning Israel to a biblical nation, a kingdom of priests. He was born of old Zionistic stock, whose family emigrated to Jerusalem from Vilnius in Lithuania in the late eighteenth century. The newcomers dreamed of forging a messianic revolution, and his forefathers believed that the messiah would arrive in 1840. So the dream of a biblical nation has been in Gershon's heart since childhood; he drank this idealism with his mother's milk.

Just before the Six-Day War, he experienced a revelation that would transform his life. At the age of nineteen he was serving as a commander in northern Israel, defending kibbutzes and villages from Syrian attack. A mere three days before he was due to finish his tour of duty, his unit was caught in a terrible ambush and attacked by thousands of Syrians during an eight-hour battle.

"God saved my life," Gershon maintains. "A tank drove over my body and I lay in the corner of the field of battle, more dead than alive. At night the Syrians surrounded me, but as they prepared to shoot, they suddenly turned and ran back to the mountains. Illuminated by a shining light from the God of Israel, lying there, I felt the presence of the spirit of God around me in my heart, as if he were telling me, 'You still haven't finished your work, you still have something great to accomplish in your life." Salomon was taken to hospital in a coma.

After a few weeks he reawoke to the world and tried to make sense of his surreal experience. Eventually, United Nations officers fed back to him a firsthand report from the Arab officer who had commanded the battle against his unit.

"Why didn't they shoot me?" inquired the bemused Israeli soldier. Apparently they had harbored every deadly intention of finishing him off, but simply couldn't. At the exact moment when they were ready to inflict the coup de grâce, thousands of angels appeared out of thin air

— 61 —

and surrounded his body. The Syrians fled in horror back to the Golan Heights.

Gershon Salomon spent a year in the hospital contemplating what God planned for him. Despite his severe injuries, he returned to his unit and participated in the liberation of the Temple Mount in 1967. He told me how he stood with his troops inside the Dome of the Rock weeping, and heard God tell him, "For this moment I brought you here. Build my house, build Israel as a kingdom of God, a biblical kingdom." A historical circle had closed.

At that date, when the world's spotlight was firmly on Israel and the entire Arab world was up in arms, the commander of Jerusalem's liberation, Moshe Dayan, chose to return the keys to the Temple Mount to the Jordanians. Although many Israelis still denounce him as a senseless traitor for this single act, Dayan knew that even with the aid of America, Israel would never know peace if it retained the Mount. The image of 1.5 billion Muslims descending on Israel from surrounding countries was enough to make him gamble on returning the keys to the House of God.

Salomon remains intensely bitter at this action. Thousands of Jews may recognize the Western Wailing Wall as the holiest site to Judaism, but for the leader of the Temple Mount Faithful it symbolizes exile and destruction: "As long as the Temple Mount is not liberated and does not become a Jewish site with a Temple, as long as our mentality will not change to become a free biblical nation, never will there be peace in this land. What they call peace is a false peace. Actually the country will be cut up, piece after piece."

The sun set over the Old City and against the backdrop of an Israeli flag unfurled across Gershon's office wall we discussed the dreams and fears of the Temple Mount Faithful. Salomon is convinced that we are living in an exciting end-time and that a Third Temple will be built within his lifetime. He calls this event "the biggest in the history of mankind and Israel. This event is irreversible. God wants a different kind of life, not based on materialism or chasing after physical achievements."

- 62 -

As it turns out, the prophetic promise of the red heifer story was actually somewhat premature. For the animal to be certified for sacrificial purity rites, it has to remain red for the first three years of its life. Those reported in 1992 failed this test by turning white and brown after a few months. However, in recent years at least three red heifers raised on a Texas ranch owned by a fundamentalist Christian pastor have passed the test.

So why isn't he eagerly reestablishing biblical sacrifice? For obvious reasons, it turned out. The Israeli government has blocked delivery of the red heifers to Israel for sacrifice on the Mount of Olives because this act is considered excessively provocative. The Faithful's ideology also runs contrary to Orthodox Judaism's belief that a spiritual messiah, not a secular human, will redeem Israel. Opponents of a Third Temple are fearful that the red heifer has apocalyptic repercussions.

After hearing Gershon Salomon's side of the story, I asked the million-dollar question about the whereabouts of the Temple treasure of Jerusalem. Certainly in his mind, Gershon has no shadow of a doubt that the menorah and other Jewish symbols of faith looted by Titus in AD 70 languish deep in the Vatican. He finds the lack of a formal denial from the Vatican deeply suspicious.

But what about evidence to back up these claims? He reeled off the names of medieval travelers who documented Jewish customs across the Mediterranean basin and personally claimed to have seen the Temple treasure in Rome. Now we were getting somewhere, although it was becoming clear that Gershon was good on the big picture but poor on detail. To be fair, however, why should he be? He is neither an academic nor an historian. The main sources, it turned out, were Benjamin of Tudela, Benjamin II, and David Hareuveni, all of whom traveled to the Vatican, saw the sacred vessels, and recorded their experiences in travelogues. Regrettably, Gershon Salomon didn't have the evidence on hand, but relied on the expert advice of an enigmatic Jewish bookseller in Canada who possesses the relevant papers and historical books. I was informed that the president of Israel also personally holds a copy of the incriminating evidence.

— 63 —

So my meeting with the leader of the Temple Mount Faithful passed off successfully. I had new leads from unfamiliar sources and a frightening firsthand impression of a biblical future that hoped to turn the world on its axis. The objectives of the Faithful were pure dynamite, incapable of being realized without immense suffering and bloodshed. Yet the individuals leading the movement's battle are far less dangerous than the waves of fanatical Islamic suicide bombers who have plagued Israel in recent years. The main weapon of the Temple Mount Faithful is the spoken and written word.

It would be a mistake to dismiss Gershon Salomon's warriors as a minority fringe movement. The Faithful receive donations from India, at least two Arab countries, Australia, the Philippines, Japan, and almost every country in Africa. Gershon has been invited to lecture across the world from Norway to the Congo and claims that a revolution is spreading across the world. I pushed for statistics about what percentage of Israeli society the Temple Mount Faithful speak for and raised my eyebrows at the response. Apparently a Gallup poll taken eight years ago showed that more than 60 percent of Jews supported the movement's ideas. Its leader claims that it has grown increasingly since then to represent 80 percent of Israeli Jews.

"We are the only surviving idealistic movement left in Israel," Gershon Salomon concluded as I prepared to leave. "Israel is in a very deep spiritual and idealistic crisis and we give the nation hope. Emptiness looks for something to fill it."

I left the shadowy backstreet of central Jerusalem promising to read Isaiah 2:1–5, and Zechariah, chapter 8, from which the movement draws its inspiration. My head spun with thoughts and ideas. New names now preoccupied my quest: What exactly did Benjamin of Tudela, Benjamin II, and David Hareuveni see in Rome, and could their testimony be trusted? Would the president of Israel release his documentation to me?

Walking back to the nineteenth-century quarter of the German Colony where I was staying, I passed restaurants and shops all defiantly open to the world but from behind iron barriers patrolled by eagle-

eyed security guards determined to thwart suicide bombers. This is the real face of the Arab-Israeli conflict, this hypersensitive volcano that blows its stack at the smallest provocation. I was just a visitor to Jerusalem and so could escape home to my comparatively cozy world. And as I traveled home, Gershon Salomon's final words echoed in my mind: "I believe that when the Vatican basement is opened, all the world will be shocked by what we find there."

10

BENJAMIN OF TUDELA

As soon as I was back in England I locked myself away in the Bodleian Library, Oxford, to tackle Gershon Salomon's leads. The director of the Temple Mount Faithful had introduced me to three travelers who had allegedly viewed firsthand the Temple treasure of Jerusalem imprisoned in the Vatican: Benjamin of Tudela, Benjamin II, and David Hareuveni. I was able to discount the last two figures very swiftly. Benjamin II was a nineteenth-century traveler who was born in Moldavia and recorded his wanderings across the Near East, Asia, and Africa from 1846 to 1851 in search of the lost tribes of Israel in *Cinq années en Orient*, published in 1856. Actually born Israel Joseph Benjamin, he assumed the name Benjamin II in mimicry of Benjamin of Tudela. However, I. J. Benjamin was living in times when travel was far easier and much of his testimony had already been comprehensively covered in earlier travelogues. There was nothing about Rome he could add to his namesake's far earlier testimony.

Although David Hareuveni was a relatively early and thus revealing source, his highly subjective religious agenda makes him positively unreliable. In the 1520s David declared himself the messiah and his brother king of lost ancient Jewish tribes living in Africa. So soon after the Spanish Inquisition trials and the forced conversion of Jews to Catholicism between 1486 and 1492, Europe's literary and religious circles were intrigued by Hareuveni's originality and boldness. Although he did engineer a meeting with the pope to propose a military alliance

— 66 —

between the tribes of Reuben and the pope's army against Islam, David Hareuveni was an extremist whose testimony is inadmissible.

Of all three characters, Rabbi Benjamin Ben Jonah of Tudela is by far the most important historical source. A Jewish merchant from modern Navarre in Spain, he spent significant time in Rome after the election of Pope Alexander III in 1159 and again from November 1165 until 1167. Rabbi Benjamin was a true pioneer, whose mission was to record the lifestyle of Sephardic Jews across Europe and Africa. His travels took him from Spain to France, Italy, Turkey, the Near East, including Beirut and Jerusalem, and as far as Babylon—an incredible feat for the age.

Inside the Oriental Reading Room in Oxford's Bodleian Library I consulted two versions of *The Itinerary of Rabbi Benjamin of Tidela*, one translated by A. Asher in 1840, the other published by Marcus N. Adler in 1904. Both commentators held their subject in high esteem. Adler observed, "In every place which he entered, he made a record of all that he saw, or was told of by trustworthy persons—matters not previously heard of in the land of Sepharad." Asher's praise for Rabbi Benjamin was even more glowing:

The whole work abounds in interesting, correct and authentic information on the state of the three quarters of the globe known at his time and in consideration of these advantages, stands without a rival in the literary history of the middle-ages, none of the productions of which period are as free from fables and superstitions as *The Itinerary of Rabbi Benjamin of Tudela*.

The traveler's text is easy to follow and it didn't take long for me to find the appropriate passage referring to Temple treasure in Rome. After mentioning the existence of two hundred Jews in the Eternal City, who pay no tribute to the state and occupy an honorable position within society, including the great Hebrew scholars Rabbi Daniel, the chief rabbi, and Rabbi Jechiel (a papal official), Rabbi Benjamin reported thus:

In Rome there is a cave which runs underground, and statues of King Tarmal Galsin (Galba?) and his royal consort are to be found

— 67 —

there, seated upon the thrones, and with them about a hundred royal personages. They are all embalmed and preserved to this day. In the church of St. John the Lateran there are two bronze columns taken from the Temple, the handiwork of King Solomon, each column being engraved "Solomon the son of David." The Jews of Rome told me that every year upon the 9th of Ab they found the columns exuding moisture like water. There also is the cave where Titus the son of Vespasian stored the Temple vessels which he brought from Jerusalem. . . . In front of St. John in the Lateran there are statues of Samson in marble, with a spear in his hand, of Absalom also the son of King David.

Everything written and resolutely placing the Temple treasure of Jerusalem in Rome today comes down to this single sentence written almost 850 years ago. To say the least, I was sorely disappointed: Rabbi Benjamin offered no validation of why or how the spoils had ended up there or been retained. In fact, reading between the lines it was patently obvious that Rabbi Benjamin made no pretensions at all: he was just passing on a piece of folklore, undoubtedly based on a kernel of truth rooted in Josephus's *Jewish War* and on historical memories of Vespasian's Temple of Peace. Exactly the same folklore undoubtedly also underlies the mosaic inscription of 1291 later built into the same church complex.

Nowhere does the rabbi explicitly state that he saw with his own eyes the treasure in the Lateran or elsewhere. While pondering this text I casually skimmed the rest of his *Itinerary* and soon realized that as a pioneer Benjamin was very much an innocent abroad. In an age preceding the widespread translation of ancient writers and scholarly commentators, knowledge of antiquity was largely based on word of mouth, which always leaves ample scope for misinterpretation. One particular passage convinced me that while Rabbi Benjamin should be much respected, his testimony cannot be trusted as true history. Around Sorrento in Italy, he described how "from this place a man can travel fifteen miles along a road under the mountains, a work executed by King Romulus who built the city of Rome. He was prompted to this by fear of King David and Joab his general."

- 68 -

Not only is Romulus a mythical figure for whom no concrete proof exists for such an ancestor of true flesh and blood, but the relocation of the biblical King David to Iron Age Italy is historical nonsense. With dedication I had chased the Israeli government, the Vatican, and Gershon Salomon all down to their major source, which had come up wanting. Frustratingly, I had been on one very time-consuming wildgoose chase. But I did have my answer. The "undeniable facts" placing the Second Temple Jewish treasure in Rome and the Vatican was a fable, an elaborate castle in the air.

My experiences with the Temple Mount Faithful had brought home just how time and faded memory have distorted the truth about the Temple treasure and replaced it with alternative pseudo-histories from the logical to the absurd. Historically, each generation rewrites the past to dovetail with its own particular ideologies. But which, if any, might be accurate? Four very different legends vied for the trophy of truth. As I had just learned, Rabbi Benjamin could be discounted. But what did the Parker Expedition to Jerusalem discover beneath the Temple Mount in 1909? Alternatively, did God's gold really end up in rural southern France, discovered by a parish priest in the village of Rennes-le-Château? Or as many scholars still stake their reputations on today, did one of the famous Dead Sea Scrolls, the Copper Scroll found in Cave 3, hold the ultimate secret to my quest? Not all of these questions could be explored through physical exploration. Rather, their answers lay amid the dusty papers and books of Oxford's Bodleian Library.

THE PHILOSOPHER'S FOLLY

The earliest physical quest to uncover the great legacy of the Temple treasure was ill-advised fantasy based on very shaky grounds. In 1908, the eccentric Finnish biblical scholar and master philosopher, Valter H. Juvelius, supposedly unraveled a coded passage in the book of Ezekiel in a library in Constantinople describing the precise location of Solomon's treasure—or so he claimed. Juvelius believed that a fabulous \$200 million windfall awaited him beneath the Temple, where it was hidden when King Nebuchadnezzar conquered Jerusalem and burned down the First Temple in 586 BC.

After much hunting for a suitable project leader, Juvelius was fortunate to come across a former soldier, bored and itching for adventure. A thirty-year-old Englishman, Montague Brownslow Parker, the son of the Earl of Morley, had served with distinction in the Boer War, rising young to the rank of captain in the Grenadier Guards. An eager Parker was easily convinced by Juvelius's mouthwatering scheme. After raising \$125,000 from various wealthy donors, the Parker Expedition left for the Holy Land and two years of excitement, toil, and trouble.

In August 1909 the team anchored off Jaffa, the port of call for Jerusalem. In Constantinople, Parker had already greased the wheels of the expedition by promising the commissioners of the Ottoman government 50 percent of any treasure uncovered. Meanwhile, Juvelius had secured the services of a Danish clairvoyant to "guide" the search, and had bought up land around the slopes of the hill of Ophel immediately

II

south of the Temple Mount, where his new employee and partner had advised him to dig.

The instructions of the Danish clairvoyant were strictly followed to the letter, and a shaft first dug by Charles Warren of the Palestine Exploration Fund in 1867, leading down to the so-called Virgin's Well, was reopened. The expedition believed this would expose a secondary tunnel veering straight to the Temple and its underlying treasure. Here Parker made his first bad move. The unwanted curiosity and attention of the local inhabitants was immediately aroused by the stationing of bodyguards and soldiers around the excavation. The city's cosmopolitan archaeologists, resident in the city's European and American archaeological institutions, were suspicious of the cloak-and-dagger secrecy of the project and why it was not bothering to record the ancient remains scientifically.

Complaints were formally submitted to Jerusalem's Turkish governor. Parker responded shrewdly by inviting Père Louis Hughes Vincent of the Dominican Fathers in Jerusalem to join the team as archaeological adviser. As the director of the French École Biblique et Archéologique de Saint Étienne, and one of the most respected authorities on ancient Jerusalem, Vincent was a perfect front to dampen protest. And for Père Vincent, this was a golden opportunity to study more of the biblical past. Everyone seemed content with this marriage, even though Parker conveniently kept the French priest in the dark over the true objectives of the mission.

By early 1910 heavy winter rains forced the team to retreat home to England empty-handed. The poor weather was compounded by further bad news: back in Jerusalem the local Jews had accused Parker of violating King David and Solomon's tombs, a profound offense with extremely disturbing implications. By August, however, he was back in the Holy City, reinforced with the more efficient skills of British engineers who had worked on the recently opened London Underground. By now the honeymoon period extended to the expedition by the Ottoman government was over. The Turkish patrons were bored by the absence of treasure and had given up hope of any discoveries.

— 7I —

To make matters worse, the excavators now had heavyweight competition in the form of Baron Edmond de Rothschild, who supported the Jews' claims of ancestral disturbance by buying up land around Parker's excavation. Faced with this political containment and isolation, Parker now had to contend with the Turks announcing the project's closure at the end of summer 1911. The team only had eleven months to find the legendary treasure.

Even though the engineers did manage to clear out the entire length of Hezekiah's Tunnel, recording some curious Bronze Age burial caves along way, the secret passage to the Temple never materialized. Time was running out fast. At this stage Parker played his last hand, taking a huge gamble by bribing the Ottoman governor of Jerusalem, Azmey Bey, with \$25,000 to let him excavate on the Temple Mount itself, sacred to Judaism and the second holiest place on earth to Islam, whose holy ground was closed to Westerners. The image of Parker and a select team dressed in Arab costume sneaking over the walls of this religious compound is straight out of an Indiana Jones Hollywood film. Yet for a week they did excavate the southeast corner of the Temple Mount under the shadow of nightfall. This time, the Danish clairvoyant assured the expedition that the riches were close by, awaiting them beneath Solomon's Stables.

Despite the change in location, the team was still getting nowhere. Utter desperation spread and as time finally ran out Parker made one final desperate decision. On the night of April 17, 1911, the engineers entered the sanctuary of the Dome of the Rock itself—epicenter of the religious world—to explore a natural cavern beneath the sacred rock where, according to legend, Abraham offered Isaac as a sacrifice to God and where Mohammed ascended to heaven. Hardly surprisingly, the ungodly sound of pick and shovel awoke a mosque attendant, who shrieked in horror at the scene of sacrilege he discovered, and ran into the city like a banshee to expose the violation.

Rumor quickly spread that the English had dug up and stolen the Crown and Ring of Solomon, the Ark of the Covenant, and the Sword of Muhammed. Jerusalem was in uproar, and several days of violent

- 72 —

rioting broke out. Governor Azmey Bey was mobbed, spat at, and called a pig for his complicity, and the Parker Expedition sped off to their yacht at Jaffa in fear for their lives. Even though their personal baggage was impounded by customs officers, the team managed to escape by sea, only to return to a seven-column headline in the *London Illustrated News* inquiring, "Have Englishmen Discovered the Ark of the Covenant?"

The answer to the question was a resounding no. Public ridicule put Parker in an impossible situation with his sponsors. Even though he successfully arranged for Père Vincent to publish the "scientific" results in the book *Underground Jerusalem* in an act of damage control, the scaffolding around the project was giving way. Even Vincent couldn't help but remark in his book that "subterranean tunnels have always been a favourite element in oriental romance, and their popularity in contemporary folklore has certainly shown no signs of diminution." Meanwhile, in Jerusalem, a Turkish Commission of Inquiry appointed a new sheikh as guardian of the Dome of the Rock, and Azmey Bey was dismissed as governor. The Turkish commissioners who had brokered a deal with Parker in Constantinople were censured and the entire event hushed up.

From the critical distance of the modern day, it is easy to discount the Parker Expedition for the Temple treasure of Jerusalem as a fatally flawed caper. After all, clairvoyants, government bribery, illegal excavations, and wild Arabs brandishing swords are the stuff of Hollywood films and novels, not of science. Obviously the background and methodology of this project were flawed from the outset. The team hadn't even bothered to assess the true character and history of the treasure they lusted after. So how could it really know what to look for?

But how different was their dream from modern quests that still try to find Noah's Ark on remote Turkish hilltops and Atlantis off the coast of Crete? Renowned institutions that ought to know better still dig deep into their pockets to sponsor such "scientific" ventures. At one level I cannot help but admire the political manipulation, logistical know-how, and energy of the Parker project. Also, when it comes to this particular Temple, we must bear in mind one very particular x-factor: passions here always run very high, strangling logic and common sense.

- 73 —

The Parker Expedition is a potent reminder that we should be extremely wary of quests that first concoct an idea, nail it to a wall, and then set about proving it. Putting the donkey in front of the cart in the world of treasure hunting has absolutely no chance of success.

Yet even more disturbing and ill founded are theories obsessed with the intrinsic power of ancient treasure to heavily influence political history, even hundreds of years later. To many people, the Jewish icons from Jerusalem's Temple are saturated with such power because of their unique divine history. Guy Patton's and Robin Mackness's *Sacred Treasure, Secret Power: The True History of the Web of Gold* really sets the alarm bells ringing because of the sweeping assumptions it makes about the Temple treasure. The authors believe that the spoils of Jerusalem were seized by the Visigoth leader Alaric during the sack of Rome in AD 410 and carried off into the French Pyrenees around AD 415 by his successor, Ataulphus. When threatened by the Franks and the rise of early Islam, the Visigoths allegedly retreated to their last stronghold at Rennes-le-Château in the Languedoc region of southern France, where the treasure was hidden underground.

Patton and Mackness weave a fantastic conspiracy theory, which strings together a web of coincidences linking the Temple treasure to numerous infamous historical organizations from the Knights Templar to the Nazis. In the shadows lurks the veiled institution of the secretive Priory of Sion, supposedly a medieval order that succeeded the Templars and remains dedicated to this day to protecting the bloodline of the Merovingian kings of Gaul, who ruled from the fifth to eighth centuries. With its shadowy Grand Masters, allegedly including Leonardo da Vinci and Sir Isaac Newton, the priory is also considered by some to be the guardian of the secret of the Temple treasure of Jerusalem.

For all their meandering argument, and its far-reaching and longterm implications, Patton and Mackness neglect to characterize the nature of the very "treasure" that apparently greatly influenced many major acts of history—exactly like Valter Juvelius and Montague Parker ninety years earlier. Again, I was mystified how the transferable powers

74 -

or scales of wealth of a treasure can be understood without its composition being clear.

In all fairness, the Rennes-le-Château enigma has long been a favorite stomping ground for treasure hunters and conspiracy theorists. Over the decades its association with the Knights Templar and the Priory of Sion has spawned a minor industry, yielding nearly three hundred books and three television programs. According to legend, in 1885 Bérenger Saunière was appointed parish priest of Rennes. One fine day he chanced upon a folded ancient parchment crammed inside the carved-out hollow of a Visigothic pillar used as an altar in his church. This coded Latin text spoke of a treasure belonging to a seventh-century AD Merovingian king, Dragobert II (died AD 679).

Soon after this discovery, Saunière sped off to Paris with his "treasure map" to seek scholarly advice, and is said to have returned home having purchased three paintings, including *The Shepherds of Arcady* by Nicolas Poussin. Within this painting the shepherds point to an inscription on a tomb apparently resembling one still standing at Arques, a few miles east of Rennes. Part of Saunière's deciphered code was said to read "Poussin holds the key." So *The Shepherds of Arcady* painting was a coded treasure map literally pointing the way to the treasure of Jerusalem.

The foundations of the Rennes Temple treasure legend lie in the Abbé Saunière's extraordinary building program initiated in 1891. Out of nowhere this man of the cloth somehow found the funds to set up new statues, rebuild much of the village, and provide it with a new water supply and access road. Oddly for a man of sworn humility, the priest also built himself a luxurious villa alongside the church with elaborate gardens, an orangery, and a mysterious locked tower. On his deathbed in 1917, Saunière's final confession was apparently so shocking that the priest who heard it is said to have never smiled again for the rest of his life. Where did this humble parish priest, overseeing a small village community of 298 inhabitants, get the funds for these ambitious renovations?

Perhaps the most fascinating intrigue surrounding the myth of the

- 75 -

Rennes-le-Château treasure is the character of Noel Corbu, founder and proprietor of the Tower Hotel in Rennes, and self-styled biographer of Saunière and his bizarre antics. Corbu claimed that the priest accessed treasure worth 18.5 million francs, but later upped his estimate to a staggering 4 trillion francs. When Corbu first exposed the tale of the treasure, the story was dynamite. The hotelier quickly invited a journalist called Albert Salamon to visit Rennes and record his testimony.

Salamon and hundreds of other devotees swallowed Corbu's story hook, line, and sinker. But something stank of fraud beneath the veneer of Templars, Jewish treasure, and secretive priests. In 2003, Bill Putnam and John Edwin Wood convincingly lifted the lid on the truth in *The Treasure of Rennes-le-Château: A Mystery Solved*. Noel Corbu, it turned out, was not a quietly dedicated local historian. Really he was an entrepreneur who had written his own detective story and dabbled in the black market. Most of his historical narrative was a literary invention designed with one specific aim in mind: to put the area on the map and bring fame and fortune to his humble hotel.

Saunière's own bookkeeping shows that his building renovations actually cost 193,000 francs, the equivalent of about \$2.9 million today. While this is a considerable sum for a rural parish priest to get his hands on, it is hardly an immense golden treasure. The priest did have good reason to behave secretively, but this had nothing to do with the discovery of the long-lost treasure of Jerusalem, but everything to do with pious fraud. Quite simply, Saunière was trafficking mass for the dead, personally giving fifty-five masses a day and also taking payment for further masses not rendered. Ecclesiastical law set the limits of saying mass for the dead at three a day. The priest was keen for his illicit moonlighting not to come to light. There is no doubt that Putnam and Wood are correct in calling the Rennes/Jerusalem treasure link pseudohistory and "fantastic in the extreme."

So far, everything I had read about previous attempts to find the Temple treasure of Jerusalem could be comfortably excluded. In terms of scientific accuracy it simply wasn't worth the paper it was written on.

— 76 —

12

DEAD SEA TREASURES

Driving south out of Jerusalem down the Judean Hills to the Dead Sea, the lowest place on earth, my ears popped. The lush, landscaped parks of the Holy City gave way to an alien world of open space, uncultivated and barren. Even under the pleasant skies of late April 2005, the hills were largely bare. Sporadic wiry green bushes desperately rooted for water amid the most arid of sandy brown soils.

Unchanged since biblical times, this wilderness is hostile to all forms of life—the perfect place to retreat from society and meditate about the meaning of life, like various Old and New Testament prophets, but home to no man: wilting 104-degree Fahrenheit temperatures for nine months of the year, few freshwater sources, and infertile saline soils. Here and there Bedouin lazily attended their goatherds; the occasional inquisitive camel looked up from the roadside.

Haze danced off the looping road winding down to the northern tip of the Dead Sea. Already, in spring, it was baking hot. A particularly vile smell of rotting eggs drifted off the distant lake, a noxious concoction of naturally formed dry salt and sulfur. The road plateaus out at sea level and I swept passed the military checkpoint and turnoff north to Tiberias and Beth Shean in the Galilee through the West Bank.

I steered south on a deserted sea road meandering toward the oasis of Ein Gedi, Beersheba, and eventually Eilat and the Red Sea. Not a single person could be seen, not a welcoming blade of grass. The landscape is stunningly alien. The Dead Sea refuses to sustain marine life;

- 77 -

the flat foreshore is thick with reeds, and sulfurous spits of sand form narrow bays far too shallow for use as natural harbors. What on earth did the Romans make of this place when they were dispatched here in AD 68 to decapitate the few Jewish revolutionaries making trouble on the edge of the civilized world? Were they proud of the vastness of the empire or, after sweating pounds marching south, did they start to question the wisdom of war? The Tiber's cool, caressing winds must have seemed a world away.

My destination was Qumran, a tiny oasis in this desert wilderness, whose occupants are credited as the authors of the two-thousand-yearold Dead Sea Scrolls. Craggy mountains composed of loose pockets of sandstone and rock—giant dollops of geological apple crumble dominate Qumran. Over the centuries earthquakes and landslides have concealed a labyrinth of caves overlooking the ancient settlement. But between 1949 and 1962 illegal looting by roaming Bedouin, and subsequent research by Jordanian, Israeli, and American archaeologists, uncovered one of the most sensational finds of the twentieth century: religious books and social commentaries written on 850 leather and papyrus scrolls.

One document, however, turned out to be unique: scroll 3Q15 was the only example written on copper and has nothing to do with divine issues. When first translated by Dr. John Marco Allegro in Manchester, England, in October 1955, the Copper Scroll (as it is more conveniently called today) proved a sensation by apparently revealing the hiding places of thirty-one tons or more of gold and silver worth a cool \$3 billion. Many specialists maintain to this day that the scroll lists the hiding places of Jerusalem's Temple treasure, spirited away around AD 70 to prevent it from falling into Rome's eager hands. Could they be right?

If the Temple treasure isn't under the Temple Mount of Jerusalem, in the Vatican, or tucked away in Rennes-le-Château under the watchful guard of a knight of the Priory of Sion, where on earth is it? Of all the weird and wonderful possibilities, the curious case of the Copper Scroll offers the most tantalizing reason for optimism to date. Without doubt the most unusual of the Dead Sea Scrolls, this document has

- 78 -

courted controversy ever since it was found propping up the inner wall of Cave 3 at Qumran on March 14, 1952. For a year and a half its mysterious content remained sealed, although the unique copper medium generated more curiosity than the likelihood of an innovative read. If the other 850 Dead Sea Scrolls were anything to go by, this would turn out to be either a biblical tract or ancient community rulebook. As it turned out, nothing would be further from the truth.

The first hints that the folded leaves contained something unusual emerged in 1953. After staring at some uncleaned, obscure letters scratched onto its eroded copper surfaces through a glass museum showcase in Jerusalem between September and October, an obsessed German professor, K. G. Kuhn, arrived at the outrageous conclusion that the scroll was nothing less than an inventory of buried treasure, perhaps deposited two thousand years ago by the Essenes, a pious Jewish sect who lived in the secluded wilderness around the western Dead Sea. As John Marco Allegro later recalled in *The Treasure of the Copper Scroll* (1960), "Some blamed the heat of the Jerusalem summer, others the strength of the local *'arak*, few took the learned professor seriously."

Nobody would really be sure about the scroll's content, however, until it was opened and translated, a precarious job that held every chance of shattering the brittle metal. Certainly no suitable laboratory facilities existed in the Middle East. So in the summer of 1955 Dr. Allegro, the first British member of the Dead Sea Scroll editorial team and a lecturer at Manchester University in England, arranged for the copper to be opened at the College of Technology in Manchester with precision saws designed to cut through human skull bone in brain surgery. The successful operation revealed three plaques about one millimeter thick and 11.5 inches high, riveted together to form a unique 8-footlong document.

Even though formal publication had been allocated to the Polish scholar and former priest Józef Milik of the Dominican École Biblique in Jerusalem, Allegro couldn't contain his excitement. Soon after the opening he broke protocol by personally translating the text and, in the process, confirmed that the scroll was indeed an inventory of buried

- 79 -

treasure. In October 1955, Allegro wrote to inform Lankester Harding, director of the Jordanian Department of Antiquities, that "these copper scroll are red hot. . . . Next time you're down at Qumran, take a spade and dig like mad by the airhole of the iron smelting furnace . . . there should be nine of something there."

Despite facilitating the opening in Manchester, and thus being the key to the Copper Scroll's stunning revelations, Allegro soon found himself sidelined. Roland de Vaux, the head of Jerusalem's École Biblique et Archéologique Française, and editor in chief of the Dead Sea Scrolls publication team, informed Allegro by letter that he found his reading of the text inaccurate, and somewhat haughtily thanked him for "making transcriptions in case an accident should happen." Perhaps these more cautious elder statesmen of archaeology had good reason to dampen Allegro's enthusiasm. Privately they were aware that he was a controversial figure, a maverick who could not be trusted to stick to professional scholarly ethics. After all, this was the man who would even tell the BBC that his interpretation of the commentary of the book of Nahum from Cave 4 at Qumran suggested that the Essenes had worshipped a "teacher of the righteousness," who was crucified by gentiles and was expected to rise from the dead. Sound familiar? Allegro's theory that Christianity's own messianic worldview was disseminated from the highly religious Essene Jews was considered an unqualified smear against the Church. A hornet's nest of public resentment had been stirred up.

Allegro's frustration at being unable to publish details about the Copper Scroll continued to simmer. In 1958 his book *The Dead Sea Scrolls: A Reappraisal* went into a second edition and, as he wrote in a letter, if he could update it with the spectacular results from Cave 3 at Qumran, "it would sell another million." Other than the odd comment, however, he reserved his translation and interpretation for a major new book, walking a tightrope by publishing *The Treasure of the Copper Scroll,* the same year that Milik's official report on the scroll appeared in the *Annual of the Department of Antiquities in Jordan.* Allegro beat the official publication team to the punch and got his exclusive.

- 80 ---

For the first time, the Englishman's impressive translation exposed the full wonders of this "treasure map." Here was a formulaic description of sixty-one buried items listing types of wealth, quantities, and locations. For instance, Items 1 and 7 read respectively:

In the fortress which is in the Vale of Achor, 40 cubits under the steps entering to the east: a money chest and its contents, of a weight of 70 talents. In the cavity of the old House of Tribute, in the platform of the Chain: 65 bars of gold.

Over the last forty years the Copper Scroll has been dissected and debated in hundreds of articles and special conferences. Yet other than the facts that the scroll dates to the Roman period, is written in proto-Mishnaic Hebrew, and is a list of sixty-one buried items of varying monetary value, a dense fog still swirls around the text. The scroll is unique in metallic composition, paleography, language, content, and genre, and even though the text is extremely well preserved, scholarly opinion remains as wide as the Grand Canyon. The doyen of Dead Sea Scrolls studies, Professor Frank Cross of Harvard University, identified the script as a late Herodian substyle of the "vulgar semiformal" hand of AD 25–75. The official publication by Józef Milik, on the other hand, favored a far wider potential date range of AD 30–130.

Today, most scholars accept the Copper Scroll treasure as real. But who owned it, why was it concealed, and under what historical circumstances? Everyone seems to have their own favorite theory:

1. The treasure was tithes collected by Essene priests. The scroll was an inventory of treasure of the Essene bank, hidden by members of the Qumran community either before or during the revolt of AD 66–70 and recovered afterward.

— 81 —

- 2. The treasure is so great that, if real, it can only have been objects saved from the Jewish Temple of Jerusalem destroyed in AD 70 and hidden by its priests.
- 3. The Essene community of Qumran was destroyed in June AD 68, and reoccupied by the Zealots (Jewish patriots named after Greek *Zelotai* famous for their suicidal last stand against Rome at Masada). The Copper Scroll records sacred materials, tithes and tithe vessels sanctified by dedication or actual use in God's service that the Zealots had plundered from the holy places for money and to buy food. The scroll was written and hidden in Cave 3 during the three months of Zealot occupation at Qumran before the settlement fell to Rome.
- 4. The treasure was money that the Zealot general, Eleazor ben Simon, captured during a battle with the Roman governor Cestius Gallus in autumn AD 66; Cestius's baggage had been transporting public taxes.
- 5. The scroll was a record of accumulated funds that were still systematically collected after the destruction of Jerusalem in AD 70 for rebuilding and maintaining a new Jewish Temple at some future date. The funds were deliberately hidden away to await the arrival of the day of redemption.
- 6. The treasure comprises redemption funds accumulated as religious taxes and tributes. Because Jerusalem was inaccessible due to the Roman siege (and later its destruction), the tribute had to be deposited in genizas (sanctified synagogue storerooms) between the First and Second Jewish Revolts against Rome, pending the rebuilding of the Temple. As imminent disaster approached around AD 135 with the failure of the Second Jewish Revolt, the positions of the inventory were registered in the Copper Scroll.
- The scroll is a record of treasure hidden by Simon Bar-Kokhba during the Second Jewish Revolt in autumn AD 134.

One piece of evidence, seven incompatible interpretations from some of the world's greatest minds. Even the magnitude of the Copper Scroll treasure is open debate. Dr. Allegro could be a loose cannon at

- 82 -

times, but to his credit he possessed extremely perceptive powers of observation and was a brilliant scholar. Calculating the volume of treasure was a simple process, or so he thought:

> Silver—3,282 talents, 608 pitchers, 20 minas, and 4 staters Gold—1,280 talents Vessels of unknown precious metals—619

The quantities certainly seem impressive, but are misleading because nobody has successfully worked out the equivalent weight or value of the talent in first-century AD Israel. This was clearly not the talent of rabbinical literature or of Old Testament times because, if true, the eighty talents of gold stored in two water pitchers listed in Item 33 would have weighed 1.5 tons, an impossibility for clay pitchers measuring less than eight inches in height. The mathematics simply do not balance.

Allegro concluded that the talent concerned was close to the Greek *mina* of 12 ounces, yielding an overall comparative value for the treasure of about \$1 million (in 1960). Elsewhere, the Copper Scroll's treasure has been estimated to be anywhere from 58 to 174 tons of precious metal. On the basis of another Dead Sea scroll, 4Q159, where the talent equates to 6,000 half-shekels, the 5,000 talents of the Copper Scroll have been equated to a staggering \$3 billion.

Although the jury clearly remains out about the exact value of the Copper Scroll treasure, the overwhelming majority opinion accepts that this document refers to money and religious objects originating in the Second Temple of Jerusalem. If correct, the answer to my quest would lie somewhere in the stifling heat of the Dead Sea wilderness.

- 83 -

13

CASTLES IN THE AIR

Against a backdrop of foreboding dark chocolate mountains nestles Qumran, a sprig of green relief and a peaceful oasis in the wilderness. The ancient settlement sits halfway up the mountainside, straddling a plateau with spectacular views of the Dead Sea's flat desert hinterland below, here and there interrupted by islands of date plantations. On clear days the Jordanian hills are framed dramatically against the eastern skyline. For both seclusion and security, Qumran occupies a perfect setting. But perfect real estate for what purpose: a religious retreat or welldefended stronghold?

By examining the ruined settlement near which the Copper Scroll was found in 1952, I wanted to confirm certain key points that would determine whether or not this document really held the secret to the lost Temple treasure of Jerusalem. In particular, was Qumran really a monastic settlement settled by the Essenes, the most pious sect of Jews in the ancient world? If so, who better to silently watch over a Temple treasure snatched from the jaws of Rome in AD 70. Or, as the latest research by Professor Yizhar Hirschfeld of the Institute of Archaeology at the Hebrew University of Jerusalem favors, was the site actually a wealthy manor house owned by a rich and Romanized Jewish member of the ruling class of Judea?

This matter is crucial. If Qumran was not an Essene retreat, then there would be no reason to attribute the Dead Sea Scrolls to this sect. And if this was true, then the Essenes were not necessarily either the au-

- 84 -

thors or the owners of the precious texts concealed in the nearby caves or possible keepers of the secret hiding place of the Temple treasure.

Qumran is one of the most famous archaeological sites in the world and also one of the most controversial. The settlement was thoroughly excavated between 1953 and 1956 after the same type of "scroll pots" recovered from the nearby caves containing the Dead Sea Scrolls was spotted overlying Qumran, leading to speculation that the scrolls were the concealed belongings of these mysterious inhabitants who both made the jars and wrote the texts.

History has not been especially kind to Qumran's excavator, Roland de Vaux, the director of the École Biblique et Archéologique Française in Jerusalem. On the one hand, he successfully supervised rapid excavation, turning out quality preliminary reports. On the other, his scientific methodology was dubious by modern standards and his leap of faith between the physical evidence and interpretation somewhat creative. But what really troubles modern scholars are the thousands of small finds and pottery. Uncovered in three different chronological phases, these have never been fully researched or made available to fellow scientists through publication. So we remain unclear about which coins and finds relate to which periods of the site's history. Without this level of knowledge, the story of Qumran will remain forever jumbled and incomplete.

Consequently, Qumran has become all things to all men. De Vaux was a man of the cloth, a French priest with his own singular mind-set and background. Living in a communal environment in Jerusalem, it is hardly surprising that he read into the ruins a monastic life based on agriculture, stock-rearing, and basic industry. Clay inkwells found amid the ruins conjured up images in his mind of a scriptorium of the form common in medieval monasteries. No doubt, it was here, postulated de Vaux, that the Dead Sea Scrolls themselves were written.

The identification of Qumran and its caves as an oasis of Essene monastic life was based on what in the 1950s seemed to be a watertight holy trinity: de Vaux's archaeological results; the nearby scrolls, whose mystery gripped the imagination; and vivid historical descriptions of

— 85 —

Essene life around the western shore of the Dead Sea preserved in the writings of Josephus and Pliny the Elder.

The most influential factor was the Essenes. As a youth, the firstcentury AD historian Flavius Josephus was so obsessed by this sect that he spent three years living with one of its most pious members, Bannus, who only ate wild plants, wore clothes made of tree bark, and frequently immersed in cold water for purposes of ritual cleanliness. Back in the Eternal City, having turned from a Jewish commander into an imperial informer for Rome to help crush the First Revolt in Israel, Josephus wrote at length about this Jewish sect, for whose extreme and unwavering religious observance he held a profound respect.

The Essenes were not fun-loving. They rejected pleasure as evil and considered the conquest of passion virtuous. Rather than marry, Josephus tells us that the sect's line of succession continued because they "choose out other persons' children, while they are pliable, and fit for learning . . . and form them according to their own manners . . . they guard against the lascivious behavior of women, and are persuaded that none of them preserve their fidelity to one man."

Personal possessions were renounced by the Essenes, who were renowned for their white robes worn until they literally dropped off their bodies. Of all Jewish sects, including the Sadducees and the Pharisees, Josephus considered the Essenes most religiously observant. After sunrise, he records, "they are sent away by their curators, to exercise some of those arts wherein they are skilled, in which they labor with great diligence till the fifth hour. After which they assemble themselves together again into one place; and when they have clothed themselves in white veils, they then bathe their bodies in cold water." Purification conditioned the movements of everyday life.

Of key interest to the archaeological discovery of the Dead Sea Scrolls is Josephus's testimony that the Essenes were unusually studious and secretive. The sect studied the writings of the ancients dutifully, and newly recruited members swore "to communicate their doctrines to no one . . . and will equally preserve the books belonging to their sect." This religious integrity eventually even impressed the Romans, who

- 86 ---

mercilessly tortured captured Essenes in AD 68 to try to force blasphemy from their lips and to make them eat nonkosher food. Sect members responded by smiling at their suffering and laughing at their tormentors. In Essene doctrine the body was corruptible but the soul immortal.

Following de Vaux's excavation at Qumran in the 1950s, his picture of an Essene settlement remained common currency for over thirty years. Here, an extremist Jewish sect shied away from society, wrote the Dead Sea Scrolls, and hid them in the surrounding caves when the fearful tramp of Roman boots echoed along the desert roads during the First Jewish Revolt. The imprint of the Essenes was everywhere: the inkwells from a scriptorium linked the thoughts of a studious people to the physical scrolls themselves, the dominance of water systems and *mikvaot* proved their compulsion for ritual purity through cleanliness, and their pottery workshop reflected a self-sufficient economy closed to the outside world.

Confronted with such staggering physical remains, and before the scrolls and ruins of Qumran were fully studied, most scientists of the day would have arrived at precisely the same conclusions as Roland de Vaux. And though he remains an easy target because he never published a final excavation report, he was a meticulous recorder. Today, sixty years later, the vast body of diaries and artifacts he left behind have prompted an archaeological revolution over the mysteries of the "Qumran Triangle."

The traditional picture of Qumran as a quiet "monastic" Essene outpost was recently shattered by the late Professor Yizhar Hirschfeld of the Hebrew University. Hirschfeld jettisoned the Essene-Qumran theory wholescale. His forceful new argument envisages the site as a manor house set among a wealthy estate—similar to the setting of a medieval castle—and owned by one of the king's favorite lords. Here a wealthy aristocrat and his estate manager and slaves reaped the riches from highly specialized produce: dates, bitumen, and balsam. Qumran, then, was the local version of a Roman villa, but with a tower and reinforced outer walls to defend against regional insecurity. In Judea, such fortified manor houses were known as *baris* in antiquity. Hirschfeld be-

- 87 -

lieves the Essenes did not live at Qumran but at Ein Gedi in a cluster of huts he excavated on a mountainside 650 feet above the ancient town. Such a remote shantytown, he believed, was a far more appropriate setting for pious, nonmaterialistic Jews.

Even though lords, knights, and manor houses smack rather inappropriately of medieval Europe and feudalism, and so require a leap of faith across the chasm of time and place, Professor Hirschfeld's theory has done "Qumranology" a great service. The site is now out of the closet. Qumran does only make sense among a wider regional canvas. Contrary to today's vivid image of the Dead Sea as a no-man's-land, the lowest place on earth was actually a bustling hive of activity in antiquity. Forget the relentless sun that can fry an egg. Ignore the lack of fresh spring water and the poor nutritional resources that suggest (according to anthropological studies based on Qumran's ancient cemetery) that only 6 percent of adult males lived beyond the age of forty (compared to 49 percent at Jericho). Set aside the superficial uselessness of the Dead Sea as a maritime resource.

The truth is that in the Hasmonean and Roman periods the oases of the Dead Sea were organically linked to Nabatea in modern Jordan by small ports strung along its shore. Here man overcame matter and a hostile environment to turn this wilderness into the equivalent of an ancient Silicon Valley. The region's unique geography may have supported extremely limited industry, but these were highly coveted and extremely lucrative. Most appealing were the royal date plantations King Herod bequeathed to his descendants.

Judean dates were world famous as gourmet food and for their medicinal qualities. In the Bible, Jericho was known as the "town of dates" (Deuteronomy 34:3) and in his *Natural History* Pliny the Elder remarked that the "outstanding property [of Judean dates] is the unctuous juice which they exude and an extremely sweet sort of wine-flavor like that of honey." The shores of the Dead Sea were carpeted with oases of sweet-smelling date plantations two thousand years ago, stretching at least from Jericho in the north to En Boqeq on the southern shore, where hundreds of date pits from a first-century AD processing plant

- 88 ----

have been unearthed. New research suggests that the so-called wine press at Qumran, as well as its satellite farm at Ein Feshkha, actually specialized in date honey.

If dates were the mainstay of the economy, traded the length and breadth of the civilized Roman world, the Dead Sea was also renowned for two other specialist products, balsam and bitumen. An inscription on the mosaic floor of a mid-fifth-century AD synagogue at Ein Gedi mysteriously refers to the "secret of the town" that must be guarded from outsiders. The mystery that made Ein Gedi such a wealthy oasis in the middle of a wilderness was almost certainly balsam. The historian Galen wrote in De Antidotis that this plant "is called Engadinne after the place where it grows most abundantly and is most beautiful, being superior in quality to that which grows in other parts of Palestine." Although balsam is extinct today along the Dead Sea, this large shrub whose bark, shoots, and twigs yielded resin and juice coveted across the Roman world for perfumes and medicine, was used to treat headaches, eye disease, cataracts, and myopia. In the mid-third century AD, the medical writer Solinus knew about opobalsamum from the Dead Sea, and Statius described how Palaestini liquores was used to scent corpses in embalming.

Perfumes in general were a high-value luxury item in the Roman world that permeated the classes and everyday life. Pliny rather tartly recorded how

their cost is more than 40 *denarii* per pound. . . . We have seen people put scent on the soles of their feet . . . somebody of private station gave orders for the walls of his bathroom to be sprinkled with scent. . . . This indulgence has found its way even into the camp . . . using hair oil under the helmet. (*Natural History* 13.20–23)

Various ancient historians, ranging from Josephus to Diodorus, Pliny, and Strabo, all agree that Judean balsam was the finest in the world. And securing the balsam plantations and local economic interests was the real key that drew the might of Rome to this isolated part of Israel in

— 89 —

AD 68. So valuable were the resources of the Dead Sea and its balsam groves that the area was subjected to a scorched-earth policy during the First Jewish Revolt.

The overpowering reason for Rome's invasion of the Dead Sea wilderness was money. In this Rome was highly successful, seizing and subsequently controlling the balsam plantations of the Ein Gedi region. As Pliny confirmed to his Roman readership:

The balsam tree is now a subject of Rome and pays tribute together with the race to which it belongs . . . the immense value of even the cheapest part of the harvest, the wooden lopping, fetched only five years after the ravages of war of the destruction of the Temple, 800,000 *sesterces*. (*Natural History* 12.118)

Balsam and financial profit tell you all you need to know about why farmers worked so hard in the Roman era to make the geographically hostile western Dead Sea wilderness blossom. Economics is the main reason why Roman coins of Vespasian and his sons commemorating the Jewish War victory depicted a handcuffed Jew standing against a palm tree beneath whom sits a mourning Jewess and a pile of discarded armor. The date farms of Palestine were now controlled by Rome.

Was Qumran somehow involved in the lucrative luxury production and trade of dates and balsam, perhaps as a center of cultivation in its own right? If so, this would disprove the contention that settlement was a hub of Jewish learning. Strong grounds certainly exist to argue thus. Even though Qumran's own small date press probably only served the estate community, the industrial complex at its farm, Ein Feshkha, was a far bigger affair, most probably specializing in date honey. A thick burnt level excavated at Ein Feshkha, plus the subsequent appearance of Roman tiles stamped with the logo of the Roman army, certainly fits into the pattern of a deliberate imperial takeover in AD 68.

Today we can be certain that the settlement of Qumran—allegedly the home where the Dead Sea Scrolls were written by dedicated Jews—was not the isolated monastic settlement envisaged by Roland de Vaux. One clinching piece of evidence is the rich collection of 679

- 90 ---

ancient coins the site has yielded, 94 dating to the period of the First Jewish Revolt.

The large cluster of coins recovered certainly creates a headache for enthusiasts of the Essene theory because Josephus was explicitly fascinated by the nonmaterialistic character of the sect, which forsook all earthly pleasures to serve God. Emphatically, he noted:

These men are despisers of riches. . . . Nor is there any one to be found among them who has more than another; for it is a law among them, that those who come to them must let what they have be common to the whole order—insomuch, that among them all there is no appearance of poverty or excess of riches, but every one's possessions are intermingled with every other's possessions. (JW 2.122-123)

Science also casts a long shadow over the idea that whoever occupied Qumran was truly reclusive. It has long been assumed that the settlement's clay pots were produced for exclusive use at Qumran and the surrounding caves. This image fitted neatly with the idea of Qumran as an Essene settlement because in-house production ensured that the sect need not deal with the outside world and could also guarantee that their pots would not be rendered ritually unclean by being handled by Gentiles or menstruating women.

However, samples of pots from both Qumran and the surrounding scroll caves have recently been examined by Neutron Activation Analysis (NAA), a process that identifies the unique chemical "fingerprint" of the clay using nuclear chemistry. The results show that only about 33 percent of the pottery was local to Qumran, with the rest imported from Jericho. Even more disturbingly, the so-called scroll jars weren't even crafted from a clay source local to Qumran. The link between the people of Qumran and the Dead Sea scrolls has thus been fully severed. The "holy trinity" linking the scroll and Qumran to the Essenes lies in pieces. Whoever lived there, it was certainly not the exclusive sect of super pious Jews known to Josephus.

But what about eight Jewish ritual baths that dominate Qumran,

- 91 ---

the largest concentration in Israel and surely certain proof of extreme Jewish piety at Qumran? Even this time-honored assumption is no longer clear-cut. Just how efficient can these baths have been in such an arid part of the world? Qumran is not fed by natural springs and, in antiquity, relied on the meticulous channeling of water during the few occasions when winter flash floods swept the area. Even with the capture of this rainfall, Qumran would still only have received a miserly two to four inches of rain each year. While this was enough for date palm cultivation, ensuring the flow of fresh water for ritual purity was quite impossible.

If Qumran was really occupied by a pious Jewish community undertaking ritual immersion several times a day, this behavior would have been wholly counterproductive. With no constant means of replenishment, the water within the pools must have stood stagnant for up to nine months between rains. Full-body immersion in such disease-ridden waters, or even the simple washing of the hands and face, would have been sufficient for the bather to contract the parasites *Ascaris lumbricoides* (roundworm) and *Trichuris trichiura* (whipworm) or other enteropathogenic microorganisms that are friends of cholera, hepatitis A, and shigellosis. The notion that the occupants of Qumran would have exposed themselves to such a harmful environment is simply absurd and opens up the possibility that these water features were more about spectacle and social prestige than religious observance.

Even though the full answer to the riddle of Qumran remains unresolved, the Essene model becomes increasingly hard to justify. The site can only have been owned and controlled by a wealthy Jewish landlord, a member of the Rome-loving ruling class of Judea. The current "keeper" of Qumran (artifacts, diaries, and master plans), Jean-Baptiste Humbert, believes Qumran is more reminiscent of a Pompeian villa than a rural estate. The eastern extension may have been a triclinium (dining room) with flashy plaster decoration and fancy tiles.

So where does this leave the Copper Scroll as a possible map identifying the hiding places of the Temple treasure of Jerusalem? With the Essenes out of the picture, the probability opens up that the scrolls were

- 92 -

not their property at all. Instead, the scrolls could represent ancient wisdom accumulated in Jerusalem and relocated to the Dead Sea to escape the wrath of Rome. This alternative idea could also mean that the list of treasure in the Copper Scroll was compiled by Jewish priests in the Holy City itself.

Today we know of 57 caves holding ancient cultural remains within a network of 279 caves and crevices that honeycomb the mountainside at Qumran. The 850 scrolls are also hugely diverse in subject matter and date, spanning a period from the end of the third century BC to AD 68 or later (the Copper Scroll is the latest deposit). And this massive body of writing could hardly have been the work of a few scribes toiling at one site like Qumran: paleography points to the hands of five hundred different scribes. Quite simply, the only place on earth that could have produced and stored such an educated collection in the first century AD was Jerusalem.

So, if the Copper Scroll was not a list of hidden Essene treasure, and if the majority of the Dead Sea Scrolls originated in Jerusalem, surely this makes the likelihood that the Copper Scroll describes the wealth of the Temple more than plausible? Not exactly: nothing is ever simple with Qumran and the Dead Sea Scrolls.

There are worrying objections to the Copper Scroll/Temple treasure theory. If your most prized possession was on the verge of being seized by an enemy force, such as the Romans in Jerusalem, would you calmly pour yourself a glass of wine and slowly set about the laborious process of writing a shopping list of your earthly belongings? The Copper Scroll bears no resemblance to a list hastily jotted down on a memo pad. Its formality is more akin to hiring a specialist in calligraphy. And incising on copper rather than writing on papyrus must have been at least ten times slower. If the threat was immediate, you would surely have made some rapid notes on a scrap of paper and run for the hills. The desperation of the Jews in Jerusalem and the meticulous record keeping of the Copper Scroll are incompatible. Also, why resort to laboriously etching on copper when ink and papyrus would have been far simpler and swifter?

— 93 —

Furthermore, if the treasure was so sacred, why conceal it in locations that can at best be described as temporary hiding places? Many of the "secret" hiding places were random and wholly unsuitable for even short-term concealment. Thus, 42 talents were hidden in a salt pit under some steps; others were placed in cavities, fissures, and the spur of a rock in a cistern. Untithed goods and 70 talents even ended up in a wooden barrel in an underground passage. Equally temporary was the dam sluice and winepress pit holding 200 talents of silver. But perhaps most desperate of all was the decision to hide wealth beneath corpses in graveyards, a very strange practice for observant Jews. Thus, Item 55 reads:

In the grave of the common people who (died) absolved from their purity regulations: vessels for tithe or tithe refuse, (and) inside them, figured coins.

The scroll text also suggests that the innovator was not planning for a long-term eventuality. The descriptions of the hiding places are vague, and it is highly questionable whether even a native intimate with the local landscape could have identified the place-names from the scroll itself. Even more strange, most of the topographic citations are not actual names but coded mnemonic indicators, highly abbreviated references that would have made sense only to a select inner circle. Would Jewish High Priests really have relied on such ad hoc descriptions to stash away, and more important to recover, the most important treasures known to man?

The incompatibility between the enduring copper medium of the scroll and the relatively uninspired hiding places cited has led to strong arguments that the Copper Scroll actually describes Jewish taxes rather than Temple treasure. As soon as the scroll was translated, John Allegro quickly pointed out that various terms in the document indicated tithes. Temple economics was based on an annual half-shekel poll tax levied

- 94 -

throughout Israel and among the Jews of the Diaspora, which was used for the upkeep of the Temple and its services. Israel also levied a cattle tithe for feast days in Jerusalem, while charity collections for the poor were collected every third year. For John Allegro, at least some of the wealth in the Copper Scroll was just this kind of basic taxation.

If the Copper Scroll's wealth was real, the tax model interpretation makes best sense. Certainly, the geopolitics of the First Jewish Revolt and pattern of treasure interment remain completely illogical. Why preserve something on copper for perpetuity when its supposedly invaluable contents refer to materials hidden in places meant to be known only to a select few insiders, but which were nonetheless relatively easy to locate? The use of copper reflects a desire to preserve memory of the concealed treasure long term. Yet the scroll's style and nature of the hiding places could only have permitted short-term concealment. The scroll is a confusing paradox. The dubious character of the scroll is cemented by its mysterious final entry:

In the Pit adjoining on the north, in a hole opening northwards, and buried at its mouth: a copy of this document, with an explanation and their measurements, and an inventory of each thing, and other things.

The interpretation of such text is surely the stuff of a fictitious treasure hunt. In reality, not one item on the Copper Scroll inventory has ever been found, even though Israel is one of the most intensely excavated countries in the world. In the golden age of excavation in the 1990s, the country possessed the largest number of archaeologists per capita in the world. You might have expected at least a slither of silver to have materialized. But nothing has come to light apart from Dead Sea Scrolls themselves, which begs one final question: If the caves of Qumran were such reliable hiding places, why on earth didn't the author of the Copper Scroll hide his blessed treasures inside them?

A passionate John Allegro, convinced he had deciphered the modern locations of the ancient names listed in the scroll, even led expeditions to Jerusalem, the Vale of Achor, and Qumran between 1960 and 1963 to uncover the legendary treasures. Despite the support of King Hussein of Jordan, the team returned to England empty-handed.

There is one very good reason why nothing in the enigma of the Copper Scroll adds up. It can't have been Essene wealth because the sect shunned material goods. It clearly wasn't precious religious Temple treasure because such poor hiding places would never have been acceptable. And nowhere at all are the gold candelabrum, silver trumpets, and other chief instruments of Jewish faith worshipped in the Second Temple of Jerusalem mentioned.

If the treasure was ever real, then it can only have been tax collected after the Temple of Jerusalem had been razed. Just as many Jews today still devotedly save money in a tin labeled FOR JERUSALEM, so it would seem that within the decades after the First Jewish Revolt the Temple tax was privately reintroduced. But rather than plans for a new Temple ever coming to fruition, the iron fist of Rome gripped the province of Palestine ever more tightly. Finally, Judea exploded into the Second Revolt under Bar-Kokhba (AD 131–135). Once again Jerusalem and the Dead Sea were flooded by troops, leaving no alternative but to conceal the Temple taxes in the most convenient hiding places. Perhaps no treasure has ever turned up because Rome tortured Jewish priests into disclosing these places.

To me this interpretation is still highly charitable. I share the opinion of Józef Milik, the official expert on the Copper Scroll, who denounced the document as ancient Jewish myth-making, an inspirational piece of fiction mourning for a brave old world destroyed and doomed to oblivion. Typically, in *Ten Years of Discovery in the Wilderness of Judaea* (1959), he writes that the scroll

contains a list of about 60 deposits of treasure, hidden in various sites scattered over the Palestinian countryside, but mainly concentrated in the region of Jerusalem, near the Temple and in the cemetery of the Kedron valley. The total of gold and silver

- 96 -

said to be buried exceeds 6,000 talents, or 200 tons—a figure that obviously exceeds the resources of private persons or of small communities.

In addition to these quantities of gold and silver, the roll mentions incense and precious substances which are said to be stored in vessels also made of valuable materials. . . . All these motifs recur in other folkloristic works that give clues to buried treasure. An example of such folklore is found in Egyptian Arabic literature, the *Book of Buried Pearls and Hidden Treasures*, which Ahmed Bey Kamil published in Cairo in 1907.

A nonliteral interpretation of the Copper Scroll has also been backed up by T. H. Gaster, who proposed in *The Dead Sea Scriptures* (1976) that the scroll was humorous literature, a literary invention addressed "to hearts and minds of men who were looking to an imminent restoration of the past glories of Israel." In other words, once the Temple fell under the might of Rome in AD 70, such folklore was written as myth to remind Jews living in the Diaspora of a faded golden age and, more important, to offer hope for a future revival of Jewish fortunes within Israel. As fascinating and multilayered as the Copper Scroll undoubtedly is, the document certainly takes us no closer to the truth behind the fate of the iconic objects in the Temple treasure of Jerusalem.

TEMPLE Treasure

14

DIVINE LIGHT—THE MENORAH

The disappearance of the vast collection of art and money that Rome plundered from the Temple of Jerusalem is easily explained. Vespasian systematically liquidated the bulk of the Jewish treasure into ready cash for the imperial coffers exhausted by his predecessor, Nero. Some of this new income was invested in building the Colosseum in Rome, while an inscription from the theater of Daphne in Antioch, modern Turkey, reading "Ex praeda Iudaea" ("From the Judean Booty"), reveals that the new emperor publicly showcased his wealth across the empire. The fate of the greatest symbols of the Jewish faith, however, is far more complicated. The Arch of Titus displays the looted gold menorah, the gold Table of the Divine Presence, and a pair of silver trumpets. But what did these objects mean to Judaism and Rome, and were the images depicted on the arch real or imagined?

Although the Star of David is Judaism's most popular symbol today, the menorah remains the ultimate symbol of faith, the most powerful image connected with the lost Temple. Whereas the Star of David became popular only in the last two hundred years, the menorah is steeped in history. It is the most characteristic and prevalent motif of ancient Jewish art, recorded 216 times in Israel and at 270 other locations throughout the Mediterranean basin. Wherever great ancient cities have been excavated, such as Ostia in Italy, Sardis in Turkey, and Saranda in Albania, the menorah flourished.

This symbol was also adopted by Israel in 1948 as the official insig-

— IOI —

nia of state, which, in an act of supreme irony, plucked the image from the Arch of Titus in Rome. Quite simply, this was considered a faithful representation of the original menorah from Jerusalem's Temple. So a depiction commissioned in the Eternal City by a pagan emperor, and plastered across one of its greatest victory monuments as a graphic expression of Israel's destruction, ended up resurrected by twentiethcentury conquerors, a phoenix rising from the ashes. But is the Arch of Titus menorah an accurate depiction of the Temple candelabrum, and what did this object really mean to Judaism?

The menorah carried aloft by celebratory hands on the Arch of Titus was Rome's ultimate prize. What may seem to us incorrectly today a simply designed object of limited function, restricted to Temple worship in Judaism, had a deep value to the conquerors. This twentyeight-inch-tall form of primitive lighting was far more than just a shining piece of war booty. Rome was fully aware that the candelabrum was impregnated with symbolic importance beyond the physical and functional. For this was the very light of the Jewish people extinguished.

Both the post-Hellenistic and modern image of the menorah in art is conservative, always comprising a one-piece base and central shaft flanked by six branches divided symmetrically into two sets of three. The arms of the candelabrum rise in a semicircular fashion (although less frequently more angular with a V-shaped anatomy). Light fixtures traditionally holding sacred oil and lit with wicks were fitted onto the ends. This is the earliest form of the menorah depicted in ancient art and represented on the Arch of Titus, and allegedly the form that graced the Holy of Holies in Herod's Second Temple.

However, a careful look at the 486 artistic representations, and immersion among the literary texts, actually reveals a dizzying array of different menorah shapes and styles potentially used in Temple times. But which one illuminated Jerusalem in AD 70? Was this an original Solomonic antique dating back a thousand years or a later form? What type of menorah does Israel accuse the Vatican of imprisoning in its vaults?

The major reason for the menorah's spiritual mystique is its im-

— 102 —

mense antiquity as a religious concept and object. From the pivotal moment of revelation, when God carefully instructed Moses on how to create a menorah on Mount Sinai, until the dark days when Rome looted the Second Temple, like its people the Jewish menorah suffered a tortuous history. The prototype described in the book of Exodus was a pre-Israelite design crafted and used in the desert after Moses led the flight from Egypt across the Red Sea, if you accept the biblical tradition. As with all aspects of Jewish worship, not least the plan of the Temple itself, the Bible furnishes precise regulations about the requisite shape of the prototype:

You shall make a lampstand of pure gold. The base and the shaft of the lampstand shall be made of hammered work; its cups, its calyxes, and its petals shall be of one piece with it; and there shall be six branches going out of its sides, three branches of the lampstand out of one side of it and three branches of the lampstand out of the other side of it; three cups shaped like almond blossoms, each with calyx and petals, on one branch, and three cups shaped like almond blossoms, each with calyx and petals, on the other branch—so for the six branches going out of the lampstand.

On the candelabrum itself there shall be four cups shaped like almond blossoms, each with its calyxes and petals. There shall be a calyx of one piece with it under the first pair of branches, a calyx of one piece with it under the next pair of branches, and a calyx with one piece with it under the last pair of branches—so for the six branches that go out of the lampstand. Their calyxes and their branches shall be of one piece with it, the whole of it one hammered piece of pure gold. You shall make the seven lamps for it; and the lamps shall be set up so as to give light on the space in front of it. Its snuffers and trays shall be of pure gold. And see that you make them according to the pattern for them, which is being shown you on the mountain. (Exodus 25:31–40)

At the end of the period of the Exodus, dated between 1250 and 1200 BC, this candelabrum shone in the Tabernacle, a temporary tentlike sanctuary, and its oil lamps were burned from evening to morning

— 103 —

before God (Exodus 27:21) as a "statute for ever throughout your generations" (Leviticus 24:3).

When King Solomon built the first permanent Jewish Temple in Jerusalem between 965 and 925 BC, he is credited with equipping the Holy House with a multitude of "lampstands of pure gold, five on the south side and five on the north, in front of the inner sanctuary; the flowers, the lamps, and the tongs, of gold" (1 Kings 7:49). To complicate the picture further, Flavius Josephus undoubtedly exaggerated wildly by claiming that Solomon crafted ten thousand candelabrums according to the laws of Moses, with one dedicated specifically to Temple worship "that it might burn in the daytime, according to the law" (AJ 8.90).

In the days of the Exodus wandering in Sinai, when the oil necessary to keep the Tabernacle menorah burning was a rare commodity, the lamp was understandably only lit between sunset and sunrise. In the tenth century BC, King Solomon commanded great wealth and lush agricultural lands throughout Israel, especially in the Galilee. Abundant sacred olive oil could now be pressed, not only to keep the holy menorah burning around the clock, but to create an immense spectacle by displaying a whole host of additional burning lamps on golden stands. The Judaic concept of the perpetually lit lamp was born.

Despite the detailed commandments handed to Moses on Mount Sinai, the question of the shape of the Tabernacle and Solomonic menorah remains a matter of intense speculation. Rabbinical scholars maintain that the modern shape emerged fully formed and sevenbranched. To skeptical academics, however, the Exodus is nothing more than a priestly legend of dubious historical content edited in the sixth or fifth century BC to legitimize and rationalize later religious practice. In other words, the priests fabricated a Jewish foundation myth to validate the centrality to Judaism of Temple worship based on sacrifice in Jerusalem.

A major problem that continues to obscure the matter is an absence of physical evidence. Of the 486 ancient artistic images recorded, not one dates to the periods of the Tabernacle or Solomonic Temples. Even

— 104 —

though casual graffiti was relatively less common at the time, lavish royal art still adorns contemporary temples, palaces, and tombs across Egypt, Iran, and Iraq. The absence of traditionally shaped menorahs in these contexts is distinctly strange because Judaism would have based its prototype on current fashions.

Contrary to the modern assumption that the style of the Arch of Titus candelabrum, and the menorah of modern Judaism, stretches back into the mists of time, the earliest forms were unmistakably different in concept. Archaeological research conducted across the Near East leaves no doubt that lamps shaped like a seven-branched menorah did not exist during the desert wanderings of the proto-Israelite Exodus in the Late Bronze Age period (1400–1200 BC).

Dozens of ancient settlements, tombs, and temples of this period have been excavated in the Near East and Egypt, revealing a wealth of religious paraphernalia, but nothing resembling the traditional menorah. The modern mind has created a major misconception by approaching the book of Exodus with a preconceived image. Another underlying problem is flaws in biblical translation. The term "base and shaft" is actually a mistranslation that should read "base-forming shaft" or "thickened shaft" because the Hebrew word employed, *yerakh*, derives from the anatomical term for a thigh. The image implies a cylindrical object flaring at its base, not a branched object at all.

Whereas candelabra with branching arms are entirely unknown in this period, cultic stands used to support incense bowls, libation vessels, offering tables, and sacred ritual objects were common. The Tabernacle candelabrum of the Late Bronze Age can only have resembled this form. At the time Egypt was the dominant political and cultural superpower, and it is south toward the fertile banks of the Nile that we should seek the menorah's original artistic inspiration. The Nile was the source of all life to Egyptians, and so all things Nilotic were elevated to the sacred plane and mirrored in contemporary art and architecture. At least one element of the vegetal symbolic decoration of the Tabernacle menorah was inspired by Egyptian culture.

If the lamp of the Late Bronze Age Tabernacle sanctuary was a tall,

- 105 -

flaring cylindrical object, did the seven-branched form evolve under the Early Iron Age inspiration of King Solomon? Contrary to tradition, once again this is improbable. The fully formed Jewish candelabrum remained a futuristic design in ancient art, yet to be invented. Instead, cult lamps of this era tended to be flat based, or slightly convex, with seven spouts rather than seven branches. Such an oil-lamp bowl would have sat atop a cylindrical cult stand, numerous examples of which have been excavated across the Near East. This style dovetails neatly with a contemporary Temple lamp description handed down by the prophet Zechariah who, in a dream, saw a "lampstand all of gold, with a bowl on top of it; there are seven lamps on it, with seven lips on each of the lamps that are on the top of it" (Zechariah 4:2). The cylindrical candelabrum remained the dominant shape beyond the period of the United Monarchy and is clearly depicted on wall reliefs preserved in the royal palace of Nineveh in modern Iraq. Here looters cart off various religious objects from the city of Lachish in Palestine, including a cylindrical cult stand, during King Sennacherib's conquest of Judah in 701 BC.

Historically, like all world religions, Judaism has consciously sought out umbilical links to create continuity between the religion that emerged in the wilderness years of the Sinai and the religion of the modern day. Just as Greek myth crucially transmitted "historical" explanations for the imponderable perplexities of life to a predominantly illiterate society—how the planet was formed, the origins of life, love, and culture—so Jewish symbols of the post-Roman era served as psychological reminders that despite the destruction of Jerusalem and life in the Diaspora, not all links with the past were severed. Ever since the destruction of the Temple in AD 70, the menorah has symbolized hope for the future. To some Jews it is a flickering light keeping the messianic dream on a low burn, to others a daily reminder of the divine presence that must be remembered and kept alive.

As uncomfortably as the truth may sit with modern Judaism, however, the preeminent physical image of faith did not exist throughout much of the period of the Old Testament. If the Second Temple me-

norah immortalized on the Arch of Titus bears no physical resemblance to the lamps of the Tabernacle or Solomon's Temple, what exactly is the antiquity of this holy vessel?

Both 2 Kings (24:13–15) and Jeremiah (52:17–23) emphatically describe the plunder and destruction of the Temple treasures by King Nebuchadnezzar's henchmen in 587–586 BC, when the Jews of Israel were expelled to Babylon. Although one Old Testament tradition subsequently sees some Temple vessels liberated by King Cyrus of Persia returned to Jerusalem for use in a new Temple (Ezra 1:7–11), there is absolutely no tangible proof to confirm this wishful thinking. Once again, priests writing centuries after the event tried to spin history to legitimize and, to an extent, mythologize the Jewish present—not for political reasons linked to territorial wrangling, but simply to bolster the historical and religious substance of biblical Judaism. Such revisionism typifies the foundation myths of all religions across the globe.

The earliest appearance of the traditional seven-armed menorah in art turns up on coins struck by Mattathias Antigonos, the last king and High Priest of Judea's Hasmonean dynasty. The reverse side of issues struck from 40 to 37 BC featured a seven-branched lampstand with a triangular base. Just how long the form had graced Temple worship is uncertain, but one specific moment in time demands attention.

In 168 BC Antiochus Epiphanes attacked Jerusalem with a strong force and desecrated the Temple. At this time of anguish the Bible specifically confirms that "he arrogantly entered the sanctuary and took the golden altar, the candelabrum for the light, and all its utensils. . . . Taking them all, he went into his own land" (1 Maccabees 1:21–24). The reality of their looting is confirmed by Josephus (AJ 12.250). Three years later, Jerusalem was reconquered by Judah Maccabee, who purified and renovated the Temple. For this occasion a new menorah was crafted (1 Maccabees 4:48–50; AJ 12.318), according to the Babylonian Talmud from melted-down weapons. After a lapse of two years without sacrifice and worship, the lamp was once again relit on 25 Kislev 164 BC, a major moment of joy that led to eight days of celebrations, a tradition commemorated today as the winter festival of Hanukkah, the Festival of Lights.

- 107 -

A century later, when Pompey the Great and his military entourage violated the Holy of Holies in 63 BC, a single sacred menorah was seen alongside many other wonders. All these treasures were left in their original locations. In all probability it was this gold candelabrum—already an antique more than a century old, and crafted under the inspiration of Judah Maccabee—that Titus would seize from Herod's Temple in AD 70. By the time the sacred Jewish menorah reached Rome a year later, the most precious symbol of Judaism was already more than two centuries old.

However, the story does not end there. A perplexing feature adorns the Arch of Titus menorah, a highly elaborate base consisting of a twotiered octagonal pedestal that remains the subject of great controversy for one very good reason: it is covered with highly conspicuous "pagan" figures in the form of sea monsters and eagles holding a wreath in their beaks. With the Old Testament's fierce prohibition against precisely this kind of artistic idolatry, many historians forcefully reject any notion that this specific lamp was the Second Temple original. So could the elaborate artwork of the Arch of Titus menorah expose the object as nothing more than a fantastic product of the mind of a Roman sculptor?

With ideas and counterarguments spinning through my mind, I decided to go to the one place I knew where this enigma could be settled once and for all: the ancient Jewish underground cemetery at Beth Shearim in the Galilee. 15

HUNTING GRAVEN IMAGES

Bottle-shaped Besara, ancient Beth Shearim—House of the Gates in Hebrew and called Besara in Greek—nestles in a shallow wooded basin of the Lower Galilee, peering out westward toward the Jezreel Valley and the far-off Mediterranean Sea. For the home of one of the greatest Jewish necropolises of ancient Israel, this hill of death is remarkably tranquil. Perhaps the shaded terrain and geographical seclusion becalmed the atmosphere to form the perfect spot for intellectual thought and the rabbinical academy that evolved within the peaceful pine forest.

In the second century AD, the Jewish town of Beth Shearim became home to the Sanhedrin, the highest legislative body of Jewish Palestine and its supreme judicial council. With its fertile foothills and opportune location at a crossroads linking the cities of the Galilee and the Jezreel Valley with the Mediterranean coast, over time the settlement flourished to become rich in mind and pocket, especially renowned for its vast glassworks. Even today echoes of the town's proud inheritance stud the hillside across 1,650 by 650 feet in the form of the ruins of a giant press for producing exportable olive oil and a nine-ton slab of glass, imperfectly cast and abandoned 1,600 years ago. Following extensive excavations initiated in 1936, the ruins of Beth Shearim are today one of the country's heritage highlights, although local Israelis and bar mitzvah boys learning about their ancestry frequent the ruins more often than do overseas tourists.

By far the most startling remains, however, are underground. Over

- 109 ---

the course of three hundred years, both local celebrities and the rich and famous of the Diaspora chose Beth Shearim as the favored Jewish burial place in the Mediterranean basin once Jerusalem was destroyed. Epitaphs written in Hebrew, Greek, and Palmyrene speak of the burials of the head of the Council of Elders of Antioch and his family, and the leading rabbis of the synagogues of Tyre, Sidon, and Beirut. Rubbing shoulders with the great and wise were the finest families of Byblos, Palmyra, and Messene in Babylonia, all shipped back to the heartland for a perpetual peace: from Atio, the daughter of Rabbi Gamaliel who died still a virgin at age twenty-two, to Rabbi Judah HaNasi, who established the Sanhedrin at Beth Shearim and edited the Jewish Mishnah. With the Temple fallen, Beth Shearim served as a surrogate cemetery—Judaism's prime piece of mortuary real estate. Catacomb 20 alone, cut through 246 feet of limestone, held 125 sarcophagi and about 200 burials.

With its elegantly sculpted and arched facades and landscaped courtyards, Beth Shearim is a gem of design and engineering. Beneath the ground the dark tunnels, monumental sarcophagi (burial coffins), and inscriptions in many tongues create an eerie, macabre atmosphere. A third-century AD Aramaic inscription chillingly warns, "Anyone who shall open this burial upon whomever is inside it shall die an evil end." I had no alternative but to descend into this underworld if I was to unravel the mystery of the Arch of Titus menorah. With its elaborately decorated base that seemed to ignore Deuteronomy's severe prohibition against idolatry, was this artistic depiction accurate or a Roman fantasy? The character of Jewish art officially permitted in Beth Shearim would answer this key question once and for all.

Every shred of evidence conspired to suggest that the golden candelabrum originated in the Hellenistic period, seemingly crafted by order of Judah Maccabee. But with its eagles and sea monsters, a string of scholars have vehemently denounced the Arch of Titus menorah and its sacrilegious base as nothing more than an abominable product of imperial Rome.

Wandering around the hillside sloping down to this Jewish underworld brought back unwanted memories. In 1992 I had managed to

— IIO —

contract tick-borne relapsing fever (TBRF) here. A rare condition more commonly known as cave fever, TBRF has the genetic ability to vary its surface antigens like malaria, with relapsing fever endemic for years afterward. Only 10 percent of caves in Israel are infested by cave fever's specific offending ticks, but in the Lower Galilee, where Beth Shearim lies, this figure soars to 55 percent. Hence, my reluctance to dip back into these catacombs.

However, I soon refocused on the menorah's fancy pedestal base and recalled the lines of the Ten Commandments that Moses carried down Mount Sinai on two tablets:

You shall not make for yourself an idol, whether in the form of anything that is in the heaven above, or that is on the earth below, or that is in the water under the earth. You shall not bow down to them or worship them; for I the Lord your God am a jealous God, punishing children for the iniquity of parents, to the third and fourth generation of those who reject me. (Deuteronomy 5:8–9)

This command was emphatic and, if taken verbatim, then the base of the Arch of Titus menorah clearly broke Israel's covenant with God. Equally damning were the high emotions provoked when King Herod dramatically bolted the figure of a golden eagle over the entrance to the Temple in Jerusalem. Two of the most celebrated interpreters of Jewish law of this period, Judas son of Saripheus and Matthias son of Margalothus, considered this act a blasphemous violation of God's commandment. Josephus vividly recalls these two ancient academics inciting the youth of Jerusalem to

pull down all those works which the king had erected contrary to the law of their fathers . . . for that it was truly on account of Herod's rashness in making such things as the law had forbidden, that his other misfortunes, and this distemper also, which was so unusual among mankind, and with which he was now afflicted, came upon him: for Herod had caused such things to be made, which were contrary to the law . . . for the king had erected over

— III —

the great gate of the temple a large golden eagle, of great value, and had dedicated it to the temple. Now, the law forbids those that live according to it, to erect images, or representations of any living creature. (AJ 17.150–151)

Jerusalem's rebellious teenagers didn't need a further invitation to rip down the eagle in broad daylight and hack it into pieces with an ax. Would the Jewish necropolis of Beth Shearim confirm this prohibition against graven images? If it did, I would be back to square one again with the Arch of Titus menorah. If the lamp's base wasn't Jewish art, then perhaps the entire representation was the fabrication of Roman imagination. Trying not to think about ticks and cave fever, I ducked through the triple-arched entranceway cut through the Eocene limestone into the distant past of my ancestors.

The light abruptly died, the air became damp and heavy, the temperature plummeted by at least eighty degrees—the perfect playground for ghouls. An icy breeze hovered over the hallowed halls. As my eyes adjusted to the darkness, ghostly shapes of centuries gone by rose from the shadows. This city of the dead was impressively planned. Arched ceilings and narrow corridors of soft, white limestone led to discrete chambers containing family tombs. The deceased were laid to rest in massive stone sarcophagus boxes, and it was these that intrigued me most. Just how these highly observant ancient Jews chose to adorn their tombs would get me closest to the realities of Temple law and to the precise styles of decoration acceptable in the Bible lands.

Although underground Beth Shearim is something of a menorah city, with dozens of representations incised into walls and even sculpted out of the living rock, other weird and wonderful images, equally conspicuous, came as a shock. The sarcophagi are all alike: simple rectangular limestone boxes about five to six and a half feet high and ten feet long, with corresponding lids whose edges are sculpted into horns resembling ancient altars. Was this a deliberate replication of Temple ritual, I pondered, with the deceased offering his or her soul to God?

While most of the stone sarcophagus containers I came across were simply adorned with plain circular roundels and rosettes, several others

— 112 —

were staggeringly elaborate. Stylized lions with hungry large eyes and sharp teeth made sense as symbols of the Lion of Judah. In the Early Iron Age, for instance, King Solomon notably adopted this beast as the symbol of royalty:

The king also made a great ivory throne, and overlaid it with pure gold. The throne had six steps and a footstool of gold, which were attached to the throne, and on each side of the seat were arm rests and two lions standing beside the arm rests, while twelve lions were standing, one on each end of a step on the six steps. The like of it was never made in any kingdom. (2 Chronicles 9:17–19)

Why the Beth Shearim lions were aggressively chewing an ox, however, was a completely different matter. This composition didn't seem particularly holy to me. But sights even more perplexing were to follow. The front of yet another sarcophagus blatantly displayed two flying Nikes—Roman Victory—alongside a pillar. Long before she was elevated to shoe manufacturer's paradise, the perfect brand image, Nike was a mainstream Roman goddess of victory throughout the empire—you really couldn't get closer to an archetypal pagan symbol.

The apparent contradiction between the law of God and earthen reality continued. I hardly had time to draw a breath and mull over the meaning of the weird and wonderful images of Beth Shearim before Deuteronomy was profaned yet again. In front of me stood a sculpted soldier with a menorah on his head, a scene that could have been lifted straight out of the sketchbook of the Jewish painter Marc Chagall, whose surreal art included rabbis standing on people's heads. This candelabrum was typically seven-branched with a common three-pronged base. Intriguingly, however, its shaft was elaborately adorned with the twisted knot of a tree. Clearly the deceased had personally commissioned a highly original piece of mortuary art. As the symbol of eternal light, the menorah in this composition was an obvious divine plea for enduring life in the afterworld.

Figurative art is traditionally considered an abomination in Judaism. Any image in human form detracted from the omnipotence of God

— 113 —

and, hence, was prohibited. So much for theory. In reality, from the Hellenistic period onward the Near East was flooded with highly vivid images drawn from the broad panorama of paganism. Initially a source of religious tension, it didn't take long for ideas and images to be absorbed into local culture and given new meaning. Irrespective of historical age or religious context, this is one of the common laws of human behavior. Unless you live inside a ghetto, it is simply impossible for people to be unaffected by changing cultural tastes and fashions.

By the Early Roman period—contrary to the view of many modern historians—there is no shadow of a doubt that Judaism was successfully evolving culturally with changing times. What we would traditionally term *graven images* became mainstream Jewish symbols, with alternative layers of meaning tailored toward the ideology of the user.

Stepping gingerly along the corridors of death, an uninvited guest, I considered the reality of Second Temple Judaism. Because it lies underground and was untouched for two thousand years, the necropolis of Beth Shearim is amazingly well preserved. And if the observant Jews of the headquarters of the Sanhedrin were allowed to decorate their tombs freely with figurative art, then certainly any Jewish community across the Diaspora must have enjoyed the same liberty.

Abruptly, two sets of images of my old friend the eagle peered at me from the sides of further sarcophagi and I knew I had absolute proof for the authenticity of the base of the Arch of Titus menorah. The art from Beth Shearim and on the candelabrum's base on the arch were identical. The vandalism of Herod's eagle over the Temple entrance had been a political act, not driven by religion. Herod may have been many despicable things, but he was no fool. Why spend a king's ransom on a spiritual home for Judaism and then antagonize its people? Ipso facto, the Arch of Titus candelabrum and its base, adorned with eagles and sea monsters, was indeed an authentic depiction of the sacred one from Jerusalem's Holy of Holies, the perpetual lamp from Herod's Temple. Though stylized, there was no mistaking the beak, outspread wings, and talons of this lord of the birds confronting me in Beth Shearim's catacombs.

- 114 —

Having safely obtained the evidence I needed, I scrambled out of this hole in the ground, scrubbed my hands and face at length in the hope of purifying myself of any residual mold, and walked up to Beth Shearim's ancient synagogue to collect my thoughts. Arches and walls spring from the living bedrock of this house of prayer.

My research trip to Beth Shearim had revealed watertight proof that Judaism had no issue with figurative art in the Roman period, as long as the images told the right religious message. Take the eagle, for instance, which in reality is a primary symbol of the Old Testament. The eagle of ancient Judaism was clearly not the bloodthirsty, violent bird of prey that topped the military standards of Roman soldiers marching into battle. If anything, Rome stole this image from the Near East where, as early as the third millennium BC, the thunderbird represented the sun in Mesopotamia.

The biblical eagle has manifold meanings: the symbol of God and his protection of the chosen people; a sign of royalty; an expression of immortality. In Exodus (19:4), God reminds Moses of his protective powers: "You have seen what I did to the Egyptians, and how I bore you on eagles' wings and brought you to myself." Deuteronomy (32:11–12) reveals how the Lord watches over Israel: "As an eagle stirs up its nest, and hovers over its young; as it spreads its wings, takes them up, and bears them aloft on its pinions, the Lord alone guided him."

Perhaps even more graphic were the dreams of the exiled prophet Ezekiel in Babylon, which confirm the eagle as a divine symbol in Judaism. One particularly vivid dream explains the presence of both the eagle and the ox in Jewish art:

As I looked, a stormy wind came of the north: a great cloud with brightness around it and fire flashing forth continually, and in the middle of the fire, something like gleaming amber. In the middle of it was something like four living creatures. This was their appearance: they were of human form. Each had four faces, and each of them had four wings. Their legs were straight and the soles of their feet were like the sole of a calf's foot; and they sparkled like burnished bronze. Under their wings on their four

sides they had human hands. . . . As for the appearance of their faces: the four had the face of a human being, the face of a lion on the right side, the face of an ox on the left side, and the face of an eagle. (Ezekiel 1:4-10)

All three of these animals through which God chose to appear to Ezekiel turn up in the Jewish necropolis of Beth Shearim and the eagle, of course, stars on the base of the Arch of Titus menorah. As the symbol of God, the heavens, and immortality, its existence in Second Temple Jewish art makes complete sense. For the same reason, the eagle remained popular in the Late Roman and Early Byzantine period above the door of the synagogue at Capernaum in the Galilee and standing behind the figure of Orpheus playing his lyre on a wall relief in the third-century AD synagogue of Dura-Europos in Syria.

So Judaism's allegedly strict ban on figurative decoration turned out to be a modern myth rooted in Orthodox Judaism's literal interpretation of the Old Testament. The view is understandably myopic; it is the belief of a group stuck in the shtetls of early modern Eastern Europe. When confronted by persecution, people typically gravitate toward the purist expression of religion, in this case the harsh words of Deuteronomy. Today, however, archaeology has exposed a very different truth, and even a careful reading of Late Roman rabbinical texts reveals all kinds of figures displayed in Jerusalem at the time of Herod (except human beings), including exactly the kind of sea monsters that turn up on the pedestal of the Arch of Titus menorah.

My underground research in the catacombs of Beth Shearim confirmed that the art on this base was authentic and didn't violate the Jewish sensitivities of two thousand years ago. The photolike scene of the emperor Vespasian's triumph of AD 71 on the Arch of Titus was thus a real snapshot in time, not the invention of a Roman artist. Finally, I had tangible proof that the arch's menorah, and hence the one plundered from the Temple by Titus, was the same antique crafted by Judah Maccabee in 164 BC. Now I had an accurate visual image of the most important part of the treasure for which I was hunting.

- 116 —

16

THE TREE OF LIFE

Idling against a wall in Beth Shearim's ruined Roman synagogue, I conjured up images of Jews sitting on the synagogue benches praying and chatting about the town's latest olive harvests and shiploads of raw glass sent to their Jewish brethren in Tyre. After all, the ancient synagogue wasn't just a pious house of worship, where reverent voices spoke in hushed tones. These places were also community centers where businessmen made deals, people congregated for social events, and children got into trouble out back.

Somewhere inside, Beth Shearim's synagogue may well have possessed a menorah like the Temple original. The town's Jews would have been aware of the object's historical symbolism. They would have incorrectly assumed that the seven-branched shape dated back to the days when Moses crafted the first Tabernacle menorah in the wilderness of Sinai. The fateful destruction of Solomon's lamp by King Nebuchadnezzar would have been imprinted on their memory. And Judah Maccabee would have been celebrated as a superhero who rekindled the Temple ritual in the second century BC, an event celebrated in the depths of winter as Hanukkah, the Festival of Lights. Every time Vespasian and Titus were mentioned, their memories would have been cursed.

After studying the Arch of Titus menorah base, however, the realization dawned on me that modern history has forgotten by far the most primitive meaning of the ancient Jewish candelabrum. My walk in Beth Shearim's valley of the dead revealed that the pedestal symbols

- 117 -

were very specifically chosen to reflect God's control over the entire world. As a bird of the skies who soars closest to God's throne, at one level the eagle represented the heavens. Conversely, the sea monster or *ketos* stood for the depths of the sea. In this sense, the base designed for the Second Temple rather neatly advertised with one quick glance the extent of God's omnipotence. But this was just the veneer of a far deeper symbolic cosmology.

Other than evoking curiosity and amusement, the scene of the soldier "wearing" a menorah on his head in the ancient cemetery left me bemused. I felt I had missed a crucial clue in this composition, a small detail that held the key to unlock a completely different meaning of the ancient Jewish menorah. I replayed the images just taken on my digital camera without inspiration. What was I missing?

Straining to stir my imagination, I stared at the blue skies overhead. The answer was all around me, laughing in the light breeze—trees. What had registered in my subconscious beneath the ground was the central shaft of the soldier menorah, which had very clearly been designed to resemble a knotted tree trunk.

The Tree of Life is the central spine of all Near Eastern creation myths. It is perhaps the most powerful symbol of all time, an image that unites—rather than divides—world religions across time and place. The earliest human symbol of fertility, eternal life, salvation, and the divine presence, the sacred tree is a rarity that makes nonsense of supposed differences and hatred between religion. What remains is a startling truth: all religions evolved from the same trunk.

The Tree of Life is best known from Genesis, where it stood at the center of the Garden of Eden at the dawn of civilization. The same motif, however, is actually a far older primal image first known from the epic tale of Gilgamesh, an historical king of Uruk who lived in Babylonia along the River Euphrates (modern Iraq) around 2700 BC. In ancient Mesopotamia this divine tree grew in Dilmun, Paradise, at the source of the Water of Life. Here, the cosmic world tree is described as having its roots in the underworld and its crown in heaven. An almost identical corresponding myth prevails in Judaism, as is clear from a me-

- 118 -

dieval record cherished by Jewish communities of the Diaspora:

In Paradise stand the tree of life and the tree of knowledge, the latter forming a hedge about the former. Only he who has cleared a path for himself through the tree of knowledge can come close to the tree of life, which is so huge that it would take a man 500 years to traverse a distance equal to the diameter of the trunk. . . . From beneath it flows forth the water that irrigates the whole earth, parting thence into four streams, the Ganges, the Nile, the Tigris, and the Euphrates. (Legends of the Jews 1.321)

All across the ancient Near East the sacral ruler responsible for temples and holy groves was also the traditional guardian and caretaker of the sacred tree. God's appearance to Moses in a burning bush on Mount Horeb in modern-day Jordan would have thus made complete sense to someone living in Bronze Age Palestine, where even cities were named after the sacred tree. The "lighting" of the bush symbolized life, in this case God's anticipated liberation of his people from Egypt. Especially famous was the Canaanite city of Luz, where Jacob dreamed about climbing a ladder to heaven. Luz translates as "City of Almond." So perhaps the "ladder" on which Jacob dreamed he climbed to heaven was actually the branches of an almond tree.

Although this is little more than educated guesswork, the relation of the almond to the Tree of Life and Exodus's description of the menorah is definite and crucial to my investigation. From time immemorial the almond tree and its fruit have been blessed with great potency in early religion. Its modern botanical term, *Amygdalus communis*, incorporates the biblical term Luz, which also meant Great Mother in the ancient Near East. Not only was the insignia of the Bronze Age sacred ruler a rod or scepter made from a branch of the Tree of Life but, at least in the Bible, the most powerful staffs were cut from the almond tree.

Thus, during the power struggle between the twelve tribes of Israel in the wilderness of Sinai, Moses was instructed by God to take twelve staffs from the tribes, one for each ancestral house, and to inscribe them with the name of the head of each. Rather like drawing straws, only the

- 119 —

staff of Aaron of Levi "put forth buds, produced blossoms, and bore ripe almonds" as a sign of his leadership chosen by God (Numbers 17:23). It is with this deep history and symbolism in mind that the almond was chosen to be the central motif of the golden menorah in Temple worship, which had to possess "cups shaped like almond blossoms, each with calyx and petals" on each branch (Exodus 25:33).

So, what is so outstanding about the almond tree? Quite simply, it is the first tree to herald the arrival of spring in the Near East, when it blossoms in glorious white petals, and also the last to shed its leaves. For communities far more intimate with nature, and whose everyday existence was so precariously bound to the seasons, such a long-lived cycle provided an ideal model of life, stability, and resurrection. For this reason, according to Jewish rabbinical legend, Paradise could only be reached through a hole in an almond tree, where the angel of death's power was neutralized. For the same rather more scientific reason, as well as being a food delicacy and a product with potent medicinal qualities, the biblical term for the almond, Luz, was also in ancient pathology the indestructible bone where the neck meets the spinal column.

At its core, therefore, in shape and symbolism the Jewish menorah is inextricably linked to the Tree of Life in the ancient Near East. It is an object representing God's eternal dominance over the heavens, earth, and sea, and also the very life force of Judaism. The lamp's eagle and sea monster base merely strengthens this symbolism.

Nowadays, it is largely forgotten how profoundly the Tree of Life has inspired all world cultures. One of the earliest and most remarkable examples of organized religion in Britain also revolved around a tree: in 1998 a circular henge was exposed by coastal erosion at Holme next the Sea in Norfolk, consisting of fifty-five wooden posts enclosing the lower trunk and roots of a large oak tree weighing two and a half tons. Just before 2000 BC in the Early Bronze Age, the oak had deliberately been placed in the henge with its roots exposed upside down, as if it were protecting worshippers from the dark underworld beneath and channeling the life force from its roots into the realm of man.

Over time, the primitive memory of the Jewish menorah's sym-

bolism was forgotten and replaced by more "scientific" interpretations. From the late Hellenistic period onward, many Jewish scholars focused instead on numerology. The lamp's magical seven branches replicated the seven planets known in antiquity as well as the seven days of creation, over which God's shining light literally ruled supreme. Thus, Philo of Alexandria equated the menorah's six side branches and position in the Temple to planetary inspiration:

The candlestick he placed at the south, figuring thereby the movements for the luminaries above; for the sun and the moon and the others run their courses in the south far away from the north. And therefore six branches, three on each side, issue from the central candlestick, bringing the number up to seven, and on all these are set seven lamps and candle bearers, symbols of what the men of science call planets. For the sun, like the candlestick, has the fourth place in the middle of the six and gives light to the three above and the three below it, so tuning to harmony an instrument of music truly divine. (*On Moses* 2.102–103)

Medieval Jewry took the kabbalistic mystical power of the number seven even further, claiming Solomon's ten menorahs furnished seventy burning lamps. This value symbolized the seventy nations over whom the great king held sway. Even today, Jewish brides encircle their husbandsto-be seven times in Jewish marriage ceremonies, to demonstrate a will to make a home as fine as the world God created in seven days.

The Jewish menorah's most potent inspiration, however, is not numerology, but the Tree of Life, a universal symbol that has touched all major world religions. When the True Cross of Christ was captured in Jerusalem by Sasanian forces in AD 614, Christian commentators compared their loss to the death of the Tree of Life. Even the modern Christmas tree and its electric lights is a faded memory of the Jewish Temple candelabrum and thus the Tree of Life. The most primeval of Near Eastern images is also the root of the Buddhist stupa cut in stone, Chinese wooden layered pagodas, South American totem poles, and the British maypole. There is no escaping the Tree of Life from where all

— I2I —

creation emanates. We may not notice it today, but the symbol continues to shine all around us.

Unlike the master philosopher Valter Juvelius, who excavated in vain around the Temple Mount in 1909, and treasure hunters seeking the Temple treasure of Jerusalem in Rennes-le-Château, I was now equipped with a thorough understanding of the most important part of God's gold plundered by Rome from Jerusalem in AD 70. Ever since 1991, when I first stumbled across Israel's accusation that the Vatican has secretly imprisoned the golden menorah, I had been obsessed with understanding what this object meant to Judaism and subsequent possessors. The image that we see on the Arch of Titus was saturated with layers of symbolism that gave the candelabrum a vast life force. If the menorah stood for the light of Israel and Judaism, what was the meaning of the Table of the Divine Presence that takes pride of place at the head of Vespasian's triumph of AD 71 on the arch's wall relief?

17

BREAD OF HEAVEN

If it should ever surface at public auction, the priceless gold menorah from King Herod's Temple—the preeminent symbol of Judaism would shatter all records for an antiquity. By comparison, the Table of the Divine Presence looted from Jerusalem in AD 70 and seen on the Arch of Titus is largely neglected today, a poorly understood object of worship in mainstream Judaism. Yet until the second century AD, it was actually venerated as the central symbol of faith.

After the Ark of the Covenant, the Divine Table was the second most important vessel created to God's command by Moses at the foot of Mount Sinai as an instrument of worship and offering. Since the Ark of the Covenant was destroyed by the forces of Nebuchadnezzar in 586 BC, historically the Table became the most valuable piece of Temple furniture. Only from the fourth century AD onward did the menorah assume a central symbolic role in the Jewish Diaspora, largely as visual competition to the cross and the emerging dominance of Christianity as the official state religion of the Mediterranean basin.

As with the golden candelabrum, Moses's instructions about how to craft the Table were strict and precise:

You shall make a table of acacia wood, two cubits long, one cubit wide, and a cubit and a half high. You shall overlay it with pure gold, and make a molding of gold round it. . . . You shall make for it four rings of gold, and fasten the rings to the four corners at its four legs. . . . You shall make the poles of acacia wood, and

- 123 -

overlay them with gold, and the table shall be carried with these. You shall make its plates and dishes for incense, and its flagons and bowls with which to pour drink-offerings; you shall make them of pure gold. And you shall set the bread of the Presence on the table before me always. (Exodus 25:23–30)

Equally specific was the ritual of stocking the Table and its position within the Tabernacle sanctuary in the wilderness and later Temples. Twelve loaves were baked using choice flour, with two-tenths of an *ephah* allocated to each. The finished product was stacked on the gold table in two rows, six to a row, alongside pure frankincense. At least in the wilderness of Sinai, hot bread was placed on the Table every Sabbath by Aaron "before the Lord regularly as a commitment of the people of Israel, as a covenant for ever" (Leviticus 24:8). Table and bread stood in the Tabernacle tent to the north, immediately outside the Holy of Holies (Exodus 40:22–23).

By the Second Temple period, the Table of the Divine Presence had become far more elaborate and was most probably crafted entirely of pure gold. Cost was hardly an issue, and solid gold had the added advantage of being far easier to maintain than a decaying acacia wood table covered with cracked gold leaf. During the triumph in Rome of AD 71, Josephus described the Table simply as golden and weighing many talents (JW 7.148). Elsewhere, he expanded on this description, labeling the object one of the "most wonderful works of art, universally renowned" and confirmed that the Herodian version was not entirely plain, but was like "those at Delphi" with feet "resembling those that the Dorians put to their bedsteads" (AJ 3.139).

Measurements based on the comparative proportions of human figures visible on the Arch of Titus relief conjure up an image of a table measuring twenty inches in height, and the artwork reinforces the view of an elaborate piece of furniture. Despite the arch's false perspective (that fails to show the back of the Table in order to give pride of place to the silver trumpets tied across its front plane), the Table is clearly either hexagonal or, more probably, octagonal, with six to eight corresponding legs.

- 124 -

An extraordinary account of a Table of the Divine Presence crafted in Egypt by order of King Ptolemy II Philadelphus (285–247 BC) is preserved in a letter allegedly written around 270 BC by Aristeas, an influential diplomat in Philadelphus's court. This letter, addressed to his brother, describes an Egyptian embassy dispatched to Eleazar, the High Priest of Jerusalem, to try to patch up relationships with the Jews following a generation of persecution in Egypt.

Ptolemy II Philadelphus is credited in this work as liberating 100,000 Jewish captives and ordering the Hebrew law to be translated into Greek to encourage racial equality in Alexandria. To this end the king sent a diplomatic treasure chest to Jerusalem containing 50 talents of gold, 100 talents of silver, 50 gold and silver bowls, and 5,000 blocks of stone for Temple renovations. In return, Egypt invited six elders from each of the tribes of Israel "who have led exemplary lives and are expert in their own law" to come to Alexandria and translate the Torah (Jewish teachings).

Aristeas specifically claimed that the Table crafted in Egypt was "of pure gold and solid on every side; I mean, gold was not overlaid upon other material, but a solid metal plate was put in place." The border around the Table was a handbreadth wide with a rope, egg, and fruit design and a revolving rail, in which precious stones were secured with golden pins. An egg pattern with precious stones was set along the upward-slanting border.

The main plane of the Table was even more spectacular:

On the surface of the table they worked a meander pattern in relief, with precious stones of many sorts projecting in its midst, carbuncles and emeralds and also onyx and other species of outstanding beauty. Next to the arrangement of the meander there was placed a marvelous design of open net-work, which gave a rhombus-like effect to the middle of the table; inlaid into this were rock-crystal and amber, affording spectators an inimitable sight.

The legs were made with capitals of lily shape, the lilies making a bend underneath the table, and the upright leaves being the part in view. The base of the leg which rested on the floor was entirely of carbuncle, a handbreadth high and eight fingers in

- 125 ---

width. . . . And they represented ivy intertwined with acanthus growing out of the stone and encircling the leg, together with a grapevine and its clusters, all worked in stone, right up to the top; the style of the four legs was the same. All the parts were carefully made and fitted, the ingenious art corresponding to truth to such a superlative degree that if a breath of wind blew the leaves stirred in their place; so closely was every detail modeled on reality. (*Letter of Aristeas* 66–70)

Toward the end of his letter, Aristeas concluded, "You have the story, my dear Philocrates, just as I promised. I believe such an account will afford you greater pleasure than the books of the romancers." Despite Aristeas's protestations that his description was factual, and not a work of romance like so many doing the rounds in literary Alexandrian salons of the era, readers would have recognized the genre as a contemporary work of historical fiction written between 132 and 100 BC, some 150 years later than when the story is set. Regrettably, this testimony about the Table of the Divine Presence must be largely thrown out of court, although there is every reason to suspect it is based on contemporary records and thus contains a kernel of truth. In an era of wonderful, creative ability and skill, the Table of Jerusalem is far more likely to have resembled Aristeas's elaborate affair than the prototype of Exodus.

To increase the mystery swirling around this object, it is known that a series of tables actually served the Showbread ritual in Jerusalem. When freshly baked bread was initially carried into the sanctuary, it was placed on a marble table to the side of the porch. Opposite stood a gold table from which old bread was removed. With its gleaming white purity, marble was appropriate for fresh offerings; gold reflected the divine presence in which the bread had stood and been blessed by God. Both tables "promote what is holy to a higher status and do not bring it down," according to the Mishnah. Finally, the actual gold Table of the Divine Presence stood inside the sanctuary with its bread offerings, according to the Mishnah baked and administered in the Second Temple period by the House of Garmu.

How can we be certain that the Table was venerated more highly

than the menorah? Between AD 132 and 135, at the height of the Second Jewish Revolt, the Jewish military leader, Simon Bar-Kokhba, struck silver coins showing the facade of the destroyed Temple sanctuary alongside the inscription JERUSALEM. The reverse of the coin displayed a *lulav* (palm branch) and *etrog* (citron) and the inscription YEAR ONE OF THE REDEMPTION OF ISRAEL. Four columns support a schematic view of the entrance to the Temple and at its center stands the Table of the Divine Presence visible from its narrow side, with raised and arched ends. None of these coins depicted the candelabrum.

The minting of this money had little to do with economics and everything to do with propaganda. Small and mobile, coins traveled swiftly across vast distances from pocket to pocket and were thus the perfect "advertisement" for promoting ideologies. With the silver series of AD 132-135, Bar-Kokhba was trying to stir up trouble and incite sedition against Rome. His highly potent message was the equivalent of dropping thousands of paper flyers over Iraq during the First and Second Gulf Wars as part of the softening-up process to create a sympathetic atmosphere and civil disobedience for toppling Saddam Hussein. Here, though, the Jews were expressing their intention of beating Rome and renewing sacred Temple service around the central symbol of the Table. The lulav and etrog reflected a desire to restore the three pilgrimage festivals, particularly Sukkoth, while the Table symbolized the restoration in perpetuity of the Temple ritual itself. Once again, Bar-Kokhba was informing Jews throughout the length and breadth of Israel to be brave and strong and to anticipate the renewal of Temple worship; God would continue to feed his people.

In Temple times the Table of the Divine Presence was an intensely symbolic religious apparatus, a divine message from God to his people. In one of the earliest and most important commentaries on the books of the Bible, Philo of Alexandria (c. 25 BC to c. AD 40) was intrigued by the Table. His enquiry in *Questions and Answers on Exodus* led to a simple explanation:

The loaves of bread are symbolic of necessary foods, without which there is no life; and the power of rulers and peasants by the

— 127 —

ordering of God [consists] in the necessities of nature, [namely] in food and drink. Wherefore He adds "before me continually thou shalt place the loaves of bread," for "continually" means that the gift of food is continual and uninterrupted, while "before" means that it is pleasing and agreeable to God both to be gracious and to receive gratitude.

Philo correctly exposed an obvious message. Bread was the primary life force of antiquity. By demanding constant exposure to fresh bread, an eternal reminder was circulated for farmers to attend their fields "religiously." By blessing the bread, God favored the fields of Israel and its farmers. While bread stood within the Temple sanctuary of Jerusalem, Israel's agricultural well-being was guaranteed and divinely protected. The importance of bread was etched into the Jewish psyche from the time of the Exodus, when, in the haste to escape the pharaoh, bread had insufficient time to rise. The Jews' lucky escape was later ritualized in the festival of Passover, when all bread is thrown out of homes and replaced with unleavened matzah.

When Titus plundered the Table of the Divine Presence in AD 70, he knew exactly what he was doing. The gold value or artistic brilliance of the object didn't concern him. What interested Rome was the message conveyed—once the empire possessed the Table of the Divine Presence, it also controlled the fields, farmers, crops, and economy of Israel. This was a statement of intent that spoke volumes to Jews across the world: now we are your masters and if you want protection and prosperity you must answer to Rome. The position of the Table at the head of the triumph of AD 71, as depicted on the Arch of Titus, is a perpetual reminder of these facts.

For these reasons bread retains particular significance in Judaism. Every Friday, Jewish families enthusiastically bake or buy challah, special Shabbat bread. After the genocide and starvation of the Second World War, many Jewish families adopted a private habit of buying fresh bread every day as a reminder of former atrocities and as a sign of a return to health and prosperity. And as bread remains a central symbol of Judaism, so the biblical ritual of the Showbread metamor-

128 -

phosed over time into the Catholic communion. Today's grab-and-go society tends to take for granted just how important wheat remains to life, but it is around us every day as we fly from meeting to meeting—in the buns of our burgers and the crusts of our pizzas. These are the messages that pass through my mind when I stand and stare at the unique artwork of Rome's Arch of Titus.

18

TRUMPETING MESSAGES

Whether the occasion was the appearance of God from a clap of thunder, a cry to battle, or Temple worship, music was a constant source of inspiration in the Old Testament. Among the biblical orchestra of lyres, cymbals, and singers, the silver trumpet was the noblest instrument. From Exodus to the Arch of Titus and beyond, as the announcer of pageantry in medieval and modern royal courts, the trumpet's special status is secure. But what exactly was so special that compelled Rome to parade the two silver trumpets of Herod's Second Temple in the triumph of AD 71 and depict both tied to the Table of the Divine Presence on the Arch of Titus? Were they examples of the wealth of the House of God or vanguished symbols now rendered impotent?

The trumpet evolved from the shofar, the earliest wind instrument used in the ancient Near East. Derived from the Akkadian word *shapparu*, a wild goat, this natural instrument was originally a goat's horn, but was quickly replaced by a ram's horn in early Judaism. Even though the shofar survives today as a symbol of redemption blown in the festivals of Rosh Hashanah (New Year) and Yom Kippur (Day of Atonement), certainly by the time of King Solomon and the First Temple period it had been replaced by the trumpet in more general, everyday Jewish ritual and worship.

Along with the menorah and Table, the trumpets were the last of the key religious items that God commanded Moses to create on Mount Sinai:

The Lord spoke to Moses, saying: make two silver trumpets; you shall make them of hammered work; and you shall use them for summoning the congregation, and for breaking camp. . . . The sons of Aaron, the priests, shall blow the trumpets; this shall be a perpetual institution for you throughout your generations. When you go to war in your land against the adversary who oppresses you, you shall sound an alarm with the trumpets, so that you may be remembered before the Lord your God and be saved from your enemies. Also on your days of rejoicing, at your appointed festivals, and at the beginnings of your months, you shall blow the trumpets over your burnt-offerings and over your sacrifices of well-being; they shall serve as a reminder on your behalf before the Lord your God. (Numbers 10:1–10)

Unlike the golden lamp, the silver trumpets may well have existed in this biblical form from the very beginning. Archaeologists generally date the emergence of Israel within Canaan to the Late Bronze Age, placing the historical period of the Exodus toward the middle of the thirteenth century BC. Rather neatly, the stunning discovery in 1922 of the tomb of Tutankhamun, the Eighteenth Dynasty pharaoh of Egypt, leaves no shadow of doubt that such trumpets graced this period. Tutankhamun ruled from 1334 to 1325 BC and his military trumpet was a cylindrical tube of bronze, silver, and gold inlay terminating in a flaring bell depicting the king wearing the Blue Crown of Egypt and holding the crook scepter.

Following the discovery of Tutankhamun's trumpets, in 1939 Egypt's Antiquities Service agreed to allow James Tappern, a bandsman from a British Hussar regiment, to play the silver trumpet. Against a backdrop of intermittent power failures in Cairo, which prompted fears of the resurfacing of the boy-king's curse, Tutankhamun's trumpet was broadcast live by the BBC to an estimated global audience of 150 million people.

This wonder of the age of the ancient pharaohs, however, was nothing short of a mirage. Bandsman Tappern's rendition of the Grand March from *Aida* and the *Posthorn Gallop* may have produced gasps of amaze-

- 131 -

ment at the time, but he did enjoy a little help from modernity. Tappern had quite normally, and in all innocence, inserted his own moveable mouthpiece into the end of Tutankhamun's trumpet. This time travel enabled the instrument to be manipulated like a modern version. Unfortunately, pharaonic musicians had access to no such advantage.

Both the trumpets of Tutankhamun and of biblical Temple worship would only have been able to produce three notes. The lowest was dull and poorly centered; the middle one was excellent and would have traveled across any battlefield admirably; the upper note, however, would have been useless, requiring extreme pressure that would have damaged the player's lips. Thus, in effect, the silver trumpet was a onetrick pony.

The natural trumpet lacking valves, slides, or pistons dominated history into the eighteenth century and, as the baroque trumpet, was especially popular in royal circles from 1600 to 1750. Only in 1815 would Heinrich Stölzel and Friedrich Blühmel invent the modern-day version equipped with valves. The prototype, however, was never intended to be a musical instrument. Sounding the shofar was a cry to God for relief and help. Its sound combated evil and averted catastrophe (war, pestilence, and locusts); it was, in short, a loud noise that frightened away spirits in the same way that church bells protected Christian communities in medieval Europe.

The elongated trumpet, crafted from the medium of silver, denoting truth, held greater religious sway in the Old Testament. This instrument emitted a purer note than the ram's horn. The biblical silver trumpets were blown almost exclusively by a guild of seven priestly trumpeters at times of daily burnt offerings, celebrations, feasts, and the beginnings of each month. Thus, when Solomon dedicated the Temple in Jerusalem:

Then the king and all the people offered sacrifice before the Lord. King Solomon offered as a sacrifice 22,000 oxen and 120,000 sheep. So the king and all the people dedicated the house of God. . . . Opposite them the priests sounded trumpets; and all Israel stood. (2 Chronicles 7:4–6)

- 132 —

After the return from exile in Babylon, silver trumpets replaced the shofar for most cultic activities within Judaism. The priestly trumpet sounded three times every morning to mark the opening of the Temple gates; nine blasts accompanied morning and evening sacrifice; and the start of the Sabbath was announced by a threefold trumpet blast from the top of the Temple.

The pair of trumpets so conspicuous on the Arch of Titus relief measure twenty-eight and thirty-one and a half inches in length and conform to Josephus's description of these holy vessels as "a narrow tube, somewhat thicker than a flute, but with so much breadth as was sufficient for admission of the breath of a man's mouth: it ended in the form of a bell, like common trumpets" (AJ 3.291). Remarkably, both closely resemble Tutankhamun's trumpet and also a pair depicted on the revolutionary coins of Simon Bar-Kokhba during the Second Jewish Revolt of AD 132–135. Of all the Temple treasure (menorah and Table), the silver trumpets remained the least changed over time and were essentially standardized into the eighteenth century.

After the fall of the Temple in Jerusalem, however, the trumpet disappeared from Jewish worship. In a deliberate search for individual cultural identity, early Christianity avoided the trumpet. To the Christian God the trumpet was idolatrous, a cry of war. Thus, in the eighth book of the second-century AD *Sibylline Oracles*, Christianity was described as vastly different from pagan and Jewish worship:

They [Christians] do not pour blood on altars in libations or sacrifices. No drum sounds, no cymbal, no flute of many holes, which has a sound that damages the heart, no pipe, which bears an imitation of the crooked serpent, no savage-sounding trumpet, herald of wars.

Similarly, in his *Paedagogus (The Tutor)*, Clement of Alexandria (c. AD 150–215) advised Christians to "leave the syrinx [Greek trumpet] to the shepherds and the flute to the superstitious devotees who rush to serve their idols. We completely forbid the use of these instruments at out temperate banquet."

Usually, where the instrument does feature in the New Testament, it is as an allegory of peace and tranquility. The exception is the book of Revelation, which predicts that seven trumpets blown by seven angels will announce the destruction of man:

The fifth angel blew his trumpet, and I saw a star that had fallen from heaven to earth, and he was given the key to the bottomless pit . . . and from the shaft rose smoke like the smoke of a great furnace. . . . Then from the smoke came locusts on the earth, and they were given authority like the authority of scorpions of the earth. (Revelation 9:1-3)

For Judaism, redemption and the second coming of the messiah will also be heralded by the brassy sound of the trumpet.

The Messiah will have Elijah blow the trumpet, and, at the first sound, the primal light, which shone before the week of the Creation, will reappear; at the second sound the dead will arise . . . at the third sound, the shekiah [sunset] will become visible to all; the mountains will be razed at the fourth sound, and the Temple will stand in complete perfection as Ezekiel described it. (*Legends of the Jews* IV.234)

Once the trumpets were in the hands of Rome, however, no temple stood and no messiah could come. The empire had not just imprisoned Judaism in the present; it now owned its future, too. At this stage of my quest I now finally understood why the emperor Vespasian refused to sell or melt down the silver trumpets of truth and emblazoned their image across the Arch of Titus: by possessing these icons, the empire had literally silenced Israel.

REVOLUTION

19

CITY OF UNBROTHERLY LOVE

Now that I understood what the main icons from the Temple treasure meant to Judaism, a logical extension was to fathom the spoil's value to Rome—monetary windfall or symbol of eternal victory? Was the torching of the Temple icily premeditated or just a sad casualty of war? The answers lay hidden amid the complex causes of the First Jewish Revolt. Rarely triggered by a single event, wars are invariably the culmination of interrelated provocations. The First Jewish Revolt was a snowball rolling down a mountainside, starting slowly but eventually accumulating uncontrollable mass and speed. An ugly crash was inevitable.

Josephus's account of the slippery slope that descended into war is a saga of epic complexity and bloodshed that resonates profoundly with the modern Arab-Israeli conflict. When I gaze at the intriguing art on the Arch of Titus, I don't just see ancient Jewish treasure worth perhaps over a billion dollars but a deeper reflection of one of the most devastating battles of antiquity. It shows the ambitions of Rome and its military machine in action, the inner workings of the mind of an emperor. I see, too, a string of tragic and selfish decisions made by a small minority of megalomaniac Jewish politicians, who were responsible for the tragedy that subsequently befell Judaism—expulsion into a dark Diaspora and far-off lands.

The Temple treasure of Jerusalem makes little sense dislocated from its historical setting. But the tale is a maze of complications and only the bare bones can be summarized here. Today, leading scholars such

- 137 -

as Professor Martin Goodman of Oxford University package the First Jewish Revolt not so much as a war against Roman colonialism and culture but as an internal class struggle between Judea's peasantry and ruling class. However, while the destruction of Jerusalem was admittedly paved by Jewish factional infighting and hatred, the roots of the fall actually lay in the emergence of Roman cultural values that led to the suffocation of local religion.

The first fifty years of the first century AD were precarious for Israel. Ever since King Herod assumed the throne as a client king of Rome in 40 BC, the Jewish ideal of a land ruled by a wise leader of esteemed ancestry had faded. The two-faced Herod could not be trusted. Despite being the brains and purse behind the Second Temple of Jerusalem, one of the architectural wonders of the age, Herod forfeited the people's trust. This half-Jew of Edomite extraction—an isolated group from southern Israel and Jordan not recognized by mainstream Judaism—lacked morals and wisdom, preferring to court status and wealth by playing politics for high stakes.

Herod may have paid lip service to Jewish values, but his soul had been bought by Rome. In return for keeping the peace, controlling Israel's Jews, and collecting taxes for the empire's coffers, Herod was granted rulership over a fertile land ripe for the picking. With the construction of the port of Sebastos at Caesarea in the late first century BC, Israel suddenly found itself linked to a commercial revolution that was sweeping across the former backwaters of the eastern Mediterranean. Wine, oil, glass, wheat, purple dye, and dates found a highly receptive market across the empire, bringing unparalleled wealth to the rulers and middlemen of Israel. As lord of all he surveyed, everything was available to Herod for royal taxation. Eager to be more Roman than the Romans, he became filthy rich on the sweat of his subjects. His introduction of athletic festivals, musical contests, wild beast fights, and gladiators to Jerusalem fueled local antagonism to the new culture.

To the Jews of Israel the Roman dream was a shock and an affront. But nobody could have predicted just how destructively the old and the new worlds would collide. After all, Rome's model of puppet kings and

— 138 —

taxation was a tried and tested formula. From Britain to Syria the imperial war machine had annexed the known world by military strength and political stealth. Contrary to the stereotype of popular history, the empire did not court perpetual war. Instead, it shrewdly selected sympathetic local rulers to serve as puppet kings. It was an easy sell: join the greatest political and economic union the Mediterranean world had ever seen, merely offer a daily prayer to Rome while retaining your old domestic gods, and grow fat on the fruits of globalization. The alternative: a toxic cocktail of poverty, enslavement, or death. The opulent mausoleums scattered across the pre-Saharan fringe of Roman Libya remind us today that even the primitive tribal Garamantes bought into the new worldview. In the end, everyone signs.

With the Jews of ancient Israel, however, Rome had made a serious miscalculation—they would not blindly enter the wolves' lair. In AD 6 the emperor Augustus established the new Roman province of Judea over land formerly ruled by Herod. From the very start, might was right and Rome failed to acknowledge the deep sensitivities of the local Jewish population.

From the day Pontius Pilate controversially carried Rome's legionary standards into Jerusalem and dipped into the sacred Temple funds to build an aqueduct, violence was only ever one provocation away. The new coins minted in Israel carried pagan symbols of sacrifice, a source of daily revulsion to Judaism. Rome behaved however she wished, with Felix Antonius, a lowly ex-slave forced by the emperor Claudius to turn procurator from AD 52 to 60, stealing the Herodian princess Drusilla from her husband and marrying her without converting to Judaism. The painful truth is that Roman aristocrats considered Judea the soft option on the path to political promotion. Most governors were appointed through favor and patronage, not on merit. Lacking skills of negotiation and an understanding of Near Eastern customs, after serving in Judea most governors like Pontius Pilate, Cumanus, and Festus quickly disappeared from the pages of history. Most proved to be rotten eggs.

Yet these were minor complaints compared to the provocations of

- 139 -

the megalomaniac emperor Gaius Caligula who, in AD 40, demanded the High Priests erect his statue inside the Temple of Jerusalem as a living god. To enforce his demand, the emperor ordered Publius Petronius, governor of Syria, to march from Antioch to Jerusalem with three legions and Syrian auxiliaries. To the Jews erecting a statue of a Roman emperor in the Temple was a direct attack on monotheism and thus absolutely nonnegotiable. To no avail the High Priests pointed out that sacrifices were already offered to Caligula and Rome twice a day, and grimly promised that "if he would place the images among them, he must first sacrifice the whole Jewish nation" (JW 2.197). Caligula was unforgiving, and ordered anyone opposing his demands to be slain. Outright war was only avoided by the emperor's timely assassination in AD 41.

For a short time the inevitable was merely delayed. During Passover a Roman soldier guarding the Temple "pulled back his garment, and cowering down after an indecent manner, turned his breech to the Jews" (JW 2.224). The Jews responded in time-honored biblical tradition by stoning the Romans, and in the subsequent Temple riot 10,000 Jews were trampled underfoot. Not long after, a soldier at Beth-Horen tore up a copy of the Jewish prayer book and threw it into a fire.

During the reign of the emperor Nero (AD 54–68) the Jews started to fragment into various seditious sects to fight the Roman presence. In particular, the Sicarii, knife-wielding anti-Roman contract killers, arose in Jerusalem with a deadly reputation for mingling with crowds during festivals and slaying people by stealth before silently vanishing back into the crowd. The Jewish revolution was born; the seditious called for Jews obeying the Roman way of life to be killed. The houses of great men were plundered and villages set on fire "and this till all Judea was filled with the effects of their madness" (JW 2.265).

Finally, in AD 66 Gessius Florus, Roman procurator of Judea, "blew up the war into a flame," according to Josephus, by seizing seventeen talents from the sacred Temple treasure. When the inevitable anti-Roman riot erupted, Florus got his excuse to march on Jerusalem, where he plundered houses and killed the inhabitants of

- 140 -

the Upper Market Place. Some 3,600 men, women, and children were slain according to Josephus, but Rome had now made its final irreversible mistake. These Jews included nobility from the Roman equestrian upper classes, former allies.

Now the empire would have to contend with not just the mob, but also the most resourceful citizens of Judea. Sacrifices in Jerusalem to Rome were ended, a sign of a complete breakdown in political relations. Josephus is quite clear on the effects of these actions: "And this was the true beginning of our war with the Romans; for they rejected the sacrifice of Caesar on this account" (*JW* 2.409).

I n a wonderfully comic cameo in Monty Python's *Life of Brian*, a group of Jewish revolutionaries quietly plot against Rome in Jerusalem's amphitheater when they are rudely interrupted by the hero and messiahin-waiting, Brian, peddling Roman fast food: otters' noses, wrens' livers, and badgers' spleens. In hushed, reverent tones, Brian inquires whether the schemers are the Judean People's Front. The response is incredulous, with the leader literally spitting, "We're the People's Front of Judea."

Although written for humorous effect, this scene faithfully reflects the confusion and tragedy that befell Jerusalem between AD 67 and 70. Fiction mirrors the sad reality of a Holy City fragmented into a web of hostile Jewish revolutionary groups. Each swore by its own High Priests, ignoring the legal line of succession. Over time intergroup alliances collapsed and re-formed, so when Titus arrived to besiege Jerusalem four sets of Jewish revolutionaries were locked in open warfare on the streets of the Holy City. Personal ambitions made a mockery of centuries-old tradition and loyalty. As Josephus explained, this was "a sedition begotten by another sedition, and to be like a wild beast grown mad, which from want of food from abroad, fell now upon eating its own flesh." Internal revolution went a long way to weakening Israel militarily and politically, making Rome's task much easier. The empire could sit back and save energy while they watched the Jewish zealots slit Israel's wrists.

How did such an ungodly situation arise? Once Rome had dealt

- 141 -

with revolution in the Galilee in AD 66, at Jotapata defeating Josephus himself as commander of the Jewish forces, the empire marched toward Jerusalem. One logical response to this extreme military threat might have been to combine forces for a final showdown. Yet as gleaming Roman armor appeared on the horizon, the chasm dividing Jerusalem's Jews widened. This was not mere differences of opinion but entrenched civil war.

The direct seed of the revolt in Jerusalem was the green-eyed monster—personal greed. In the 50s AD, members of the ruling class of Judea exploited countrywide anarchy as an opportunity to increase their personal power at the expense of their friends. By AD 62 various gangs, such as the *poneroi* revolutionary party, led by the former High Priest Ananias, roamed Jerusalem like medieval warlords surrounded by their own court and private army.

The three most extreme factions dividing Jerusalem were controlled by Eleazar ben Simon, Simon ben Giora from Gerasa, and John of Gischala. For a year, from AD 68 to 69, the city was run by a coalition of John, Eleazar, and the Idumeans, descendants of the Edomites forcibly converted to Judaism by the Hasmonean kings. Eleazar may have been from solid priestly stock, but he was removed from office by the High Priests and so subsequently joined the Zealot leadership. Unwilling to share power, however, he later split from the central Zealot group and set up a new camp within the inner court of the Temple, hanging his weapons over the holy gates in a public display of defiance.

John of Gischala was equally partisan. With a force of 6,000 men, 20 commanders, and the support of a further 2,400 Zealots, he pursued a reign of terror between the Temple and the south, as far as the Ophel and the Kidron Valley.

Despite an acrimonious split with Eleazar, John eventually forced his old ally to reunite factions. During the Passover of AD 70, John's armed men sneaked into the Temple Mount to overpower Eleazar. But by now their constant bickering had allowed a third revolutionary to take over Jerusalem.

Simon was a splitter from the Zealot faction, whose reputation had

been cemented when he successfully attacked the rearguard of Cestius Gallus, governor of Syria, in AD 66 and seized the imperial baggage. Through this display of courage he attracted the respect of establishment figures. By October, Simon controlled 10,000 men and 50 commanders backed up by a further 5,000 Idumeans. His anarchic band of men terrorized the Upper City of Jerusalem and the Acra district of the lower city. To the general Jewish population Simon and the Zealots were "a greater terror to the people than the Romans themselves" (JW 4.558). Between the spring of AD 69 and the destruction of the Temple in the summer of AD 70, he forged a position as the leading commander of an independent State of Israel.

The general will of Jerusalem was disgusted by the chaos in its midst. Thus, Jesus, son of Gamala, denounced the revolutionaries:

The scum and offscourings of the whole country, after squandering their own means and exercising their madness first upon the surrounding villages and towns, these pests have ended by stealthily streaming into the holy city: brigands of such rank impiety as to pollute even that hallowed ground [the Temple], they may be seen now recklessly intoxicating themselves in the sanctuary and expending the spoils of their slaughtered victims upon their insatiable bellies. (JW 4.241–243)

Such was the anarchic madness polluting Jerusalem when Titus arrived at the gates of Jerusalem in spring of AD 70. Three different leaders, three different armies dividing the Jews, one faith. Within six months the ambitions of all three warlords would be strangled by Rome; John would be sentenced to lifelong imprisonment, Eleazar was probably killed at Masada, and Simon was executed in the Eternal City the following year.

TURNING THE SCREW

By the time Titus was ready to strike, Jerusalem badly needed a respite. Families were bitterly divided by factional infighting, father pitted against son. But with morale at an all-time low, the exhausted Jewish armies were about to receive a rude awakening.

The battle for Jerusalem was among the bloodiest in recorded history. The Jewish revolutionaries proved immensely stubborn, refusing honorable surrender and Rome's hand of peace. More crucially, the eyes of the world were focused on the Holy City. Vespasian may have been dispatched to Israel with a hard-man reputation and a track record for bringing troublesome provinces to heel, but by the time the siege of Jerusalem started he was emperor of the entire Roman Empire. Priorities had changed. Vespasian was back home in Rome sweet-talking the Senate and putting the imperial house in order after years of abuse under Nero. Titus alone was left to mop up Jerusalem.

The Flavian dynasty now on the throne had been elevated to power by nothing other than diligence. Farmers by background, Vespasian's ancestors had little military pedigree and no aristocratic history. So the new emperor desperately needed a foundation myth to solidify his claim to fame. And Israel, with the huge prize of Jerusalem and the Temple of the Jews, was the perfect opportunity for a propaganda coup. Time and circumstance had dealt the Jews an unlucky hand of cards. With a shattering victory essential, Titus marched out of the coastal port of Caesarea with four legionary forces, bolstered by Syrian auxiliaries familiar

20

- 144 ----

with the local terrain. The sight of the greatest force ever assembled in ancient Israel must have been terrifying.

In theory, the logistics for taking Jerusalem were a nightmare. The city was protected by three walls and built on two hills divided by a valley. Even if you managed to punch a hole through these fortifications, the Antonia Tower mocked invaders—the brainchild of King Herod to protect the Temple and his own palace complex. The tower was impenetrable, perched 82 feet up a rocky precipice and built of seamless, polished stone to complicate assault. Four towers protected the fort's corners, one soaring 115 feet high into the heavens.

Poorly led and disenchanted, however, the divided Jews were unprepared for a long siege. Once again, Titus could rely on Josephus's inside information about city planning to draw up battle lines. Since offering his military and geographic knowledge to Vespasian after being captured during the battle for Jotapata in the Galilee in July AD 67, the former Jewish commander had proved invaluable to his new masters. Rome's engines of war—enormous platforms equipped with battering rams, catapults, and archer emplacements—were instruments of pure fear. Some eighty-two feet high and iron-plated, they went about their mischief, pounding walls with a tortuous thud day in, day out. The first city wall fell after fifteen days, the second wall only five days later.

With the military operation proceeding to plan, Titus started the psychological war. His soldiers caught, whipped, and crucified up to 500 Jews a day. From rage and spite, Roman soldiers amused themselves by nailing the prisoners in different positions until so many bodies lined the approach to the old city that wood for crosses ran out. Next Titus ordered the hands of prisoners to be cut off and sent to John of Gischala and Simon ben Giora, now united in fighting Rome. These brutal measures had one main objective: to scare the city into surrender.

Once the outer walls were leveled, only the Antonia Tower stood between Rome and the ultimate goal, the Temple, the beating heart of Israel and Judaism. Four mighty earthen siege ramps were built against the tower to bring the machines of war to close quarters. Jewish forces retaliated by undermining these banks and smearing timbers with inflam-

- 145 ----

mable pitch and bitumen, thus burning down the siege ramps that had taken the Roman engineers seventeen days to complete. For the first time, the Roman troops were downcast. The tower would not yield, so Titus changed tactics and decided to play the waiting game. If he couldn't get into Jerusalem, the Jews would not get out. He started building a new city wall guarded by thirteen towers. The townsfolk were now prisoners in their own city.

Inside Jerusalem, daily survival was a battle. Even at the start of the siege rations of corn had been worryingly low. Josephus tells us that the Roman army scorched Israel's wheat fields, and the Jews did themselves no favors by setting fire to Jerusalem's grain reserves during factional infighting. The grip of Rome intensified and famine incited grim tragedies of survival. The Jewish revolutionaries tortured the lower classes into revealing their secret stashes of food, while mothers snatched morsels from the mouths of their own babies. Old men were dragged through the streets, and fellow citizens stabbed them with sharp stakes until they revealed the location of any food they may have concealed. Josephus condemned this behavior particularly strongly, concluding:

No other city ever endured such miseries, nor since the world began has there been a generation more prolific in crime. Indeed they ended up actually disparaging the Hebrew race . . . what indeed they were, slaves, the dregs of society and the bastard scum of the nation. It was they who overthrew the city, and compelled the reluctant Romans to register so melancholy a triumph, and all but attracted to the temple the tardy flames. (JW 5.442-444)

If Josephus was reporting fact—and both historical and archaeological evidence exists to back up his testimony—then the actions of the rebel mob during the siege of Jerusalem marked a terrible descent into barbarity. The city turned into an endless "kind of deadly night." Multistoried houses became charnel houses for the dead. The distress of the famine turned the town crazy. Some Jews staggered through the streets like mad dogs in search of sustenance. Others searched the sewers and dunghills for scraps of food, gratefully chewing even a blade of grass

— 146 —

like cattle. When even these scraps ran dry, the famished city turned on belts, shoes, and leather.

Even this desperation seemed tame compared to one particular atrocity, whose notoriety resonated across the entire Roman Empire. Mary, the daughter of Eleazar from the village of Bethezuba, fled into Jerusalem from her rustic villa as the wrath of Rome swept south. Because she was renowned for her good family and fortune, the Jewish rebels lost no time plundering her home and raiding her kitchen every day, almost as if in sport. Rather than kill her, her tormentors preferred to toy with her by demanding daily meals. When stocks were exhausted, she committed the ultimate sin. Believing that "famine is forestalling slavery, and more cruel than both are the rebels," she slew her infant son and roasted his body (JW 6.202-213).

After eating half she saved the remainder for the rebels, who were paralyzed with horror at the evil they had inspired. Soon the city was abuzz with the latest tale of urban atrocity. Titus was appalled to learn of this cannibalism. There and then he swore to bury this accursed memory beneath the ruins of the country "and would not leave upon the face of the earth, for the sun to behold, a city in which mothers were thus fed" (JW 6.217). Such was the psychological reality of the war raging in battleground Jerusalem in AD 70.

The city was hell on earth, and with so many terrible actions tearing apart the fabric of society it was hardly surprising that Jewish revolutionaries lost their focus on occasions. At one such moment of vulnerability, twelve Roman soldiers, a trumpeter, and a standard-bearer from the Fifth Legion crept into the Antonia Tower and cut the throats of the Jewish guards.

Titus lost no time smashing through the tower's earthen defensive banks to dig a passage for the Roman army to reach the very edge of the Temple. Once again, the Romans attacked the Temple guards by night. Four siege ramps were thrown up over the corners, gates, and cloisters. From here, the capture of Jerusalem literally hinged on the lighting of a match. Titus and his generals chose to smoke out the Jews: the Temple gates were far too heavy to succumb to Rome's battering

- 147 ---

rams. Swords drawn, the soldiers waited to pounce while silver door plating melted around their sandals.

Josephus dated the final assault on the Temple of Jerusalem to August 30, traditionally the day when Solomon's Temple was burned to the ground by the Babylonians in 586 BC. The implication is that the end was fated: a Roman soldier, without orders, "but moved by some supernatural impulse," according to Josephus, flung a burning timber through a low golden doorway leading to the northern side of the sanctuary. The Temple blazed, the Roman troops enthusiastically plundered its treasury, and the Jewish army was decimated. All the priests could do was tear golden spikes off the sanctuary wall and hurl them in desperation at the Romans. The air was thick with the war cries of legions, the howls of the rebels, and the shrieks of the dying. Finally, the people of Jerusalem were all reduced to the same class and status. As Josephus confirmed, "No pity was shown for age, no reverence for rank; children and graybeards, laity and priests alike were massacred" (*JW* 6.271).

The Temple, spiritual heart of Judaism, was lost. The Romans carried their standards into its court and offered sacrifices; Titus then gave his troops permission to burn and sack the city. The Archives building went up in smoke and with it hundreds of years of Jewish history. A similar fate befell the council-chamber and the palace of Queen Helena, a Jewish convert and ruler of the kingdom of Adiabene in Mesopotamia.

Finally, the Jewish forces deserted the impregnable Acra Fortress in the Upper City of Jerusalem and its huge towers, Hippicus, Phasael, and Mariamme, whose walls were so thick that they were capable of defying every engine of war known to man. On September 26, AD 70, Titus was master of all Jerusalem and raised Rome's standards along the towers. From this lofty height, the belly of Jerusalem was exposed beneath him. The strength of the towers, the size of their masonry, and the accuracy of their seams amazed Titus. While he gladly burned the rest of Jerusalem to a crisp, the Roman warlord left the Acra towers standing as a symbol of Rome's omnipotence.

21

DEATH OF A TEMPLE

The 140-day siege of Jerusalem changed the religious world order forever by destroying ancient Judaism centered on animal sacrifice, and by setting the stage for the rise of Christianity. By feeding the fires of sedition and civil war, Israel fell on its own sword. Upper-class avarice and arrogance brought a tidal wave of death and destruction to the land. Between 600,000 and 1.1 million Jews are said by Tacitus and Josephus to have been killed during the fighting. Another 17,000 were dispatched to a life of hard labor in Egypt's mines and a further 700 shipped to Rome as stage props for the triumph of Vespasian and Titus and a grim end in the amphitheater.

Rome's razing of Jerusalem was meticulous. Gone were the Temple, religious sacrifice, and homeland. The legend of the wandering Jew was born, and the stereotype of this people as social scapegoats would endure until the United Nations voted to recognize Palestine as the State of Israel in 1948. Early Christianity, the son of Judaism, was also flushed out of the land, relocating to the banks of the Tiber in Italy, where it would establish deep roots to become a global religion. Without the fall of Jerusalem, Christianity would never have been free to soar to such lofty heights.

In late April 2005, I stared across Jerusalem from the top of the Acra Fortress in the Upper City, today misleadingly called the Tower of David. Of its original three towers, only Phasael still stands. This beacon is the only major ancient landmark to survive the events of AD 70. Tracing

- 149 ---

the excavated outline of the first-century AD Jewish city, my eye took in a dense cluster of stone ballista catapult balls abandoned in the fortress corner. The landscape and atmosphere of AD 70, however, is long gone.

Jerusalem has been intensively explored since the nineteenth century, from Edward Robinson's discovery of an arched pier at the southern tip of the western Herodian Temple wall to Professor Nachman Avigad's excavations of the Jewish Quarter from 1969 to 1983. All this fieldwork has exposed one clear truth: Titus really did impose a scorched-earth policy on Jerusalem, devastating the old city with fire. Today almost nothing survives from Herod's Temple Mount.

From the summit of the Acra Fortress I surveyed the same battle lines Titus had examined in September of AD 70. From here Titus gave the order to raze the city to its bones. The rectangular boxlike girdle that surrounded the Temple Mount in the first century AD still dominates Jerusalem, but within these walls not one piece of masonry survives from the Second Temple. I turned toward Robinson's Arch and the street it used to span, a main thoroughfare once abuzz with markets, shops, and screaming urchins. The original paving slabs of the street have been uncovered and above them the silent witness of Titus's resolve: three-ton blocks of white stone thrown down from the Mount by Roman engineers systematically dismantling the hulking exterior of the Temple. These stones are taller than men and offer a hint of the Temple's former monumental splendor.

Beyond Robinson's Arch, along the outer edge of the southern perimeter of the Temple wall, Professor Benjamin Mazar exposed the main staircase entrance sweeping up toward the Huldah Gates, still visible today as ghostly blocked doorways with semicircular arches. A series of first-century AD *mikvaot* reminds us where Jews were obliged to purify their bodies before approaching God's Temple. Although immaculately landscaped today, a collage of Jewish, Christian, and Islamic monuments, the bustle of life two thousand years ago is sadly long gone.

From my vantage point I enjoyed a perfect spring day. A light breeze licked the flag of Israel planted on top of David's Tower, fluttering across the city. Israeli schoolchildren ran along the fortress walls.

It was time to leave Israel, but one question still disturbed me: Why did Titus go to such lengths to put Jerusalem to the torch?

In general, Rome didn't believe in the wholesale erasure of foreign civilizations. Using a friendly local king, they preferred to crucify and enslave a few leaders, but to leave the infrastructure of the state intact to serve the long-term interests of the empire. Josephus ascribed the destruction of the Temple to an appalling mistake by an ill-disciplined, overeager soldier. Resting in his tent at this time, Titus is said to have sprinted to the Temple in anger when word reached him that it was alight. Among the din of clashing swords and burning timbers, the soldiers pretended not to hear his order to extinguish the flames, but continued slinging firebrands. Liberalius, the centurion of Titus's bodyguard of lancers, was even allegedly ordered to restrain his men with clubs. Jerusalem in summer was a tinderbox and the fire was uncontrollable. While Titus was trying to restrain the forces, a soldier shoved a firebrand into the Temple gate hinge. "Thus, against Caesar's wishes, was the temple set on fire," concluded Josephus.

Rome had nothing to gain by decapitating Israel. The land was diverse and immensely fertile, rich in wheat, olives, and grapes. The Sea of Galilee yielded exquisite fish and the Dead Sea lands all manner of luxury produce, such as dates, balsam, and bitumen. By restoring order, Rome could encourage specialized production and get a massive slice of the pie. Taxation greased the wheels of society and was the foundation of domestic and foreign policy. So why burn Israel to a crisp?

On no less than five occasions during the siege, Titus allegedly called a halt to the clash of steel to offer Jerusalem's Jewish leaders the hand of peace. At one stage even Josephus reminded the revolutionaries about the futility of resistance against an invincible force, stressing that the legacy of Judaism stretching back to the Exodus from Egypt was now in jeopardy. Quoting common Roman policy, Josephus reminded his people that "the Romans are but demanding the customary tribute. . . . Once they obtain this, they neither sack the city, nor touch the holy things, but grant you everything else, the freedom of your families, the enjoyment of your possessions, and the protection of your sacred laws" (*JW* 5.405–406).

- 151 ---

During a conference of war with Titus's six generals, many Roman commanders passionately argued that by being used as a base for warfare, the Temple was technically a fortress and could thus be legally attacked. Despite these logical appeals, again we are told that Titus refused to "wreak vengeance on inanimate objects instead of men, nor under any circumstances burn down so magnificent a work" (JW 6.241). Finally, even a frustrated Titus beseeched the Jews to surrender, promising them life and liberty. The reply was a resounding no. Something inside Titus cracked.

The image of Titus as a sympathetic commander cornered into action has filtered down the centuries. Once the Temple was razed, the emperor's son was solemn rather than relieved:

Contrasting the sorry scene of desolation before his eyes with the former splendor of the city . . . he commiserated its destruction; not boasting, as another might have done, of having carried so glorious and great a city by storm, but heaping curses upon the criminal authors of the revolt, who had brought this chastisement upon it: so plainly did he show that he could never have wished that the calamities attending their punishment should enhance his own deserts. (JW7.112-113)

If the destruction of the Jewish Temple, one of the wonders of classical antiquity, brought Titus no pleasure, how did he feel about the treasure inside? The fledgling Flavian dynasty's attitude to this prospect would prove to be a completely different matter.

22

FLAVIAN SPIN

On a Friday morning in late April 2005 I left the buzz of Jerusalem and headed west toward the coast. I had a nagging suspicion that the final days of the siege were not quite as arbitrary as Josephus claimed. Did the freak throw of a burning firebrand really destroy the Temple; was it really lost by the saddest of accidents? Something didn't quite add up.

My destination was Caesarea, the primary port into ancient Israel between the late first century BC and the early seventh century AD. This was where I believed the Temple treasure was kept under very heavy guard until it was shipped to Rome from the city's majestic quays. With its ruined Roman aqueducts marching into town from the north and the submerged port lying thirty-three feet beneath the waves—a casualty of seismic subsidence—Caesarea is endlessly fascinating and romantic. Every year a little more of the city is excavated and another chapter in the port's sweeping history written.

Driving along the Sharon Plain, ancient Judea's roaming wheat lands, I imagined the lay of the land in AD 70. As far as the eye could see, a ragged exodus would have been under way. Long lines of Jews, impoverished and emaciated, shuffled across the horizon. The great Temple of Jerusalem was razed, families had been brutally torn apart, and now the people of Judea had been exiled from the walls of Jerusalem. To the thin hill air and fragrant fields of the Galilee the dispossessed made their way toward a new home, where spiritual wounds would be slowly healed over time. As the right hand of his father, Vespasian, Titus had

- 153 -

not only killed thousands of Zealots, he had wiped out one of the most learned and sophisticated cultures of antiquity—or so he believed.

I swung west off the Tel Aviv-to-Haifa highway and noted how great swaths of coastal sandbanks had been chewed up by urban development since my last visit. Caesarea is one of Israel's most buoyant playgrounds for the rich and famous, just as in antiquity, and each year its villa quarter encroaches ever closer to the ancient ruins.

This was the modern economic reality, but I wanted to explore the economics of ancient Roman Caesarea. Leaving my rental car by the Byzantine Esplanade, where headless statues of emperors preside over a fifth-century AD marketplace, I walked down to the beach through the Crusader gateway, past colossal columns and sprawling Roman warehouses.

Sebastos, the port of Caesarea, was the world's first artificial harbor, a state-of-the-art facility into which Herod poured much of his life's savings. She would certainly have been the largest and most reliable port city from which to dispatch spoils of war. Titus's reliance on Caesarea as his naval base in the battle for Israel is also implicit in Josephus: "On the return of Caesar [Titus] to Caesarea-on-sea, Simon was brought to him in chains, and he ordered the prisoner to be kept for the triumph which he was preparing to celebrate in Rome" (JW7.36). If the human cargo intended for the triumph was already in Caesarea, there is every reason to expect the Temple treasure to have passed through the city. Having just demolished Herod's Jewish Temple in Jerusalem, Rome was now using his port to ship the loot and symbols of a vanquished state west to the Eternal City.

Sitting on the end of the breakwater I stared out over the Mediterranean. Arab fishermen idled the day away in the forlorn hope of a little dinner. Fat chance: the fishing grounds here were overexploited before the 1960s and have never recovered. By contrast, in the first century AD Vespasian knew Israel to be ripe for the picking and must have made a pact with his son whereby the destruction of Jerusalem was inevitable. The burning of the Temple was regrettable to Rome, but the looting of its treasuries was coldly calculated and deliberate.

What started as misfortune ended in personal glory for Vespasian. Here was a man of relatively humble origins, a late developer and something of a country hick. Vespasian is alleged to have got the call to lead the Roman forces against Israel by bad luck. Having committed the ultimate sin of falling asleep during one of the emperor Nero's poetry readings, he was refused permission to pay his respects at the palace the following day. Soon after, he found himself shipped off to an uncertain future in the mosquito-infested backwaters of the eastern Mediterranean. Little could he have guessed how fate would unfold.

Vespasian was born in a small hamlet in the Sabine countryside, the hill country northeast of Rome renowned for olives, herbs, and cattle raising. His lineage was far from noble, and throughout his life he would be teased about his rural accent. Even though one of his forebears, Titus Flavius Petro of Reate, had fought as a centurion for the Republicans at Pharsalus in 48 BC, he had been reported for cowardice in fleeing the battlefield. At best, Vespasian's father, Titus Flavius Sabinus, may have achieved the post of leading centurion in a military legion. Sabinus was also something of an entrepreneur, a moneylender in the Helvetian region of Lake Geneva, into which Rome was fast expanding and where new opportunities were arising. Commercial awareness would later stand his son in good stead.

Vespasian was hardly an eager political player in his early years. His elder brother had long received the *latus clavus* (broad tunic stripe), a "badge" of membership to the senatorial order. But Vespasian was indifferent to politics, and only got his act into gear when his mother teased him about becoming his brother's footman.

During his early political career he served on the so-called Board of Twenty, probably in the unglamorous but practical position of head of street cleaning in Rome. At this stage of his career the emperor Gaius Caligula noticed thick mud in an alley and ordered it to be thrown over Vespasian's toga for failing to do his job properly. New ambitions started to burn in the face of such public humiliation.

At the age of twenty-four Vespasian stood for the senatorial office before being sent to Crete. By thirty-nine he was elected to the prae-

— 155 —

torship, and now he had the right to command armies. Yet even as he was mastering the political ladder, money worries forced him home to work in the mundane mule business. His nickname, the "muleteer," hardly gave any indications of his future imperial aspirations. In AD 41, Vespasian's career took him abroad to the Rhine and then Britain.

Despite an ever-swelling portfolio of experience, Vespasian continued to pull the short straw. On drawing lots in AD 62 for his proconsulship he landed the unpopular tenure of Africa, where turnips were thrown at him at Hadrumetum in Tunisia for failing to prevent food shortage. However, by the time he was commanding three legions in Judea, the Flavian dynasty was enjoying significant power and prestige. His brother was also Prefect of Rome.

When Vespasian went to command the complicated but winnable war in Israel, he was simply a servant of the empire; a few years later he would return as the most powerful man in the world. The end of the 60s AD were years of confusion and tyranny. After the dreaded Nero committed suicide, Servius Sulpicius Galba, governor of Hispania Tarraconensis in Spain, was appointed his successor. But before Vespasian could even send his son, Titus, back to Rome to salute the new emperor, Galba was butchered in the Roman marketplace and Marius Salvius Otho, governor of Lusitania in Portugal, had seized power. Simultaneously, Aulus Vitellius Germanicus, commander of Germania Inferior, proclaimed himself emperor and the empire was at war in turmoil and disorder. After losing the battle of Betriacum, Otho committed suicide. Never before had Rome experienced anything like the Year of the Four Emperors in AD 68–69.

Not far south of where I sat by the sea at Caesarea stands the outer walls of a Roman amphitheater. Here the first-century Roman garrison took residence, and it was probably precisely here that Vespasian was declared emperor by his commanders and soldiers in AD 69. The empire was in chaos and needed a strong ruler to save the government. With his humble background Vespasian initially refused the offer. When his commanders drew their swords and threatened to kill him unless he agreed, Vespasian reluctantly accepted.

- 156 -

This startling turn of events may sound fortuitous, but imperial ambitions awoke in Vespasian soon after arriving in Judea. His accession was actually well planned and immaculately timed. In reality, he was first proclaimed emperor in Alexandria on July 1, AD 69, with the support of its governor, Tiberius Alexander, and his two legions. With its copious wheat fields, Egypt was crucial to Rome; control Egypt and you owned the breadbasket of the empire and the allegiance of its hungry mouths. It was really only days later that the supposed spontaneous proclamation was made at Caesarea, 330 miles north of Alexandria. By July 15 all of Syria hailed him as emperor. By the last week of December, AD 69, Vespasian was back in Rome on the imperial throne and Vitellius the pretender decapitated. The general of the First Jewish Revolt was now lord of the inhabited world.

Even though history packages these events as due merely to the throw of the dice, Vespasian and his cronies actually had harbored these ambitions for many months. How did this dramatic turn of the tide affect Israel and what instructions were left with Titus about mopping up Jerusalem? The two Flavians must have engaged in dialogue deep into the night, no doubt right here in Caesarea from where Vespasian then sailed to Rome and from where Titus marched to bring Jerusalem to its knees.

Vespasian and Titus placed two problems at the top of their list of pressing priorities: the need of the new dynasty for a propaganda coup and hard cash—loads of it. With no ancestral history to reinforce the Flavians' claim to the throne, a great military victory was essential. Vespasian had the support of the army and, with his humble, no-nonsense background, also of the people. But this would not be enough to establish a dynasty and to see his sons succeed to the throne in later years. Suddenly, events in Judea were crucial to the Flavians—the destruction of Jerusalem and the Temple would legitimize their right to rule down the generations. Every leader has his own defining moment—31 BC and the battle of Actium for Octavian, the future emperor Augustus; General Jackson's victory in the battle of New Orleans that won America independence over Britain in 1815. The battle for Jerusalem would be Vespasian's ultimate claim to fame.

The Roman historical commentator Tacitus described the times preceding the rise of Vespasian as "rich in disasters, terrible with battles, torn by civil struggles, horrible even in peace." Once on the throne, however, he added that the new emperor "purged the whole world of evil." Despite his slow start in life, and possibly because of the wealth of military and commercial experience accumulated on his journey, Vespasian was not only an accomplished military general, he was also a very smart politician.

Modern politicians consider themselves the masters of political spin, spending fortunes on advertising campaigns that spread subliminal messages and sound bites across the land into the front rooms of the electorate. Perhaps they might be humbled to learn that Vespasian cracked this art two thousand years earlier. Soon after being proclaimed emperor, the Flavian propaganda machine swung into action. Vespasian, and hence the Flavian dynasty, would be "branded" as the team that chained chaos and brought *pax*, peace, to the world.

Soon after July 1, AD 69, Vespasian ordered coins be struck worded PACIS EVENTVS (The Coming of Peace). The Roman Empire enjoyed a global economy, and the same coins used in London were common currency as far as the Jordanian port of Aqaba, gateway to the Red Sea. This was Vespasian's way of quickly spreading his message. By the middle of his reign, the emperor's coins simply stated PAX. Peace had arrived, and with a bust of Vespasian on the coin's reverse, the world knew who was responsible.

Throughout the first century AD, the Roman Empire had tackled several irritating insurrections in Britain, Germany, Gaul, and Syria. All were suppressed without any of the fanfare of the First Jewish Revolt. But the sack of Jerusalem would be the Flavians' eternal claim to fame, and the defeat had to be packaged as something much more than just a bare-knuckle fight. The destruction of the Jews had to be portrayed as a global event orchestrated by great leaders. Suetonius tells us that Vespasian famously boasted to the Roman Senate, "My sons will succeed me or no one will," and the First Jewish Revolt would be the dominant argument for Flavian rule and succession.

- 158 -

This was bad luck for the Jews, who found themselves troublemakers in the wrong place at the wrong time. Vespasian pursued a sweeping set of measures to boost the Flavian image, not least ensuring that his accession was seen to be fated. Among the eleven supernatural explanations given by Suetonius for Vespasian's claim to power was a statue of Julius Caesar on Tiber Island in Rome that turned from west to east, pointing toward the region from where the new ruler and peace would come.

Yet, at least in the short term, the most effective piece of propaganda was the minting of a remarkable series of silver coins bearing a bound Jewish prisoner in front of a palm tree, symbol of Judea, his arms tied behind his back, and with a Jewess crying at his feet. Arms and armor of the defeated Jew lie abandoned in the background. Latin text inscribed around the scene reads JUDAEA CAPTA: Judea Captured. This popular piece of Flavian propaganda, minted continuously over a twelve-year period, left no member of the empire unaware of where peace originated and who created it.

Stage-managing propaganda was one matter, fulfilling a grand strategy quite another. Without a massive injection of cash to pay for the new image, the Flavian brand would remain hollow. Where could Vespasian get his hands on a king's ransom? The answer was obvious for the imperial schemers. Both knew from various government reports that the Temple of Jerusalem was loaded. It had to fall.

In his *Natural History*, Pliny the Elder, a contemporary of Vespasian, described Flavian Rome as a city enjoying

the immeasurable majesty of the Roman peace, a gift of the gods, who, it seems, have made the Romans a second sun in human affairs. And all the wonders of the world have been matched in Rome itself over its 800 years' history: the buildings it has accumulated are enough to make another world, and of these the culmination is the Temple of Peace itself. (*Natural History* 27.3)

In other words, Vespasian and the Flavian dynasty transformed the architectural face of Rome. This was another essential strategy. By AD 67,

- 159 -

the greed and poor financial planning of the emperor Nero had bankrupted the Eternal City. War in Asia Minor from AD 54 to 63 and in Britain during AD 60–61 had diminished the imperial gold reserves. The army was behind in paying its soldiers—a fatal sin. To make matters worse, Rome itself looked tattered, its marble veneer streaked black by the great fire of AD 64. Despite this serious predicament, Nero had continued to please himself with gross extravagance: costly leisure pursuits, a tour of Greece, theatrical performances, racing, and palace building. His relentless pursuit of personal gratification spread across the Mediterranean, where he ransacked provinces in search of the finest works of art, which he imported for his palace in Rome for his own pleasure, not for the entertainment of the people.

To finance his public relations campaign and the rebuilding of Rome, Vespasian needed to raid the Temple of Jerusalem. As many assets as possible had to be liquidated—and fast. The new emperor estimated that 4 billion sesterces were required to pick the state up off the floor, the equivalent of about \$4.25 billion today. The annual taxation of the provinces yielded 800 million sesterces (\$854 million). Thus, the equivalent of five years' revenue was urgently needed. Back in Italy Vespasian was already liquidating public property and increasing rates of taxation. New census programs were organized in Egypt and Gaul to assess the empire's productive capability, and mines previously considered exhausted were reopened as government concerns, especially in goldand lead-rich Spain.

In Judea, Vespasian continued the asset stripping. Rich Jewish estates were sold to the highest bidder and the Temple tax that previously went to the Temple was now diverted as an annual poll tax, the *Fiscus Juda-icus*, to the Temple of Capitoline Jupiter in Rome. Free Jewish males between the ages of twenty and fifty, women up to age sixty-two, and children over age three paid 8 sesterces. If the Jewish population across the Roman Empire totalled 5 to 6 million, a new tax windfall of 40 to 48 million sesterces was created (\$42 million to \$51 million).

Despite these swift initiatives, there was still not nearly enough cash. The Temple treasure of the Jews, however, was a godsend, the

- 160 ---

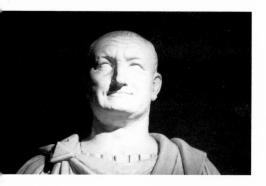

Vespasian, commander of the Roman forces during the First Jewish Revolt, AD 66–70, and founder of the Flavian dynasty. In AD 69 he was appointed emperor of Rome and returned to the Eternal City to take the throne. (Museum of Roman Civilization, Rome)

Founding a dynasty required enormous finances. Vespasian left his son, Titus, in charge of razing Jerusalem to the ground and plundering the treasures of the Jewish Temple. (© CNG, Inc)

Map of ancient sites associated with the Temple treasure of Jerusalem. Most of the Temple poils were quickly turned into cash. The greatest symbols of faith survived for more than 00 years.

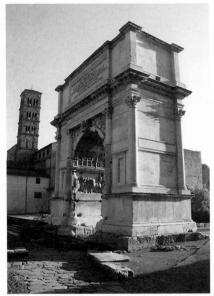

In AD 80, Titus celebrated the Flavian dynasty's victory over Israel with a triumphal monument built on the summit of the Sacred Way in Rome's Forum, the Arch of Titus.

A relief on the Arch of Titus shows the greatest symbols of Judaism paraded along the streets of Rome in Vespasian and Titus's triumph of AD 71 *(from left to right)*: the seven-pronged gold candelabrum and the gold and bejeweled Table of the Divine Presence, with a pair of silver trumpets tied to its front.

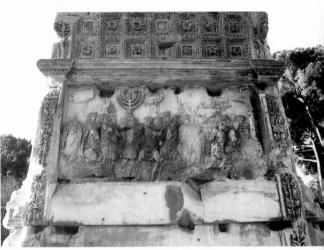

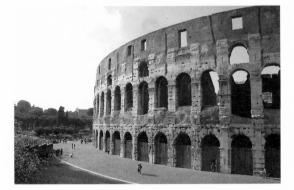

Rome's 50,000-seat Colosseum, the greatest entertainment facility of the ancient world. Epigraphic evidence reveals that it was built in AD 72 from spoils Vespasian had looted from the Temple of Jerusalem. Herod's Temple n Jerusalem, first entury AD; the Holy of Holies, which housed he candelabrum and Table of the Divine Presence, ises at the right. "Z. Radovan, www. BibleLandPictures. om)

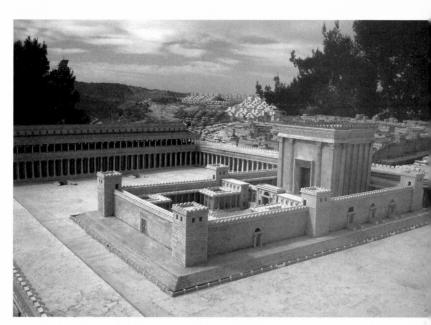

Any scholars believe the Temple reasure of Jerusalem was spirited way to the Dead Sea and hidden round the Essene settlement of Qumran. A vast number of *mikvaot*, itual baths, superficially suggest the ite was occupied by pious Jews.

The fortified tower and water channels at Qumran, the site where the Dead Sea Scrolls are traditionally believed to have been written, as well as the Copper Scroll and its list of sixty-one buried items from the Temple, worth up to \$3 billion, according to some estimates.

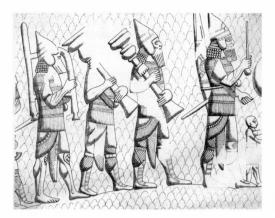

By 165 BC, the candelabrum in the Temple of Jerusalem had evolved into the seven-pronged form. It was this antique that Titus seized in AD 70, complete with a pedestal adorned with pagan images of eagles and sea monsters.

Entrance facade into the Jewish catacombs of Roman Beth Shearim, Israel. The site's rich sarcophagus decoration confirms which images were acceptable to the Jews of Roman Palestine. Royal spoils looted from Lachish, Israel, by Assyrian soldiers in 701 BC, including two cylindrical cult stands. The candelabrum described in Exodus, and found in King Solomon's Temple, would have resembled this form. Wall relief, King Sennacherib's palace, Nineveh. (From Ussishkin, 1982, fig. 83)

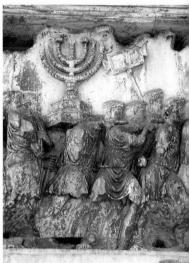

Nike, the Roman goddess of victory, an acceptble image for a Jewish burial sarcophagus at Beth Shearim.

An eagle on the side of a secondto-third-century AD sarcophagus at Beth Shearim corresponds exactly to eagles on the base of the Arch of Titus candelabrum pedestal, confirming its ancient ancestry.

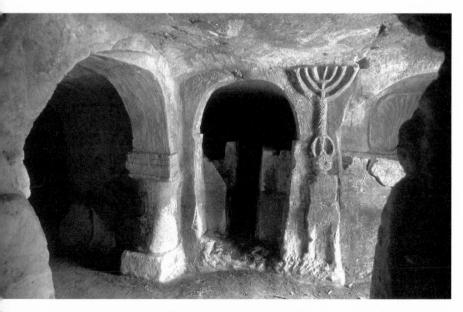

A soldier with a candelabrum on his head in Beth Shearim's Roman catacombs. The andelabrum's knotted central shaft replicates the Tree of Life, which was its original nspiration. (*Z. Radovan, www.BibleLandPictures.com*)

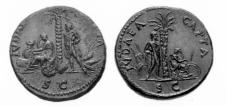

The bronze Judaea Capta coin series, struck by Vespasian from AD 71 as Flavian propaganda. The reverse shows a mourning Jewess along-side a conquered Jew with tied hands, a palm tree—the symbol of Judaea—and conquered enemy armor. (© *CNG Inc*)

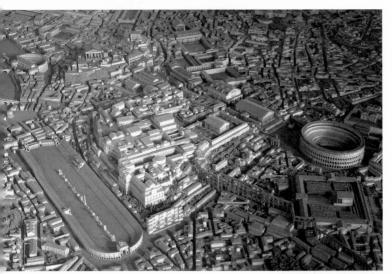

Model of imperial Rome by Italo Gismondi (Museo della Civiltà Romana), showing the highlights of the route followed by Vespasian and Titus in their triumph of AD 71 celebrating Israel's defeat. Top left: Marcellus's theater in the Field of Mars. Bottom left: The Circus Maximus. Middle right: The Colosseum and, to its left, the Temple of Peace.

A sixth-century BC Egyptian obelisk originally marked the location of the Temple of Isis, where the triumph began.

Madam Lucretia in the Piazza di San Marco, Rome, is probably the original cult marble statue of the Egyptian goddess Isis.

On the morning of the triumph, Vespasian and Titus offered brayers at the Pantheon in the Field of Mars, Rome.

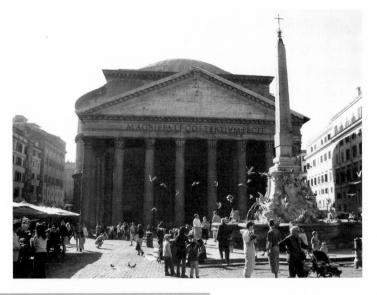

The Senate House in Rome's Forum (brick structure at right), with the rostra, state orator's platform, at left. Here Vespasian received formal congratulations in AD 71 from the Senate for defeating Israel.

The triumph of AD 71 was a dark day for Rome's Jews. Of the city's original thirteen synagogues, only one Jewish temple survives today at Ostia, with its Torah shrine intact.

A column capital in Ostia's synagogue decorated with a candelabrum.

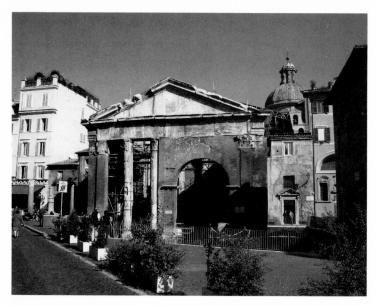

The arched Porticus of Octavia, Rome, across which Vespasian's triumph paraded in AD 71.

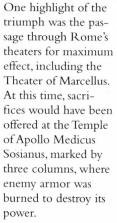

The medieval Church of Saint Nicholas literally sits on three Roman temples (columns at left), where sacrifices were offered by Vespasian in AD 71. The temples were dedicated to the gods Spes, Janus, and Juno Sospita (Hope, Beginnings, and Savior).

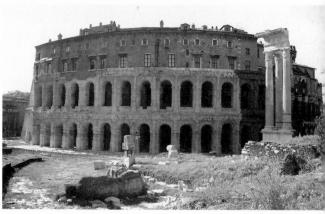

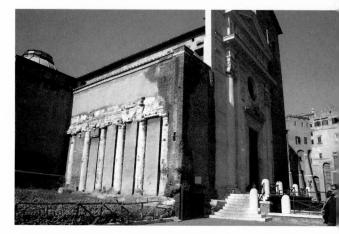

The arcades of the mighty Triumphal Gate, the Porta Triumphalis, Rome, which was opened only for triumphs. By closing the gate immediately afterward, the power of the Roman conqueror was locked inside for the benefit of the city.

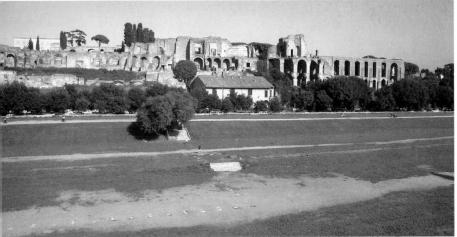

The Circus Maximus, Rome, with the royal palace on the Palatine Hill in the background. In AD 80, Titus built a second triumphal arch here to celebrate victory over Israel.

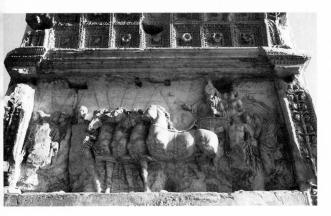

The Arch of Titus, built AD 80–81, shows Titus parading along the Triumphal Way in AD 71, alongside the goddess Roma. A winged Victory holds a wreath over the general's head.

In AD 75, Vespasian put the Temple treasure of Jerusalem on public display at the heart of his new Temple of Peace in Rome. The exotic marble floor of its main hall has just been excavated.

In AD 211, the emperor Septimius Severus decorated one of the Temple of Peace's walls with a giant marble map of Rome. This wall survives today as the facade of the Church of Saints Cosmos and Damian (see holes at left used to peg the map together).

Reconstruction of Vespasian's Temple of Peace precinct. (© E-Spaces and UNESCO, 2000)

In AD 455, the Vandals looted Rome and relocated Jerusalem's Temple treasure to the palace in their capital, Carthage, in modern Tunisia, which afforded majestic views of the great port.

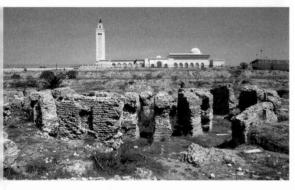

The Arian Vandals earned their barbarian reputation in Carthage for religious atrocities against the local Catholic community. The Circular Monument, dominated by the modern President's Palace, witnessed particularly evil attacks in AD 439.

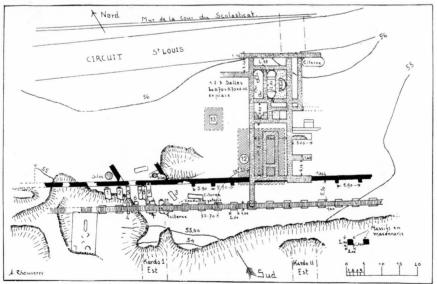

A plan by Father P. Lapeyre of Punic tombs *(left)* and the rectangular palatial structure exposed in 1933 *(at right angles)*. This marks the spot of the Vandal palace, where the Temple treasure of Jerusalem was displayed from AD 455 to 533. *(From* Revue Africaine *1934, pl. 2)*

The Vandal palace on Byrsa Hill, Carthage (*right*), looking south toward pier supports for a garden terrace and beyond down to the port.

The Vandal palace's dining platform, *stibadium*, on Byrsa Hill, Carthage, with its apse and remains of marble veneer *(left)* and a rectangular foundation for a fountain *(right)*.

The second-phase triconchal dining room in the Vandal palace, denoted by the apse, with the lower *stibadium* platform behind.

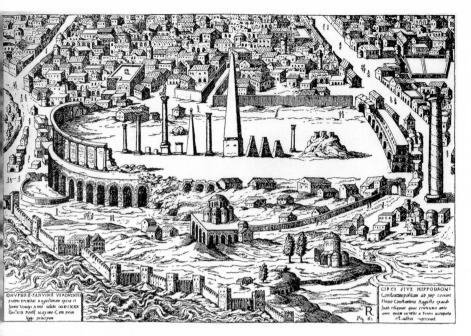

In AD 534, the Byzantine emperor Justinian granted General Belisarius a Roman-style riumph in Constantinople's hippodrome in honor of his victory over the Vandals. The Temple treasure of Jerusalem was shipped to Constantinople and paraded in the hippolrome on this occasion. (Onofrio Panvinio, c. 1450)

The ghost of an Ottoman building overlying the walls und an arched entrance to Constantinople's Byzantine uppodrome.

The hippodrome was also a museum of antique artwork, including a bronze serpent column originally dedicated at the Temple of Apollo at Delphi in 479 BC.

The southern Byzantine monument and Theodosius's Column in the center of Constantinople's hippodrome.

The base of Theodosius's Column in Constantinople's hippodrome. The emperor Valentinian II hands out a laurel wreath to a sporting victor from the royal box, the *Kathisma*. Below, the crowd watches a chariot race. Although sculpted in AD 390, the scene captures the atmosphere of the triumph of AD 534, when the Temple treasure arrived in the Hippodrome.

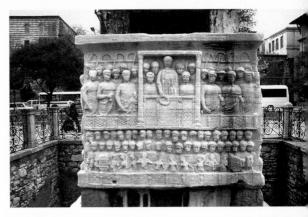

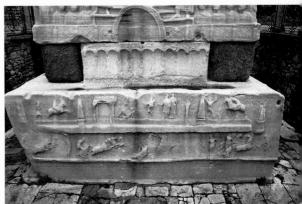

A hippodrome chariot race on the base of Theodosius's Column, Istanbul. The ruins of the Church of Saint Polyeuktos, built by Princess Anicia uliana in AD 527, using the royal biblical cubit of King Solomon's Temple. This house of God accommolated the Temple reasure of Jerusaem while it was in Constantinople.

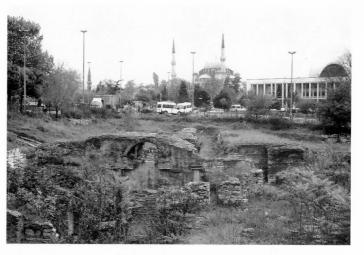

Sculpted vine leaf and grape motifs in the Church of Saint Polyeuktos recalled the decoration of King Solomon's Temple in Jerusalem.

The emperor Justinian's royal apartments in the Byzantine palace of Constantinople.

The Monastery of Saint Theodosius in the West Bank. Its superior, Modestus, spirited the Temple treasure away from Church of the Holy Sepulchre around AD 614 into the wilderness to escape the clutches of Persian invaders and their Jewish allies.

The back of the Monastery of Saint Theodosius in the West Bank, its walls built of ancient Byzantine masonry from the original sixth-century monastery.

> Disturbed soil and the entrance to an underground cave on the grounds of the Monastery of Saint Theodosius. The Temple treasure of Jerusalem ended up concealed in just such a place.

answer to all of Vespasian's prayers. A demand for ready cash was the main reason why, ultimately, Jerusalem had to fall. Titus's preference for a peaceful surrender was honest; the Jews' inflexibility cost them their lives, liberty, and homeland. I am also convinced that Titus had no plans to burn down the Temple. The Temple treasure, however, was quite another matter. Rome needed the Jewish treasure chest—this was nonnegotiable.

Caesarea was the main witness to this budgetary policy making: the base of the Roman army; the headquarters of Vespasian and Titus; the port from where the Temple treasure—and with it the extinguished hopes of a lost people—sailed over the horizon to Rome. As I stared out to sea, I picked out dark shadows deep offshore: the submerged Roman breakwaters that sank beneath the waves two thousand years ago. Caesarea was built along a seismic fault line, a geological problem of which King Herod was ignorant. In the end it didn't matter how much money he threw at the world's first purely artificial port in 22 BC. The project was doomed from the very beginning.

Similarly, Vespasian and Rome would realize that it is the nature of civilization that all crests of waves are followed by deep troughs. However much money he threw at redesigning his own dreams and image, a fall was brewing over the distant horizon. Would the Jewish Temple treasure of Jerusalem, one of the greatest artistic and spiritual legacies ever known to man, survive the fall? Or, in a fit of economic desperation, were the gold menorah, the Table of the Divine Presence, and the silver trumpets to be thrown into the melting pot, crudely liquidated to help build a new Rome?

Before looking so far ahead, I needed to focus on the immediate fate of the Temple treasure in AD 71.

— 161 —

IMPERIAL Rome

23

WALKING WITH GOD

Italy in spring is an absolute delight with its alluring sunshine, flowers in bloom, and lightly caressing winds—the scents of promise. As my plane banked over Rome's Ciampino airport in May 2005, a smattering of bloodred poppies stained motorway turnouts, quarry edges, and backyards, welcoming us to Arcadia. Rome's ancient agricultural ideals reverberate into the modern day in the form of giant circular haystacks lying idly between runways like giant organic column drums. Gypsies kicked a football across the ancient cornfields, where they had encamped close to a primary artery of communication. Their geography mirrored Rome's ancient foreigners, who lived along the southern banks of the River Tiber, the bustling "airport" of antiquity, where wooden ships served the same role as modern airplanes.

My plans for Rome were simple, but ambitious: to try to reconstruct the route of Vespasian and Titus's triumph in AD 71 (would any of the ancient landmarks even survive, I wondered?); to get a sense of the atmosphere, gravity, excitement, and sorrow of that fateful day; to find out what it was like to be a foreigner in ancient Rome, a society defined by its oppression of barbarians; and to locate the Temple of Peace, where the emperor Vespasian put Jerusalem's Temple treasure on show as war booty and an eternal expression of Rome's status as the global superpower. In truth, I was not especially confident. After all, no one had taken on this daunting task for nearly two thousand years.

The quest would succeed or sink on my ability to locate several key

— 165 —

monuments, major ancient highlights of the spectacular triumph described in Josephus's original text: the Temple of Isis; Octavian's Walks; the Gate of the Pomp; a cluster of theaters; the Temple of Jupiter Capitolinus; and finally the Temple of Peace. Each ancient landmark illuminates a path to a subsequent clue. With my copy of Josephus's *Jewish War*, medieval and modern maps, and numerous photocopies of scholarly literature, I wasted no time before pounding the streets of Rome.

The triumph of the emperor Vespasian and his son, Titus, was the greatest of the 320 or so that Rome ever celebrated. The event was a meticulously planned theatrical affair deliberately staged around high moments of drama and spectacle steeped in symbolism. As I roamed the backstreets of Rome, piecing together the route of the triumph of AD 71, and as astonishing snapshots of the ancient Triumphal Way emerged from among the hybrid collage of Rome's architecture—the new recycling the old—I was bowled over by Rome's tight planning of the triumph. Timing, locations, scenery, and actors—nothing was left to chance.

Specific gods whose spirits hovered over the fourteen city quarters were courted in their temples of worship before celebrations could commence. Unlike the population of modern cities, who characterize various districts primarily by function (retail, residential, or municipal), the citizens of Rome also referred to its individual quarters according to the nature of their resident gods. When the triumph snaked boisterously across the Field of Mars, hugging the Capitoline Hill and then entering the Forum itself, the gods' local to each district had to be appeased by prayer and sacrifice. To neglect a god was to awaken and set loose harmful spirits. Similarly, the architects of the triumph selected historical landmarks for both their visual impact and their symbolic effect on the expectant hordes enjoying a Roman holiday at the emperor's expense.

Although Vespasian and Titus were each technically entitled to separate triumphs by decree of the Roman Senate, they chose to share the honor, cleverly realizing that this would double the sense of pomp and ceremony. The night before the momentous day, the formalities started.

- 166 -

Josephus claims the entire city turned out, so that within its walls "not one of the immense multitude was left." The crowds had assembled over the course of the afternoon and early evening in the Field of Mars, ancient Rome's Region IX. This was the most appropriate setting for the event's first act, the starting point from which to set in motion the celebration of a famous military victory. Mars, of course, was Rome's god of war, who had so potently cast his spell over the scarred battlefields of Israel.

The Field of Mars (the Campus Martius) was a vast swathe of lowlying ground encompassing just over a mile from the Capitoline to the River Tiber. Despite being highly susceptible to flooding due to its lowlying terrain, some of Rome's greatest monuments and finest craftsmen were found close to the banks of the river.

A snapshot of its character was captured by the great historian, geographer, and philosopher Strabo (c. 64 BC to c. AD 24). Although to the Romans the term *strabo* generally described someone whose eyes were physically deformed, the scholar was actually a visionary, credited with compiling the first comprehensive geographical encyclopedia of the inhabited world. On the basis of personal travels as far and wide as Ethiopia and Egypt, he subsequently published his seventeen-volume *Geography* between AD 7 and 18.

The *Geography* paints a lively picture of early Roman life in the wide-open spaces of the Field of Mars:

Indeed, the size of the Campus is remarkable, since it affords space at the same time and without interference, not only for the chariot-races and every other equestrian exercise, but also for all that multitude of people who exercise themselves by ballplaying, hoop-trundling, and wrestling; and the works of art situated around the Campus Martius, and the ground, which is covered with grass throughout the year, and the crowns of those hills that are above the river and extend as far as its bed, which present to the eye the appearance of a stage-painting—all this, I say, affords a spectacle that one can hardly draw away from. (*Geography* 5.3.8)

- 167 -

The district was also studded with hot sulfurous springs, ponds, and lush wooded groves, all instilling a uniquely mystical atmosphere. With a dramatic and iconic background of such natural beauty and ancestry, it is no surprise that Vespasian chose the Field of Mars for the start of his triumph. Historically, religiously, and geographically simply nowhere else would do.

But where precisely in the Field of Mars did the celebrations start? Josephus oddly confirms that the night before the great day, Vespasian and Titus did not purify themselves at one of the great shrines of Rome, but at the place of worship of the mystery cult of Isis:

Now all the soldiery marched out beforehand by companies, and in their several ranks, under their several commanders, in the night time, and were about the gates, not of the upper palaces, but those near the temple of Isis [Iseum]; for there it was that the emperors had rested the foregoing night. And as soon as ever it was day, Vespasian and Titus came out crowned with laurel, and clothed in those ancient purple habits which were proper to their family. (IW7.123-124).

Strange. Why the Iseum? Wouldn't this have been a callous slap in the face of Rome's pantheon of established gods? The worship of Isis arrived up the Tiber in the first century BC on the ships of Alexandrian merchants eager to hang on to their tried and tested domestic gods. According to myth, the god Osiris had ruled over Egypt until his brother Seth severed him into dozens of pieces in a fit of jealousy at his sibling's power. A mourning wife, Isis, managed to recover Osiris's dissected body parts and carry them into her own body to give birth anew to her husband.

Even though the inner workings of this cult remain a mystery, new members certainly participated in initiation rites that replayed the ritual of death and rebirth. Isis was especially popular among slaves and freedmen through her virtue of resurrection, and she welcomed both female priests and the worship of women. The cult grew swiftly in Rome as Isis became a universal mother goddess. By the early fourth century AD

- 168 -

she was Christianity's main competition, and even today icons of the Virgin Mary bear more than a passing resemblance to Roman artistic depictions of Isis.

Mainstream acceptance was one thing, but imperial benediction during a Roman triumph? This mystery ate away at me as I passed the Monument of Victor Emmanuel II of Savoy, who became the first king of a unified Italy in 1861. Earlier research had left me in little doubt that nothing still stands of Rome's Temple of Isis. So how do you find a building that was knocked down centuries ago and whose masonry was recycled century after century into medieval, baroque, and Renaissance buildings? Downhearted and not a little frustrated, I racked my brain and set up office on the steps of the Victor Emmanuel monument as statues personifying victory and the sea seemed to laugh at me from their comfortable perches above the city, smugly concealing their secrets.

Surrounded by paperwork, and with my laptop sparked into life, the realization began to dawn that even if the Temple of Isis is nothing more than a memory, its legacy lives on in a meandering trail of Egyptian sculpture. The first trace of this phantom temple is Madam Lucretia, the modern Italian name for the bust of a monumental Roman marble statue of a woman abandoned in a urine-infested corner of the Piazza San Marco. Cloaked in perpetual shadows, she surveys the daily flow of thousands of visitors gasping at the majestic sight of the Victor Emmanuel monument across the road.

Lucretia was moved to this spot around AD 1500 and, despite her high monetary and artistic value as a museum piece, she remains a modern icon. During festivals she is often painted and adorned with carrots, onions, garlands, and ribbons. She remains a much-respected figure of the community, a knowledgeable stone known to "speak" on important occasions. Thus, in 1799 she fell forward on her face to reveal a black ink inscription on her back that declared, "I can't stand it any longer." Rather than her commentary on the degenerate nature of contemporary society, this exclamation actually reflected the political opinions of a failed attempt to oust the papacy and establish an independent repub-

— 169 —

lican government. Ancient Lucretia, it would seem, is a modern medium for social commentary.

This marble madam shows many scars of life's adversities, including heavily eroded hair and facial features, and lead staples that surgically pin her fractured rib cage together. Today she is something of a "Renaissance woman," a figure of unity standing directly next to the entrance of the United Nations building. Her dress, however, suggests an altogether different ancestry as the Egypt-inspired goddess of Isis, possibly the actual cult statue that adorned her Roman temple in the Field of Mars.

Three minutes' walk away from the Piazza San Marco I discovered that the Egyptian theme of this sector of the Field of Mars continued with the unlikely sight of an Egyptian obelisk carried on the back of a white marble elephant in the center of the Piazza della Minerva. The eighteen-foot-tall red granite obelisk came to light in 1665 in the cloister of the Church of Santa Maria sopra Minerva, whose elegant facade casts a deep shadow across the piazza. Originally erected by the pharaoh Apries in the sixth century BC in Sais, a town of lower Egypt, the emperor Caligula shipped it back to Rome for installation in the Campus Martius's large temple dedicated to Isis and Serapis.

Soon after its discovery, Pope Alexander VII Chigi decided to display the obelisk publicly in the piazza in front of the church, entrusting the design of the monument in 1667 to the genius artist of the baroque, Gian Lorenzo Bernini. The elephant was considered an image of great strength, and so symbolized the divine wisdom of a strong mind. An inscription on the statue base cites the personal philosophy of Alexander VII: "A strong mind is necessary to support solid wisdom." Over time this symbolism faded away, so that by the eighteenth century the elephant was more prosaically known as Minerva's Piglet due to a regrettable perceived resemblance to a pig.

In ancient Egypt obelisks, the Greek for "skewers," were designed as physical manifestations of the sun god Atum-Ra. The apex represented the starting point of the sun's ray and the center of the sun's power, while the base signified the formless matter that the divine light of the

- 170 ----

sun transforms into the cosmos. After being transported to Rome, their original religious function was lost as they became high-prestige artistic expressions of Rome's dominance over her provinces, its peoples, and their gods.

As is so common in Mediterranean cities, towns, and villages, the site of the Church of Santa Maria sopra Minerva in front of Minerva's Piglet literally sits on ancient foundations, in this case the Temple of Isis itself. Nothing of the temple survives today other than the bits of masonry and sculpture that once adorned it and come to light from time to time during building work in the church's precinct. Using a former building as a stone quarry for a later building, of course, is efficient and perfectly logical. Ever since the fourth century AD, however, early Christianity has deliberately rooted thousands of churches over former Roman temples to deliberately seal over and imprison paganism's rampant power. This was the ulterior motive for the destruction of the Temple of Isis.

Walking around the perimeter of the former temple, I realized that the entire structure has indeed been completely devoured by the church, later baroque-period tenement blocks and souvenir stores. Particularly popular are open-fronted shops peddling *gelati*—Isis abandoned in favor of ices. On the far eastern flank of the Roman *insula*, the narrow Via delle Paste is a haven for motor scooter parking. Here the first two courses of masonry aboveground are distinctly Roman. Were the raucous Germans knocking back their drink in the dark lane outside the Bar Miscellanea aware this was once the southeast corner of the Iseum? Here waiters serve vast quantities of beer where the priests of Isis once chanted in mysterious tongues.

Just around the corner from the Piazza della Minerva the heavens opened and in a blinding flash of revelation the reason why Vespasian and Titus really spent the night before the triumph at this spot became blatantly obvious. Josephus, it seems, didn't do his research too well. True, there certainly was a Temple of Isis at this spot two thousand years ago, and as if to hammer home the point, yet another Egyptian obelisk stands in the middle of the Piazza della Rotonda, a needle pointing

— I7I —

heavenward. But Isis and obelisks, I now realized, were a complete red herring.

What Josephus neglected to report, perhaps because the reality would have been so obvious to a Roman audience, is that the most important religious building of the Roman Empire stood next to the Temple of Isis. His reference to Isis was just an elementary act of signposting, whose importance has become overstated across the centuries. Vespasian and Titus did not choose this spot to purify themselves the night before their triumph; this location chose them. A gentle hill would have given a perfect view of proceedings for the multitude converging on the Field of Mars by the thousands. The open space would have comfortably accommodated the hundreds of soldiers shining their armor, not to mention fussy directors putting finishing touches to the triumph's elaborately designed floats. At the foot of the hill, today engulfed by vendors peddling handbags, sunglasses, leaning towers of Pisa, and plastic guns firing bubbles that float around the piazza like messages from the gods, stands one of the most magnificent and important architectural monuments of antiquity, the Pantheon.

The Pantheon has stood undisturbed by the destructive hand of man for almost 1,880 years. The building planted on the site today owes its survival to the temple's conversion into the Church of Saint Mary of the Martyrs in AD 608. The earliest incarnation was commissioned by Marcus Agrippa in 27–25 BC, only to be destroyed like much of ancient Rome by one of the great fires that consumed large swathes of the city in AD 80. Domitian's subsequent rebuild fared even worse, being struck by lightning thirty years later and, once again, burning to the ground. The current temple is the handiwork of the emperor Hadrian, who rededicated the building to the original founder, Marcus Agrippa.

The Pantheon consists of a front porch annexed to a rotunda, in combination 200 feet long. Its pedimented classical facade is supported by Corinthian columns with monolithic shafts of Egyptian granite and by bases and capitals of white Greek Pentelic marble. A set of holes cut into the pediment once formed an eagle and wreath design, the attributes of the supreme god Jupiter, crafted from gilded bronze. The porch, rest-

— 172 —

ing beneath 6.5-foot-wide monster marble columns, originally housed statues of the emperors Augustus and Agrippa and of the god Mars. Another statue, of Venus, was famous for her earrings made from a pearl once owned by no less a celebrity than Cleopatra of Egypt.

Although no one really knows how the Pantheon functioned in antiquity, it may well have been the seat of all the gods, a Roman version of the Greeks' Mount Olympus. But more than this, Roman emperors also held court here, hearing petitions and handing out judgments. The Pantheon was thus a perfect symbolic choice from where to prepare for the triumph.

The majestic spectacle of that day emerged in narrow snapshots. The piazza is heavily built up, and the ancient view distorted in my mind by twenty-first-century hawkers crying "Uno euro" for their tacky goods. An androgynous Sicilian in black shades and a coffee-andcream shirt buttoned up to his throat played surreal elevator Muzak on his electronic organ, while his wife and two toddlers looked on with bittersweet pride and hunger.

After offering sacrifices in the early morning sun, it is almost certain that on the great day itself it was from the Pantheon that Vespasian and Titus walked out in purple robes to the roar of the city. Tens of thousands of Roman citizens tightly packing the Field of Mars as far as the eye could see would have cheered on their heroes as the gods of war looked on in satisfaction. The stench of death on the streets of AD 70 Jerusalem seemed worlds away.

A WORD FROM THE SPONSORS

24

Once the pantheon of the gods and the ancestral dead had been respectfully appeased in the Field of Mars, a final formality awaited Vespasian and Titus before the spectacle could begin. Battles may have been won and lost through the strategic guile and bravery of these commanders in chief and the unconditional loyalty of their soldiers, but the business of war was the matter of the Senate, which was chief executive and treasury rolled into one. Naturally it had nervously followed the Jewish Revolt, voting for troop allocations and the supply of generous funds.

One false move and armies were known to turn against the Senate, and the city mob to grind more than just its teeth if excessive funds were wasted on war rather than more immediate tasks like cleaning stinking sewers. Vespasian had left Rome out of favor with Nero and returned an emperor. From humble beginnings the new imperial ruler was well aware of the Eternal City's political sensitivities.

Before the pageant of the triumph could start, Vespasian and Titus thus received the blessing of the Roman Senate and the congratulations of their "sponsors." Josephus dwells on this morning meeting at some length, explaining how the commanders

then went as far as Octavian's Walks; for there it was that the Senate, and the principal rulers, and those that had been recorded as of the equestrian order, waited for them.

Now a tribunal had been erected before the cloisters, and ivory chairs had been set upon it, when they came and sat down upon them. Whereupon the soldiery made an acclamation of joy to them immediately, and all gave them attestations of their valour; while they were themselves without there, and only in their silken garments, and crowned with laurel: then Vespasian accepted of these shouts of theirs; but while they were still disposed to go in such acclamations, he gave them a signal of silence.

And when everybody entirely held their peace, he stood up and covering the greatest part of his head with his cloak, he put up the accustomed solemn prayers; the like prayers did Titus put up also; after which prayers Vespasian made a short speech to all the people, and then sent away all the soldiers to a dinner prepared for them by the emperor. (JW7.124-129)

The whereabouts of Octavian's Walks is not common knowledge, but can only have existed at one very special location. At the far west end of the Forum, just past the monumental triumphal Arch of Septimius Severus, stands a well-preserved rectangular building. Although the current incarnation dates to AD 283, the original building was devised as a Senate house (the curia) by Julius Caesar and completed by Augustus in 29 BC. Even though stylized images of the Senate on contemporary coins show a building more reminiscent of a Chinese pagoda than a Roman temple, this was one of the most powerful buildings of the empire. Inside its hallowed walls, lined with expensive Phrygian marble, three hundred senators would congregate and debate matters of state. Three statues perched on the top of the facade's pediment, including a Winged Victory on a globe, guarded its doors.

The Augustan building was decorated inside with marble balustrades depicting on one side an anonymous emperor burning the book of debt and, on the reverse, a sow, ram, and bull being led to sacrifice in the Forum and a scene of imperial benefaction. A similar *suovetaurilia* ceremony of animal sacrifice would have taken place on the morning of the triumph, but not in front of the Senate house. About 130 feet west of the curia is the symbolic heart of Rome, the Umbilicus

- 175 -

Urbis (Navel of the City) where, according to legend, Romulus dug a circular pit when he founded Rome. Here all new citizens arriving at the city traditionally threw in a handful of dirt from their place of origin, as well as the first fruits of the year as a sacrifice. The Navel of the City was also a gateway to the underworld, whose lid was prized open three times a year to liberate bottled-up evil spirits and stop them from brewing undue mischief for the empire.

Against this powerful political backdrop of symbolism and power, Vespasian and Titus would have been received at the *rostra*, a massive rectangular orator's platform that still stands today. The podium dominates the Forum of Julius Caesar and would have been unmissable in AD 71 with its colored paneling of pink-gray marble from Chios cut with vertical bands of black-red marble from Teos. Reinforcing the spectacle of power, the platform was decorated with bronze rams (*rostra*) ripped from vanquished enemy warships.

Once the "sponsors" had been appeased, Vespasian and Titus followed tradition by serving lunch to their troops as a sign of respect and as a morale booster. The entourage then moved into the suburbs of Rome to freshen up before the main event. According to Josephus:

Then did he retire to that gate which was called the Gate of the Pomp, because pompous shows do always go through that gate; there it was that they tasted some food, and when they had put on their triumphal garments, and had offered sacrifices to the gods that were placed at the gate, they sent the triumph forward, and marched through the theaters, that they might be more easily seen by the multitude. (JW7.129-131)

This enigmatic passage offers little to go on. Our only clues are a Gate of the Pomp where Roman triumphs started, which must lie in proximity to a cluster of theaters. Fortunately, the route of the Triumphal Way can be reconstructed from dozens of ancient references given by different historians: starting at the Circus Flaminius in the Field of Mars, it then passed through the Porticus of Octavia and between the temples of Apollo and Bellona before heading for the ancient Vicus

- 176 —

Jugarius by way of the Triumphal Gate (Gate of the Pomp) in the Republican-period city walls.

How many of these landmarks still stood to illuminate the public display of the mighty Temple treasure of Jerusalem? Would I be able to find the ruins of the Circus Flaminius, the monument that symbolized the satisfactory completion of Rome's subjugation of the Jews?

25

ALIENS IN ROME

The Circus Flaminius, laid out by Gaius Flaminius Nepos in 220 BC to the west of Rome, hugs the hips of the River Tiber close to Fabricius's Bridge. This Roman thoroughfare once led into the heart of the ancient city's foreigners' quarter, the Transtiberinum (Trastevere in modern Italian). The term *circus*, however, is really something of a misnomer. From time to time emperors such as Augustus held Egyptian crocodile fights here, and the Taurian Games were held here every five years.

But on an everyday basis the open communal space of the circus served as a lively venue for public meetings, markets, banking transactions, and funeral speeches. Here the state presented gifts and money to the army on special occasions—an emperor's birthday or after military victories—and enemy spoils of war went on public show. If the Forum was the administrative and political heart of the city, then the pulse of cosmopolitan Rome beat from the 850-foot-long by 325-foot-wide Circus Flaminius.

Making my way toward the main landmark of Rome's Region IX, I wondered what the mood around the circus was like that day in AD 71, as chained Jews were herded in preparation for humiliation. The area would have been abuzz for days with officials putting up decorations, painting over the odd bit of graffiti, and mounting security operations. The Circus Flaminius marked the edge of the city's great foreigners' quarter, which sprawled across both sides of the Tiber. Its residents included 40,000 Jews, who considered themselves both sons and daughters

— 178 —

of Israel, yet also Romans. On the day when the Temple treasure was paraded across the city, would their loyalties have been divided? Would the Jewish community living along the riverside ghetto have been in mourning behind closed shutters? Before closing in on the final resting place of God's gold in Rome, I decided to investigate the foreigners' quarter and try to find out just how far the local Jews' sympathies stretched.

Trastevere remains fiercely independent today and there is no better place to mull over these questions than from the far side of the river. I crossed the fast-flowing Tiber by the Pons Fabricius, the stone bridge thrown across the river in 62 BC by Lucius Fabricius, commissioner of roads, and passed over Tiber Island, a no-man's-land in the middle of the water once graced by a temple dedicated to the healing god Asclepius and by shrines to Jupiter Jurarius (guarantor of oaths), Gaia, and Tiberinus (god of the river). Although peaceful today, covered with lush vegetation and evergreens, this part of downtown Rome would have been a hive of activity and babbling tongues in the first century AD. Here foreigners begged for menial jobs down by the docks and heaved sacks of North African grain and amphorae filled with Spanish oils into the city center.

Today the Trastevere region is tranquil and bohemian, none too different from the laid-back atmosphere of Paris's Rive Gauche. Students picnicked on the sloping stone revetment under the setting sun and a gentle red glow cast across the water. As they chugged local red wine and picked at salami, they animatedly discussed Nietzsche, Prime Minister Berlusconi, and the latest crisis with the AS Roma football team.

Within the narrow streets of Trastevere, the city's insane traffic quietens. Extensive graffiti covers the walls declaring MORTE IL FASCIO (Death to the Fascists). The rickety stone houses have a medieval feel, while the piazzas emit a sense of great energy, warmth, and intellectual endeavor, as if this district has given birth to major works of philosophy, art, and literature over the centuries. Small stalls peddle local crafts of leather and glass, turning their backs on the trite tourist goods sold outside the Pantheon.

To be a foreigner trying to scrape a living in imperial Rome could have been daunting. The babble of Latin, the overpowering fascist ar-

- 179 -

chitecture, and the marble masterpieces adorning almost all street corners can only have increased the sense of inferiority. Even today, when I rode the elevator to my hotel room by the Terminali railway station, the conspicuously framed Codified Text on the Sojourn of Foreigners in Italy (June 1931) still reminded visitors of their legal obligations under Articles 142–144:

Foreigners must report within three days of their arrival in the state to the local police. . . . The police is entitled at any time to ask foreigners to exhibit their identity papers in their possession and to give account of themselves. . . . Wherever there is reason to doubt the identification of a foreigner the latter may be requested to undergo a personal examination . . . the Prefect may prohibit foreigners from residing in districts or localities of military importance for the defense of the State.

Xenophobia and class prejudice were without doubt rampant in ancient Rome, like any great cosmopolitan city past and present, but the extent to which it was institutionalized within society depends on which ancient voices you trust most. Certainly the Jewish community must have felt deeply vulnerable peering through closed shutters at their brethren being dragged in triumph through the streets in AD 71. But did such oppression of "others" really typify everyday life? Would Rome have considered its own city Jews to be part of the same problem they had overcome in Israel and thus decided that this was an opportune moment to liquidate local Judaism?

Certain lines of inquiry undeniably expose Rome's Jews as troublemakers who flaunted the law and needed suppressing from time to time. The earliest rumblings of disquiet date to 139 BC, when Gnaeus Cornelius Hispanus, the *praetor peregrinus* in charge of foreigners, expelled the Chaldeans and astrologers and "also compelled the Jews, who attempted to contaminate the morals of the Romans with the worship of Jupiter Sabazius, to go back to their own homes." Even though Valerius Maximus, author of the *Memorable Deeds and Sayings* in which this reference appears, undoubtedly got his religious wires crossed (Jupiter

— 180 —

Sabazius was Phrygian, not Semitic), this event probably reflects a more general clampdown on non-Roman religious activity. Valerius Maximus almost certainly also confuses Sabazius with observance of the Sabbath. Nevertheless, the cry of "foreigners go home" was just as familiar on the streets of the Eternal City as in the West today.

Several emperors seem to have had it in for the Jews and their ghetto of 40,000 people amid an overall urban population of some 1.2 million people (substantially larger than the modern community of 27,000 Jews). In AD 41, the mentally impaired Claudius forbade them the right of assembly, excluded them from the welfare state's free wheat dole, and eight years later "expelled from Rome the Jews who persisted in rioting at the instigation of Chrestus," according to Suetonius's biography of the emperor. The reason for this clampdown seems to have been a wave of missionary activity across the Mediterranean stirred up by the Jews of Alexandria, to whom Claudius penned a letter warning them not to "stir up a general plague throughout the world." Hadrian (AD 117–138) is acknowledged as one of the ablest and most enlightened of all Roman rulers, yet even he forbade circumcision and desecrated the site of the Temple in Jerusalem with a pagan sanctuary dedicated to Venus, the goddess of love.

Judaism crops up fairly regularly in literary circles of post-Augustan Rome, painting a picture distorted by misinformation and prejudice. The prevailing attitude was generally one of amused contempt at the exotic and seemingly absurd Jewish customs. A far harder line, however, was taken in a speech delivered by the great orator Cicero in 59 BC, in which he stated:

Even while Jerusalem was still standing and the Jews at peace with us, the demands of their religion were incompatible with the majesty of our Empire, the dignity of our name and the institutions of our ancestors; and now that the Jewish nation has shown by armed rebellion what are its feelings for our rule, they are even more so; how dear it was to the immortal gods has been shown by the fact that it has been conquered, farmed out to the tax-collectors and enslaved. (*Pro Flacco* 69)

The philosopher Seneca objected to the Jews' observance of the Sabbath because they lost one-seventh of their lives to idleness, while the satirist Persius scorned the awed prayer of silently moving lips on the "circumcised Sabbath." Jewish abstinence from pork—a staple foodstuff reared on government farms—also puzzled the Romans; the satirical writer Petronius explained this behavior as due to the Jews' veneration of the pig. Martial, the witty epigrammatist of the time of the emperor Domitian (AD 81–96), included in a catalog of the unpleasant smells of Rome the odorous breath of the fasting Jew and, among the unendurable noisemakers of the city, the Jewish mendicant "taught to beg by his mother."

Incredibly uninformed and inaccurate commentary about the history of the Jews and their customs was evidently institutionalized, a reality reinforced by perhaps Rome's greatest historian, Publius Cornelius Tacitus, who also misunderstood their origins. One of his legends portrayed the Jews as fugitives from the island of Crete, where the mountain of Ida and the neighboring tribe, the Idaei, came to be called Judaei "by a barbarous lengthening of the national name." Tacitus's take on Jewish origins, I suspect, should largely be ignored as little more than political propaganda geared toward discrediting the rich legacy of this people. The far younger history of mighty Rome, based largely on a dense forest of myth, was not to be eclipsed.

The hostile stories swirling around the origins of Rome's Jews would resonate down the centuries. From his great fascist residence at the Villa Torlonia in Rome, Benito Mussolini typically denounced the Jews as strangers lacking any ancestry in the Eternal City. Yet 30 feet below his own villa and rolling gardens stretched the grave-lined chambers of an ancient Jewish cemetery haunted by the bones of the very people whose forebears he denied.

In reality, much of the Jew-bating that oozed off the quills of Roman writers was wishful thinking, a desire to keep foreigners at bay. Actually, many of the Jews of Rome enjoyed a special relationship with the political heavyweights of the empire that relegated the "Jews as slaves"

image to the garbage can of history. They may have been sons and daughters of Israel, but they were nonetheless valued by the Eternal City.

With his "Magna Carta of the Jews," Julius Caesar (100–44 BC) bestowed special privileges that prevailed, on and off, for three centuries until the advent of Christianity. These decrees granted full freedom of worship and permission to raise money for communal purposes and to send the Temple tax to Jerusalem.

Caesar similarly permitted Rome's Jewish community to try its own cases under a Jewish tribunal instead of the regular Roman courts. Modern Israel's exemption of its most observant Jewish population from compulsory military service is also nothing new. Surprisingly, this policy dates back to the reign of Julius Caesar and was initiated as a result of the impossibility of enforcing a compromise between enrollment, keeping the Sabbath, and observing Jewish dietary laws. Little wonder Rome's Jews wept openly at Caesar's grave following his death at the hands of Brutus.

Religious toleration was especially relaxed during the reign of Augustus (27 BC–AD 14), when the greatest of emperors enhanced the Jews' privileges even further. In Jerusalem he donated costly gifts to the Temple and commanded that a burned offering be made there daily in perpetuity at his expense as a token of his homage to the supreme God of the Jews.

Beyond the personal grief and deep empathy that must have consumed the Jewish community of Rome in AD 71, the outbreak of the First Jewish Revolt in Israel and the destruction of the Temple in Jerusalem triggered no political repercussion among the Jewish residents of Rome itself. Even though Israel had been wiped off the map, Jews' privileges in Rome and throughout the rest of the empire remained unchanged. As far as we know, no race riots ensued. Vespasian's tolerance toward the local Jews underlines just how extreme was the annihilation of Israel and burning of Jerusalem in September AD 70.

Imperial politics were complicated two thousand years ago and, in reality, Rome needed the Jews. The historical sources leave the im-

— 183 —

pression that, as a collective, the Jews of Rome were a powerful group whom emperors, ready to commit mass genocide elsewhere, would actively court. In 59 BC, the Roman aristocrat Lucius Valerius Flaccus was charged with extortion and misappropriation of the "Jewish gold" (the Temple tax) collected in Asia Minor and destined for Jerusalem. During his trial and in reference to the Jewish community Cicero confirmed, "You know how large a mob they are, how unanimously they stick together, how influential they are in politics" (*Pro Flacco* 66). The Jewish "mob" permeated society.

Between the first and fifth centuries AD a flourishing middle- and upper-class Jewish community owned as many as thirteen synagogues, from where at times it pursued an aggressive policy of securing converts, possibly including Nero's second wife, Poppaea, as well as the distinguished writer Caecilius of Calacte, one of the top rhetors and literary critics of the Augustan age. Hard work and diligence also created deep-rooted respect among Roman society, which no doubt was the real reason for satirists' wrath.

The basic tenets of Judaism even touched everyday life, with the Sabbath judged to be a sacred day, unfavorable for starting a journey but an opportune time to court a girl, according to the poet Ovid. This is the real background behind the spiteful sneers of the likes of Seneca, who complained that Judaism had become so widespread that "the practices of this damnable race have already prevailed in every land. The vanquished have given laws to the victors." The empire's divided attitude toward the death of Israel, the survival of God's gold, and tolerance of Rome's Jewish community is a humbling tale that reflects the complexity and flexibility of Roman politics. 26

OF CIRCUSES AND ARTICHOKES

Back on the tree-lined Lungotevere Pierleoni that snakes around the River Tiber, I made my way to the exact spot where the triumph bestowed on the emperor Vespasian and his son Titus started out—the Circus Flaminius. But all I could see were elegant eighteenth-century apartment blocks, paint-chipped palaces, coffee stops, and urchins kicking a half-deflated ball across the narrow lanes. The site of the Circus, from where the triumph was sent on its way into the heart of the city to the acclamation of thousands of people, is today completely replaced by later architecture.

The Circus may have had a built-up core, but it was predominantly an open space ringed by funerary monuments and temples. Although a considerable amount of the arena still stood in the twelfth century, by the sixteenth century the Mattei Palace and urban sprawl had consumed it. Only the memory of the rope makers who plied their trade from dingy medieval arcades on the north side of the Circus's shops lives on today in the names of the Via dei Funari and the sixteenth-century Church of Santa Caterina dei Funari.

After the physical exertion of tramping around Trastevere, one of the most remarkable revelations in the quest for the lost Temple treasure of Jerusalem became apparent. Although I was aware that Rome's present-day Great Synagogue stood, out of respect for the city's Jewish ancestry, on the banks of the Tiber within the ancient foreigners' quarter,

— 185 —

as I looked around and checked my maps, I realized that it was built on the exact spot of the Circus Flaminius.

This surprising revelation was full of profound implications and symbolic overtones. The four walls of the synagogue, the former Circus, marked the scene of Judaism's greatest humiliation—the beginning of the end—the start of the Triumph that culminated in the "imprisonment" of the Temple treasure from Jerusalem and the decapitation of the leader of the Jewish revolt.

The modern "temple" is a 150-foot-high monument spanning an area of 36,305 square feet and was built between 1901 and 1904 in an eclectic style of Roman, Greek, and Assyrian-Babylonian with the intention of sympathetically blending in with the existing city architecture—a modern variety of sensitive acculturation.

In a twist of fate unappreciated by the Jews of present-day Rome whom I met, modern Judaism has quite literally supplanted the memory of Rome's subjugation two thousand years ago by refounding itself in the Circus Flaminius. The religious ritual of the Jewish community has rooted itself in the profane soil and has purified the past. Alongside the archaeological strata dating back to the time of the arena's foundation in 220 BC is a second superimposed level, invisible to the eye and only felt: the emotional. Perhaps more than anywhere else on earth, Rome's Great Synagogue stands as a symbol of endurance against the odds, against warfare and genocide. Not in their worst nightmares could Vespasian and Titus have imagined that their conquest of Israel would have unfolded with such historical circularity, with the vanquished becoming the conquerors and a two-thousand-year-old wrong being righted.

When this realization dawned, a surge of invigorating thoughts and questions swept through my mind. During my search for the Temple treasure I had the good fortune to visit Rome on several occasions, always coming back to the Great Synagogue in search of answers. This spot is endlessly intriguing. On a former visit in May 2004, lost in reflection, my face must have mirrored my turbulent feelings because it was at this time that I was almost arrested.

At the front of the synagogue, this part of the Field of Mars was un-

der siege by hundreds of people, just as it would have been in AD 71. A ferocious security operation was under way. Scores of Jews in their Sunday best patiently queued to pass through the first of two security cordons, while television cameras surveyed the scene. What was going on? Rome's carabinieri, out in droves, was unimpressed by my impassioned request for entry and swatted me away like the unwanted foreigner I was. Ducking alongside streets I decided upon an oblique attack from the flanks, assuming the lost tourist persona. Unfortunately, the Israeli security monitoring entry to the synagogue was quick to pounce, charmlessly repelling my advances. My photography of the synagogue was apparently a security risk; I was invited to either have my camera confiscated and be introduced to the carabinieri or to scram. Finally, I played the Jewish card, explaining in Hebrew my lifelong desire to explore Rome's Jewish ghetto. The guards relented and I surged through the crowd-a popped cork-into the narrow lanes of the medieval ghetto. Though this is no longer really a ghetto, because the city's 27,000 Roman Jews-among a total population of 3.5 million Romans-are happily integrated into the fabric of society, the overwhelming tapestry of history and pain lives on in this special place.

My research in London had been intensive and systematic, but nothing had hinted that so much of the atmosphere and architecture extant on the day of the triumph could be resurrected. This was no mere aura or whisper of memory: I had stumbled across a twothousand-year-old bridge of continuity linking the word of Josephus with the standing archaeology.

As I tried to make my way once more toward the Great Synagogue, the waiters from La Taverna del Ghetto had explained that my trip had coincided with the centenary celebrations of this House of God's foundation. Hence the security and television coverage to welcome Israel's religious and political leaders, two archbishops representing the pope, and Prime Minister Berlusconi.

My ham-fisted attempts to avoid officialdom were doomed to fail. But edging my way east down the Via del Portico D'Ottavia, past the

— 187 —

phalanx of machine gun-toting carabinieri, I was confronted by the last thing I had expected to see: part of the first monumental Roman arched gateway through which the imperial triumphs passed, the Porticus of Octavia itself, still standing. Originally this covered *porticus* had been a dominant landmark, elegantly marching 165 feet eastward and 460 feet north toward Balbus's Roman theater. The full range and visual impact, of course, is lost today because only the gateway survives, having been incorporated in the eighth century AD into the atrium of a church, today surviving as the Church of Sant'Angelo in Pescheria ("in the fish market").

The double-sided columnar porch is monumental, impressively crafted of Corinthian columns of Italian marble from Luna and Greek Pentelic marble architraves offset against thousands of red clay bricks. When you walk between the double gateway, sculpted dolphins and tridents overhead remind the viewer of Rome's naval prowess. Though impressive enough today, the gateway was an artistic wonder in Roman times. After the Porticus of Octavia (sister of the emperor Augustus) had replaced that of Metellus around 27–25 BC, Augustus tacked on schools, meeting rooms, and a library housing a stunning display of Greek statuary and paintings. Pride of place was given to a bronze composition by Lysippos of Alexander the Great on horseback alongside his twenty-five cavalry companions who died in the battle of the Granicus in 334 BC. Not surprisingly, this statuary was not an original Roman commission, but part of the spoils of war seized by Metellus from the Sanctuary of Dion in northern Greece.

Absorbed by the moment and the fascination of coming across such an important part of the triumphal experience, I jumped abruptly when an austere voice behind me interrupted my reflection as I scribbled.

"Journalists not possible. What do you write?" proclaimed an armed policeman in shining uniform.

After explaining that I was a tourist keeping a diary for my own amusement, two carabinieri frog-marched me beyond the security cordon. Rather than incensed, however, I was entirely sympathetic to the police's harsh tactics. After all, the safety of Prime Minister Berlusconi

and the pope's personal representatives, Cardinal Camillo Ruini (papal vicar of Rome) and Cardinal Walter Kasper (head of the Vatican's Commission for Religious Relations), depended on the keen eye of the security forces. Even on such a relatively low-key political occasion, for reaching out to Rome's Jewish community to foster interfaith harmony, some Catholics would denounce John Paul II as the "antipope."

Outside the security cordon a middle-aged woman dressed in ghetto black scowled down at me with a mix of pity and pedagogic impatience. She stood on the top step of the Jewish bookshop Menorah: Libreria Ebraica. Rather than engage in conversation, and keen to conceal my embarrassment at being ejected, I pointed to a poster showing a photo of the menorah from the Temple in Jerusalem being carried along the streets of Rome in AD 71, as depicted on the Arch of Titus on the high point of the Forum.

"Any idea where I can find that?" I asked, playing the lighthearted joker.

"Everyone knows where it is," sneered the shopkeeper. "All the Jewish community knows that the menorah fell into the Tiber and was recovered by the Christians who took it to the Vatican, where it remains to this day."

THE TRIUMPHAL WAY

27

Once I had tracked down the Circus Flaminius and been stunned by its geographical symbolism, and then stumbled across the Porticus of Octavia, the rest of the triumphal route fell into place neatly. Just as Josephus asserted, the procession did indeed pass "through the theaters, that they might be more easily seen by the multitude," namely the Circus Flaminius followed by the Theater of Marcellus and, lastly, the theatrical wonder of the age, the Circus Maximus.

Marcellus's theater enjoyed continuous entertainment since the reign of Julius Caesar. Named after Marcus Claudius Marcellus by Augustus, in honor of his deceased nephew, this stadium was the most important of Rome's three contemporary entertainment facilities and, with its two superimposed arcades of travertine stone fronted by semicircular columns, this structure became the model for contemporary theaters throughout the western empire, including the Colosseum. A capacity crowd of 20,500 would have watched the passage of the Temple treasures of Jerusalem in the Triumph of AD 71 between the theater and the temples of Apollo and Bellona.

Here the gods of war within the Field of Mars were especially vigilant. The crowded presence of so many powerful monuments dedicated to warfare would have magnified the sense of might expressed by thousands of soldiers parading in polished breastplates, jangling swords, and shields recalling the sound of steel on a battlefield. First, the triumphal soldiers would have acknowledged the Temple of Bellona, a warrior

- 190 -

mother-goddess who personified the battle frenzy that made victory in Israel possible.

Alongside, three white marble Corinthian columns from the Temple of Apollo Medicus Sosianus (the Healer) still stand today, their capitals supporting a frieze of laurel branches strung between bulls' skulls and candelabra with tripod bases. Appropriately, the temple once displayed sculpted battle scenes and even a triumphal procession, in which captives were tied back to back.

In passing the Temple of Apollo Medicus Sosianus, Rome deliberately began the process of forgiving itself the killing fields of Palestine so that man and the military machine might move away from the stench of war and the psychological scars of the battlefield. At this point a huge bonfire would have been lit and onto it thrown the spolia opima, enemy armor captured by Rome. These spoils could not be kept as souvenirs of victory because they were impregnated with negative enemy power, a danger if brought within the city walls.

Now the triumph escaped the suburbs to be buffeted by the unwholesome smell of the Forum Holitorium, the vegetable market. Where the city usually bought its cabbages and onions, Vespasian and Titus once again made respectful offerings at the triple temple complex dedicated to Spes, Janus, and Juno Sospita to absorb these gods' personal attributes—hope, beginnings, and savior. With so much blood on their hands they needed the blessing of as many willing gods as possible. The monumental foundations and facades of these buildings still grace the hybrid architecture of the medieval Church of San Nicola in Carcere. The church has literally boxed over the temples.

I f we could have frozen the action at this precise spot on that fateful day of AD 71, what would the movers and shakers of Rome—from the city poor to the senatorial elite—have been thinking and feeling? Here the triumphal parade escaped the humidity of the bottlenecked temples and theaters of the Field of Mars and prepared to surmount the dip in the road at the modern junction of the Via del Teatro Marcello and Vicus Jugarius that hugs the edge of the Capitoline Hill. This place

- 191 -

was immensely important in the ritual of the day because here the arcades of the Triumphal Way created a physical barrier between the Field of Mars and the Forum, between war and civilization.

To the modern eye the jubilant atmosphere would have resembled the homecoming parade of a sports team that had just won the Olympics, adrenaline inflated and on top of the world. But the Roman triumph was far more than just adulation for the victors and a holiday celebration for the people. The dozens of floats theatrically reenacting battles from the victory and the products of strange cultures in far-flung lands, mixed with the sounds of trumpet and cymbal and the sweet smell of eastern spices released from silver censers, lent a flavor of the circus and carnival to the proceedings. In the triumphal pageant, Romans also learned about the prowess of their armies and generals, foreign people, and the art, architecture, flora, and fauna of the newly conquered lands. The event was a mix of entertainment and education, the *National Geographic* played out in street theater.

The excitement of the spectacle jumps off the pages of Josephus who, in his description of Rome in AD 71, gives the most remarkable and detailed account of a Roman triumph to survive from antiquity:

There was here to be seen a mighty quantity of silver and gold and ivory, contrived into all sorts of things, and did not appear as carried along in pompous show only, but, as a man may say, running along like a river. . . .

But what afforded the greatest surprise of all was the structure of the pageants that were borne along; for indeed he that met them could not but be afraid that the bearers would not be able firmly enough to support them, such was their magnitude; for many of them were so made, that they were on three or even four stories, one above another . . . for there was to be seen a happy country laid waste, and entire squadrons of enemies slain; while some of them ran away, and some were carried into captivity; with walls of great altitude and magnitude overthrown, and ruined by machines; with the strongest fortifications taken, and the walls of most populous cities upon the tops of hills seized on, and an army pouring itself within the walls; as also every place

- 192 —

full of slaughter, and supplications of the enemies, when they were no longer able to lift up their hands in way of opposition.

Fire also sent upon temples was here represented, and houses overthrown and falling upon their owners: rivers also, after they came out of a large and melancholy desert, ran down, not into a land cultivated, nor as drink for men, or for cattle, but through a land still on fire upon every side; for the Jews related that such a thing they had undergone during this war. Now the workmanship of these representations was so magnificent and lively in the construction of the things that it exhibited what had been done to such as did not see it, as if they had been there really present. On the top of every one of these pageants was placed the commander of the city that was taken, and the manner wherein he was taken. (JW7.132-147)

Josephus describes a lavish show that was a combination of entertainment, imperial self-glorification, and a moving image to justify the investment of millions of sesterces spent subjugating troublemakers in a far-off province. To the citizens of Rome the awesome spectacle of the triumph would have had the sensory impact of the publicity staged by the armed forces of America and the United Kingdom during the First Gulf War. Like the scenes of precision smart bombing in Iraq, beamed through televisions into millions of Western living rooms, the triumph acted as political propaganda to explain and justify the cause.

But the triumph was much more than a political statement, it was also a crucial magico-religious ceremony that goes beyond the rationale of the modern mind. Pomp, spectacle, and largesse were all well and good, but in the final analysis the ceremony of the triumph was an incredibly important rite of passage for Rome, thickly steeped in symbolism.

The ritual of the procession took a standardized route following a meticulously preplanned format. First of all came white oxen destined for sacrifice to Jupiter (these beasts had the same connotations of purity and liberation that the white dove plays today in Western consciousness). Next followed lictors in red war dress carrying fasces, the double-

- 193 --

headed axes and traditional emblems of power in pre-Roman times from which we have inherited the term *fascist*. Magistrates and the Senate then proceeded in front of the emperor, whose two-wheeled chariot was drawn by four white horses, perhaps symbolizing the four points of the compass controlled by the empire. Chained prisoners walked with heads bowed directly in front of the chariot. Finally, soldiers wearing laurel wreaths and singing coarse songs brought up the rear.

These tunes were odd. Rather than celebrate the good deeds of their commanders, they actually derided them in the satirical style of fraternity songs. Moreover, the motley crowd supposedly out in celebration similarly hurled insults at the passing emperor. How can the triumph's contradictory combination of veneration and derision be explained?

Because the emperor was elevated to the status of a god for the day, Roman society had to set in motion a complicated web of apotropaic measures to protect itself from the potential fury of the divine pantheon. For on the very day of a Roman triumph, the victorious commander in chief was given the highest honor bestowed on a mortal by being elevated to the status of the supreme god, Jupiter. The actual term *triumph* was originally not used as a noun in the context of the Roman ritual, but as an exclamation. As Vespasian and Titus drove their chariots along the streets of Rome the call of *triumpe* was not a cheer of victory but an invocation of the god within the mortal to "reveal yourself."

Superstition was rampant in Roman society, which, at the drop of a hat, would consult the gods and animal entrails for advice on the most beneficial course of action, from the mundane to the monumental. In conferring the title of a god on a triumphant commander, Rome was aware that it ran the serious risk of unlocking the anger of the pantheon. Hence, the lewd marching songs and public insults. But even this was not enough protection for the commander in chief, so several further layers of religious armor were created to protect the *triumphator* from the envy of the gods.

Chests swelling amid the adoration of the people, Vespasian and Titus would have been clothed in purple tunics and togas—family heirlooms reserved for state occasions. In their right hands each carried a

laurel branch that imparted the power of plant life and regeneration (for the same reason that flower petals are strewn in front of a newlywed couple today). Their left hands gripped ivory scepters surmounted by an eagle, the ultimate symbol of Roman domination. Around their necks were placed a gold bulla to deflect the evil eye. Both emperor and son would also have been painted red for purposes that are not entirely clear, but possibly to imitate blood, perhaps to incite fear (in the manner of war paint) or to imitate the brilliance of the sun. Certainly statues of Jupiter, the ultimate Roman god, were painted red in antiquity, so this symbolic act mirrored the physiology of the supreme divinity.

Beneath the triumphant chariot—also decorated with laurel branches—hung a massive erect bronze phallus fastened with bells, whose purpose was again to instill strength to the riders and to counteract any ill feeling of the gods. The giant phallus served as a kind of imperial lightning conductor against unwanted thunderbolts from the sky. The final ingredient of antigod plating was the heavy gold oak leaf crown (the *corona Etrusca*) that a state slave suspended above the head of the triumphator. Both Vespasian and Titus may also have worn iron leg chains as expressions of humility, as their personal slaves also on the chariots whispered into the victors' ears, "Look behind you and remember that you are a man." In other words, a god for a day but, nevertheless, nothing more than a mere mortal elevated thus by the people of Rome. The gods were watching eagle-eyed and ready to pounce.

The spot where we have frozen the triumph (at the junction between the Campus Martius and the Capitoline Hill, where the Via del Teatro di Marcello and the Vicus Jugarius meet today) was by far the most sensitive point of the procession. Not because of what Vespasian and Titus or the artistic directors of the pageant were doing, but because of the sacred landscape. For here most probably stood the mighty Porta Triumphalis, the triumphal Gate that was only ever opened on the occasion of the triumph.

The gate was reached by a covered arcade, some of whose columns and arches can still be traced at the foot of the leafy Capitoline Hill, whose slopes would have offered a breathtaking view of the parade. The

- 195 —

porta, however, was strangely not a true gate at all, but actually a freestanding structure that was not incorporated into a city wall. So why do ancient writers emphasize the importance of being able both to open and to close the gate during the ceremony when, on any other day, you could simply walk around it to pass between city and riverside?

The brilliant mind of Sir James George Frazer pondered this precise enigma in his epic book *The Golden Bough* and concluded that rites of passage such as in the Roman triumph were intended to free people from certain taints or hostile spirits. For Frazer, the Porta Triumphalis was almost certainly a barrier meant to protect Rome against the pursuit of the spirits of the slain. By passing through the arch, and immediately locking its doors, any taboo could be lifted. The Triumphal Gate was thus a physical barrier between Rome and the angry ghosts of the Jews of Israel. Purification was extremely important for Rome to minimize war-born posttraumatic stress disorder. As the Roman writer Festus clarified, "Laurel-wreathed soldiers followed the triumphal chariot, in order to enter the city as if purged of blood-guilt."

Whether or not the victor swiftly left town through another gate after the triumph was immaterial because symbolism equated to reality. The Triumphal Gate, an isolated structure set outside the city walls, may sound like nothing less than pious fraud to us, but its powers were very real to Rome. Entry and closure until the celebration of the next triumph guaranteed the ongoing blessing of good fortune upon the city, by literally locking inside the bearer's newly acquired power. It was with the intent of not wasting a single drop of this energy that generals were compelled by the Senate to reside outside the sacred city boundary (typically at the Temple of Bellona or the Temple of Apollo in the Field of Mars) until the triumph started. 28

A DAY AT THE CIRCUS MAXIMUS

On the days when I pounded the route the Temple treasure of Jerusalem took during the triumph of AD 71, the passage beyond the Vicus Jugarius always left me uncomfortably numb. Immediately after exiting a landscape dedicated to blood and war, the Field of Mars, Rome forgave itself the estimated 1.1 million people Josephus alleges were killed in Judea. In an instant the solemn air of the ceremonial fell away, forgotten, and the carnival kicked in.

The road leading up the Vicus Jugarius to the southwestern entrance of the Forum and the Precinct of the Harmonious Gods is a pleasant landscape where birds sing from coniferous trees, despite the storm rumbling overhead that matched my mood. Taking a rest on the steps of the Church of Santa Maria della Consolazione, built between 1583 and 1606 and polished to a shine by a million dedicated feet, vivid snapshots of the historical triumph flashed across my mind. I found that I could not forgive Rome and share her ferocious celebrations. Consolazione? The irony fell as thick as the downpour lashing the afternoon sky. What consolation would the Jews of Israel have felt, dragged in front of the gleaming chariot of the emperor Vespasian? The triumphal Gate was their personal Bridge of Sighs. Death or enslavement, at best, would be their prize.

Elegantly dressed Italians sauntered to church through the Piazza della Consolazione, located toward one end of the route of the ancient Triumphal Way, and a cacophony of joyous bells competed with the deep drum of thunder over the Palatine. Rome's bedrock peered out from un-

- 197 —

developed parts of Capitoline Hill, gasping for air, and I gazed at where it met the Forum's ponderous black cobbled orderly streets. Here the law of nature ended and the cruel civilization of Roman rule began.

Illuminated by lightning, I took in the view of the short leg leading from the Triumphal Gate to the Forum and immediately doubted whether Vespasian would have chosen this corner-cutting processional option. Josephus emphatically described the route as marching through the theaters in the plural, and certainly meant the Circus Flaminius and the Theater of Marcellus. In view of the modest length and scarcity of monuments leading up the Vicus Jugarius, I was now convinced Josephus also alluded to the greatest entertainment facility of pre-Flavian Rome—the Circus Maximus. Why was I so confident?

First of all, this makes absolute sense geographically. Rather than winding up narrow streets toward the southwestern flank of the Forum, by continuing in a straight line parallel to the River Tiber, the triumph would have escaped the narrow roads to emerge into the wide Forum Boarium, Rome's cattle market. The triumph was thus structured to be a process of revelation, initially glimpsed in short sections by the dense crowd but, after the Field of Mars, appreciated in its full glory. Along the way, various Roman temples offered a perfectly theatrical backdrop before the most spectacular act: procession down the Circus Maximus itself, opposite the Palatine Hill and the imperial palace. By taking this route the triumph would have pursued Rome's logical topography and completed a perfect circular itinerary without ever cutting back on itself or compromising the maximum theatrical impact.

A further signpost of certainty is a second Arch of Titus that was built within the Circus Maximus itself in AD 80–81. Today it is completely destroyed, so the mouthwatering question of whether it, too, depicted scenes of the triumphal subjugation of the Jews—a very fair bet—remains a tantalizing enigma. As well as its depiction on the Severan-period marble map of Rome, a record of the bold wording written large on the Circus arch's facade inscription was preserved in the medieval period:

The Senate and People of Rome . . . to the emperor Titus Caesar, son of Vespasian . . . tribunician power for the tenth time (AD

198 -

81), their *princeps* . . . because following his father's advice and policy, and under his auspices, he conquered the Jewish people and captured the city of Jerusalem, which by all kings, generals, or peoples before his time had been assailed in vain or left unassailed.

Even though Titus's claim was yet again a flagrant piece of Flavian spin—both Pompey the Great in 63 BC and Sosius, Roman governor of Syria, in 37 BC had subdued parts of Palestine—the emperor clearly plastered this piece of personal propaganda on the Circus arch as a memorial to the precise route of the triumph of AD 71.

Despite the storm, I was now committed to getting a soaking in exchange for some historical clarity. Springing down the steps of the Piazza della Consolazione, I moved fast through the tempest, cutting left down the Via Luigi Petroselli, and swiftly passed the Comune di Roma—City Hall—a great lump of fascist architecture. Posters demanded "Non Stop Per Cuba! Bush Vergogna" (Shame on George Bush for Sanctions Against Cuba), and two-tone faces of a black-andwhite woman on a poster sponsored by the Ministry of Equal Opportunities invited victims of racial discrimination to call a toll-free telephone number. Beneath my feet, the city's manholes, commissioned by Benito Mussolini, were emblazoned with the letters SPQR. The abbreviation once proudly carried into war on top of legionary standards means *Senatus Populusque Romanus* (the Senate and People of Rome), and it would have been stamped on every piece of military kit amid the triumph of AD 71.

In the later part of the first century AD, this part of town, the Ripa district, was thick with wharves and warehouses. Here the triumph flirted with the rough-and-ready spectra of society, marching past the Temple of Portunus dedicated to the god of harbors and the circular Temple of Vesta of the sacred fire, who celebrated victory and successful commercial enterprise. Before heading uphill through the Via dei Cerchi, a giant eagle guarding the entrance to the old pasta factory on the Piazza Bocca della Verità (Square of the Mouth of Truth) watched my progress with beady eyes.

Today the Circus Maximus just looks like a pleasant park. Good folk

- 199 -

lose themselves in books under shaded trees and dogs chase sticks across the long shadows cast by the grass incline where the Circus seating was once installed. Joggers pound the ground where immaculately polished horse chariots once raced. Oblivious, tramps sleep off the night's hangover on beds of newspapers. The scene today is nothing like the backdrop to AD 71, when the Temple treasure entered the lion's den of 250,000 deafening cheers reverberating across the stands.

The Circus Maximus is by far the oldest and largest of ancient Rome's entertainment facilities and was founded by the Etruscan king Tarquin the Elder (616–578 BC) in the Vallis Murcia for horse racing during the Consualia festivities held in honor of Consus, the god of counsel and protector of harvests, a very serious issue in the pre-pesticide age.

The Circus through which the Temple spoils of Jerusalem paraded in AD 71 owed its anatomy largely to Julius Caesar, the Jews' champion, who cemented its canonical shape with two long sides terminating at a semicircular end for his own triumph of 46 BC. Caesar's three-story Circus measured 2,037 feet long and had stands rising 92 feet above the racetrack. Colonnades swept along its edges; boisterous shops abutted the outside of the stands.

Entering the Circus from the northwest, the treasures of Jerusalem and captive Jews were frog-marched through the Circus, lambs to the slaughter. The sheer size of the Circus and the cacophony of the raucous mob would have been terrifying. Never before could these provincials have seen such artistic wonders: along the central *spina* barrier a statue of Magna Mater (the ultimate mother goddess) mounted on a rampant lion alongside a palm tree; Victoria with her chest puffed out; sculpted dolphins playing amid flowing water. High on their palatial crow's nest on the Palatine Hill, an audience podium jutting out over the center of the Circus, the imperial family would have cheered on Vespasian and Titus.

The Circus was all about promoting an inclusive feel-good factor for all of Rome's hierarchy of citizens from the imperial family to the plebs rubbing shoulders in the unsegregated arena. The unusual freedom of seating earned the place a reputation as a great pickup joint.

- 200 -

And if you weren't lucky, you could always buy sex. As Ammianus Marcellinus would complain in his history of AD 353–378, the plebs

devote their whole life to drink, gambling, brothels, shows, and pleasure in general. Their temple, dwelling, meeting place, in fact the center of all their hopes and desires, is the Circus Maximus. [They swear] that the country will go to the dogs if in some coming race the driver they fancy fails to take a lead from the start, or makes too wide a turn round the post with his unlucky team. (*Res Gestae* 28.4.29–30)

The Circus Maximus was the people's palace, a surreal dreamland where they could watch a live form of reality television, a theater of dreams with a crowd capacity over three times greater than the New York Giants stadium. The social status of the drivers gave the Circus mass appeal. The charioteers were *infamis* of low standing, slaves or freedmen who were wholly dispensable. Yet fortunes could be won on the racetrack: the second-century AD Portugese immigrant Gaius Appuleius Diocles earned over 25 million sesterces in 4,257 races (about \$23 million) over a twenty-four-year career. The likes of Diocles gave the masses dreams of wealth and celebrity, an escape from the gutter.

To this backdrop of thousands of faces, the stench of horse dung, and prostitutes making hay while the sun shone, I would like to think that the noise dwindled into amazed murmurs with the passing of the Temple treasure. Of all the great theater enjoyed that day, this was the crowning moment of ultimate acclaim for the emperor Vespasian and Titus. Again we are indebted to the meticulous mind of Josephus for capturing this moment in time:

The spoils in general were borne in promiscuous heaps; but conspicuous above all stood out those captured in the temple at Jerusalem. These consisted of a golden table, many talents in weight, and a lampstand, likewise made of gold, but constructed on a different pattern from those which we use in ordinary life. Affixed to a pedestal was a central shaft, from which there extended slender branches, arranged trident-fashion, a wrought lamp being attached

- 201 ----

to the extremity of each branch; of these there were seven, indicating the honor paid to that number among the Jews.

After these, and last of all the spoils, was carried a copy of the Jewish Law. Then followed a large party carrying images of victory, all made of ivory and gold. Behind them drove Vespasian, followed by Titus; while Domitian rode beside them, in magnificent apparel and mounted on a steed that was itself a sight. (JW7.148-152)

After soaking up the adulation of the crowd in the Circus Maximus, the triumph turned left onto the modern Via di San Gregorio and passed the pink rosebushes flourishing today where Romulus and Remus were reared, according to Roman tradition. Opposite the Palatine Hill, the Church of San Gregorio Magno, named after Pope Gregory the Great (AD 590–604), stands on the spot where classical antiquity ended and the medieval age was born. The aqueduct supplying the imperial palace on the Palatine is today severed by a fast-flowing thoroughfare speeding up to the Colosseum.

In AD 71, the Colosseum, however, was still in the planning process, even though its funding—looted Jewish gold—was now secure. Once proclaimed emperor, Vespasian would have spared no time recutting the 115-foot-high gilded bronze Colossus of Nero commissioned from Zenodorus. Where the emperor playing god once looked down his monstrously huge nose at the citizens of Rome to the right of the Sacred Way, Vespasian refashioned the statue into the sun god Helios. Under the Flavians the sun would shine on Rome every day. The memory of Nero, the perpetual showman who ransacked the provinces of its finest art for personal pleasure and left the treasury deeply in debt, was officially damned.

For scale of town planning and monumental architecture, the Forum is breathtaking. Though amazed by the panoramic grandeur unfolding around me, and by my success in unraveling the route of the triumph of AD 71, after entering the heart of empire my heart wasn't in the chase anymore. The sixth sense of death and jostling crowds baying for Jewish blood were all too savage.

Soaked to its core by the storm overhead, the Forum was deserted. At the summit of the Sacred Way the triumph reached the high point

202 —

of the Forum and gazed down on the most powerful and elaborate urban artery of the civilized world. On this precise plateau in AD 80–81, Titus would immortalize the triumph with the best known of his three arches. Artistic reliefs would replicate the all-conquering royal commander, and later emperor, parading by chariot across this very spot, and capture the Temple treasure being carted in triumph on wooden stretchers through this monumental arch—the golden Table, the pair of silver trumpets, and the seven-branched candelabrum.

Under heavy skies I continued the pilgrimage down the Sacred Way. Its original black-cobbled path was now flooded, and a stream of water ran through my Timberlands. So much for Rome's legendary hydrology. The narrow lane of the Via Sacra would have strung out the triumph at this point, slowing its progress, which no doubt suited the patient and packed Forum. The Porticus (covered walkway) of Gaius and Lucius (the grandsons of the emperor Augustus) would have welcomed the head of the snake. The fear of the Jewish captives would have mounted as they gawked at statues of barbarians crafted from Numidian yellow marble and Phrygian purple foreshadowing the Jews' pending life of slavery. The Land of Israel can never have felt farther away.

I passed the Senate and Orators' Platform, the *rostra*, where Vespasian and Titus received the blessing of Rome that morning. By now emperor and son would have symbolically nailed the most important spolia opima to an oak tree within the city gates. Although most military spoils had to be burned outside the city precinct in the Field of Mars, the personal weapons of the enemy general were believed to still retain magical powers. An impressive public trophy and a symbol of conquest, the spoils also emitted positive energy for the possessor, in this case the city of Rome.

A hushed silence now fell over the Forum as the final bloody ritual approached, again reported in detail by our chief witness, Josephus:

Now the last part of this pompous show was at the Temple of Jupiter Capitolinus, whither when they were come, they stood still; for it was the Romans' ancient custom to stay, till somebody brought the news that the general of the enemy was slain. This general was Simon, the son of Gioras, who had then been

- 203 —

led in this triumph among the captives; a rope had also been put upon his head, and he had been drawn into a proper place on the forum, and had within been tormented by those that drew him along, and the law of the Romans required that malefactors condemned to die should be slain there.

Accordingly, when it was related that there was an end to him, and all the people had sent up a shout for joy, they then began to offer those sacrifices which they had consecrated, in the prayers used in such solemnities; which when they had finished, they went away to the palace. And for some of these spectators the emperor entertained them at their own feast; and for all the rest there were noble preparations made for their feasting at home; for this was a festival day to the city of Rome, as celebrated for the victory obtained by their army over their enemies, for the end that was now put to their civil miseries, and for the commencement of their hopes of future prosperity and happiness. (*JW*7.153–157)

For the sake of completion I did also track down the Temple of Jupiter Optimus Maximus Capitolinus up the Clivus Capitolinus, or rather its foundations hidden beneath scaffolding used to restore the exterior of the Palazzo dei Conservatori. There, Vespasian and Titus awaited the screams of delight announcing the death of Simon the Jew.

Nearby, the Mamertine Prison—that "proper place" where Simon was killed—still exists in the peaceful Church of San Giuseppe dei Falegnami; pigeons perched on the top steps washed themselves in puddles of rainwater. The prison is a foul, damp place into which spring water continuously dripped in antiquity. In 40 BC, the Roman writer Sallust described this cell as "a place called the Tullianum . . . about twelve feet deep, closed all round by strong walls and a stone vault. Its aspect is repugnant and fearsome from its neglect, darkness, and stench." Go there if you must.

Emotionally exhausted, I made the personal decision not to enter Rome's subterranean death hole; instead I wondered what the leader of the Jews' last earthly sight might have been. Desperately looking over his shoulder as he was pushed into this evil hole, Simon ben Giora's gaze would have wandered across the Precinct of the Harmonious Gods and the Umbilicus Urbis, the Navel of the World and gateway to hell.

— 204 —

29

A TEMPLE FOR PEACE

With the head of the Jewish uprising decapitated, and the triumph confined to collective memory as one of Rome's most glorious days, Vespasian planned a more enduring legacy of his Judean conquest.

What the emperor had in mind was something not just functional, but a visually stunning memorial that would endure for generations to come as a physical symbol of Rome's global power—military, political, economic, and cultural. The Temple of Peace, Templum Pacis, was designed to be that symbol, an eternal reminder of the death and destruction wreaked by the Jewish Revolt, and also, crucially, a monument to Vespasian's brilliance in forging universal peace between Rome and the peoples pulled within its borders. Thus Josephus informs us:

The triumphal ceremonies being concluded and the empire of the Romans established on the firmest foundation, Vespasian decided to erect a temple of Peace. This was very speedily completed and in a style surpassing all human conception. For, besides having prodigious resources of wealth on which to draw he also embellished it with ancient masterpieces of painting and sculpture; indeed, into that shrine were accumulated and stored all objects for the sight of which men had once wandered over the whole world, eager to see them individually while they lay in various countries. Here, too, he laid up the vessels of gold from the temple of the Jews, on which he prided himself. (*JW* 7.158–161)

- 205 -

So the Temple treasure of Jerusalem, symbol of the spiritual heart of Judaism seized in the most bloody of circumstances, ended up "imprisoned" in yet another temple across the seas. The tranquil-sounding name of the new place of rest should not deceive us into assuming that Rome retained immense respect for the holy icons' religious significance. Rather, the heart of Judaism had been torn out of a living body and conspicuously displayed as the centerpiece of a public museum. The image of the Temple of Peace was both paradoxical and rhetorical. Although Vespasian packaged the temple complex as a memorial to the domestic peace he forged after the civil wars that followed the death of Nero and the repression of the Jewish rebellion, to Jews it symbolized public humiliation. The monument was a continual thorn in the flesh of Rome's Jewish population, a constant reminder of its precarious position in the empire.

But what did this Temple of Peace look like and how long did the Temple treasure remain there? To digest these heavyweight questions I took a breather to regain my momentum in the Angelino ai Fori pizzeria, whose prime location at the very top of the Via dei Fori Imperiali in Rome, the modern road that dissects the ancient forum, offers panoramic views of the Eternal City of two thousand years ago.

Behind me rose the theatrical stage of the Colosseum, where every stone seat concealed a thousand tales. Directly in front, Trajan's Column recorded in picture-book relief the exploits of the emperor Trajan's conquest over the Germanic tribes. To my right stood the first-floor portico where, according to tradition, Nero wept as he watched his beloved Rome burn in the great fire of June AD 64.

Today we take architectural marvels in our urban jungles for granted and hardly blink at yet another Norman Foster architectural delight rising in London or the erection of the world's highest skyscraper in Kuala Lumpur. But imagine trying to break the design mold, as Rome did, in the absence of three-dimensional computer modeling programs? Ancient engineers had no computers, cranes, or bulldozers to rely on, only manpower and human sweat. An estimated 15 percent of Rome's adult population toiled in the building industry, manhandling some

195,000 cubic feet of marble quarried over the course of four hundred years for the Eternal City.

Wearily, I cast down my dusty maps and reams of written testimony transmitted down the centuries that would help me pinpoint the modern location of the Temple of Peace. Research back home in England had revealed that the monument once lay close by. As I oriented myself using maps, the realization dawned that by coincidence I was actually eating inside the walls of the Temple of Peace. Or rather, had the temple survived I would be sitting within its eastern corner. According to my research, Vespasian commissioned the Temple of Peace in AD 71 on a vacant plot of land northeast of the Forum of Nerva, formally used as the Republican cattle market, and celebrated its dedication four years later. So Josephus wasn't quite accurate about it being built in so short a time that was "beyond all human expectations." It was quick, but not that quick. The term temple is also inappropriate because the Pacis Opera, as ancient texts initially called it, was a large precinct housing a suite of monuments and functions. Modern literature usually calls the complex the Forum of Peace.

The area certainly comprised a large assembly point similar to a forum, and was not just an elite monument standing in splendid isolation. The temple complex was square in shape—a typical Forum design measuring some 354 feet along both sides, with a large altar recessed inside a semicircular exedra. The entire complex was surrounded by a lavish enclosed walkway supported by huge marble columns reaching 59 feet into the sky. The massive size of the temple, some ten times larger than Augustus's Altar of Peace, was a deliberate architectural expression of Vespasian's power. Size counted for everything in Rome, especially to the Flavian dynasty, which needed to camouflage its lack of an imperial birthright. The finished creation was considered by Pliny the Elder one of three most beautiful buildings ever to grace Rome.

Annexed to the temple were two intriguing structures, the Bibliotheca Pacis (Library of Peace) and a later addition of the Hall of the Marble Plan. Naturally, as the self-styled center of the civilized world, Rome took its libraries very seriously, but not in the modern sense.

- 207 -

Certainly logs of imperial accounts, military events, and taxation were systematically maintained alongside scrolls of literature and plays. But the earliest libraries were assembled as spoils of war.

By the time the emperor Augustus died in AD 14, Rome boasted three great libraries: Pollio's library next to the Forum, another at the Porticus of Octavia, and Augustus's library connected with the Temple of Apollo on the Palatine Hill. Over time libraries even appeared inside Roman bathhouses to increase the recreational experience. However, we should not be misled. These institutions were not designed just as dusty centers of learning for educated bookworms, but were excellent excuses for the ostentatious display of the owner's wealth.

The name of the Bibliotheca Pacis is thus misleading because, although it would have held papyrus manuscripts, its main purpose was the conspicuous display of Vespasian's artistic masterpieces. As well as the Temple treasure, Pliny records how Vespasian returned to the public art originating in Greece and Asia Minor that Nero, his predecessor, had privately hoarded for personal gratification in his golden palace, the Domus Aurea. This included antique Greek statues such as the Galati group from Pergamon, the Ganymede of Leochares, and masterpieces by Pheidias and Polykleitos, as well as an anonymous Venus, goddess of love.

The largest recorded example of a statue crafted of Ethiopian *basanites*, a rock described by Pliny as of the same color and hardness as iron, also graced the Temple of Peace. This personification of the Nile in human form was surrounded by sixteen of the river god's children playing merrily, standing for the number of cubits reached by the river in flood at its highest desirable level for watering agricultural fields. The masterpiece was an expression of perfect harmony and prosperity. Alongside hung vast paintings, including Nicomachus's Scylla, and Ialysus, the mythical founder of Rhodes, immortalized by Protogenes of Caunus holding a palm tree. In other words this "library" was a very public and deliberate expression of its patron's wealth, taste, and munificence.

But where were the spoils and these other museum masterworks actually displayed? By a generous twist of fate, substantial evidence ex-

- 208 -

ists for the anatomy of the Temple of Peace: a whole wall of it. The last structure to grace the temple, the Hall of the Marble Plan, was a brilliant example of cutting-edge art and design. This room was custombuilt to accommodate the Forma Urbis Romae, or what is known more familiarly today as the Severan Marble Plan, a giant-sized map of ancient Rome displayed vertically on the southeastern wall of the Temple of Peace. The layout of the Eternal City between the River Tiber to the north and beyond the Colosseum to the south was incised between AD 203 and 211 at a scale of 1:240 on large rectangular slabs of white marble imported from quarries on the island of Proconessus in modern Turkey's Sea of Marmara.

The map was enormous, measuring about 59 by 42 feet, and covered one entire wall of the Temple of Peace. Whether a Roman citizen or foreigner, the observer would have never seen anything like it. To a backdrop of the most important art in the world—much antique and most looted—here Rome's rulers illustrated the very city that was responsible for its world domination. The Severan Marble Map was a flagrant form of self-publicity and imperial pride rather than an information point for lost tourists.

By virtue of early Christianity's respect for classical antiquity, the original Roman wall onto which the Severan Marble Map was fixed still stands as the outer wall of the Church of Saints Cosmas and Damian built by Pope Felix IV in AD 527, complete with a Swiss cheese of holes that once held pegs bolted to the backs of the slabs of Proconessian marble. The map itself disappeared in the course of the early fifth-century Gothic invasions, to be cut up and reused in new building projects across the city; other fragments were thrown into limekilns, melting into historical obscurity.

Nevertheless, 1,186 fragments have cropped up in excavations across Rome since 1562. Even though the surviving "document" only equates to 10 to 15 percent of the original map, these fragments remain the single most important form of surviving evidence for reconstructing the ancient Roman ground plan of every architectural feature in the city.

By sheer luck, several surviving marbles show the Temple of Peace,

- 209 -

allowing its square shape with an eastern main hall to be reconstructed. Ongoing excavations around the edges of the Via dei Fori Imperiali are also exposing its key features, allowing Italian archaeologists to confirm that the monument was a vast square surrounded on three sides by an arcade built with pink Egyptian Aswan granite columns. A fifty-nine-foothigh outer wall slanted inward to create an internal arcaded walkway.

The monumental entrance leading into two rectangular halls, fronted by gigantic Aswan granite columns and multicolored marble revetment, was situated to the northwest, facing onto the Forum of Nerva. Long presumed destroyed by later development, especially Renaissance shops, in October 2005 the Soprintendenza Archeologica di Roma found the Temple of Peace's original spectacular floor surface beneath ten feet of smashed pottery and piles of horse bones. The fieldwork uncovered ritual libation basins adjacent to a raised *cella* reached by steps, and on it the five-foot-wide rectangular plinth where the statue of the divine being maintained law and order. The marble floor is a fitting architectural wonder, combining exotic imperial purple granite from Egypt's Mons Porphyrites with Libyan peachy *giallo antico*. Circular foundations for six colossal six-foot-wide columns remain in their original positions.

A final outstanding riddle about the Temple of Peace's design has long perplexed archaeologists: the purpose of twenty-four interconnected rectangular slots visible on the Severan Marble Plan. The new excavations have finally resolved this enigma by interpreting them as garden water features. Six five-foot-high walls proved to be brick installations with marble veneer and channels used for water drainage. The tank podiums are thought to have held exotic plants, probably the highly prized Gallic rose.

The main area of the Temple of Peace thus seems to have been dedicated to a serene garden filled with fragrant flowers, peaceful flowing water, and rolling gardens—a perfect backdrop for the artistic masterpieces that Vespasian positioned inside the temple. It was here, as the showpiece of a memorial to one of Rome's finest hours, that the Temple treasure of Jerusalem would be gazed at in wonder for more than 350 years.

VANDAL Carthage

30

JEWISH GOLD, BARBARIAN LOOT

Something strange hovered in the air. Downtown Tunis was gasping for breath amid dense smog. Ghostly outlines of cars weaved in and out of traffic; people and buildings were swallowed by a vile, thick pea soup of pollution and swirling Saharan sand boiled to a sticky 80 percent humidity. Whatever Tunisians claim to pour in their gas tanks, it surely wasn't entirely lead-free fuel. With manic policemen frantically waving their hands and blowing whistles in a vain attempt to control the lawless traffic from red-and-white-striped patrol booths—looking for all the world as if they were orchestrating a Punch and Judy show—I couldn't help but wonder whether I'd landed in the aftermath of some kind of chemical meltdown.

The surreal feeling was exacerbated by the blurred image of an oversize Super Mouse waving from the side of a street. Was I dreaming? My taxi driver laughed and explained in lyrical French laced with a local Arabic patois that this cartoon figure is the national symbol of government initiatives to protect the environment. The politicians may be seriously tackling local pollution, but when the mighty Sahara stirs and takes to the skies like a biblical swarm of locust, nature beats civilization with a stick every time. I would lose count of the number of Tunisians I met with a permanent frog in their throat, endlessly clearing grains of sand from their mouths.

Arriving in Tunisia in early October 2005, and observing this proud ancient country on an off day, suited the purpose of my visit—chasing

- 213 -

Armageddon. Over the weeks the smog would lift to reveal glorious azure skies and beaches confirming why this most democratic of North African countries is such a popular package holiday destination.

Ancient Tunisia, or rather its capital, Carthage, was where the final death toll of classical antiquity sounded. For two hundred years after the epic triumph of the Jewish Temple treasure in AD 71, Rome basked in its magnificent superiority, successfully commanding a labyrinthine globalized empire. Of all the satellite provinces great and small, far and wide, economically Tunisia dazzled most brightly within the imperial crown jewels. A guide to the glory of Rome written in the mid-fourth century AD, the *Expositio Totius Mundi et Gentium*, described the region as "rich in all things. It is adorned with all goods, grains as well as beasts, and almost all alone it supplies to all peoples the oil they needed."

Tunisia was Rome's breadbasket par excellence. Not only did its wealthy estates and endless wheat fields, vine trellises, and olive groves yield by far the largest taxes for the imperial treasury, but its corn and oil were staple forms of welfare doled out to Rome's city poor on a daily basis. Bottom line: the imperial government needed Tunisia desperately. She was irreplaceable.

However, in AD 429 Rome's love affair with its favorite mistress was brutally shattered—the barbarians were on the move. In May of that year a wave of 80,000 migrants, soldiers, children, and slaves sailed across the Strait of Gibraltar, having marched through Italy from the Danube, and swept east along the North African coast. Although this motley crew included various barbarian tribes, including Goths, Alans, and even Hispano-Romans, at its core was an east Germanic tribe whose bloody worldview conjures up extremely dark images to this day: the Vandals.

For generations, the Vandals had heard tales about the luxuries of the Mediterranean lands from their frozen Germanic heartland. Across the icy Danube they envied the lifestyle of Roman soldiers manning their frontier and enjoying wine and oil imported from exotic shores, including the finest Tunisian produce. Toward the end of the fourth century AD Rome was rocked by internal civil war, which left the im-

- 214 ----

perial infrastructure stretched and vulnerable. The time was ripe for the Vandals to introduce themselves to the high life. In *The Fall of Rome and the End of Civilization*, Dr. Bryan Ward-Perkins of Oxford University explains: "The new arrival had not been invited, and he brought with him a large family; they ignored the bread and butter, and headed straight for the cake stand."

Following the Gothic raid of Rome in AD 408–409, and with imperial rule now divided between the west and an eastern capital at Constantinople, the empire's resources were emaciated. Rome despaired as the barbarians, "pressed by hunger" according to the Byzantine court historian Procopius, helped themselves to the best cakes in the land. Vast tracts of North Africa were conceded to the *rex Wandalorum et Alanorum*, as Rome knew the Vandals, by a treaty of AD 435. Four years later the barbarians seized the icing on the cake, Carthage, the second-greatest city of antiquity after Rome and, by AD 477, controlled an enormous swathe of the Mediterranean including the Balearic Islands, Sardinia, Corsica, and parts of Sicily. The Roman Empire had relied on Tunisia for food and sustenance for so long that it had no alternative but to swallow its pride and trade with the new masters of Africa. It was the only way to maintain a way of life to which it had grown accustomed for over four hundred years.

Less than a generation after leaving behind their life as barbarian giants, the Vandals had shed their animal furs, taken over the empire's old aristocratic estates, and were mimicking the dolce vita. For decades they had watched the masters of decadence and oppression—and waited. Now they wasted little time in replicating Rome's extravagant ways. Only one final action remained, to seize the cake shop itself—Rome.

Y taxi sped across the endless flatlands of suburban Tunis, a blend of 1970s France and Middle Eastern immaterialism. Few people were at large. Unfinished low-rise housing drifted endlessly across the sandy soils. Most of it sat empty, like a makeshift refugee camp, awaiting more dinars for completion. Much of the typically single-story housing seemed ill at ease in the landscape, as unwelcome as the Vandals. This

- 215 -

was not the result of poor city planning, but because the flat terrain is not terra firma at all but the ancient seabed, long silted up.

A few miles east of Tunis the flatlands were interrupted by a lush, wooded hill straddling the sea of suburbia. Its summit is dominated by an enormous cathedral that announces the site to be the acropolis of ancient Carthage. The Cathedral of Saint Louis was built in 1890 in dedication to King Louis IX who, in 1270, died of the plague while besieging Carthage in an attempt to convert the Muslim king to Christianity. An ignoble end and a grand memorial have sliced away and destroyed the heart of this once great city.

We drove past this imposing island of civilization set amid sea and sand, and the mighty power of the place struck home. From here the Vandals planned the sack of Rome; from its military port the fleet sailed directly to the Eternal City in AD 455. Opinion is divided as to why the barbarians ravaged Rome: Was this act driven by greed, expansionist policies, or a will for sheer retribution? The historian Procopius offers a pretty elementary explanation: "And Gaiseric, for no other reason than that he suspected that much money would come to him, set sail for Italy with a great fleet. And going up to Rome, since no one stood in his way, he took possession of the palace" (*Wars* 3.5.1).

Delving a little deeper, however, Rome was simply too large a prize for the Vandals to ignore, especially since petty palace intrigue pretty much handed the city to Gaiseric on a plate. The roots of the sack of the Eternal City involved a cruel love triangle and the wantonness of the emperor Valentinian III, who was infatuated with a woman described by Procopius as "discreet in her ways and exceedingly famous for her beauty." The only obstacle stopping Valentinian from seducing her was the woman's inconvenient marriage to Petronius Maximus, an aristocratic Roman senator.

After scheming for some time, the lustful Valentinian invited Maximus to the palace for a relaxing game of draughts. On winning, the emperor lightheartedly accused the senator of never making good his debts, and forced the senator's ring from his hand as a temporary pledge of payment. Valentinian now had his leverage and duped Maximus's wife

- 216 ----

by sending her the ring. Assuming her husband had summoned her, she sped to the palace, where the emperor had his way with her.

Racked with rage and guilt, Maximus relentlessly plotted against Valentinian, finally killing him to seize the throne in AD 455. With his own wife now dead, Maximus sealed the ring of fate by forcefully marrying Valentinian's own wife, the empress Eudoxia. With nothing left to lose, Eudoxia responded by writing to the Vandal king, Gaiseric, and entreating him to come to Rome and avenge the death of the emperor. The Vandal king needed no second invitation. Eudoxia has gone down in history as the empress who personally handed the barbarians the keys to Eternal Rome. No surprise, then, that one of the greatest historians of Late Antiquity, Theophanes Confessor, immortalized her in his *Chronographia* as an immoral witch who "cohabited with other women in demonic fashion and continually conversed even with those who practiced magic."

The Vandals adopted a conflicted approach to Roman culture. On the one hand they torched, raped, and pillaged property. On the other, they mimicked aristocratic Roman lifestyles, minting imitation coins and keeping traditional forms of architecture. With no indigenous ideology to promote, the barbarians seized a ready-made culture as their own.

So with time-honored Roman flair the Vandals set Italy alight as they marched on Rome in AD 455. History has largely spared Rome detailed accounts of its ignoble fall under the barbarian ax. But there can be no denying the true objectives of the sacking of the city: first, it aimed to create chaos at the heart of the imperial political infrastructure; second, it was designed to fill the Vandal coffers. To this end, Procopius of Caesarea recorded how King Gaiseric's troops plundered the Temple of Jupiter Capitolinus, where almost four centuries earlier the emperor Vespasian and his son Titus celebrated the end of the triumph in honor of the subjugation of the First Jewish Revolt. Now, Gaiseric tore down the gilt bronze roof that had cost Vespasian's second son, Domitian, 12,000 talents—the modern equivalent of over \$4.7 million.

Moreover, the official Byzantine court historian went on to give an

- 217 ---

overview of the massive scale of fourteen days' looting from June 15 to June 29, AD 455:

Now while Maximus [the emperor] was trying to flee, the Romans threw stones at him and killed him, and they cut off his head and each of his other members and divided them among themselves. But Gaiseric took Eudoxia captive, together with Eudocia and Placidia, the children of herself and Valentinian, and placing an exceedingly great amount of gold and other imperial treasure in his ships sailed to Carthage, having spared neither bronze nor anything else whatsoever in the palace. (*Wars* 3.4.2–3)

This passage has long intrigued me. So few words, such great implications. Reading between these lines of history, did the Temple treasure of Jerusalem possibly accompany these shipments back to Carthage? We left the treasure on public display in the Temple of Peace, opened in the heart of imperial Rome at its peak in AD 75. But just how long did it survive there? Did it still exist to be hauled to Carthage in AD 455?

It is a source of great regret that very little of the physical infrastructure of this temple survives to answer this key question. As I write, Italian archaeologists are currently unraveling these secrets in the Roman Forum. Yet other than the odd column, floor, and wall foundation, the Temple of Peace has been largely despoiled by Renaissance shops superimposed over its walls. So we are forced to return to the written word.

What we do know from Cassius Dio's contemporary *Roman History* is that the temple was apparently partly burned just before the death of the emperor Commodus around AD 191:

Many eagles of ill omen soared across the Capitol and, moreover, uttered screams that boded no peace, and an owl hooted there; and a fire that began at night in a dwelling leaped to the Temple of Pax [Peace] and spread to the storehouses of Egyptian and Arabian wares, whence the flames, borne aloft, entered the palace and consumed very extensive portions of it, so that nearly all the State records were destroyed. (*Epitome* 73.24.1–2)

Whatever the extent of the damage—evidently exaggerated by the historian's fertile imagination—the temple must have been subsequently restored, probably under the emperor Severus, because Ammianus Marcellinus mentions the Forum of Peace as one of the most magnificent spectacles in the city that most impressed Constantius II, the Roman emperor of the east, during his first ever state visit in AD 357. The district was still intact in AD 408, when Rome was rocked by seismic disturbances for seven successive days. However, by the time Procopius of Caesarea wrote his history of the barbarian wars, the Temple of Peace had succumbed to lightning. Crucially, however, some original works of art were still displayed in its vicinity, including a bronze statue of a bull and a calf crafted by Myron. The implication is that the major works of art in the Temple of Peace survived on display in a nearby structure.

By the fifth century AD, Rome's glory days were over. Masterly wall paintings were peeling off palace walls, and temples were abandoned to the ravages of time. Yet as the Eternal City strove to keep up appearances, her ideology lived on. If the years of global domination were a thing of the past, the Eternal City still traded on those past splendors, and the Temple treasures of Jerusalem remained in or around the Temple of Peace into the mid-fifth century. The sack of Rome in AD 455, however, was the beginning of the end. Tunisia was lost to the Vandals, and now the barbarian king had seized the finest imperial art from the Eternal City as a new birthright. As Victor of Vita, a priest writing in Carthage in AD 484, confirmed, "At that time he took into captivity the wealth of many kings, as well as people."

Did this wealth include the Temple treasure? The reply must be a resounding yes. Not only do historical circumstances point to this conclusion, but Theophanes Confessor confirms the theory. This grand seigneur was no mere bookworm, but a man of high culture. Even though a Christian monk, Theophanes loved sport and enjoyed taking the waters in the fashionable spas of Constantinople and Bithynia, where he lived and wrote. His twelve-hundred-page *Chronographia*, an epic history of the period AD 284–813, is the most ambitious and systematic

- 219 -

account of the ancient past ever written by a Byzantine historiographer. His words carry serious weight.

Theophanes was convinced about the fate of the Temple treasure. After accepting Eudoxia's cry for help, Gaiseric,

with no one to stop him, entered Rome on the third day after the murder of Maximus, and taking all the money and the ornaments of the city, he loaded them on his ships, among them the solid gold and bejeweled treasures of the Church and the Jewish vessels which Vespasian's son Titus had brought to Rome after the capture of Jerusalem. Having also taken the empress Eudoxia and her daughters, he sailed back to Africa.

Compelling, unequivocal evidence thus places the menorah, silver trumpets, and Table of the Divine Presence on a slow boat to Carthage in AD 455. But what was their fate at the hands of the Vandal nouveau riche?

31

HERESY AND HOLOCAUST

The transfer of Jerusalem's Temple treasure to Carthage in AD 455 completed the tribal Vandals' dream of seizing the Roman high life, lock, stock, and barrel. Roman loot would drive hunger and poverty from their door. Nevertheless, how did the relocation of the treasure fit the sociological and psychological profile of the Vandals? Was the treasure simply a money chest or were the Vandals perhaps aware of its religious and symbolic power? The barbarians had to confront the same dilemma as Vespasian had almost four centuries earlier: to melt down the symbols of Jewish faith or show them off as signs of their new superiority.

Vandal Carthage is the ugly stepsister of ancient history. The period is completely misunderstood for one very good reason: no one is interested in suspending for one moment the popular preconception that these barbarians were anything other than the most evil assassins of culture. That the Vandals perpetrated uniquely heinous forms of torture on the Catholics of North Africa and had no regard for Roman property is clearly chronicled. Yet this is only one side of a very complex argument stacked heavily in favor of the Romans. For it was both a Byzantine court historian, Procopius of Caesarea, employed by the emperor Justinian, and a Romanized Catholic native to Libya, Victor of Vita, who recorded the Vandals' sins.

Other than a few Vandal poets, no record explains events from the barbarian perspective. So how can we be certain of the truth? Should

— 22I —

we condemn the Vandals outright as enemies of culture? Would they have callously melted down God's gold with little thought about its meaning and legacy?

If you accept the written word to be the gospel truth, then the Vandals should be immediately condemned. Typical is the bleak judgment of Victor of Vita writing in his *History of the Vandal Persecution*:

Finding a province which was at peace and enjoying quiet, the whole land beautiful and flowering on all sides, they set to work on it with their wicked forces, laying it waste by devastation and bringing everything to ruin with fire and murders. They did not even spare the fruit-bearing orchards, in case people who had hidden in the caves of mountains or steep places or any remote areas would be able to eat the foods produced by them after they had passed. So it was that no place remained safe from being contaminated by them. (*HVP* 1.3)

These lines echoed in my ears as I drove to my hotel in the Gammarth district of northeast Tunis in October 2005. Today the country is well disposed to outsiders, and the colossal sculpture of an outstretched open hand at the center of a fountain in front of my hotel seemed a perfect reflection of Tunisia's singular welcome amid countries renowned for Islamic fundamentalism. Despite the allure of a pool flanked by palm trees, the sky looked ominous and I was keen for the quest to resume. If the true character of the Vandals and their psychological attitude toward the Temple treasure could be gauged anywhere, then the ancient port was that place. Did they basely crush Carthage and live their own barbarian lifestyle or did they wholeheartedly adopt Roman forms of administration and culture?

After being conned by a taxi driver for the second time within an hour in Tunisia, I set off by foot from the edge of Carthage's Byrsa Hill, the heart of the ancient metropolis. The scale of modern development engulfing the site surprised me; no wonder UNESCO felt compelled to call in crack international teams of archaeologists in the 1970s to try to resuscitate stories from these endangered grounds.

- 222 ----

The Byrsa district of Carthage is a million miles from Tunis's drab suburbia some six miles away. Dark red and purple bougainvillea drooped from trees and crept around palm trees. White villas adorned with blue doors and railings roll down the hill toward the Antonine Baths—among the largest public washing facilities of the ancient world—and the sea. Freshly polished Mercedes-Benz cars are parked outside pristine villas, the updated counterparts of Roman Carthage, where the houses of the rich and famous, replete with landscaped gardens and elaborate mosaics, were blessed by the same sea breeze.

Even the street names recall past splendors. I passed down Rue Hannon, named in honor of the pioneering Phoenician sailor who was the first man to circumnavigate Africa, and turned onto Rue Baal Hammon, a reminder of the chief male god of the Phoenicians. Large drops of rain started to splatter the seaside and I quickened my walk in search of the ancient port. How much of this prosperous district survived the arrival of the Vandals, I wondered, as the rain turned into a storm. Roman writers condemned the Germanic barbarians for flattening the Odeon (theater) and the Via Caelestis, a two-mile-long swanky avenue—Carthage's very own Rodeo Drive—adorned with mosaics, columns, and pagan temples flowing down to the Mediterranean. Did this destruction typify Carthage's mind-set as a whole and hint at the sad fate of God's gold? I wondered.

With 200,000 citizens, Carthage was the second-largest city of classical antiquity after Rome. On previous trips to Tunisia I had walked in amazement across the enormous La Malga Roman water cisterns, fifteen colossal semicircular installations at the foot of Carthage's Byrsa Hill. The cisterns are still intact today, so the Vandal administration clearly maintained parts of the key urban infrastructure, an approach that was potentially good news for the Temple treasure.

One of the main reasons why Vandal Carthage has earned its reputation as the ugly stepsister of classical antiquity is because of the absence of archaeological remains attributable using coins or inscriptions to the period of Vandal occupation. It is said that archaeology never lies, like the camera. But how you read excavation results can be twisted.

- 223 -

Even if the Vandals did build major new villas and public monuments, they could be invisible.

Unlike the Romans, the barbarian masters weren't interested in blowing their own trumpets and slapping each other's backs by plastering imperial marble inscriptions into walls unashamedly advertising how much money they had invested in public monuments. And then there's the problem of the coins—or, rather, the lack thereof. For the first forty years of their rule, the Vandals didn't mint any coins and so failed to leave us any calling cards about where they lived, played, and died. For instance, only eight graves across the whole of North Africa have been identified as unequivocally Germanic, which is ridiculous given that the 80,000 migrants who crossed into Morocco in AD 429 must have swollen to over 100,000 by AD 500.

To cloud the picture even more, the archaeological remains of Late Roman Carthage are a mess. Rather than dealing with regular decay, we have to contend with the ruins of ruins. Not only is the superstructure of most buildings long gone, but even the veneers of foundations have been rudely stripped bare for recyling, a reality confirmed in 1899 by Ernest von Hesse-Wartegg's *Tunis: The Land and the People*, in which he described the modern city:

[There were] many houses in which the colonnades were marble monoliths with splendid capitals, evidently taken from that great quarry which lies in the immediate neighborhood, where the building stones are ready cut, and beautifully ornamented, and where there is no dearth of them—Carthage. The ancient town was such a fruitful field for the Tunisians that in every second house are found Roman stones with inscriptions or sculptures, parts of columns or capitals. If Tunis were destroyed her ruins would be the ruins of Carthage!

For these reasons it's extremely tricky to work out what the Vandals did and didn't do to Roman buildings and thus to understand the mentality toward great art. One of my reasons for visiting the ancient port was to give the Vandals a fair press and to assess whether their at-

- 224 ----

titude toward the Temple treasure of Jerusalem would have been based on pure greed or respect. In other words, did ignorant barbarians melt down the treasure or did they preserve these centuries-old symbols of divinity?

As a marine archaeologist I had read about the greatest port of antiquity for over a decade and had even lectured about it at an international conference in Oxford. Yet physically visiting the site was an altogether different experience, which I had been eagerly anticipating for months. Soaked to the skin by an early autumnal downpour, I was nevertheless tense with excitement as I rounded a corner to the sea and walked down rue de l'Amirauté. And there she was: the Circular Harbor, first built by the most famous merchants the world has ever known, the Phoenicians, and then developed by Rome.

The island's soils were thick with pottery, commercial waste abandoned by the ton in antiquity. Enough rims of African Red Slip semiluxury bowls were scattered at my feet to make it absolutely certain that the port continued to be exploited by the Vandals. The harbors were also still standing in AD 533, when Belisarius, general of an invading Byzantine force dispatched from Constantinople, entered a sheltered basin called Mandracium. So our modern stereotype of Vandal culture seemed to be entirely unfounded. Commerce continued to flow and the barbarians looked forward, not backward, to the Danube. But before I could use this psychological pattern to feel confident that they would have followed Roman customs to preserve God's gold, I had to explore one very real problem: the Vandals hated all religion other than their own. What on earth would they have made of Jewish spoils from the Holy Land?

I f the Vandals were selective about the property they chose to demolish in Carthage, depending on what message they wished to hammer home, their attitude toward the early Christian church was systematic and cold-blooded. As I headed up to Byrsa Hill to work out where the barbarians stored the Temple treasure of Jerusalem from AD 455 to 533, I mulled over their cold-blooded hatred of the local Christians

— 225 —

and whether this mentality extended to a loathing of Jewish symbols of faith.

I ducked past the Antonine Baths and headed west up the avenue 7 Novembre. A quick detour into the deserted grounds of the Roman theater confirmed written testimony that the Vandals did indeed smash this structure to smithereens. Now reconstructed for Tunisian music extravaganzas, only three minor sections retain the original Roman stonework.

With their religious intolerance and penchant for pandemonium, the Vandals set the scene for the emergence of Islam and its rigid doctrines in seventh-century North Africa. At the end of the nineteenth century, Ernest Hesse-Wartegg, visiting Tunis, wrote:

The customs of the Middle Ages and religious intolerance are the commanders who rule over an army as obstinate as it is orthodox. . . . At the gate of the fortress the Islam keeps watch and rejects every innovation, and every change of what has existed for centuries, with the conscientiousness of a Prussian custom-house officer. Emancipation of women, the press, machinery, free trade, social entertainments, theater, sport, dinners, evening parties—all stand outside this gate.

How times change. As a French colony up to 1956, fanaticism was flushed away and Tunisia was exposed to Western customs. Today the country is a constitutional republic and a bulwark of democracy between the chaos and instability of Algeria and the dictatorship of Gaddafi's Libya. Islam, of course, is alive and well but avoids the frenzy found in other eastern countries. The Tunisians are of proud, traditional, Godfearing stock, but not extremist: they resist throwing their beliefs down your throat. It feels safe to walk the streets late at night.

I emerged into rue Tanit, the street dedicated to the goddess of child sacrifice. Crossing the street, I mulled over the character of Victor of Vita, author of the *History of the Vandal Persecution*. This is a no-holdsbarred tale of blood and thunder, a record of fact that makes Quentin Tarantino's fictional *From Dusk Till Dawn* seem like child's play. But did

— 226 —

this holocaust against the early Christian church ever really happen?

The degree of the Vandals' religious observance is a matter of great uncertainty. Their mother religion, Arianism, may simply have been a convenient weapon with which to beat up the local Catholics. In the end, however, it would induce the collapse of the Vandal occupation of North Africa.

By the time the Temple treasures of Jerusalem were on a ship bound for Carthage in AD 455, the Church had already been fighting Arianism for two hundred years. Arius was a deacon of Libyan descent who lived between AD 250 and 336, and was a source of great controversy about the fundamental truth of the nature of Christ—a row that persists today. In 321, Arius, and his views based on earlier Gnostic philosophy, were condemned at Alexandria by a synod of a hundred Egyptian and Libyan bishops. Excommunicated, he fled to Palestine. Although his books would later be burned, his approach would divide the Church forever.

In the simplest terms of a very complicated debate, Catholics worshipped Christ as the true Son, a God in his own right, inseparable from the Father. However, Arianism questioned this relationship because the technical terms of the doctrine were never fully defined: Greek words like essence (*ousia*), substance (*hypostasis*), and nature (*physis*) bore a variety of meanings. Hence, the opportunity for misinterpretation. Arians could not accept that God could have spawned a physical Son and, thus, denied any notion of the Son as of equivalent essence, nature, or substance as God. Christ was not consubstantial with the Father or equal in dignity, or co-eternal, or existing within the real sphere of Deity.

Victor was a priest who lived through the Arian atrocities perpetrated by the Vandals before becoming bishop of Vita in Byzacena. As a man of the cloth who witnessed his fellow clergy submitted to such harrowing torture, he deplored the Vandals. He opens his history with a simple overview: "In particular, they gave vent to their wicked ferocity with great strength against the churches and basilicas of the saints, cemeteries, and monasteries, so that they burned houses of prayer with fires greater than those they used against the cities and all the towns" (*HVP* 1.4).

— 227 —

If you were one of the lucky members of the clergy, the barbarians simply stripped your clothes and exiled you from your church, naked, without a possession to your name. Other favorite bully-boy tactics of King Gaiseric included forcing open the mouths of bishops and priests with poles and stakes, and pouring dirt into their jaws to force confessions about the hiding places of ecclesiastical funds. Victor of Vita added that the Vandals "tortured others by twisting cords around their foreheads and shins until they snapped."

A far more evil atrocity was the Vandal policy of burning bishops' bodies with "plates of glowing iron," as befell Pampinianus and Mansuetus. By the time Gaiseric died in January AD 477, only 3 of the original 164 bishops preaching in Tunisia at the time of the barbarian invasion were still active.

The start of the reign of Huneric, the son of Gaiseric, enjoyed a return to religious tolerance. General assemblies of Catholics were once again permitted, Eugenius was ordained bishop of Carthage in AD 480–481, and almsgiving resumed. Vandals were even spotted frequenting Catholic churches. But this was a false dawn, a calm before an even more ferocious storm.

Huneric's mood swiftly darkened when the Arian bishop Cyrilla accused the king of unacceptable moderation and of disrespecting the mother religion. Victor of Vita writes that Huneric then "turned all the missiles of his rage toward a persecution of the Catholic church." The first step was to stop Vandals entering Catholic churches. A very special torture was reserved for enemies of Arianism: "They were straightaway to thrust tooth-edged stakes at that person's head and gather all their hair in them. Pulling tightly, they took off all the skin from a person's head, as well as the hair. Some people, when this happened, immediately lost their eyes, while others died just from the pain" (*HVP* 2.9).

The anti-Catholic holocaust swiftly intensified, with conversion to Arianism being forced on all palace officials and Romans in public employment. Those who refused had their tongues cut off. Catholics were now barred from even eating with Vandals. The heretic government also ended the hereditary ownership of church lands, seizing bishops'

- 228 -

possessions as their own by riding their horses into churches and forcing out the clergy. Churches were closed down throughout Africa and their rich estates gifted to Arian bishops. In total, Huneric exiled 4,966 bishops, priests, and other members of the Church to the desert. Papyrus prayer books were burned by the thousands.

Elsewhere, the Vandals had license to enjoy themselves in other terrible ways. Consecrated virgins were sexually violated and then tortured "by hanging them in a cruel way and tying heavy weights to their feet; they applied glowing plates of iron to their backs, bellies, breasts, and sides."

Huneric's rule of religious bloodshed lasted for seven years and ten months. "His death," spat Victor of Vita, "was in accordance with his merits, for as he rotted and the worms multiplied it seemed not so much a body as parts of his body which were buried" (*HVP* 3.71). The king had proved a shameful assassin.

KEEPING THE FAITH

32

The Vandals' persecution of Catholic North Africa turned out to be their downfall. From his palatial perch overlooking the Bosphorus— Constantinople, the new capital of the Late Roman Empire—the Catholic emperor Justinian's outrage increased with every fresh report of the Arian atrocities. Yet his hands were technically tied by a peace treaty signed by his royal predecessors.

Moreover, Justinian's advisers were strongly opposed to war. The Vandals had settled on the other side of the world—a logistical nightmare. It would take 140 days for a Byzantine army to reach Carthage and launch a strike. More pressing was the perilous condition of the imperial coffers, running dry through a combination of Justinian's free and easy spending and prolonged skirmishes with the Persians hammering at the gates of the eastern borders. Gold was getting scarce. The imperial troops were exhausted.

In addition, the empire had already attempted in vain to invade Vandal Africa with disastrous consequences. Justinian, however, was not easily dissuaded. The hungry ambitions of the Vandal king Gelimer posed a clear threat to peace. Here was a volatile man who had usurped the kingship from Hilderic and imprisoned both the king and his sons, Euagees and Hoamer, whom he also blinded for good measure. How could you trade with a man who was willing to commit dynastic murder to gain the throne? In a final ultimatum, Justinian sent envoys to Gelimer, accusing him of acting in an unholy manner and demanding

- 230 -

the safe passage for Hilderic and his sons to Constantinople. Gelimer's reply bluntly told Justinian to mind his own business.

Belisarius, general of the East, was immediately summoned and ordered to prepare for battle. The Byzantine invasion of Libya was packaged by the Byzantine Empire as a holy war. It is alleged that the turning point for Justinian came when God visited a bishop in a dream and rebuked Justinian for his caution: Christianity had to be protected from the Arian heretics of Libya. Forget what you may have been taught at school or read in later years about Richard the Lionheart and the eleventh- to twelfth-century Crusades. The invasion of AD 533 was, in fact, the first Crusade of history, the earliest holy war between Christianity and infidel. Once in Tunisia, Procopius tells us that on one occasion the tips of the Byzantine spears were said to have "lighted with a bright fire and the points of them seemed to be burning most vigorously," a sure sign of divine blessing.

Fearful of the barbarians' reputation and access to untold North African riches and resources, Justinian almost certainly exaggerated the perceived Vandal military threat. In reality, the Vandal force of AD 533 lacked the primitive hunger of a hundred years earlier after growing fat off the splendors of the land. Luxury had made the barbarians soft, just as it made the Roman Empire susceptible to a fall in AD 455.

The Vandals' metamorphosis from barbarians to lovers of culture is clarified by Procopius:

For all the nations which we know, that of the Vandals is the most luxurious. . . . For the Vandals, since the time when they gained possession of Libya, used to indulge in baths, all of them, every day, and enjoyed a table abounding in all things, the sweetest and best that the earth and sea produce. And they wore gold very generally, and clothed themselves in the Medic garments, which now they call "seric" [silk], and passed their time, thus dressed, in theaters and hippodromes and in other pleasurable pursuits, and above all else in hunting. And they had dancers and mimes and all other things to hear and see which are of a musical nature or otherwise merit attention among men. And the most of them dwelt

- 231 -

in parks, which were well supplied with water and trees; and they had a great number of banquets, and all manner of sexual pleasures were in great vogue among them. (*Wars* 4.6.6–9)

This passage is key to getting inside the mind of the Vandals. A love of theater, hippodromes, banquets, and orgies made the "barbarians" as Roman as Rome. Despite the Vandals' appalling attitude toward Catholicism, fanatic hatred did not extend to Roman culture and forms of rule. The Vandals certainly demolished the churches of North Africa, but embraced the pagan Romans' way of life. If they kept the hippodrome and baths open, might they also have spared the Temple treasure of Jerusalem?

In Constantinople, Justinian assembled a mammoth military machine comprising 10,000 foot soldiers and 5,000 horsemen. Some 500 ships manned by 30,000 Egyptian and Ionian fighting sailors converged on the capital to man 92 *dromones*—sleek and swift warships ("runners"). This battle of the sea was to witness a new and deadly weapon explode onto the Mediterranean: the *dromones* were equipped with flamethrowers that spat "Greek fire" from their bows.

Justinian granted the blessing of absolute imperial power to Belisarius, originally a native of Germania who was an all-action hero. His life reads like a modern soap opera. The general was equipped with a brilliant strategic mind, endless courage, and, as events would unfold, both good fortune in his military career and the devil of days in his personal life. As Procopius recorded, in North Africa Belisarius earned "such fame as no one of the men of his time ever won nor indeed any of the men of olden times."

While taking on provisions in Sicily, Belisarius received an immediate stroke of great luck: the Vandal king Gelimer, he learned, was away from court, staying near Hermione in Byzacena, four days inland from Carthage. The coast was clear for a full-scale assault, aided by favorable winds that blew the fleet past Gozo and Malta far out to sea. Belisarius deliberately gave Carthage a wide berth to land at Caputvada, Shoal's Head, in Libya, five days east of the Tunisian capital. If

Carthage was ever attacked, the Vandals would be expecting to spy a fleet approaching from the west, not sneaking up unawares from the unprotected eastern flank.

General Belisarius was as much concerned with the battle for the hearts and minds of the local population as with military success. In Libya he was quick to let it be known that the stealing of farmers' produce would result in corporal punishment. The holy war had to be accompanied by just behavior:

For I have disembarked you upon this land basing my confidence on this alone, that the Libyans, being Romans from of old, are unfaithful and hostile to the Vandals . . . this is the time in which above all others moderation is able to save, but lawlessness leads to death. For if you give heed to these things, you will find God propitious, the Libyan people well-disposed, and the race of the Vandals open to your attack. (*Wars* 3.16.3–8)

Belisarius was proving to be a born leader of men. Later, after capturing the all-important public post used to ferry political dispatches by horse, rather than killing the chief courier, the general gave him a pledge of loyalty and a letter from Justinian reading: "Do you, therefore, join forces with us and help us in freeing yourselves from so wicked a tyranny, in order that you may be able to enjoy both peace and freedom." The point was crystal clear: acquiesce, save your souls, enjoy prosperity. Only once did the general have to resort to a brute show of force when the local Romanized Libyans sold information about Byzantine strategy to the Vandals. Belisarius responded by impaling a Carthaginian called Laurus on a hill in front of Carthage on the charge of treason. An "irresistible fear" gripped the capital—problem solved.

Once the Byzantines had killed Gelimer's brother, any Vandal military master plan went out the window, and Belisarius was able to march on Carthage unhindered. In the Circular Harbor of Mandracium the Carthaginians lifted the iron chains guarding the harbor mouth from enemy ships and waved in the Byzantine fleet. The Vandals had proven to be parasitical leeches, sucking the life out of Tunisia. Marching up

— 233 —

toward Byrsa Hill, Belisarius must have been overcome by the sight of hundreds of locals cheering the arrival of Byzantium and a return to Roman values. As evening fell on Tunisia's Byzantine independence day, the general was amazed by the welcome: "For the Carthaginians opened the gates and burned lights everywhere and the city was brilliant with the illumination that whole night, and those of the Vandals who had been left behind were sitting as suppliants in the sanctuaries" (*Wars* 3.20.1).

But did the light of the golden menorah from the Temple of Jerusalem also still sparkle on this occasion among the Vandal treasuries on Carthage hill?

33

IN A VANDAL PALACE

Sitting cross-legged on the summit of Byrsa Hill, dominated by the ruins of a library dedicated by the emperor Augustus, I too watched the brilliant lights twinkle across Carthage—or rather across the Bay of Tunis. Only these were generated by electricity rather than olive oil and wick. The whole kaleidoscope of Tunis past and present played out in front of me in the few minutes it took for the orbiting sun to set. Imams in dire need of singing lessons hollered from minaret towers, completely ignored by children playing football next to the Roman amphitheater.

From the acropolis of Carthage the ancient port set within a fertile lagoon of calm water and palm trees faded into the shadows. Wherever you may be in the Mediterranean, there is something uniquely magical about watching a city unwind after a stressful day. Flickering lights sprinkle beauty across highways and suburbia as families come together to share stories of daily anguish and joy. Urban landscapes, ugly by day, assume a mantle of bewitched mystique by night.

This was both a highly peaceful and satisfying moment for me. I came to Tunisia in October 2005 with a few major expectations: to make sense of the Vandals' religious, political, and economic agendas; to understand how much of Carthage was "Vandalized" in this era. In truth, however, these were secondary interests. My main aim was to search for an ancient building excavated in 1933 that looked suspiciously regal to me.

After three days on Byrsa Hill I had exposed a startling piece of

- 235 -

evidence that left me jubilant. Now I knew where the Temple treasure of Jerusalem had been housed by the Vandals from AD 455 to 533. The enigma of the Temple treasure's fate was once again falling into place.

My reading of Procopius and other lesser sources made it clear that the Vandals' palace lay on Carthage's Byrsa Hill. As the capital of all North Africa, and hence the Vandal world, this would have been the showcase where King Gaiseric and his descendants would have stored their extraordinary treasures. After warning his army against looting and harming civilians, Procopius reported that in September 533 General Belisarius "went up to the palace and seated himself on Gelimer's throne." At the same hour and on the same spot where I was watching Tunis unwind from Byrsa Hill, the Byzantine army had dined in the Vandal palace:

And it happened that the lunch made for Gelimer on the preceding day was in readiness. And we feasted on that very food and the domestics of Gelimer served it and poured the wine and waited upon us in every way. And it was possible to see Fortune in her glory and making a display of the fact that all things are hers and nothing is the private possession of any man. (*Wars* 3.21.6–8)

Other than on Byrsa Hill, the heart of the ancient city of Carthage elevated 184 feet above the plains of Tunis, there is nowhere within a six-mile radius of the port where it is geographically possible to "go up" to a palace. This expression restricts the location of the Vandal royal seat to Byrsa. Earlier in England I had spent weeks poring over all published accounts of excavations conducted across Carthage since the early twentieth century. I had very rapidly become fed up with the Phoenicians because almost all fieldwork predating the 1970s was besotted with the city's deepest foundations attributed to the legendary Queen Dido and her Punic descendants. Almost all early pioneering explorers were glorified trophy hunters in search of Phoenician tombs and rich grave goods. The Roman and later remains stratified closer to the modern ground level were largely ignored, and only uncovered because they

- 236 -

lay in the way of excavations cut beneath them down to the Phoenician "basement."

To make matters worse, the Late Antique levels that intrigued me and dated from the mid-fourth to seventh centuries AD—spanning the Later Roman, Vandal, and Early Byzantine Empires—didn't seem to exist. While Rome has always been put under intense microscopic scrutiny as the root of classical and contemporary culture, Late Antiquity has traditionally been dubbed the Dark Ages. Only from the 1980s onward have scholars come to appreciate just how many forms of Roman institutions and administration from city councils to theaters still flourished across the Mediterranean as late as the seventh century AD. The Byzantine Empire that settled in Constantinople in the early fourth century was only called Byzantine after the name of its earliest colony, Byzantium. In reality, this was no less than New Rome, the Eternal City transposed to the Bosphorus.

Immersed one evening in Oxford University's Sackler Library in a sea of plans of Punic tombs, I stumbled across a "treasure map"—or more precisely a plan of Punic tombs excavated by Father Lapeyre in 1933. The drawing looked quite abstract since above the Phoenician levels the explorer really didn't know what he was dealing with. Thankfully, Lapeyre didn't destroy the ruins he uncovered as he shifted tons of soil to descend thirty-three feet below the modern ground level to his beloved eighth-to-third-century BC tombs. This was due more to luck than cultural enlightenment: the two "Roman" structures he uncovered were so monumental that it would have been far too much bother to get rid of them. And Lapeyre, like most of his contemporaries, was interested in swift results.

What caught my eye and got my heart pounding was a massive rectangular slab of architecture running perpendicular to Lapeyre's tombs. Although his plan didn't make complete architectural sense, its overall form reminded me of a palace recently excavated at Butrint in Albania by a colleague, Professor Richard Hodges of the Institute of World Archaeology at the University of East Anglia. The mystery structure in Carthage terminated to the north with a separate wing

- 237 -

characterized by a tripartite room. Toward the late third century AD, the Roman dining experience in elite villas and palaces was revolutionized. Villa owners turned to the *stibadium*, a semicircular dining couch set around a semicircular marble table. The rigid Roman rectangular dining experience was replaced by a new style offering a more relaxed, egalitarian atmosphere. The cozy alcove with its smoothed curves was far less formal than the Roman form, which was designed for spectacle alone. Sitting on a curving couch, neither host nor guest was head of the table.

Initially, the *stibadium* was built at the end of the dining room, farthest from the entrance door. At some point in the fourth century AD, however, the scheme experienced a logical development: the creation of a three-winged triconchal room, whose curved inside walls snugly accommodated the semicircular dining tables where one sat cross-legged and low down, rather like enjoying traditional Chinese cuisine. The plan of the "Roman" structure exposed by Lapeyre looked like a template for this elite form of Late Antique dining experience. Could it be the Vandal palace? Stylistically, I was very optimistic, but a spanner in the works was a coin of the emperor Constans I that had been found in the building's foundations, the only solid piece of dating in existence. Constans ruled from AD 337 to 350, so this coin was far too early for a Vandal presence between AD 439 and 533.

I had turned up at Carthage a little green behind the ears, equipped with only Lapeyre's plan and a photocopy of a 1930s photograph showing the general area of his excavation. I figured that if I could track down the two distant buildings in the photo I might be able to at least find the spot where the "palace" was excavated, and soak up the atmosphere where the Temple treasure of Jerusalem once resided during its remarkable history. No modern maps or travel books even mention this building. Was this because modern archaeologists have failed to fathom its function or was it because the structure had been bulldozed? I simply had no idea and was taking a risk by visiting Carthage with fool's optimism. Other than in the early 1930s literature, no other photograph of the building existed in later publications. Lapeyre's find was an enigma

- 238 ----

and John Ormsby's *Autumn Rambles in North Africa* (1864) left me with little optimism of finding it intact:

From the top of a heap of rubbish [the traveler] may trace the features of a rusty hill-side, a strip of thirsty plain relieved by a patch or two of Arab cultivation, a broken line of low-lying shore, and this is all the memento of Carthage he can carry away on the leaf of his pocket-book. . . . Better for Rome's great rival to lie dead and buried in that rubbish-strewn plain, than to live on as a frowsy Moorish city.

The heart of ancient Carthage, Byrsa Hill, is something of a time warp, not because of the ruins themselves, familiar friends to me, but because the site museum and description plaques are retro 1970s. As a living museum Carthage is a little jaded and frayed around the edges. To the nonspecialist the mass of ancient walls can be utterly confusing.

Two maps carved onto stone display plinths on Byrsa Hill are all you get to help you navigate the ruins, and I was immediately dispirited to see that neither labeled any palace. Nevertheless, I started to roam around the ruined esplanade-three times the size of Augustus's Forum in Rome and twelve times larger than any other public space in Roman North Africa-from the outside inward in ever decreasing circles. My neck soon ached from continuously staring between the skyline and my "treasure map" and photo. After scrambling around the northern perimeter of the hill with no luck for half an hour, I made my way south. Standing amid piles of Roman pottery and apsidal walls, I finally found my prey. In a typically academic manner I had got lost amid the details rather than appreciating the big picture. The top left corner of my photo showed a semicircular tower annexed to a monumental building. From the south it immediately became obvious that this was the huge Cathedral of Saint Louis, which has dominated the hill since 1890. This feature allowed me to cross-reference a small one-story building with a crenellated roof, and from these bearings I soon had Lapeyre in my sights.

To my delight I suddenly realized I was standing on top of the "pal-

- 239 -

ace," which had survived the decades after its excavation intact. I quietly thanked the Tunisians for this fortune, even though no one really knew the nature of the beast straddling the southeastern hillside. I had not anticipated the sheer scale of the building, whose massive foundations plummeted some twenty-six feet down.

I spent three long days under the relentless rays of the sun studying this monument, scrutinizing the stone architecture, the building's geography, and cross-referencing the site with ancient historical texts. Lapeyre's folly turned out to be quite majestic, both an eyesore and a wonder. So much of the building's outer stone veneer, and everything above ground level, has long gone. All that survives are the deep, dungeonlike foundations of the structure, ugly rubble cemented with crude plaster in the "vulgar" Late Antique style. This was no elegant Roman building crafted according to strict Vitruvian principles. These walls were never meant to be seen, let alone undressed by a critical scientific eye. Originally they had been clad in an exquisite veneer, long plundered for new buildings.

The "palace" measures 40 feet wide and 108 feet in length. An extension to the south annexes adjoining ruins by a further 30 feet. The main wing is a rectangular structure with a raised apse to the north originally covered with shining gray marble. This was without doubt the site of the original *stibadium*, where the high and mighty feasted. A puzzling feature in the same wing is a vast central rectangular foundation, 30 feet long and 16 feet wide, which veers deep down into the ground. The question of what kind of installation needed such massive footings perplexed me. Was this the Vandal palace's dungeon, which Procopius describes as a room filled with darkness called Ancon by the Carthaginians, and into which anyone with whom the tyrant was angry was thrown?

Dark it was, true, but far too small, I concluded. However, I did recall that the barbarian soul was softened in North Africa by flowing water. During his march to Carthage, Belisarius's army passed Grasse, forty miles east of the capital, which was renowned as "a palace of the ruler of the Vandals and a park the most beautiful of all we

know. For it is excellently watered by springs and has a great wealth of woods. And all the trees are full of fruit" (*Wars* 3.17.9–10). Landscaping was key to Vandal aesthetics and I was certain that the rectangular foundation at the heart of the Carthage palace was a placement for a fountain. The soft sound of flowing water would have been a perfect feature for aristocratic meetings and feasting, and just like Vespasian's Temple of Peace a fitting backdrop to the display of the Temple treasure of Jerusalem.

North of the main rectangular hall of the building is a separate room, an audience chamber with triconchal wings, exactly like the palace of Butrint and other high-status Late Antique buildings. The floor levels are no longer intact today, but the raised dining *stibadium* base can still be seen beneath vegetation before being swallowed by a modern road. Adjacent sits a second apse.

Architecturally, the layout of Lapeyre's mystery building works perfectly as a palace. It also occupies the dominant view of Carthage's ports, the perfect geography of power: visitors to the palace would have been in awe of the unhindered vista down onto the port—master of all it surveyed—just as the jaws of merchants sailing into harbor would have dropped at the majestic sight of a marble palace gleaming against Carthage's skyline. If an emperor or king was going to build a palace anywhere in the capital, the exact space occupied by the triconchal structure was that spot.

I would have happily closed the case if it were not for two problems. First, the problem of dating and the coin of Constans I; secondly, however I juggled the evidence, the edifice was simply too small for a palace. Was I wrong after all, simply building my own castles in the air?

The dating dilemma was not so grave since Lapeyre, in his eagerness to get to the Punic levels, simply dug the palace out like a dog ferreting for a bone. No pottery, coins, or any other finds survive from inside the building. Further, I knew that we could discount the limited evidence based on one lousy coin, especially since the fourth to early fifth centuries AD were decades of extreme inflation. This meant that copper coins were largely worthless. A scarcity of metal resources also ensured

— 24I —

that early fourth-century coins remained in circulation for over one hundred years.

So there was every reason to believe that the coin of Constans I found close to the palace's foundations may have been around for a very long time before being lost. Even if it did correctly date the foundations of the palace, this was no serious problem because the Vandals would have simply assumed control of a preexisting Late Roman imperial *palatium* before adding the audience chamber to the north.

But what of the palace's relative modest size, surely insufficiently grand for imperial use? Not so, however, if this structure was merely one part of a far larger edifice whose sprawling wings are today buried to the north or were destroyed in antiquity and recycled into later buildings in Tunis. Personally, this is my preferred interpretation but one that need not be exclusive. Back in London I eagerly met up with Professor Richard Hodges, director of excavations at the UNESCO World Heritage Site of Butrint in Albania and its triconch palace of comparable date. He is a world expert on Late Antiquity and his take on my "palace" was worth its weight in gold. I was also very keen to hear about the new mosaics and headless marble statue his team had just dug up in their forum. Butrint has become a byword for meticulous excavation and publication.

Hodges turned up in my offices at *Minerva* magazine in London's West End beaming, infectious with ideas and exciting schemes. We shot the breeze about his triconch palace and, very cautiously, I took him through my plans of Carthage's equivalent and a sequence of photos. Quite honestly, I was expecting my theory to be shot down on the basis of the "size matters" equation. After all, what survives in Carthage the second-largest city of antiquity—is even smaller than at Butrint, a relatively minor provincial capital. However, I ended up tingling with excitement when he bestowed his blessing on my idea, pointing out that the walls of his palace were "tiddly" compared to the "colossal" foundations on Byrsa Hill. Then the bombshell: the Carthage palace may seem small but it was designed to go up, not out, perhaps to as many as three stories high. Of course; this made perfect sense. Byrsa

was honeycombed with endless ancient buildings of Phoenician, Punic, and Roman date. By Late Antiquity there was little room left to breathe other than upward. The Vandal palace, seat of the Temple treasure of Jerusalem, was the skyscraper of its day.

I breathed in the atmosphere of this ancient ruin, whose great legacy had been forgotten over the centuries, and imagined the spectacular impact that Jerusalem's Temple treasure would have had on the Vandal court. From AD 455 to 533 the candelabrum, Table of the Divine Presence, and trumpets illuminated this very building. But when the em peror Justinian's army marched on Carthage in 533, the Jewish spoils were nowhere to be found: they had seemingly vanished into thin air.

I twas from the mighty port of Carthage that Gaiseric's expeditionary force against Rome sailed in AD 455; the victorious army returned by exactly the same route, only this time laden down with the emperor's wife and children, and "the Jewish vessels which Vespasian's son Titus had brought to Rome after the capture of Jerusalem," in the words of Theophanes. Geographically, historically, architecturally, and archaeologically, the palatial structure on Byrsa Hill was the only place where the Vandals would have stored their riches. Just like Vespasian and Titus almost four hundred years earlier, Gaiseric would have divided the spoils into those to be converted into liquid capital and those worthy of being kept as crown jewels. Of humble origins, the Vandals had no dynastic claim to power. In such circumstances the barbarians would have eagerly assumed the Roman trappings of civilization. The Jewish treasure symbolized the heart of that mentality: empowerment through the possession of the crown jewels of vanquished cultures.

However, when Belisarius seized Gelimer's palace in AD 533, all of the Vandals' treasure had vanished. King Gelimer had moved the state treasures away and out of the reach of Byzantine hands. The main battle for North Africa didn't take place at Carthage but converged on Tricamarum, eighteen miles from the Vandal capital. Gelimer had fled west and assembled his troops, along with mercenary Moors, on the plain of Bulla Regia close to the border with modern Algeria.

- 243 -

Some eight hundred Vandals and fifty Romans died in the battle of Tricamarum, which also revealed Gelimer to be a total coward. As soon as the Byzantine army advanced, the Vandal king leaped on his horse without saying a word and fled down the road to Numidia. In the heat of battle the barbarians had no time to break camp before following suit, and it was at Tricamarum that the Byzantine army got its hands on a mountain of gold:

And they found in this camp a quantity of wealth such as has never been found, at least in one place. For the Vandals had plundered the Roman domain for a long time and had transferred great amounts of money to Libya, and since their land was an especially good one, flourishing abundantly with the most useful crops, it came about that the revenue collected from the commodities produced there was not paid out to any other country in the purchase of a food supply, but those who possessed the land always kept for themselves the income from it for the ninetynine years during which the Vandals ruled Libya. And from this it resulted that their wealth, amounting to an extraordinary sum, returned once more on that day into the hands of the Romans. (*Wars* 4.3.25–28)

Even though Procopius very strongly confirms that the Vandal treasure contained riches looted from Roman lands, we find no reference to the crown jewels or Temple treasure, only gold coins and money. Frustratingly, God's gold was not among this windfall; the most important barbarian treasures had been spirited elsewhere.

King Gelimer had bolted westward. At Hippo Regius he headed inland, climbing the precipitous Papua Mountains to try and vanish among his Moorish tribal allies—much as Osama Bin Laden disappeared in 2003, vanishing amid the impenetrable mountains bordering Pakistan.

General Belisarius sent John the Armenian in hot pursuit of Gelimer, aided by a crack force of 200 commandos charged with capturing the Vandal king dead or alive. Meanwhile, a surprise awaited Belisarius's main army at Hippo Regius. Today this ancient town sits on the coast of eastern Algeria and typifies the source of North Africa's prosperity

- 244 ----

in antiquity. As well as being a major harbor, some eight ancient roads converged on Hippo.

Iron and marble were mined nearby, but Hippo Regius was primarily a main exporter of the wheat tax shipped annually by the hundreds of tons to Rome. For this reason Hippo was the first city to be besieged by Gaiseric in AD 430; ironically, it would also be the last city a Vandal king would control before the Vandal state collapsed.

Against a backdrop of bathhouses, gleaming statues, a theater, and lavish mansions like the Villa of the Labyrinth—their floors adorned with spectacular mosaics of masks, singers, and wild animals—a rather special wooden ship rocking in the harbor of Hippo Regius cut an isolated and forlorn sight in December 533. On its deck stood a scribe called Boniface, a native of Libya entrusted with state secrets of the Vandal court. This man held the ultimate secret to the fate of the Temple treasure of Jerusalem in North Africa. Thus, according to Procopius:

At the beginning of this war Gelimer had put this Boniface on a very swift-sailing ship, and placing all the royal treasure in it commanded him to anchor in the harbor of Hippo Regius, and if he should see that the situation was not favorable to their side, he was to sail with all speed to Spain with the money, and get to Theudis, the leader of the Visigoths, where he was expecting to find safety for himself also, should the fortune of the war prove adverse for the Vandals. (*Wars* 4.4.34)

As soon as the battle of Tricamarum had begun, Boniface duly planned his escape.

But an opposing wind brought him back, much against his will, into the harbor of Hippo Regius. And since he heard that the enemy were somewhere near, he entreated the sailors with many promises to row with all their might for some other continent or island. But they were unable to do so, since a very severe storm had fallen upon them and the waves of the sea were rising to a great height. (*Wars* 4.4.35–36)

- 245 -

The scribe's well-formulated plans were destroyed by Mother Nature. Terrified of the Byzantine forces approaching the port, he resorted to seeking sanctuary in the town's church. In typical humanitarian fashion, Belisarius freed Boniface with an enormous handout plundered from this floating money chest. From Hippo it was a short sail back to Carthage where, under the long shadow of the palace on Byrsa Hill, the greatest treasures of the Vandals, including the Temple treasure of Jerusalem, finally made their way across another sea to Constantinople, capital of the Byzantine Empire.

CONSTANTINOPLE— New Rome

34

TREASURES RECYCLED

WELCOME TO HELL announced the banner unfurled outside Istanbul airport, an intimidating greeting awaiting the Swiss national football team's crucial game against Turkey on a mid-November evening in 2005. Already two goals down from the away leg, the Turks were rapaciously exploiting their home advantage. The affable Swiss were bombarded with eggs and cartons of milk on entering Galatasaray's stadium, while local fans drew their thumbs under their chins, maliciously promising to cut the players' throats should they win.

Next day the Turkish capital was in mourning. The national team gave away a penalty inside the first thirty seconds and went on to lose to European minnows, Switzerland, on aggregate, and drop out of the 2006 FIFA World Cup. A calamity.

Istanbul was fast freezing up, physically and emotionally. Icy winds blew across the Sea of Marmara, whipping around mosque domes and hundreds of ships bobbing at anchor in the Golden Horn, the greatest natural harbor in the world. V-shaped arcs of storks flew south to escape winter.

I was moving in the opposite direction, having just left the sunny shores of Tunisia. Winter was fast closing in and so was the end of my quest. But Constantinople, the Late Roman city built by the first Christian emperor, Constantine I (AD 311–337), held further secrets somewhere beneath its domes and kebab shops. The capital of the Later

- 249 -

Roman Empire was the last place where the Temple treasure of Jerusalem appeared in public before dropping off the pages of history.

By AD 534, Justinian I (AD 527–565), the most colorful ruler of Late Antiquity, had been on the throne for eight years. Not only was I certain that the menorah, trumpets, and Table of the Divine Presence passed into his personal possession, but I also had a theory—based on the discovery of some extraordinary Byzantine sculpture and poetry—about where he may have stored them: the Church of Saint Polyeuktos.

The return to town of the Byzantine Empire's new golden boy, General Belisarius, was met with great fanfare. North Africa and its rich olive groves were once again Roman, and Justinian's court historian, Procopius, reveals the emperor's eagerness to mark this great event for posterity:

Belisarius, upon reaching Byzantium with Gelimer and the Vandals, was counted worthy to receive such honours, as in former times were assigned to those generals of the Romans who had won the greatest and most noteworthy victories. And a period of about 600 years had now passed since anyone had attained these honours, except, indeed, Titus and Trajan, and such other emperors as had led armies against some barbarian nation and had been victorious. For he displayed the spoils and slaves from the war in the midst of the city and led a procession which the Romans call a "triumph," not, however, in the ancient manner, but going on foot from his own house to the hippodrome and then again from the barriers until he reached the place where the imperial throne is. (*Wars* 4.9.1–3)

Procopius seemed to think it was highly strange to resurrect the ritual of the triumph, a dead Roman custom. And why refer to Titus? The historian deliberately seemed to emphasize the historical link between the triumph of AD 71, the Temple treasure, and the loot captured from the floating treasure chest at Hippo Regius in AD 533. The streets of Istanbul held unsolved secrets and the hippodrome was the core of the mystery. If I could find it, I was confident of penetrating the mind of a dead emperor to ascertain the Temple treasure's fate under Justinian.

Outside my hotel, the morning light illuminated a poor Ukrainian ghetto filled with cold, industrious souls, their faces a pastiche of Russian and oriental features. Istanbul has always been a melting pot of cultures, a land and sea bridge where East meets West. Legend has it that the city was originally founded by Byzas of Megara around 660 BC, who lent his name to the city of Byzantium.

Byzantium was an unheralded backwater until the reign of Constantine the Great. The first Christian emperor needed a virgin capital fit for Jesus. Polluted by its bloodstained pagan altars and pantheon of gods, Rome was impure. Constantinople was consecrated on May 11, AD 330, and would remain the capital of a Late Roman and Byzantine Empire until the city fell to Sultan Mehmed II and the Ottoman Empire on May 29, 1453.

Constantinople was not only a clean slate for Christianity, it was also the spyglass for all that passed between the eastern and western Mediterranean. Here, the city could keep a beady eye on sea-lanes and land routes bridging Europe and Asia, the Black Sea and the Mediterranean. The city's natural harbors were outstanding, blessed with perfect docking opportunities along the Sea of Marmara and within a confluence of the Golden Horn and the Bosphorus. By AD 413, the city of Emperor Theodosius II had virtually doubled in size to five square miles, enclosing 250,000 citizens and monuments as impressive as any gracing Old Rome, including 14 churches, 14 palaces, 153 private baths, and 4,388 major houses.

The Russian Quarter is a concrete jungle of charmless boutiques peddling acrylic trousers and four-inch killer stilettos and boots adorned with myriad zips and straps. Up Ordu Caddesi Street I joined the daily grind of pedestrian traffic shuffling silently to work. I was unsure whether to blame the surreal hush of a city on the move on the weather or the hangover of a football defeat. My comrades and I passed Koska Helvacisi, a high-street wonderland founded in 1907 and stocked with a dizzying eleven varieties of Turkish delight stuffed with walnuts, coconut, hazelnut, and double pistachio. Later in Istanbul's Ottoman bazaars, I would see the same delights marketed as Turkish Viagra.

- 251 -

Unlike the streets of Rome—a living museum—Roman and Byzantine Constantinople rarely rears its head above the pavement. But opposite a dilapidated mosque, its facade brushed black by pollution, and Istanbul University's pink cement Faculty of Aquatic Sciences, stands a jigsaw of marble architecture quarried on the island of Proconnesus in the nearby Sea of Marmara. The emperor Theodosius's Forum, built in the late fourth century AD, is today reduced to a couple of large podiums, forgotten bases from a triumphal archway. On top, the upper sections of elegant column shafts have been gnawed away by the ravages of time. Curiously, their overall form is classically Roman, yet the decorative scheme is characteristically Byzantine. The carving is said to replicate peacock feather patterns, but looks more like the drip of giant tears.

Theodosius's Forum stood for over 150 years, and still attracted shoppers during the reign of the emperor Justinian, when the Temple treasure was in town. This marketplace was a major landmark along the Mese, the main arterial road that descended from the heart of Constantinople, the imperial palace and Church of Saint Sophia, west to the Golden Gate, and on to Thrace and the Balkans. Today the ruins are dwarfed by the main road, Anatolian gold jewelry boutiques, and kiosks offering freshly squeezed pomegranate juice. No one notices them. I walked on toward the center of ancient Constantinople.

Across the road in Beyazit Square the silent uphill commute continued. Street cleaners in glowing orange work suits swept up late autumnal leaves using old-fashioned witches' brooms and plastic pans cut out of oil cans. Constantinople would have approved: where Rome bought new and expensive, and discarded huge amounts of waste after a single use, the Early Byzantine Empire recyled everything from old stones to clay wine jars, whose broken sherds were refashioned into floor tiles and plaster temper.

Commuters quietly queuing for bread and *çay* (Turkish tea) shivered in the biting winter winds. On street curbs old men polished shoes from glass bottles filled with red, black, and brown dyes. A florist arranged wreaths on a cart, while a swarthy man grinned mischievously at me as

he sharpened his long knife and lighted rolls of charcoal to heat his kebab spit. Behind the smiling facade of Istanbul, however, is a more sinister world. Its backstreets offer a worrying array of rifles, pistols, and daggers, and for 15 Turkish lira you can also pick up *Intifada*, the video game.

A fter skirting the emperor Justinian's ecclesiastical masterpiece, the Church of Saint Sophia in the heart of modern Istanbul, I made my way down by the shore. A cart laden with fresh fish rolled past the Byzantine seawalls and I followed its progress uphill. This was the original route leading from Justinian's port to the hippodrome, although the journey taken by General Belisarius and the Temple treasure in AD 534 would have been glorious and not sullied by the smell of tuna and cod. But the route was identical and would have taken less than thirty minutes to cover. The triumph of AD 534 would have been far more low-key than in AD 71. Constantinople had nothing like the population density of first-century Rome and Justinian was paranoid about his colleagues' potential power, so downgraded Belisarius's triumph to little more than a parade. Nevertheless, its symbolism was in many ways equally as important to Justinian as it had been to Vespasian.

Trucks bursting with refrigerators, televisions, and microwaves precariously roped together rumbled down to the port, while I mulled over the similarities and differences between Old and New Rome. Rome was a brilliantly progressive empire, always looking to the future, a trailblazer in art, architecture, and politics. Thanks to endless television programs and films, we all know what the Romans did for us. But the Byzantine legacy from celebrities to wars, scandals, and art are hardly household names.

Constantinople, though, was far from a pale imitation of its older brother, but like all subsequent Mediterranean civilizations its achievements are completely dwarfed by the scale of Rome's brilliance. The Eternal City didn't just think big, it thought colossal. Compared to her, anything that followed would always look inferior. In many ways Constantinople was a bipolar place. In her preference for recycling old architecture into new monuments, New Rome was the original ecofriendly

— 253 —

society. The Byzantine state enjoyed vast wealth and could have commissioned spanking new monuments if it wished (and frequently did). Recycling is not about prosperity, it is a question of ideology, and the Byzantine Empire, in its respect for the built environment and earth's natural resources, has never been given the credit it deserves for this progressive legacy.

However, Justinian was also a tremendous patron, enabling Constantinople to produce extraordinary art and architecture. He popularized the dome, plucking the style from Roman bathhouses and temples like the Pantheon, for his flagship churches at Saint Sophia in the capital and as far and wide as Jerusalem and Ravenna, the former capital of the Later Roman Empire on the Adriatic coast of Italy. The stereotype of the dome as an Ottoman invention is myth. The gilded wall mosaics of Christ, the apostles, and New Testament scenes found in the Justinianic Church of Saint Sophia in Istanbul and Saint Catherine's monastery in the Sinai preserve the flavor of his lavish and innovative tastes. The alleys around Justinian's palace were also lively artisanal centers, where great craftsmen worked ivory and jewelry, engraved precious gems, and illuminated manuscripts. The emperor also introduced the highly lucrative and prestigious silkworm into Constantinople, converting the Baths of Zeuxippos alongside his palace into an imperial silk factory, where he could personally keep an eye on production.

Politically, modern Istanbul often feels like a tragicomedy, a hangover of the ancient Byzantine paradox. Society is progressive, yet strongly traditional. Turkey dreams of joining the money-spinning European Union; the West remains suspicious of her identity and ambitions. Many members are clearly terrified at the prospect of 63 million Muslims joining their club. The Cradle of Civilization is today trapped between East and West, geographically and socially. However, the country retains a healthy sense of humor over its geopolitics. Modern cartoons personify Turkey's current position in terms of an Ottoman man sitting backward on a donkey. The beast of burden moves slowly uphill, but his master faces in the opposite direction. Turkey is frustrated: she tries to embrace the West, yet is seen as backward thinking.

- 254 -

The emergence of this conflicted ideology can be blamed on Byzantine society. When he founded Constantinople, Constantine and his successors were besotted with Rome. Or rather, while simultaneously trying to escape her physical clutches, the new city needed to prove she was a worthy capital. Thus, New Rome—as she styled herself—also sat backward on a donkey. Politically this was the Roman Empire rekindled. Constantinople mimicked Rome geographically, claiming she too straddled seven hills. Even though the Early Byzantine Empire technically started with the relocation of Roman power to Asia Minor, her citizens still referred to their way of life as *romanitas*.

Nowhere is this split personality better exemplified than in the hippodrome, where Belisarius and the triumph of AD 534 paid homage to the emperor and the people. The hippodrome had been built by the emperor Septimius Severus at the same time as he renovated the Circus Maximus in Rome. Both used the same architectural blueprint. What was initially a freestanding theater of fun for Rome became the people's parliament in later years. The Byzantine emperors needed a forum to control the populace, a convenient soap box from which to monitor the mob. The hippodrome was that place, and how better to manipulate its political will than by sugaring a pill.

The hippodrome was the all-seeing eye of an Orwellian Big Brother that had a serious ulterior motive. The state-sponsored chariot races whirling around the arena, and the rivalry between the Blue and Green teams, were entertainments that kept the masses sweet, as were the daily dole rations distributed to the poor from here. However, the hippodrome was also the epicenter of the religious and imperial ceremonies that shaped the annual calendar.

In reality, Constantinople's inferiority to Rome was obvious. So its emperors went to extraordinary lengths to justify its imperial right of succession. Not without reason was the eastern capital dubbed New Rome. First and foremost, Constantine created a physical barrier to control his people in the form of a mighty palace surrounding the arena. Along with the city walls, which defended Constantinople from the enemy without, in his sixth-century *Chronicle* John Malalas tells us that the

- 255 -

emperor's first major building program in New Rome was to renovate the hippodrome and establish a palace to protect the empire from the enemy within:

He also completed the hippodrome and adorned it with bronze statues and with ornamentation of every kind, and built in it a *kathisma*, just like the one in Rome, for the emperor to watch the races. He also built a large and beautiful palace, especially on the pattern of the one in Rome, near the hippodrome, with the way up from the palace to the *kathisma* in the hippodrome by a staircase. (*Chronicle* 319)

In other words, Constantine deliberately emulated both the layout and the function of Rome's Circus Maximus and Palatine palace, and boosted his imperial control by merging the two: the palace now led directly to the royal box on the edge of the hippodrome. Palace and circus were thus one and the same, a physical artery bonding emperor, politics, and people. Never before had such an intimate and coercive policy been forged.

In AD 534, Justinian's city of 500,000 people was in no doubt that Constantinople, and more precisely the hippodrome and adjoining palace, was the center of the civilized world. The new didn't just imitate the old, it supplanted it. And the dominant means of conveying this message were the artistic masterpieces, steeped in symbolism, for which the Early Byzantine emperors ransacked the Mediterranean.

The hippodrome was in effect a museum where more than twentyfive famous antiquities were permanently exhibited. Here statues of the greatest rulers of classical antiquity rubbed shoulders, from Alexander the Great to the Roman dictator Julius Caesar and the emperors Augustus and Diocletian, ransacked far and wide from Rome to Nicomedia in modern Turkey. The legendary founders of Rome and, hence, of the Byzantine Empire, Romulus and Remus, were prominently displayed. Each year their foundation festival, the Lupercalia, was reenacted in the hippodrome. All of these golden memories united the great rulers of antiquity with those of the present. This was reputation by association.

- 256 -

Although Constantinople was originally selected to be a new imperial capital partly as a central Mediterranean bridgehead from which to launch operations against the northern barbarians and the eastern Persian threat, the city proved highly vulnerable. After the barbarians crossed the Danube in AD 378, no natural barrier existed to delay their menacing advance. To address this fear the emperor Theodosius created a deeper set of land walls in AD 413. Reflecting the mounting external threat, Anastasius I (AD 491–518) eventually turned to an even more extreme defense in depth, building a twenty-eight-mile-long wall forty miles west of Constantinople between the Black Sea and the Sea of Marmara. New Rome finally had its own Hadrian's Wall.

To protect the empire, palace, and people from the horrifying image of barbarians at the gates, the hippodrome was peppered with *apotropaia*: statues of Zeus, hyenas, and sphinxes, patron gods and talismans that warded off evil. This psychological shield with its veneer of imperial respectability was complemented by the greatest artistic wonders of the age, all assembled within the hippodrome's walls. The display of the Ass and Keeper originally displayed at Nikopolis in Epirus, Greece, to commemorate Octavian's momentous victory over Mark Antony—paving his transformation into the first and greatest of Rome's emperors, Augustus—now told viewers that after his decisive defeat of Licinius at Chrysopolis, Constantine was Augustus's equal.

All of these masterpieces and their conscious messages were intermixed with statues more naturally associated with a hippodrome. The great charioteers, horse tamers, and pugilists, the brothers Castor and Pollux, blessed the arena, as did Hercules, the epitomy of strength and guile, fighting the Nemean lion and outwitting the Hesperides sisters for their golden apples. Hercules' successful completion of the Twelve Labors made him the perfect symbol of male virility and aspiration, and thus the presiding genius of athletics competitions.

The reused antiquities reflected Constantinople's respect for classical Greek and Roman values, but more crucially harnessed the past to validate the present and future. The accumulation of the Mediterranean's greatest art under one roof, linked to the palace, sent out a powerful

— 257 —

message: the center of the civilized world had literally been transplanted to New Rome. The hippodrome became a microcosm of the universe, which the emperor controlled. In this respect Constantinople's hippodrome was a mirror image of Vespasian's Temple of Peace in Rome. And how better to boost control of the past and mastery of the future than to house here the Temple treasure of Jerusalem. The masterpieces already on show illuminated the Byzantine Empire's earthly domination. Possession of the Jewish menorah, table, and trumpets would allow Early Christianity to claim dominance of the heavens too.

HUNTING HIPPODROMES

35

I followed Belisarius's footsteps of AD 534 along the Kennedy Caddesi highway, only today I was pursuing the wheels of the fishmonger's cart rather than a gold-plated chariot. Other than stunted sections of seawalls, I passed little Byzantine architecture. Would the hippodrome where the Temple treasure was paraded reveal itself readily or had it been completed obliterated by modern development?

At Aksakal Sokagi Street I turned left up the steep slope of Istanbul's First Hill. Like the Palatine in Rome and Carthage's Byrsa Hill, this was the business end of ancient Constantinople, where the emperor and Senate held court—the White House, Pentagon, and Madison Square Garden all rolled into one. I roamed quiet backstreets, startling chickens looking for a comfortable bed where to lay an egg or two. Not ten minutes away from the throbbing nerve center of Istanbul, this district still feels like a sleepy peasant village.

I wound my way uphill past FedEx and UPS depots superimposed over ancient warehouses. The window of a wooden shack above a secluded children's playground suddenly cracked open to expose a buxom elderly lady, her head wrapped in a tea towel. She beat a rug against the side of her flimsy hut and stared at me, bemused by this oddity prowling the backstreets of Istanbul. I smiled back, relieved we no longer live in Ottoman times, when far worse refuse would have been thrown over me.

This distraction quickly faded as behind the shack my eyes focused

— 259 —

on a wall of red Byzantine brick. Some 50 feet tall, it curved uphill for about 100 feet. The arched entrances blocked with brick resembled one of Rome's finest architectural spectacles: the entrances to the Colosseum. Unblock the arches and you had exactly the same concept. A quick check of my medieval and modern maps confirmed my hunch: this was the monumental semicircular southern entrance to Constantinople's hippodrome, the *sphendone*, its walls now incorporated into an earthen bank supporting the edge of a hill and Marmara University. Crushed marble and pottery gleaming on the ground reminded me of long-forgotten splendors. The ghost of an Ottoman-period building, a cross section of its domed roof and floor still plastered against the Byzantine walls, made it clear just how lucky any section of the hippodrome is to survive in the urban jungle of Istanbul.

I hurried uphill, excited to discover what the hippodrome looked like on the summit. Rounding the corner, I was greeted by a series of yellow, pink, and blue wooden peasant huts opening onto a broad park dominated by the Blue Mosque to the east. But still no sign at all of any hippodrome superstructure.

Ottoman and modern Istanbul were alive and kicking, but Byzantium seemed obliterated. Turks dressed in baggy brown MC Hammer cotton trousers and suit jackets fed pigeons. The tones of an ice-cream van competed with the traditional cries of imams calling people to prayer across the city. While nothing of the hippodrome's walls still stands aboveground, a modern road now occupies the original contours of the charioteer's racetrack. I also spied the original central *spina* terrace intact, although now landscaped into a tranquil garden.

To the north the hippodrome's starting gates—the "barriers" to which General Belisarius paraded in the triumph of AD 534—have been consumed by the streetcar lines of Divan Yolu, the main road running from the Russian Quarter and Theodosius's Forum into the heart of Istanbul. The domed roof and minarets of the Church of Saint Sophia swallow the panorama and dwarf a stump of masonry, all that remains of the *Milion*, a four-way arch from which new Byzantine territories were mapped out. On the edge of the pavement a youngster sat at a

— 260 —

table with a rabbit, carrot, and a handwritten cardboard sign that invited you to part with some loose change and LET THE RABBIT TELL YOUR FORTUNE. I decided to give this wisdom a miss.

Unlike Rome's Circus Maximus, whose grassy banks still soar into the sky opposite the Palatine, Constantinople's hippodrome has been flattened. A bird's-eye view from the skies betrays its 1,476-foot-long elliptical contours, but on the ground the original layout has vanished. The stench of sweat and the 50,000-strong cheering throng are hard to resurrect. The arena's saving graces are three original antiquities still standing at the southwestern end of the central *spina* around which chariots once careered.

I walked down the flattened central terrace where bronze and marble statues of Hercules, an eagle, wolf, dragon, and sphinxes once gleamed in the eastern sun. A flower bed arranged in the shape of a crescent moon and five-pronged star, the flag of Turkey, adorns the original podium where a classical Greek statue of Helen of Troy was once on show. Today not one statue of Helen survives, but in the late twelfth century Niketas Choniates, chancellor of the Byzantine Empire, enjoyed a close encounter with this beauty, revealing:

She appeared as fresh as the morning dew, anointed with the moistness of erotic love on her garment, veil, diadem, and braid of hair. Her vesture was finer than spider webs . . . the diadem of gold and precious stones which bound the forehead was radiant. . . . The lips were like flower cups . . . and the shapeliness of the rest of her body were such that they cannot be described in words and depicted for future generations. (*Historia* 652)

Helen of Troy may have vanished, but three of the hippodrome's surviving antiquities still hint at the arena's original style. Farthest south is a roughly built pillar of stone soaring 105 feet high. Once sheathed in bronze, its original function remains a mystery. Nearby is the Serpent Column, composed of the intertwined bodies of three bronze snakes and, according to local legend, with venom enclosed in its walls. Now only eighteen feet tall, the column was originally sur-

mounted by three snake heads supporting an enormous bronze victory bowl. These relics once formed the shaft of a trophy that was the centerpiece of the Temple of Apollo at Delphi, seat of the great Oracle, where it had been dedicated to the god by the thirty-one Greek cities that defeated the Persians at Plataea in 479 BC. This Greek masterpiece remained intact in the hippodrome well into the medieval period. Only in April 1700 did the Serpent Column come to an ignoble end, when an exuberant member of the Polish embassy sliced off the snake heads under the influence of raki, the next best thing to stealing police traffic cones.

The most complete ancient monument surviving within the hippodrome, however, is Theodosius's Column. Once again, it was time to confront an old "Roman" friend. Atop a sculpted base is Constantinople's token Egyptian obelisk, yet another nod to artistic tastes in Old Rome. Commissioned by the pharaoh Tutmosis III (1504–1450 BC), it stood originally in Egypt's Temple of Amon at Deir el-Bahri opposite Thebes. Weighing 800 tons, and 88 feet tall, the skewer is covered with hieroglyphs commemorating the pharaoh's victory over Syria. The obelisk, however, broke during its sea voyage to New Rome, where a disgusted Constantine abandoned it by the shore. A few decades later, in AD 390, the emperor Theodosius salvaged the monument: the surviving upper two-thirds of the obelisk were mounted on four bronze blocks and an exquisite marble sculpted base.

I was especially keen to examine this slab of marble during my trip to Istanbul because it was decorated with the faces of Theodosius and the royal family enjoying a day out at the hippodrome: the very scenes that Justinian and Belisarius would have experienced in the triumph of AD 534. One side of the base brings to life the emperor receiving homage from barbarian captives; on another, his nephew, Valentinian II, ruler of the western Roman Empire, and his sons Honorius and Arcadius, hand out laurel wreaths to a sporting hero. I stared long and hard at the *kathisma*, the royal box sculpted onto the base of Theodosius's Column as an arched chamber supported by columns and jutting out across the hippodrome. Soldiers armed with spears and shields guarded the royal

- 262 -

box just as they would have when the Temple treasure was paraded here. The tightly packed crowd in the hippodrome is also visible, as well as chariots tearing around the arena to a backdrop of dancing maidens and musicians (whose poor artistic perspectives make them look more like aliens). This artwork gets us unusually close to the atmosphere and geography of the Byzantine triumph.

After breathing in the bygone atmosphere of a day at the races, I crossed the *spina* and entered the courtyard of the Blue Mosque, which hovers over the exact position of the Byzantine palace and *kathisma*, the most powerful seat in the Byzantine Empire. Here emperors communicated with their people, entertained the masses, and celebrated their omnipotence. The concept reminded me of a more sophisticated version of medieval jousting. From the elevated mosque podium above the entrance stairs I replayed in my mind the magic of the triumph of AD 534, as recorded for posterity by Procopius:

And there was booty—first of all, whatever articles are wont to be set apart for the royal service—thrones of gold and carriages in which it is customary for a king's consort to ride, and much jewelery made of precious stones, and golden drinking cups, and all other things which are useful for the royal table. And there was also silver weighing many thousands of talents and all the royal treasure amounting to an exceedingly great sum (for Gaiseric had despoiled the Palatium in Rome . . .), and among these were the treasures of the Jews, which Titus, the son of Vespasian, together with certain others, had brought to Rome after the capture of Jerusalem. (*Wars* 4.9.4-6)

So, I had been right all along: the Jewish Temple treasure was recaptured from the floating treasure chest at the port city of Hippo Regius. Finally, the Vandal king Gelimer had been coaxed down from his hiding place among the Moors on Mount Papua. The final straw had been the failing health of his children, who had started discharging worms. Gelimer would eventually be exiled with his family to Galatia in modern central Turkey, but for now was compelled to endure public humiliation and pay obeisance to Justinian. Procopius writes:

- 263 —

And there were slaves in the triumph, among whom was Gelimer himself, wearing some sort of purple garment upon his shoulders, and all his family, and as many of the Vandals as were very tall and fair of body. And when Gelimer reached the hippodrome and saw the emperor sitting upon a lofty seat and the people standing on either side and realized as he looked about in what evil plight he was, he neither wept nor cried out, but ceased not saying over in the words of the Hebrew scripture, "Vanity of vanities, all is vanity." And when he came before the emperor's seat, they stripped off the purple garment, and compelled him to fall prone on the ground and do obeisance to the Emperor Justinian. This also Belisarius did, as being a suppliant of the emperor along with him. (*Wars* 4.9.10–12)

Not much survives of Early Byzantine Constantinople, but enough texts and ruins to resurrect snapshots of the triumph of AD 534. Theophanes Confessor would later confirm Procopius's report of the Temple treasure's presence there. The event may have been a heavily diluted version of Vespasian's spectacular showcase of AD 71, but nevertheless this was a pivotal rite of passage. For a very brief period of time Justinian was able to enjoy the sense of being a Roman lord of the entire Mediterranean. But was God's gold kept in this place of entertainment that doubled up as a public museum? These were irrational times. The end of classical antiquity was fast approaching. Justinian's reign would mark the curtain call of *romanitas*. The Dark Ages were coming and time was running out for the Temple treasure of Jerusalem. 36

IMPERIAL WAR GAMES

Like modern Turkey, Constantinople lived for today but grounded its political institutions and social habits firmly in the past. Thus, the hippodrome wasn't a museum in the modern sense but a museum of the mind, a place where emperors and citizens were subtly brainwashed into believing they were worthy successors of Rome with no reason to feel inferior. The recovery of the Temple treasure of Jerusalem was a coup for Justinian, a divine reminder from God that Christianity was the chosen successor to the Judaism of the Old Testament. The new world religion fully appreciated the legacy. As the cradle of the Bible, Palestine was in imperial favor, reinvented as the Holy Land. Pilgrimage to the biblical sites was encouraged, popular itineraries went on sale, and the concept of tourism was invented.

Some five centuries old, the Temple treasure of Jerusalem was a terrific showcase for Justinian's city. Back in England I had pondered long and hard about the destiny of the Jewish loot in Constantinople: Where was it kept? Was it publicly exhibited? How long did it remain in the capital? After being paraded in the hippodrome, surely it would have been logical to keep it in this "museum."

The answer would have been straightforward if the reign of Justinian had been rational. So far Justinian has appeared to be a defender of the Catholic faith and a strong leader willing to make tough military decisions. However, the man was also a psychopath who could compete with Nero or Caligula for moments of mental instability.

- 265 -

Justinian has gone down in history as a master builder who made King Herod look like small fry. In Constantinople, he built Saint Sophia, the greatest church in Christendom, and filled the city with endless marbles and monuments. Across the empire he threw buckets of gold at new cities like Justiniana Prima in modern Serbia, refortified old towns, constructed new ports, and erected places of worship in a quest for immortality.

So much for the official party political line. In truth, the modern image of Justinian is of an insecure and selfish egomaniac who not only bankrupted the treasury, but also heralded the end of classical antiquity, a world that had endured for over a thousand years. His reign was saturated with scandal from the moment he married a former prostitute. Theodora, the daughter of Acacius, a keeper of wild beasts in the amphitheater of Constantinople, had a shocking reputation. In the sanctimonious words of Procopius, "On the field of pleasure she was never defeated. Often she would go picnicking with ten young men or more, in the flower of their strength and virility, and dallied with them all, the whole night through . . . she flung wide three gates to the ambassadors of Cupid" (Secret History 9).

An embittered Procopius chronicled the life of Justinian and Theodora blow by sordid blow. The same courtier who had so faithfully recorded the great deeds of the Byzantine army against the Arian Vandals returned home to Constantinople angry and disillusioned. Of course, he could do little physically or politically to counter the emperor's erosion of imperial and family values. So, with feathered nib dipped in poisoned ink he composed his *Secret History*, a work that could never be aired during Justinian's lifetime without costing the historian his life. The chance survival of this work is a unique counterbalance to Procopius's formal documentation and an amazing window into the social life of one of the greatest epochs of antiquity. Procopius clearly detested his paymaster and did not hold back the punches.

The truth about Justinian probably lies somewhere between the two extremes of the *Wars'* trumpet blowing and the *Secret History*'s venom. Certainly, Theodora calmed down after marriage, reinventing herself as

an ancient Eva Perón. The ex-prostitute turned empress founded the Convent of Repentance for reformed prostitutes and was renowned for sheltering monks in her own palace. Theodora was also the champion behind a successful campaign to end Monophysite Christian persecution. No doubt Procopius had good reason to denounce Justinian and his wife, but we must beware of accepting the full details of their scandalous life verbatim.

However, there is no smoke without fire and Justinian epitomized the ultimate Early Byzantine identity crisis with good reason. First of all, like New Rome in terms of succession he had no real ancestral claim to the throne because his uncle, Justin I, was by birth an uneducated soldier in the palace guard who started life as an Illyrian peasant. However he shuffled the pack, in the dead of night Justinian knew full well he was not of noble birth and was in many respects an imposter. This background explains his eccentric and unstable behavior. Procopius accused Justinian and his low-class wife, Theodora, of ruling like vampires, sucking the life out of the empire:

For he was at once villainous and amenable; as people say colloquially, a moron. . . . His nature was an unnatural mixture of folly and wickedness . . . deceitful, devious, false, hypocritical, two-faced, cruel, skilled in dissembling his thought. . . . A faithless friend, he was a treacherous enemy, insane for murder and plunder, quarrelsome and revolutionary, easily led to anything evil, but never willing to listen to good counsel, quick to plan mischief and carry it out. (*Secret History* 8)

Justinian was accused of ruling the empire through corruption, selling positions of power to the highest bidder, and enforcing his will through a web of spies. His personal neuroses extended to the enemy without, and the emperor stripped the treasury coffers to finance his colossal fortifications building program. Certainly, the Sasanian war drums beating in Persia were a very serious threat to western ways, but Justinian built fortifications as if they alone would protect him from his internal demons, the emperor depleting the treasury's entire gold reserve.

- 267 -

What makes it hard to second-guess Justinian's behavior, and thus the fate of the Temple treasure under his control, is his unpredictability. General Belisarius, you might presume, would have become a great celebrity back in Constantinople. After all, he was honored with a triumph. Not so. Justinian fancied that Belisarius held imperial ambitions and was a threat to the throne. He also accused him of hiding most of the loot seized from the Vandals. Whipped into a frenzy by Theodora, Justinian was riddled with jealousy at Belisarius's success.

So the battle-weary general who had put his life on the line for the empire ended up under house arrest, the ultimate humiliation. To make matters worse, Belisarius had to contend with his wife pursuing a string of public affairs that made him the talk of the town and the butt of endless jokes. Procopius tells us that Belisarius was a broken man, certain he would be assassinated: "Accompanied by this dread, he entered his home and sat down alone upon his couch. His spirit broken, he failed even to remember the time when he was a man; sweating, dizzy and trembling, he counted himself lost; devoured by slavish fears and mortal worry, he was completely emasculated" (*Secret History* 4).

Justinian was not a man of clear logic, and I seriously doubted that he would have left the divine power of the Jewish candelabrum, Table, and trumpets on public display in the hippodrome after the triumph of AD 534. God's gold was too precious. Some very peculiar archaeological evidence in Istanbul's suburban district of Saraçhane also hinted at a different reality. There, in AD 526, craftsmen were putting the final touches on one of the greatest churches in Christendom, the Church of Saint Polyeuktos, named after a soldier martyred for his Christian faith at Melitone in eastern Turkey in AD 251, and perhaps best known from Pierre Corneille's play *Polyeucte* (1642) and an opera by Charles Gounod (1878).

Of the thousands of churches that sprang up across the Mediterranean between the fourth and seventh centuries, the Church of Saint Polyeuktos was unique. Its construction was sponsored entirely from the deep pockets of one of the most formidable women of the Byzantine world, Princess Anicia Juliana (AD 462–528). Juliana was the

greatest heiress of her age, a woman of great distinction. Her mother was descended from the emperor Theodosius the Great and her father, Flavius Anicius Olybrius, traced his lineage back to notables who had fought Hannibal seven centuries earlier, and briefly served as emperor of the West. Juliana's own husband had even been offered the throne, but refused the honor.

The Church of Saint Polyeuktos was built inside three years, from AD 524 to 527, and lay along the processional route, the Mese, running from the Forum of Theodosius to the hippodrome and palace. In 1960, bulldozers developing Istanbul's new city hall bit into the side of the church by chance. The structure was subsequently excavated over six years from 1964 by Professor Martin Harrison of Dumbarton Oaks Institute in Washington, D.C., and Dr. Nezih Firatli of the Istanbul Ar-chaeological Museum.

By 1964, hundreds of ancient churches had been uncovered by eager archaeologists the length and breadth of the Mediterranean, but Saint Polyeuktos turned out to be unique. The church measures just under 560 square feet and is arranged around the usual central nave and side aisles. Its brick barrel-vaulted passageways and crypt with marble floor—which no doubt once held the bones of Polyeuktos—proved remarkably well preserved.

If the church's layout was of standard plan, the originality and scale of decoration blew the archaeologists away. Over ten thousand pieces of marble came to light, imported from across the civilized world: red porphyry from Egypt, green porphyry from the Peloponnese, yellow *giallo antico* from Tunisia, green *verde antico* from Thessaly, black marble flecked with white from the Pyrenees, purplish marble streaked with gray and white from Bilecik in Bithynia and, of course, abundant local Proconnesian marble from the Sea of Marmara.

Offset against this marble rainbow was extremely elaborate inlay: serrated leaves of mother-of-pearl and strips of yellow glass coated with gold leaf. New styles of columns appeared for the first time, decorated with squares of amethyst framed by green glass triangles and gold strips, a futuristic departure from Roman ideals. If the precious stones made

- 269 -

Princess Juliana's church gleam, the quality of the architectural sculpture set new standards for ecclesiastical structures. With their wealth of experience, Professor Harrison and his team had never seen anything approaching the underdrilled lattice- and strap-work sculpture. Exuberant vegetation, especially vine leaves, had been cut so delicately that it was virtually detached from its background. Elsewhere, painted peacocks were rendered realistically in the round. Four types of "basket" capitals, another Byzantine innovation, complemented a dazzling range of stylized plants and palmettes. For novelty, variety, abundance, and technical quality, nothing like this had ever come to light before.

What made Princess Juliana tackle an innovative project that left all previous church design schemes in its wake? The church is believed to have once annexed her palace, still undiscovered. Does this explain the glory of Saint Polyeuktos? What statement was Juliana trying to make?

These unanswered questions played on my mind as I cut through an arch of the aqueduct built by the emperor Valens in AD 375. Where freshwater once flowed into the heart of Constantinople, the aqueduct's arches now support the Bahceli Kafeterya café and a host of fizzy drink refreshments. Trucks and taxis dart through the arch, hardly pausing to gauge its dangerously narrow hips. Today, the district between the Forum of Theodosius and the Church of Saint Polyeuktos houses the core of Istanbul University. Students rushed to class past the Blue King Disco and Bar and specialist music shops stocking exotic ouds, eleven-stringed large-bodied stringed instruments with short stems, very similar to the European lute.

The key to Saint Polyeuktos is a vivid Greek poem discovered inside the church. The first forty-one lines were carved around stone grape vines and peacock sculptures extending along the church's nave before proceeding into the narthex and courtyard. The poem, preserved in full in the eleventh-century Palatine Anthology, praises Princess Juliana's royal descent and the miraculous quality of her new church. One section of the immortal dedication reads:

What choir is sufficient to sing the work of Juliana, who, after Constantine—embellisher of his Rome, after the holy golden

- 270 -

light of Theodosius . . . accomplished in a few years a work worthy of her family, and more than worthy? She alone has conquered time and surpassed the wisdom of renowned Solomon, raising a temple to receive God, the richly wrought and graceful splendor of which the ages cannot celebrate."

The princess evidently wanted to blow her own trumpet, but surely claiming to have "surpassed the wisdom of renowned Solomon" was not just arrogant but blasphemous? Why would a god-fearing Christian claim such celebrity? The plot thickens even more when the unit of measurement with which the Church of Saint Polyeuktos was laid out enters the equation. Princess Juliana boldly and bizarrely rejected contemporary architectural standards. Not for her the Greek, Roman, or Byzantine foot.

Instead, she resurrected an ancient legacy based not just on the biblical cubit but the royal cubit King Solomon used to build the First Temple of Jerusalem. This is an outstanding revelation; none of the thousands of Early Christian churches recorded as far afield as Israel and France dared follow in Solomon's footsteps. The cubit traditionally measured the length of a man's forearm, from his elbow to clenched fist, and was the principal unit of linear measurement in the Bible. Using the royal cubit of 1.7 feet, the Church of Saint Polyeuktos measured precisely 100 royal cubits (169 x 170 feet). A sanctuary that probably overlay the crypt spanned exactly 20 cubits square: the exact dimensions of the Holy of Holies in Solomon's Temple.

Given this biblical emulation, the church's decorative scheme no longer seems eccentric. Its rich vegetation simply mimics I Kings 6:29: "Round all the walls of the house he carved figures of cherubim, palmtrees, and open flowers." Only here winged cherubim were replaced by peacocks, symbols of Byzantine empresses and royalty.

The relevance of the Church of Saint Polyeuktos to the Temple treasure is obvious. It was built as a replica of Solomon's Temple, so where would be more fitting to deposit the birthright of the Chosen People than in a temple fit for God? Did Saint Polyeuktos fit the bill? This enigma was a key reason behind my trip to Istanbul. Certainly,

— 271 —

the timing fits. In AD 532, the greatest church in Constantinople, Saint Sophia, had burned down. Justinian's new creation was commissioned from Anthemius of Tralles and Isidorus of Miletus, theoretical engineers who designed a "wonderdome." Saint Sophia, however, was only dedicated in 537. So for ten years Saint Polyeuktos was the largest and most sumptuous church in Constantinople.

Modern Saraçhane is today a vibrant hub of local politics and higher education. Machine-gun-toting police saunter in front of the town hall, its exquisite gardens landscaped with fountains and water pools tiled with blue swirling mosaics. Busts of civic dignitaries like Hizir Bey Çelebi, the first mayor of Istanbul in 1453, keep a beady eye on modern wheeling and dealing.

Across the road, Şehzade Camii, the Mosque of the Prince, and its turban-topped Ottoman grave markers, weeps across the skyline. Even the graceful genius of Sinan, chief architect of the Ottoman Empire, cannot hide the structure's sadness. The mosque was commissioned by Süleyman the Magnificent in memory of his eldest son, Prince Mehmet, who died of smallpox in 1543.

Unfortunately, nothing magnificent about the Church of Saint Polyeuktos survives today, I discovered. The ruins, in fact, are an embarrassing eyesore. A fortune has been spent on a delightful park adjacent to the church. Old men mull over the good old times under shaded trees, as passing businessmen off to impress civil servants in the town hall present their shoes for a quick polish. Locals hawk tea next to the park's primeval "Stonehenge" sculpture. Students and nurses stride toward the Medical Park Hospital, but no one bothers with the Byzantine ruins, in desperate need of surgery.

Today the sagging green-mesh wire fencing surrounding Saint Polyeuktos has been cut open to facilitate a new use for one of Istanbul's most important monuments. The church has been transformed into a municipal garbage dump and, worse still, a latrine overflowing with human excrement. Princess Juliana's golden walls are now rendered black from tramps' night fires. In the West, historians speak in hushed tones about this amazing church and what it has taught us about the Byzan-

- 272 -

tine world. The reality was a deep disappointment to me. The church has died an unflattering death; both Polyeuktos and Princess Juliana must surely be turning in their graves. I couldn't help but wonder if the monument would have been better protected if an Ottoman ruler had stuck a minaret over its walls.

However, the date and unique design of the Church of Saint Polyeuktos made it the prime candidate as the destination of God's gold in Constantinople. But one major dilemma troubled the theory: Justinian's hatred of the Princess Juliana. Both royals knew that his claim to the throne was ancestrally bogus. Justin I, his uncle, had been a nobody promoted above his station. Juliana had expected the throne to pass to her own son, the younger Olybrius, after the death of Anastasius in 518, and with time her profound contempt for Justinian became increasingly public. Did more than four generations of royal blood count for nothing?

Juliana was the emperor Justinian's bête noire, the Church of Saint Polyeuktos a dynastic statement immortalizing her family's noble lineage. When the emperor demanded a contribution from Juliana for the rebuilding of the Church of Saint Sophia, she cheerfully invited him to pop over to Saint Polyeuktos and help himself. On entering the church Justinian discovered that the princess had hammered her entire wealth into golden plaques coating the divine roof. A house of Christian worship could not be ransacked, even by an emperor, and Justinian knew he had been outfoxed. No wonder when the Church of Saint Sophia was finally dedicated in 537 he declared, "Solomon, I have vanquished thee." In other words, his flashy new building outstripped Princess Juliana's.

The feisty aristocrat died in AD 528, and Justinian confiscated her church-palace after her son was implicated in a plot against the emperor and sent into exile. Under these circumstances would Justinian have housed the Temple treasure so far away from the seat of power? If not, was it put on public display in the hippodrome or thrown into his palace dungeon? Did the Temple treasure end up in Constantinople in the Church of Saint Polyeuktos, the hippodrome, or the imperial palace?

The hippodrome museum was certainly a likely candidate. Brilliant

273 -

bronze and marble masterpieces graced its central terrace, but none were royal treasures of such religious and symbolic sensitivity. This left one last alternative, Justinian's enormous terraced palace, which the emperor rebuilt from scratch after Constantinople went up in smoke during the Nika revolt of January AD 532. Over four days of rioting and anarchy, everything from the churches of Saint Sophia and Saint Irene to the Senate House and great porticoes of the city were reduced to ashes by bloodthirsty Blue and Green sports hooligans. Justinian's new palace stretched from the *kathisma*—royal box—in the hippodrome all the way down to the sea, a distance of more than half a mile.

A tantalizing clue to the riches once stored inside the palace lies in an obscure passage by Procopius. While painting a picture of Justinian's new building work after the fire, he described the Chalke (Bronze Gate), the palace's main entrance, where eight arches enclosed a miraculously decorated room:

And the whole ceiling boasts of its pictures, not having been fixed with wax melted and applied to the surface, but set with tiny cubes of stone beautifully coloured in all hues, which represent human figures and all other kinds of subjects. . . . On either side is war and battle, and many cities are being captured, some in Italy, some in Libya; and the Emperor Justinian is winning victories through his General Belisarius, and the General is returning to the Emperor, with his whole army intact, and he gives him spoils, both king and kingdoms and all things that are most prized amongst men. In the centre stand the Emperor and Empress Theodora, both seeming to rejoice and to celebrate victories over both the King of the Vandals and the King of the Goths, who approach them as prisoners of war to be led into bondage. (*Buildings* I.10.15–17)

If only this ceiling mosaic survived. In reality, almost nothing of Justinian's great palace exists amid the Ottoman ruins of Istanbul other than a few rooms of extremely fine mosaics. If it had, Procopius's allusions are sufficient to be sure that the scene would have included the actual presentation of the Temple treasure of Jerusalem to Justinian in

274 -

the hippodrome triumph of AD 534. This would have been Constantinople's equivalent of Rome's Arch of Titus. Instead, the site of the Chalke Gate is today covered by parklands between the Blue Mosque and the Church of Saint Sophia.

I walked over the original site of this forgotten legacy, but could not reconnect with antiquity. Istanbul had yielded all of its secrets and it was time to jump on another plane. Before disappearing, though, I had one final stop to make: I wanted to look through a window into the Byzantine past and collect my thoughts. Did the quest for the Temple treasure of Jerusalem draw to a close in central Istanbul? And if so, where was God's gold stored?

Down by the shore, several hundred feet east of Justinian's port, swallowed by modern urban sprawl, is a remarkably well preserved section of the Byzantine palace, seawall, and modern shacks joined together, its owners' washing flying in the wind. The ruins were deserted; I had them all to myself. Fallen leaves chased cars down the Kennedy Caddesi highway. Several hundred feet away the site of Justinian's private jetty is marked by a soaring white tower, an all-seeing eye overlooking the Sea of Marmara, its horizontal radar rotating monotonously. Next to the seawalls a Byzantine lighthouse reminded me, yet again, of modernity's debt to the past.

Exhausted from my travels, I sat on a wall and absorbed the scene confronting me. Eight arched windows with three of their windowsills intact framed the best-preserved surviving section of Justinian's sixthcentury AD palace. These delightfully situated royal apartments once accommodated the emperor and his wayward wife. Here they whispered sweet nothings and plotted how to exploit the empire for ever greater riches. The seat of their power is today an exquisite spectacle. Romantic red creeper droops down the palace walls and swallows flitted from window to window. The red-brick veneer feels more medieval castle than Roman palace.

My reverie was all too soon rudely shattered by a black-and-white sheepdog snarling down from the right-hand window. His warning bark reminded me that my journey was incomplete. I had one final

- 275 -

stop to make. The treasure's journey had not ended in Istanbul at all. In describing the "treasures of the Jews" presented to Justinian during Belisarius's triumph of AD 534, Procopius emphatically reported an altogether different fate:

And one of the Jews, seeing these things, approached one of those known to the emperor and said: "These treasures I think it inexpedient to carry into the palace in Byzantium. Indeed, it is not possible for them to be elsewhere than in the place where Solomon, the king of the Jews, formerly placed them. For it is because of these that Gaiseric captured the palace of the Romans, and now the Roman army has captured the Vandals." When this had been brought to the ears of the Emperor, he became afraid and quickly sent everything to the sanctuaries of the Christians in Jerusalem. (*Wars* 4.9.6–9)

Justinian was a split personality controlling a city of paradoxes. He was lord of the Mediterranean, yet at the same time scared of his own shadow. The emperor saw plots and conspiracies all around him. Deeply respectful of his classical inheritance, and familiar with the destructive power of the Jewish treasure, no doubt Justinian's paranoia prevented him from putting it in his own palace, either near the hippodrome or in front of me by the seashore. So in all likelihood it did end up, after all, in the Church of Saint Polyeuktos, where the emperor was happy for it to wreak havoc on the House of Anicia Juliana. The subsequent relocation of the Temple treasure back to the Holy Land was also precisely the kind of quixotic behavior to be expected of Justinian. How ironic that the birthright ripped out of the heart of Jerusalem in AD 70 to travel the world should now end up where it started: back in Jerusalem.

THE Holy land

SANCTUARY OF THE CHRISTIANS

37

The gun-toting Israeli army girls can hardly have been out of their teens. Behind amicable smiles and blue military security uniforms we exchanged pleasantries, as they methodically ransacked Abou George's rusting car. The towers of Jerusalem could be seen down the road in the morning dew. Ahead sprawled the unappetizing wasteland of the West Bank.

What would typically have taken Abou George, an Israeli Arab, several hours of pleading and negotiation, only took me three minutes. George would usually have been treated as suspicious until proven innocent. By contrast, I was virtually waved through, a jovial Westerner flashing a United Kingdom passport and conversing in basic Hebrew. What would the soldiers have thought if they knew the truth, that I was about to detonate a political explosion by exposing the fate of the two-thousand-year-old Temple treasure—Israel and Judaism's ultimate birthright—literally under their noses, less than thirteen miles from the Temple Mount?

The main road into Bethlehem's Manger Street, the traditional site of Jesus's birth, is today inaccessible. It wouldn't make any difference if you were a wise king, you would still not get through. A twenty-sixfoot-high slab of concrete bars access, part of Israel's 140-mile-long security fence. Abou George took a detour, wiggling his car over potholes until he finally found a narrow gap in the concrete curtain.

We left the ghost town of Bethlehem behind and headed into the

- 279 -

wilderness of Judea. The flattened summit of the artificial hill of Herodium, King Herod's palace and mausoleum, loomed into sight. A stench of sewage swamped the air; mangy donkeys sniffed out blades of grass by the dusty road. This no-man's-land is inhospitable and uncomfortable. I wasn't ecstatic to be here, but the truth was just around the corner. My destination was the Arab village of Ubeidiya and the Monastery of Saint Theodosius. Why was I here, playing a dangerous game in the Hamas-controlled West Bank?

We left the Temple treasure with Justinian in sixth-century AD Constantinople. Procopius had revealed that an anonymous Jewish courtier had just spooked the Byzantine emperor with a worrying revelation: every civilization possessing the treasure since AD 70 had crumbled—the Jews of Israel, Rome, and finally the Vandals. Justinian, a great student of the enduring life force of antiquity, dispatched the golden candelabrum, Table of the Divine Presence, and silver trumpets back to the sanctuaries of the Christians in Jerusalem. The treasure had come home, but when and where?

The repatriation clearly took place before Justinian's death in AD 565, and can be narrowed down further to the date when Procopius of Caesarea, chronicler of Byzantium's wars with the barbarians, put down his pen in AD 554. The historian alleged the emperor's decision was a spontaneous decision made at the time of the triumph of AD 534. Allowing for Procopius's sense of drama, perhaps chronologically compressing several historical events, the most logical conclusion dates the relocation of the Temple treasure at between AD 535 and 554.

At this time the Holy Land was enjoying a golden age when emperors and aristocrats were pampering the biblical homeland. Religious circumstances had transformed a sleepy Roman backwater into a gold mine. Between AD 330 and 640 literally hundreds of churches and monasteries emerged across Palestine, boosting the local economy and the prosperity of society at large. Nobody typified this exuberance more than the empress Eudocia, who expended 20,480 pounds of gold (1.5 million gold coins) building churches in Palestine between AD 438 and 460, at a time when one person could live off two gold coins for a year.

- 280 - "

Dozens of ecclesiastical buildings sprang up inside cities—at the latest count over 255 churches and 50 monasteries.

Even though ancient texts gloss over the precise movements of the treasure in Byzantine Palestine, only one place would have been sufficiently holy to house them: Jerusalem's Church of the Holy Sepulchre. In AD 335, five years after founding Constantinople, Constantine the Great dedicated the Martyrium basilica at Golgotha, an Aramaic term meaning "place of a skull." What would later become world renowned as the Church of the Holy Sepulchre straddled the holiest place on earth to Christianity, the traditional location of Christ's crucifixion (Rock of Calvary) and tomb (holy sepulchre).

The Church was appalled at the condition of the hallowed ground, which the Roman emperor Hadrian had polluted in AD 135 with a temple dedicated to Venus, goddess of love. Constantine tore down the temple's walls and healed its profaned soils with a Christian basilica, 192 feet long and 133 feet wide. A semicircular annex supported by a circle of columns, the Anastasis, would be added later. The basilica was surrounded by double porticoes and three gates faced the rising sun, opposite which was a dome crowned by twelve columns, symbolizing the apostles, surmounted by silver bowls.

The fourth century AD witnessed a new global phenomenon that would persist into the modern era—tourism. Rather than a cultural extravaganza, the Byzantine "grand tour" was a religious pilgrimage to the holy sites described in the Bible. Scrolls could be bought setting out itineraries, and safe hostels, *mansiones*, sprouted up every fifteen miles across the empire. The Church of the Holy Sepulchre swiftly gained a reputation as the epicenter of Christian pilgrimage. Here was the physical spot where Jesus was said to have been crucified, and where his tomb was located. Even more spectacular, however, pilgrims could gaze at the True Cross of Christ, which went on display after Helena (AD 248–329), the mother of Constantine the Great, found it rather conveniently lying between an inscription and two other crosses. Further attractions included the reed, sponge, and lance from the Crucifixion story inside the Chamber of Relics.

The True Cross was a huge sensation. Writing around AD 348, Cyril of Jerusalem confirmed that the "the holy wood of the cross, shown among us today . . . has already filled the entire world by means of those who in faith have been taking bits from it." Wearing lockets containing fragments of the cross became the latest fashion. More often than not, zealous pilgrims, who had risked life and limb to get to Jerusalem, just couldn't resist biting off a bit of the relic when they were finally allowed to bow over it and kiss the gnarled wood.

In reality, the survival of an intact Roman Cross in the soils of Jerusalem is virtually impossible. The ground is neither waterlogged nor arid enough to create a sufficiently anaerobic environment. But this didn't matter. Belief is a state of mind, and the relic certainly served a crucial missionary role. Ironically, the arrival of the far older and historically authentic Temple relics was not met with any fanfare. On the contrary, Christianity had taken over three hundred years to break free from the shackles of Judaism and paganism and was not about to have its thunder stolen. The repatriation of the Jewish treasure to Jerusalem was a double-edged sword for the city's patriarchs, which reflected the very real muscle-flexing between Church and State. But the patriarchs adhered to Justinian's imperial prerogative and, if I'm right, quietly locked the Temple relics away in a deep recess of the Church of the Holy Sepulchre.

The West Bank's timeless landscape drifted passed my window. Goatherds and flocks idled by water cisterns, a vista frozen since biblical times. Across the fields terraced walls of stones built by Jewish farmers remain fossilized since the Roman era.

The Temple treasure of Jerusalem languished beneath the Church of the Holy Sepulchre for seventy years, as untouched as this panorama. With its special status as the Holy Land, the flagship of early Christianity, Byzantine Palestine was initially insulated from the deep cracks starting to split the empire at large. But the end of antiquity was just over the horizon.

Justinian may have been a distinguished builder and resolute leader

- 282 -

who successfully reconquered Roman North Africa, but just like King Herod at the port of Caesarea, from where the Temple treasure was originally shipped to Rome, and now submerged thirty-three feet beneath the Mediterranean, he was powerless against Mother Nature. In mid-July AD 541 calamity struck the Byzantine Empire. Black rats boarded a ship at Pelusium in southern Sinai and headed for the harbor of Constantinople. The bubonic plague ravaged the city for four months, with 10,000 souls dropping like flies each day. The corpse administrators stopped counting when the dead numbered 230,000.

Once they had consumed the capital, the rats were on the move once more, jumping ship to export death as far and wide as Naples and Syria. In the great port cities, delirious merchants swore they saw headless Ethiopians sailing brass ships and maliciously spreading disease along the beaches. The leader of the Monophysite Syriac Church, John of Ephesus, moaned that in Palestine "all the inhabitants, like beautiful grapes, were trampled and squeezed dry without mercy."

The Justinianic plague was a highly contagious evil of biblical proportions. If the vehicle of death was *Rattus rattus*, the bullet was the Nilotic flea, *Xenopsylla cheopis*, which could jump sixteen inches off the ground and induced hallucinations, fever, severe diarrhea, and eventually bubonic swelling in the groin, armpits, ears, and thighs. Weeping with pus, victims would end up in a deep coma and generally die after two or three days. The first great pandemic in history had a mortality rate of 78 percent, wiping out one-third of the entire Mediterranean population. After the initial rage, like a forest fire the plague reemerged every twelve years, eventually reaching Britain and Ireland in AD 664. Only in AD 750, after eighteen outbreaks, did the curse run out of steam.

The empire never had time to recover from this initial shock. Further hammer blows continued to rain down. From AD 547 to 548 a succession of apocalyptic curses struck the East. Violent earthquakes shook the coastal metropolises of Tyre, Sidon, Beirut, Tripolis, and Ptolemais (Acre) in Palestine with such velocity that mountaintops fell into the sea. Tsunamis inundated maritime cities, and terrifying thunder and lightning crisscrossed the skies. In AD 556–557, a spear-shaped fire ap-

— 283 —

peared in the heavens and in AD 610 a solar eclipse haunted earth.

With the empire on its sickbed, the Sasanian Persians, who had been knocking on the gates of the East for decades, finally launched an all-out attack. In AD 613, Persian forces under the command of Chosroes II, the self-styled king of kings, crushed Damascus and swept south into Palestine, just as Rome had done almost five and a half centuries earlier. According to Procopius, his predecessor, Chosroes I, had dreamed of getting his hands on the treasures of Palestine since AD 542: "And his purpose was to lead the army straight for Palestine, in order that he might plunder all their treasures and especially those of Jerusalem. For he had it from hearsay that this was an especially goodly land and peopled by wealthy inhabitants" (*Wars* 2.20.18–19).

Most of the province willingly bowed down to the King of Kings, and as the coastal cities of Caesarea, Apollonia, and Lod capitulated to his Sasanian forces, a historical marvel occurred for the first and last time. The region's Jews, united in celebration at the shackles of Christianity cast off after three hundred years, joined the ranks of a Persian force and its "Arab" confederates. For the first and last time in Middle Eastern history, Arab and Jew shared swords.

The Sasanian resolve hardened as Jerusalem came into view. Following a twenty-day siege in April AD 614, the holy city was sacked for three days. Those fit and able fled town. Widely respected holy men, such as John Moschus and Sophronius, fled by ship to Syria, while the thousands of monks minding their own business in the wilderness of Judea sought refuge in Arabia. The Holy Land was abandoned to the invaders.

In Jerusalem almost every ecclesiastical building was ransacked or burned down, its treasures looted. The Churches of Gethsemane and Eleona on the Mount of Olives were torn apart, as was the Church of Saint John the Baptist. The Persians ran through the streets, inflicting random destruction and decapitating priests. In the Convent of Saint Melania, 400 nuns were raped. Tens of thousands of Christians were sacrificed for the cause and 66,000 skilled workmen enslaved to Persia.

Antiochus Strategos, a monk from the monastery of Saint Sabas in Jerusalem, saw at first hand the bloodletting across the city in AD 614 and recalled the horrors in *The Sack of Jerusalem*:

For the enemy entered in mighty wrath, gnashing their teeth in violent fury; like evil beasts they roared, bellowed like lions, hissed like ferocious serpents, and slew all whom they found. Like mad dogs they tore with their teeth the flesh of the faithful, and respected none at all . . . massacred them like animals, cut them in pieces, mowed sundry of them down like cabbages. . . . Then their wrath fell upon priests and deacons: they slew them in their churches like dumb animals. . . .

Some had their belly cloven asunder with the sword and their entrails gushing out, and others lay cut into pieces, limb by limb, like the carcasses in a butcher's shop. . . . Some had fled into the Holy of Holies, where they lay cut up like grass. . . . Others were clasping the horns of the altars; others the holy Cross, and the slain were heaped on them. Others had fled to the Baptistery and lay covered with wounds on the edge of the font. Others were massacred as they hid under the holy table, and were offered victims to Christ.

The invasion ceased as rapidly as it had started. Palestine was, in reality, no more than a launchpad for the ultimate goal, an assault on Egypt, now the richest province in the Byzantine Empire. The Sasanians returned home counting their booty and left their Jewish allies to mop up. After so many years of oppression and life as second-class citizens, the Jews reacted with grim ferocity. In Acre they set fire to a church, tortured the deacon, and burned Christian books of prayer. At Tyre they systematically destroyed churches, but ended up losing a war of attrition: every time a church fell, the inhabitants of Tyre decapitated 100 fettered Jews and threw their heads over the ramparts. The pile of headless dead was said to have numbered 2,000 by the time the Jews capitulated. The Sasanian commanders eventually lost patience with the Jews' wrath, crucifying many and seizing their property. Once again, the children of the Old Testament were expelled from the gates of Jerusalem.

— 285 —

During these decades of chaos and confusion wrought by man and nature, what happened to the Temple treasure? The texts are silent on the matter but what is the most logical historical scenario? God's gold was almost certainly spirited away. Pillage was clearly the name of Persia's game, and the Sasanians deliberately targeted the True Cross of Christ as the most valuable icon of Christianity. The anonymous author of the *Khuzistan Chronicle* clarifies that in Jerusalem General Shahrbaraz

breached all the walls and entered it, seizing the bishop and the city officials, torturing them [in order to get hold of] the wood of the Cross and the contents of the treasury. . . . God left no place secret which they did not show the Persians; they also showed them the wood of the Cross which lay concealed in a vegetable garden. The [Persians] made a large number of chests and sent them along with many other objects and precious things to Khosro.

Some five and a half centuries earlier, the Romans had seized the menorah, Table, and trumpets from Herod's Temple to leave no doubt about who was the new boss in town. The Sasanians were treading a predictable path in removing the True Cross to Ctesiphon in Iraq.

Arab sources speak volumes about the fate of the Cross, but include absolutely no reference to the Temple treasure, leading to the conclusion that it never reached Persia. With a rich cast of historians such as al-Waqidi (AD 745–822), al-Baladhuri (died AD 892), al-Muqadassi (born AD 946) and al-Bakri (1014–1094), its absence in Early Islamic texts is revealing. I suspect the Sasanians and Jews cut a deal. The discovery of the True Cross was a struggle. The Persians had to torture numerous priests, and eventually even the Patriarch Zacharias, until it was discovered buried in a gold box in a garden. Did the Jews extract a confession about the whereabouts of the Temple treasure using similar torture? Certainly this would explain what they were doing violating the tomb of Christ:

The descendants of the crucifiers also approached the Persian commander and told him that all the gold and silver and the treasures of Jerusalem were placed beneath the tomb of Jesus.

- 286 —

Their crafty design was to destroy the place of the burial. When he yielded to them they dug some three cubits around it, and discovered a casket with the inscription: "This casket belongs to Joseph the Councillor"—the man who provided the tomb for the body of Jesus. *(Khuzistan Chronicle* 23)

But God's gold was no longer present. The Jewish commanders failed to find the treasures of the Second Temple for one obvious reason. Just as the modern discovery of the ancient menorah would be met with rapture among many Jews and evangelical Christians—a divine sign paving the way for the immediate building of a Third Jewish Temple in Jerusalem—so in AD 614 the Christian community resolutely refused to furnish the Jews with any ammunition that would justify the building of a new Jewish city. But the treasure cannot simply have disappeared into thin air.

Amid the cloud of death swirling across Jerusalem, the Patriarch Zacharias was taken hostage and dragged off to Persia. A remarkable man replaced him. Modestus is one of the forgotten major luminaries of ancient history, but a rare visionary in a time of appalling chaos. While the lights of classical antiquity—a Greco-Roman world that had endured since the fifth century BC—were going out across the eastern Mediterranean, this man of God held the beacon of Christianity up high.

On the eve of the Persian invasion, Modestus was serving as *hegumen* (superior) of the monastery of Saint Theodosius at Deir Dosi, today in the West Bank. By AD 614, Zacharias and Modestus already enjoyed a close working relationship based on deep mutual respect. When the threat to Jerusalem materialized, the patriarch quickly summoned the monk and, according to the chronicle of Antiochus Strategos, "bade him go and muster men from the Greek troops which were in Jericho, to help them in their struggle."

Once Zacharias was taken hostage, Modestus filled the breach, becoming locum tenens in his absence. After a truce was agreed upon between the Sasanian and Byzantine forces, the monk dedicated what would prove to be a brief life to burying the Christian dead and rebuilding the holy places of Palestine. Modestus traveled to Lod, Tiberias,

- 287 -

Tyre, and Damascus, personally raising funds to renovate the Church of the Holy Sepulchre, which reopened amid jubilant scenes in AD 621. The monk successfully petitioned John the Almsgiver, Patriarch of Alexandria, to donate money, supplies, and a thousand Egyptian workmen to help rebuild and repair the churches.

From AD 628 to 635, Palestine was back under Byzantine control. The gleaming domes of the Church of the Ascension on the Mount of Olives and the Church of Holy Zion shone once more. In March AD 630, the Sasanians even returned the True Cross to the Byzantine emperor Heraclius, who accompanied it home to the Church of the Holy Sepulchre. During his visit the emperor was so impressed with Modestus's work that he installed him as the new Patriarch of Jerusalem and diverted Palestine's poll tax to fix up the holy places. Modestus was the new hero of the Christian Church and lost no time expanding his mission. Things were looking up.

But this proved to be a false dawn. Who knows to what heights this visionary might have soared? Somehow, somewhere during these years of instability, Modestus ruffled the wrong feathers. One dark spring day in AD 631, the new patriarch stopped overnight at the port city of Arsuf, Roman Apollonia, before sailing up to Damascus where further donations awaited him. After praying in the local church and being impressed by the revitalized commerce down by the warehouses, Modestus sat down to dinner. For reasons unclear, a member of his entourage poisoned the patriarch's meal. His death was quick. Modestus had only been in the top job for nine months.

38

DESERT CITY OF SAINTS

Abou George took the dirt road eastward toward Mar Saba, one of the oldest inhabited monasteries in the world, rock-cut and camouflaged on the side of a steep canyon. Nearby fields surround the cave of Beit Sahour, where a few humble shepherds were tending their sheep centuries ago when a supernatural light hovered over their heads and a voice proclaimed Christ's birth.

Modestus had not been ready to die—he left no will behind or plans for a successor. In the years following the Persian invasion the monk kept his unswerving eye firmly on the goal of rebuilding the city of God. Nothing else mattered. Yet if I was right, with the Patriarch Zacharias captive, it was Modestus who spirited away the Jewish treasures from the Church of the Holy Sepulchre in AD 614. After the sack of Jerusalem the city was filled with Jewish soldiers until Heraclius expelled them in AD 630. In this climate I suspect Modestus took the wise decision to keep the Temple treasure under lock and key, away from dangerous hands. As his name suggests, the future patriarch was a private man well capable of keeping decisions close to his chest.

By the summer of AD 631, Modestus was dead; three years later, four Muslim forces invaded Syria. Islam was on the move, with the prophet Muhammad advising his troops to

attack in the name of God. Fight the enemies of God and your enemies in Syria. You will find there men in cells isolated from people. Do not oppose them. You will find others in whose head

— 289 —

Satan lives like nests. Cut them off with your swords. Do not kill a woman, a nursing infant, or an old man. Do not strip any palm tree. (al-Waqidi, *Kitab al-maghazi* 2.758)

In 640, King Herod's old port of Caesarea fell after a seven-year siege. Classical antiquity, dead in the West for over a hundred years, was now also officially ended in the East Mediterranean. Islam would remain master of Palestine for the next 1,280 years until the collapse of the Ottoman Empire and emergence of the British Mandate in 1920. The secret of the Jewish Temple treasure's hiding place died with Modestus and was buried under the chaos of the Arab Conquest. Christianity was overrun and the Byzantine Empire shoehorned back into the Bosphorus.

So where would Modestus have concealed the Second Temple gold menorah, bejeweled Table of the Divine Presence, and silver trumpets? Certainly out of town, beyond Jerusalem, and most obviously in one of the myriad monasteries manned by the silent lips of monks in the wilderness of Judea. However, archaeologists have identified a baffling forty-two monastic retreats ringing Jerusalem. Which one fit the bill?

The answer seems logical. Even in his capacity as patriarch, Modestus was still the superior of the monastery of Saint Theodosius. Today, this retreat survives at Deir Dosi, seven and a half miles east of Bethlehem and close to the West Bank village of Ubeidiya. This way my date with destiny, but I would need to walk on eggshells: for political reasons I didn't want either the Israeli or Palestinian authorities to get wind of what I was working on. Furthermore, the monastery lies deep in Hamas territory. I had been warned to watch my back due to the political tension.

Saint Theodosius was born at Marissa in Cappadocia (modern Turkey) in AD 423, before assuming a life of piety in Jerusalem. The record of his life, penned by his disciple Theodorus, Bishop of Petra, confirms that he was an extreme ascetic who denounced all material comforts: "for dreading the poison of vanity from the esteem of men, he retired into a cave at the top of a neighbouring desert mountain, and employed his time in fasting, watching, prayers, and tears, which almost continu-

- 290 -

GOD'S GOLD

ally flowed from his eyes. His food was coarse pulse and wild herbs: for thirty years he never tasted so much as a morsel of bread."

In time, his piety attracted a large following, forcing him to abandon his cave and open a monastery, whose crypt overlies another cave where the Three Wise Men, the Magi, allegedly rested on their way to visit the Holy Manger. Both the fame and size of the establishment rapidly grew until the monastery of Theodosius became "a city of saints in the midst of a desert, and in it reigned regularity, silence, charity, and peace," according to Theodorus. The complex housed three infirmaries for the sick, aged, and feeble, and ended up like the United Nations. Theodosius pursued an inclusive open-door policy, building four churches:

One for each of the three several nations of which his community was chiefly composed, each speaking a different language; the fourth was for the use of such as were in a state of penance, which those that recovered from their lunatic or possessed condition before-mentioned, were put into, and detained till they had expiated their fault. The nations into which his community was divided were the Greeks, which was by far the most numerous, and consisted of all those that came from any provinces of the empire; the Armenians, with whom were joined the Arabians and Persians; and, thirdly, the Bessi, who comprehended all the northern nations below Thrace, or all who used the Runic or Slavonian tongue.

Theodosius died in AD 529, and after Modestus's poisoning in AD 631 the monasteries of the Judean desert dwindled like dried-up vines. Nobody has ever studied its ancient ruins scientifically, so its precise history under early Islam remains a mystery. Its widespread popularity certainly ceased, yet I remained intrigued by what secrets survived within its grounds.

I rounded a corner to be confronted by the Greek Orthodox Catholic monastery of Theodosius, key to so much secret history, perched on the edge of a deep valley. I imagined Modestus wearily arriving here with a camel caravan so many centuries ago, burdened by mysterious boxes. The same sense of isolation remains; nothing stirs. The air is thin

- 291 -

Sean Kingsley

and dry. Even in winter the ancient landscape is desperately parched; its thin soils support little life. Scars of white bedrock peer out of the hillside bare of sustenance. The only people who live here today are the monastery's four guardians and the Abediyah Bedouin, whose tin-can and matchstick camp I spied halfway down the valley.

My heart pounded at the prospect of the unexpected as I approached the monastery gates. Its walls were certainly built of ancient Byzantine stone masonry, but embedded within the plaster of the latest reincarnation. The tops of a redbrick dome and tower, both surmounted with a Cross, peered tantalizingly above the thirty-three-foot-high walls. What treasures lay within? The closer I got, the more I sensed something was not quite right. The outer walls were covered with Arabic graffiti, and all the windows and doorways were completely sealed with reddish brown iron gates and grilles. Were these to keep people in or out?

With the entrance barred and no sign of life visible, I walked along the monastery's facade looking for a way in. No luck. The monastery was as impenetrable as a medieval castle and silent as the grave. The only link to the outside world seemed to be a slither of orange bailing twine hanging between the inner wooden door and the iron grille. I pulled the string down sharply and a bronze bell hanging high above my head inside the monastery announced my arrival. A minute passed with no response. Abou George looked at me and sighed. I hadn't come all this way—across the seas and nearly six centuries of history—to be so simply dismissed. I yanked the bell rope twice again and hollered a "hello" at the gate. There wasn't even a letterbox to peer through. Finally, footsteps stirred somewhere deep in the bowels of the monastery.

The muffled voice of an elderly woman spat out something in Greek, completely incomprehensible. In slow English I asked her if we might enter the hallowed monastery. No reply. Abou George then tried in Hebrew and Arabic. Nothing doing. The Sister had departed. Yet again I heaved on the rope. Tired legs approached and a severe voice firmly told us, "Go away. Entry not possible." And that was that. Perplexed, I wondered if the people within were busy, fearful, or had something to hide.

Before I could collect my thoughts a couple of Palestinian police

GOD'S GOLD

cars skidded to a halt, covering us with a cloud of dust. Three young policemen jumped out and engaged Abou George in conversation, largely one-way traffic. Clearly embarrassed, George, a private and quiet man, was forced to display his passport and explain his movements so far off the beaten track. I was explained as a British tourist visiting the holy places. The team seemed satisfied. They looked me up and down and sped off. Abou George shrugged.

If I couldn't get inside the monastery, I was at least committed to poking about its grounds to satisfy my curiosity. In particular, I needed to find out if a monastery really did exist here at the time of the Persian invasion. I left Abou George looking worried, locked inside his car with Israeli license plates inside Hamas lands, and headed down the valley. The monks had grown prickly cacti all along the monastery's walls to discourage entry. I clambered over the fencing and found myself in an unpromising field.

The monastery turned out to be a simple structure, comprising a central courtyard surrounded by towers and side wings housing a chapel and accommodation. Two stone terrace walls protected the main building. Grayish white bedrock and shallow pockets of soil surrounded me, suitable for nothing other than the hardy olive tree. After scanning the landscape in vain for standing structures, I spent the next hours surveying the fields and got my answers: enough white mosaic cubes, clay roof-tiles, and fragments of oil lamps, pottery bases, and rims to be certain that a monastery stood on the site in the sixth and early seventh centuries. In particular, I picked up the tops of some bag-shaped amphoras and a bowl with a simple incurving profile known as Jerusalem Fine Byzantine Ware.

Thrilled with my results, I was just about to make my escape and liberate Abou George when I spied a pile of soil out of the corner of my eye and froze in my tracks. A cold flush of anxiety gripped me. The heap of soil was fresh and beneath it was the entrance to an underground cave. I was not equipped with a flashlight, and since most of the entrance was concealed anyway, there was no way of gaining access. What was going on?

— 293 —

Sean Kingsley

Further along the hillside were three other pockets of freshly disturbed soil, clearly less than a week old, above what looked like cave entrances. Unfortunately, I knew exactly what I was looking at: the telltale signs of illicit metal detecting. Treasure hunters had beaten me to the monastery. Why had they focused on this ancient site? How had they known about its antiquity? Had someone perhaps tipped them off? Impossible. Nobody outside my very tight circle knew what I was up to in the West Bank.

What was certain, and a surprising piece of news that made my mind race and heart pound, was the revelation that the hills surrounding the monastery of Saint Theodosius were honeycombed with underground caves and cavities. Maybe this was another compelling reason why Modestus brought the Temple treasure to his old monastery. The same local geology that had created the cave where the Three Wise Men slept on their way to Bethlehem had also riddled the region with secret subterranean hideouts. One thing was certain, only God now knew what the treasure hunters had already got their hands on.

Troubled, I returned to the car and an equally uncomfortable Abou George, who jumped out of his skin when I rattled on the window. George was clearly not amused at having been left alone for hours, here of all places. He felt like a sitting duck and was very keen to head for home. "Not safe here," he told me. "Very dangerous security situation. Everywhere not safe."

However, before he could start the engine I was off again. A yellow tour van had pulled up outside the monastery and it seemed the guide was receiving the same short shrift as I. He turned out to be Ilias, a jovial Palestinian from Bethlehem, who had recently returned from studying in Denmark and Portugal. Ilias confirmed that my welcome at the monastery gate was nothing personal. "They're not letting anyone in. Many times I come; we don't know why. It's really amazing. Is written in books it must be open every day. Little bit disappointing. The Sister refuses to speak."

He was both deeply frustrated and embarrassed. The West Bank's economy was completely shredded and he was fearful of losing his only

- 294 —

GOD'S GOLD

source of income, limited tourism. Ilias explained how the monastery felt trapped and isolated, ringed by Hamas sympathizers. The proof was all around, and he pointed to the black and red graffiti coating the monastery's walls that read "Youth . . . we are a river of giving. We don't know weakness" (the calling card of Hamas) and "You remain in our Palestinian hearts, Abu Ammar," Yasser Arafat's nom de guerre.

Since returning from Europe, Ilias had been severely stressed. Nothing changes in this Wild West of the East, he told me. "The politics is still the same. There's no development on the ground, so the people are getting more depressed, as if they've given up. I've never seen this look in their eyes—no meaning to life, no belief, no trust."

Yet again I realized just how fortunate I was to be able to return to a relatively predictable, stable world. This everyday battle for existence encapsulated everything malignant about the Middle East. I had my answers, and both Abou George and I were relieved to be heading back to the civilized comforts of Jerusalem and, in my case, on to London.

At the checkpoint out of Bethlehem we sat on the ground and left the military police to search the car for contraband and bombs. I took the opportunity to check my digital photos and quizzed Abou George about why the hill on which the monastery of Saint Theodosius sits was riddled with holes. George works in the building industry and certainly knew of no current or scheduled development work there.

After looking at my photos, out of nowhere George added, "Maybe they are looking for gold or treasure."

"Is there treasure there?" I replied, playing innocent.

"Who knows? Maybe," concluded Abou George cheekily, a twinkle in his eye.

39

CITY OF GOD, WORLD OF MAN

Back in Jerusalem I ended up where I had started, along streets where Jewish sedition had turned the Holy City bloodred in AD 69. The Wailing Wall was teeming with tourists enjoying the sounds, sights, and benefits of the twenty-first century. My memories of the West Bank seemed like from a different planet.

My quest was over, and the tides of history I'd chronicled washed over me in waves. The present felt unreal; mind and body were in chronic need of decompression. Pottering around the Old City of Jerusalem before flying back to London, I hoped that the urban buzz and oriental smells would bring me back down to earth. But instead I remained marooned between time and space.

After so many years pursuing the tail of a blazing comet, my final clue left me in a quandary. Should I try to return to the West Bank with a scientific team of archaeologists and a fluxgate magnetometer to bounce sonic pulses through the soil in search of caves and ancient cultural anomalies? Would the Israeli and Palestinian authorities even grant me a research license if they knew my true aims? What if the Temple treasure had already been looted from an underground cave in the grounds of the monastery of Saint Theodosius?

I flicked on my iPod and sat on a bench in front of the Wailing Wall watching Jews worshipping their God and Muslims quietly making their way onto the Haram al-Sharif to pray to Allah. The Herodian masonry separating both is less than ten feet wide, but a chasm broader than the

GOD'S GOLD

Red Sea divides their ideologies. The Black Eyed Peas playing "Where Is the Love" on my iPod questioned the disappearance of human values and equality, and the rise of human animosity.

The Temple treasure of Jerusalem means different things to different people. To many it is the gold at the end of the rainbow, the key to riches beyond dreams. If the menorah, Table of the Divine Presence, and silver trumpets materialized in the antiquities market, they would quite simply be priceless and stir up the mother of all political storms.

Out of curiosity, I had discussed the financial implications of the treasure turning up with Dr. Jerome Eisenberg, director of Royal-Athena Galleries in New York and one of the world's most successful antiquities dealers. He confirmed that these masterpieces are "the greatest religious treasures known to man, well beyond the value of any object or painting on the planet." Eisenberg stressed that no precedent exists for market-ing ancient art of such religious heritage. So there would be no objective means of setting a reserve price or insurance value for the Temple treasure. "Certainly some city tycoon would pay \$1 billion for the *Mona Lisa*," he pointed out, "which means that in the case of the value of the Temple treasure, the sky's the limit. You would be talking billions rather than hundreds of millions of dollars."

But the spoils of Vespasian are not just the greatest biblical treasure on earth. As the symbol of an ancient Jewish House of God and dream of a messianic future, the Temple treasure is also a source of immense danger. Justinian was right. Both Judaism and Islam have a track record of manipulating archaeological remains to try to enhance rights to the Temple Mount. Only in 2004 was a famous ivory priestly scepter, long given pride of place in the Israel Museum as an eighth-century BC original from the Temple of Jerusalem, denounced as a forgery. Inscribed "Belonging to the Temp[le of YHW]H, holy to the priests," we now know that while the artifact dates back to the thirteenth or twelfth century BC, the inscription is a modern fake. An inaccurate surface patina and incorrect syntax betray the mind and hand of the forger.

Even more controversial is a fifteen-line Hebrew inscription incised on a sandstone tablet, which surfaced in 2003. The text purports to be

- 297 -

Sean Kingsley

a record of renovations ordered by Jehoash, the biblical ruler of ninthcentury BC Judea. Here the king commands the Temple priests to take "holy money . . . to buy quarry stones and timber and copper and labor to carry out the duty with faith." Again scientific tests of the patina and studies of the language have damned the object as an outright fake. Allegedly uncovered in a Muslim cemetery east of the Temple Mount, its convenient provenance is extremely suspect and undeniably invented for political purposes. The Temple treasure is intimately enmeshed in these deadly political claims for indigenous origins. If it surfaced it would be seen as a divine sanction for a Third Temple to arise on the Mount at the expense of the Dome of the Rock—an appallingly provocative idea that could not be implemented without vast loss of life.

The question of racial diversity—what makes people different—has long perplexed mankind. Ancient intellectuals understood cultural difference in terms of environmental determinism—they blamed it all on the weather. Rome maintained a sense of what, much later, would become know as natural selection. Vitruvius, for instance, believed:

Those that are nearest to the southern half of the axis, and that lie directly under the sun's course, are of lower stature, with a swarthy complexion, hair curling, black eyes, and but little blood on account of the sun. Hence, too, this poverty of blood makes them overtimid to stand up against the sword . . . the truly perfect territory, situated under the middle of the heaven, and having on each side the entire extent of the world and its countries, is that which is occupied by the Roman people. In fact, the races of Italy are the most perfectly constituted in both respects—in bodily form and mental activity to correspond to their valour. (*On Architecture* 6.10–11)

The debate over geography, religious superiority, and the racial divide endures today in the Arab-Israeli conflict. Both Jews and Muslims alike claim the greater territorial rights to the Temple Mount. Why do politicians insist on focusing on ethnic differences rather than myriad religious and social similarities? Historians and archaeologists expose universal laws of human behavior that make a mockery of such artificial

- 298 -

GOD'S GOLD

philosophies. The prosperity, decline, and fall of the four civilizations I met during my quest for the Temple treasure—Israel, Rome, the Vandals, and the Byzantine Empire—confirmed parallel patterns of long-term action and reaction.

Take the Colosseum in Rome, for instance. Paid for by the emperor Vespasian with spoils plundered from the Jewish Temple in Jerusalem, eventually even the greatest theater of antiquity succumbed to the beating waves of history. In 1452 Pope Nicholas V ordered the removal of 2,522 cartloads of its stones for lime production. That lime ended up bonding the walls of the Basilica of Saint Peter, today inside Vatican City. So in one sense, Israel's Jewish birthright does indeed still languish, "locked away," in the heart of Rome. We are only ever custodians of ancient heritage.

In my own quest I also knew that if the Temple treasure came to light I would be guilty of fueling the battle for Jerusalem, and thus the Arab-Israeli conflict, by offering some people new dreams, others deadly nightmares. There and then in the heart of Jerusalem's Old City I decided to leave my revelations to fate. Looking out over the Wailing Wall and thinking of the glorious treasures it once housed, I recalled the words of Plato's *Laws*, written in the mid–fourth century BC, in which the Greek philosopher similarly pondered the ethics of digging up buried treasure and concluded:

I should never pray to the gods to come across such a thing; and if I do, I must not disturb it nor tell the diviners. . . . The benefit I'd get from removing it could never rival what I'd gain by way of virtue and moral rectitude by leaving it alone; by preferring to have justice in my soul rather than money in my pocket, I'd get—treasure for treasure—the better bargain.

Plato, of course, was writing about an ideal world that never existed. Even so, I like to think I am a hyperrealist and that my decision to end my pursuit for the long lost Temple treasure of Jerusalem at this stage was the most rational and responsible reaction. The amazing stories and lessons of the past are about knowledge, not possession. I had

- 299 -

Sean Kingsley

reached the end of the line. Perhaps, as I write, the most powerful objects of biblical faith are locked away in some bank vault, with billions of pounds being negotiated on a private sale. I hope not and cross my fingers that the treasure hunters who had been scouring the West Bank left empty-handed.

One thing is certain, the Temple treasure isn't in the Vatican, nor crushed beneath the ruined cities of Rome, Carthage, Istanbul, or Jerusalem. The gold menorah, precious Table of the Divine Presence, and silver trumpets ended up in a "city of saints," hidden in the grounds of the monastery of Saint Theodosius in the wilderness of Judea. As I bade my farewell to Jerusalem, I stared one last time at the Temple Mount, and offered up a little prayer that the treasures remain hidden for all time, sealed beneath swirling desert sands, far from the treacherous clutches of man.

SELECT BIBLIOGRAPHY

Ancient Sources

All books published by Harvard University Press form part of the Loeb Classical Library series.

Atwater, R. trans. Procopius of Caesarea: Secret History. New York: Dorset Press, 1992.

Brock, S. trans. The Khuzistan Chronicle. Unpublished.

- Butler, A. trans. The Lives of the Fathers, Martyrs and Other Principal Saints, Volume 1. London: Virture and Co., 1926.
- Cary, E. trans. *Dio's Roman History*. Cambridge, Mass.: Harvard University Press, 1927.
- Colson, F. H. trans. *Philo I.* Cambridge, Mass.: Harvard University Press, 1929.
- Danby, H. trans. The Mishnah. Oxford: Clarendon Press, 1933.
- Dewing, H. B. trans. Procopius of Caesarea: History of the Wars. Cambridge, Mass.: Harvard University Press, 2000.
 - ------. Procopius of Caesarea: Buildings. Cambridge, Mass.: Harvard University Press, 1940.
- Ginzberg, L. trans. *Legends of the Jews, I: From the Creation to Jacob.* Philadelphia: Jewish Publication Society of America, 1975.

—. Legends of the Jews, III: From the Exodus to the Death of Moses. Philadelphia: Jewish Publication Society of America, 1975.

-----. Legends of the Jews, IV: From Joshua to Esther. Philadelphia: Jewish Publication Society of America, 1975.

- Hadas, M. trans. Aristeas to Philocrates (Letter of Aristeas). New York: Ktav, Dropsie College for Hebrew and Cognate Learning, 1951.
- Jeffreys, E., M. Jeffreys, and R. Scott. trans. *The Chronicle of John Malalas*. Melbourne: University of Sydney, 1986.
- Jones, H. L. trans. *The Geography of Strabo*. Cambridge, Mass.: Harvard University Press, 1923.

— 301 —

Select Bibliography

Macdonald, C. trans. *Cicero X.* Cambridge, Mass.: Harvard University Press, 1977.

- Mango, C., and R. Scott. trans. The Chronicle of Theophanes Confessor. Oxford: Clarendon Press, 1997.
- Marcus, R. trans. *Philo II: Questions and Answers in Exodus.* Cambridge, Mass.: Harvard University Press, 1953.
- Moorhead, J. trans. Victor of Vita: History of the Vandal Persecution. Liverpool: Liverpool University Press, 1992.
- Morgan, M. H. trans. Vitruvius: The Ten Books on Architecture. Oxford: Oxford University Press, 1914.
- Palmer, A. trans. *The Seventh Century in the West Syrian Chronicles*. Liverpool: Liverpool University Press, 1933.
- Rackham, H. trans. *Pliny: Natural History IV, Books 12–16.* Cambridge, Mass.: Harvard University Press, 1945.

Rolfe, J. C. trans. Ammianus Marcellinus III. Cambridge, Mass.: Harvard University Press, 1939.

- Thackeray, H. St. J. trans. *The Letter of Aristeas*. Cambridge, Mass.: Harvard University Press, 1918.
 - ------. Josephus: The Jewish War. Cambridge, Mass.: Harvard University Press, 1997.
- Whiston, W. trans. The Works of Josephus. London: T. Nelson and Sons, 1890.

Select Bibliography

ROOTS

- Alfoldy, G. "Eine Bauinschrift aus dem Colosseum," Zeitschrift für Papyrologie und Epigraphik 109 (1995): 195–226.
- Claridge, A. Rome: An Oxford Archaeological Guide. Oxford: Oxford University Press, 1998.
- Hopkins, K., and M. Beard, The Colosseum. London: Profile Books, 2005.
- Kingsley, S. Shipwreck Archaeology of the Holy Land. London: Duckworth, 2004.
- La Regina, A., ed. Sangue e Arena. Rome: Electa, 2001.

ISRAEL—LAND OF GOD

- Adler, M. N. "The Itinerary of Benjamin of Tudela," Jewish Quarterly Review 16 (1904): 453-476.
- Allegro, J. M. *The Treasure of the Copper Scroll.* London: Routledge and Kegan Paul, 1960.

^{-----.} Pliny: Natural History IX, Books 33-35. Cambridge, Mass.: Harvard University Press, 1939.

- Ambrosini, M. L. The Secret Archives of the Vatican. London: Eyre and Spottiswoode, 1970.
- Asher, A. The Itinerary of Rabbi Benjamin of Tudela. Berlin: A. Asher and Co., 1840.
- Brooke, G. J., and P. R. Davies, eds. *Copper Scroll Studies*. Sheffield: Sheffield Academic Press, 2002.
- Broshi, M., and H. Esshel. "Daily Life at Qumran," Near Eastern Archaeology 63:3 (2000): 136-139.
- Brown, J. A. John Marco Allegro: The Maverick of the Dead Sea Scrolls. Grand Rapids, Mich.: William B. Eerdmans, 2005.
- Cline, E. Jerusalem Besieged: From Ancient Canaan to Modern Israel. Ann Arbor: University of Michigan Press, 2004.
- Gichon, M. "Industry," in M. Fischer, M. Gichon, and O. Tal, 'En Boqeq: Excavations in an Oasis on the Dead Sea, Volume II: An Early Roman Building on the Dead Sea Shore. Mainz: P. von Zabern, 2000.
- Goldhill, S. The Temple of Jerusalem. London: Profile Books, 2004.
- Hammond, P. C. "The Nabataean Bitumen Industry at the Dead Sea," *Biblical Archaeologist* 22:1 (1959): 40-48.
- Harper, J. E. "Too Much to Believe? 26 Tons of Gold and 65 Tons of Silver," *Biblical Archaeology Review* 19:6 (1993): 44-45, 70.
- Harter, S., F. Bouchet, K. Y. Mumcuoglu, and J. E. Zias. "Toilet Practices Among Members of the Dead Sea Scrolls Sect at Qumran (100 BCE–68 CE)," *Revue de Qumran* 21:4 (2004): 579–584.
- Hirschfeld, Y. Qumran in Context: Reassessing the Archaeological Evidence. Peabody, Mass.: Hendrickson Publishers, 2004.
- Humbert, J.-B. "Interpreting the Qumran Site," Near Eastern Archaeology 63 (2000): 140–143.
- Humbert, J.-B., and J. Gunneweg. *Khirbet Qumran et Ain Feshkha II. Etudes d'anthropologie, de physique et de chimie*. Fribourg: Vandenhoeck and Ruprecht, 2003.
- McCarter, P. Kyle. "The Mystery of the Copper Scroll," in H. Shanks, ed., Understanding the Dead Sea Scrolls: A Reader from the Biblical Archaeology Review. New York: Random House, 1992.
- Lanciani, R. Ancient Rome in the Light of Recent Discoveries. London: Macmillan and Co., 1888.
- Lehmann, M. R. "The Key to Understanding the Copper Scroll: Where the Temple Tax Was Buried," *Biblical Archaeology Review* 19:6 (1993): 38–43.
- Magness, J. The Archaeology of Qumran and the Dead Sea Scrolls. Grand Rapids, Mich.: William B. Eerdmans, 2002.
- Mazar, E. The Complete Guide to the Temple Mount Excavations. Jerusalem: Shoham Academic Research and Publication, 2002.
- Milik, J. T. Ten Years of Discovery in the Wilderness of Judaea. London: SCM Press, 1959.

- Putnam, B., and J. E. Wood. The Treasure of Rennes-le-Château: A Mystery Solved. Stroud: Sutton, 2003.
- Silberman, N. A. "In Search of Solomon's Lost Treasures," *Biblical Archaeology Review* 6:4 (1980): 30-41.
- Vaux, R. de. Archaeology and the Dead Sea Scrolls. London: Oxford University Press, 1973.
- Vincent, L. H. Underground Jerusalem: Discoveries on the Hill of Ophel (1909– 1911). London: Horace Cox, 1911.

TEMPLE TREASURE

- Ackroyd, P. R. "The Temple Vessels—A Continuity Theme," Studies in the Religion of Ancient Israel. Leiden: Vetus Testamentum Supplement, Volume 23, E. J. Brill, 1972.
- Barag, D. "The Table of the Showbread and the Facade of the Temple on Coins of the Bar-Kokhba Revolt," in H. Geva, ed., *Ancient Jerusalem Revealed*. Jerusalem: Israel Exploration Society, 2000.
- Bockmuehl, M. "The Trumpet Shall Sound: Shofar Symbolism and Its Reception in Early Christianity," in W. Horbury, ed., *Templum Amicitiae: Essays in the Second Temple Presented to Ernst Bannel.* Sheffield: JSOT Press, 1990.
- Demsky, A. "When the Priests Trumpeted the Onset of the Sabbath," Biblical Archaeology Review 12:6 (1986): 50-52.
- Feldman, L. H. "Financing the Colosseum," *Biblical Archaeology Review* 27:4 (2001): 20–31, 60–61.
- Fergusson, J. The Temples of the Jews. London: John Murray, 1878.
- Geva, H. "Jerusalem: The Temple Mount and Its Environs," in E. Stern, ed., The New Encyclopedia of Archaeological Excavations in the Holy Land, Volume 2. Jerusalem: Israel Exploration Society and Carta, 1993.
 - ——. "Searching for Roman Jerusalem," *Biblical Archaeology Review* 23:6 (1997): 34–45, 72–73.
- Goodenough, E. R. Jewish Symbols in the Greco-Roman Period. Volume 4: The Problem of Method: Symbols from Jewish Cult. New York: Pantheon Books, 1954.
 - —. Jewish Symbols in the Greco-Roman Period. Volume 8: Pagan Symbols in Judaism. New York: Pantheon Books, 1958.
- Hachlili, R. Ancient Jewish Art and Archaeology in the Land of Israel. Leiden and New York: E. J. Brill, 1988.
 - ——. The Menorah, the Ancient Seven-Armed Candelabrum: Origin, Form, and Significance. Leiden and Boston: E. J. Brill, 2001.
- Klagsbald, V. A. "The Menorah as Symbol: Its Meaning and Origin in Early Jewish Art," *Jewish Art* 12–13 (1986–1987): 126–134.

Lalor, B. "The Temple Mount of Herod the Great at Jerusalem: Recent

Select Bibliography

Excavations and Literary Sources," in J. R. Bartlett, ed., Archaeology and Biblical Interpretation. London: Routledge, 1997.

Levine, L. I. "The History and Significance of the Menorah in Antiquity" in L. I. Levine and Z. Weiss, eds., *From Dura to Sepphoris: Studies in Jewish Art and Society in Late Antiquity.* Portsmouth, R. I.: Journal of Roman Archaeology, Supplement 40, 2000.

—. Jerusalem: Portrait of the City in the Second Temple Period (538 BCE–70 CE). Philadelphia: The Jewish Publication Society, 2002.

- Mazar, A. Archaeology of the Land of the Bible, 10,000-586 BCE. Cambridge: Lutterworth, 1993.
- Mazar, B. Beth She'arim; Report on the Excavations during 1936–1940. Jerusalem: Israel Exploration Society and the Institute of Archaeology, Hebrew University, 1973.
- Meyers, C. L. "Was There a Seven-Branched Lampstand in Solomon's Temple?," *Biblical Archaeology Review* 5:5 (1979): 47–57.
- Montagu, J. Musical Instruments in the Bible. London: Scarecrow Press, 2002.
- Patrich, J. "The Structure of the Second Temple: A New Reconstruction," in H. Geva, ed., Ancient Jerusalem Revealed. Jerusalem: Israel Exploration Society n. p., 2000.
- Rosovsky, N. "A Thousand Years of History in Jerusalem's Jewish Quarter," Biblical Archaeology Review 18:3 (1992): 22-40.
- Shanks, H. "Excavating in the Shadow of the Temple Mount," Biblical Archaeology Review 12:6 (1986): 20-38.
- Ussishkin, D. The Conquest of Lachish by Sennacherib. Tel Aviv: Tel Aviv University, Institute of Archaeology, 1982.
- Yarden, L. The Spoils of Jerusalem on the Arch of Titus: A Re-investigation. Stockholm: Svenska Institut i Rom, 1991.
 - -----. The Tree of Light: A Study of the Menorah, the Seven-Branched Lampstand. London: East and West Library, 1971.

REVOLUTION

Avigad, N. Discovering Jerusalem. Oxford: Blackwell, 1980.

- Berlin, A. M., and J. A. Overman, eds., *The First Jewish Revolt: Archaeology, History and Ideology.* London: Routledge, 2002.
- Darwall-Smith, R. H. Emperors and Architecture: A Study of Flavian Rome. Brussels: Latomus, 1996.
- Geva, H. "Excavations at the Citadel of Jerusalem," in H. Geva, ed., Ancient Jerusalem Revealed. Jerusalem: Israel Exploration Society, 2000.
- Goodman, M. The Ruling Class of Judaea: The Origins of the Jewish Revolt Against Rome AD 66-70. Cambridge: Cambridge University Press, 1987.

Levick, B. Vespasian. London: Routledge, 1999.

Rajak, T. Josephus: The Historian and His Society. London: Duckworth, 2002.

- 305 -

IMPERIAL ROME

- Claridge, A. Rome: An Oxford Archaeological Guide. Oxford: Oxford University Press, 1998.
- Coleman, K. "Entertaining Rome," in J. Coulston and H. Dodge, eds., Ancient Rome: The Archaeology of the Eternal City. Oxford: Oxford University School of Archaeology Monograph 54, 2000.
- DeLaine, J. "Building the Eternal City: The Construction Industry in Imperial Rome," in J. Coulston and H. Dodge, eds., Ancient Rome: The Archaeology of the Eternal City. Oxford: Oxford University School of Archaeology Monograph 54, 2000.
- Dudley, D. R. Urbs Roma: A Source Book of Classical Texts on the City and Its Monuments. London: Phaidon, 1967.
- Goodnick Westenholz, J. The Jewish Presence in Ancient Rome. Jerusalem: Bible Lands Museum Jerusalem, 1994.
- Holliday, P. J. The Origins of Roman Historical Commemoration in the Visual Arts. Cambridge: Cambridge University Press, 2002.
- Humphrey, J. H. Roman Circuses: Arenas for Chariot Races. Berkeley: University of California Press, 1986.
- Kleiner, F. S. "The Arches of Vespasian in Rome," Mitteilingen des Deutschen Archäologischen Instituts Romische Abteilung 97 (1990): 127–136.
 - ——. "The Study of Roman Triumphal and Honorary Arches 50 Years After Kaehler," *Journal of Roman Archaeology* 2 (1989): 195–206.
- Leon, H. J. The Jews of Ancient Rome. Peabody, Mass.: Hendrickson Publishers, 1995.
- Olsson, B., D. Mitternacht, and O. Brandt, eds., *The Synagogue of Ancient Ostia and the Jews of Rome: Interdisciplinary Studies.* Stockholm: Paul Åströms Förlag, 2001.
- Pfanner, M. Der Titusbogen. Mainz: P. von Zabern, 1983.
- Richardson, L., Jr. A New Topographical Dictionary of Ancient Rome. Baltimore: Johns Hopkins University Press, 1992.
- Versnel, H. S. Triumphus: An Inquiry into the Origin, Development, and Meaning of the Roman Triumph. Leiden: E. J. Brill, 1970.

VANDAL CARTHAGE -

- Cameron, A., B. Ward-Perkins, and M. Whitby. The Cambridge Ancient History XIV: Late Antiquity: Empire and Successors, AD 425-600. Cambridge: Cambridge University Press, 2000.
- Clover, F. M. "Carthage and the Vandals," in J. H. Humphrey, ed., Excavations at Carthage 1978 Conducted by the University of Michigan, Volume VII. Tunis: Cérès Productions, 1982.

—. The Late Roman West and the Vandals. Aldershot, Hampshire, UK: Variorum, 1993.

- 306 -

Select Bibliography

- Ellis, S. "Dining: Architecture, Furnishings and Behaviour," in R. Laurence and A. Wallace-Hadrill, eds., *Domestic Space in the Roman World: Pompeii and Beyond*. Portsmouth, R. I.: Journal of Roman Archaeology, Supplement 22, 1997.
- Ennabli, A. Pour Sauver Carthage: Exploration et Conservation de la Cité Punique, Romaine et Byzantine. Tunis: Ministère et Institut, 1971.
- Ennabli, L. Carthage: Une Métropole Chrétienne du IVe à la Fin du VIIe Siècle. Paris: CNRS, 1997.
- Humphrey, J. "Vandal and Byzantine Carthage: Some New Archaeological Evidence," in J. G. Pedley, *New Light on Ancient Carthage: Papers of a Symposium.* Ann Arbor: University of Michigan Press, 1980.
- Hurst, H. R. Excavations at Carthage: The British Mission. Volume II, 1: The Circular Harbour, North Side. The Site and Finds Other Than Pottery. Oxford: Oxford University Press, 1994.
- Lancel, S. Byrsa I: Rapports Préliminaires des Fouilles (1974–1976). Rome: École Française de Rome, 1979.

-----. Carthage: A History. Oxford: Blackwell, 1995.

- Lézine, A. Carthage: Utique: Études d'Architecture et d'Urbanisme. Paris: CNRS, 1968.
- Mattingley, D. J. "Oil for Export? A Comparison of Libyan, Spanish, and Tunisian Olive Oil Production in the Roman Empire," *Journal of Roman Archaeology* 1 (1988): 33–56.
- Merrills, A. H., ed. Vandals, Romans and Berbers: New Perspectives on Late Antique North Africa. Aldershot: Ashgate, 2004.
- Sintes, C., and Y. Rebahi. *Algérie Antique*. Marseille: Musée d'Arles et de la Provence Antique, 2003.
- Van Mater Dennis, H. Hippo Regius from the Earliest Times to the Arab Conquest. Amsterdam: Hakkert, 1970.

CONSTANTINOPLE—NEW ROME

Allen, P. "The 'Justinianic' Plague," Byzantion 49 (1979): 5-20.

- Bassett, S. The Urban Image of Late Antique Constantinople. Cambridge: Cambridge University Press, 2004.
- Cameron, A. Procopius and the Sixth Century. London: Routledge, 1985.
- Harrison, M. A Temple for Byzantium: The Discovery and Excavation of Anicia Juliana's Palace Church in Istanbul. London: Harvey Miller, 1989.
- Jobst, W., B. Erdal, and C. Gurtner. Istanbul: The Great Palace Mosaic; The Story of Its Exploration, Preservation and Exhibition, 1983–1997. Istanbul: Arkeoloji ve Sanat Yayinlan, 1997.
- Maas, M., ed. The Cambridge Companion to the Age of Justinian. Cambridge: 2005.

-. Readings in Late Antiquity: A Sourcebook. London: 2000.

— 307 —

Select Bibliography

Maclagan, M. The City of Constantinople. London: 1968.

- Mango, C. "The Triumphal Way of Constantinople and the Golden Gate," *Dumbarton Oaks Papers* 54 (2000): 173–188.
- Mango, C., ed. The Oxford History of Byzantium. Oxford: Oxford University Press, 2002.
- Stathakopoulos, D. Famine and Pestilence in the Late Roman and Early Byzantine Empire: A Systematic Survey of Subsistence Crises and Epidemics. Aldershot: Ashgate, 2004.

THE HOLY LAND

- Gibson, S., and J. E. Taylor. Beneath the Church of the Holy Sepulchre Jerusalem: The Archaeology and Early History of Traditional Golgotha. London: Palestine Exploration Fund, 1994.
- Hirschfeld, Y. The Judean Desert Monasteries in the Byzantine Period. New Haven, Conn.: Yale University Press, 1992.
- Isaac, B. The Invention of Racism in Classical Antiquity. Princeton, N. J.: Princeton University Press, 2004.
- Kaegi, W. E. Byzantium and the Early Islamic Conquests. Cambridge: Cambridge University Press, 1992.
- Ovadiah, A. "Early Churches," in E. Stern, ed., The New Encyclopedia of Archaeological Excavations in the Holy Land, Volume 2. Jerusalem: Israel Exploration Society and Carta, 1993.
- Patrich, J. "Monasteries," in E. Stern, ed., *The New Encyclopedia of Archaeological Excavations in the Holy Land, Volume 3.* Jerusalem: Israel Exploration Society and Carta, 1993.
- Schick, R. The Christian Communities of Palestine from Byzantine to Islamic Rule. Princeton, N. J.: Darwin Press, 1995.

- 308 ----

INDEX

Aaron, Israelite priest, 21-22, 124, 131

- Aaron of Levi, 120
- Abraham, 4
- Absalom, 68
- Achor, Vale of, 96
- Acra fortress, 148, 149
- Adler, Marcus N., 67
- Agrippa, Marcus, 172–73 Alaric, Visigoth, 74
- Alaric, visigoui, 74
- Alexander, Governor of Judaea, 32
- Alexander the Great, 10, 256
- Alexander III, Pope, 67
- Alexandria, 157
- Alföldy, Géza, 14, 15
- Algeria: Hippo Regius, 244-45, 250, 263
- Allegro, John Marco: Copper Scroll as taxation, 89; The Dead Sea Scrolls: A Reappraisal, 80; opens Copper Scroll in Manchester, 79; search for treasure, x, 94–95; Treasure of the Copper Scroll, 79, 80
- Almonds, 119-20
- Almsgiver, John the, 288
- Amar, Shlomo, 40
- Ananias, High Priest, 142
- Anastasius I, Emperor, 257, 273
- anti-Semitism, in ancient Rome, 180-82
- Antigonos, the Hasmonean, 35
- Antioch: Council of Elders, 110; Publius Petronius, governor of Syria, 140; theater of Daphne, 101
- Antiochus IV Epiphanes, King: quarrels with Ptolemy VI, 28; ransacks Jerusalem, 29–30, 107
- Antipater of Idumaea, 31
- antiquities: fakes, 297–98
- Antonia fortress, Jerusalem, 54, 145, 147
- Antonius, Felix, 139
- Apollonia (Arsuf): captured by King Chosroes, 284; Patriarch Modestus poisoned, 288

- Apries, Pharaoh, 170
- al-Aqsa mosque, 51
- Arafat, Yasser, 295
- Aramaic, 110
- Arcadius, 262
- Arch of Titus, x; base, 110, 114–18; eagles, 118; menorah, 20, 110, 112, 122; monument in Rome, ix, xi, 20; Table of the Divine Presence, 20; Tower of the Seven Lamps, 43; trumpets, 20, 133

Arianism, 227–29

- Ariel, Rabbi Yisrael, 47
- Aristeas, 125–26
- Arius, deacon, 227
- Ark of the Covenant: cherubim, 21; destroyed by Nebuchadnezzar, 123; history, x, 18, 25; looted by Parker Expedition, 72–73; in St. John the Lateran, 41

Asclepius, 179

- Ataulphus, King, 74
- Atlantis, x, 73
- Atum-Ra, 170
- Augustine, Saint, 202
- Augustus, Emperor: altar of Peace, 207; completes Rome's Senate House, 175; donations to Herod's Temple, 35, 36, 183; establishes province of Judaea, 139; Forum of, 207; games in Circus Flaminius, 178; library at Carthage, 235; names Theater of Marcellus, 190; port of Caesarea, 6–7, 31; refurbishes Porticus of Octavia, 188; statue in Constantinople, 256; statues in Rome, 173;

Avigad, Nachman, 150

Azmey Bey, Ottoman governor, 73

Babylon, 24, 25, 32, 49, 107, 110, 115, 118 Baghdad, 26 Baiae, 223 balsam, 89–90

- 309 —

Bar-Kokhba, Simon, 82, 96, 127, 133

- BBC, 131
- Bedouin, 21, 292

Beirut, 110, 283

Bekri, El, 245

- Belisarius, General: captures Carthage, 25; captures the Vandal palace, 234, 239; fame, 232; imprisoned by Justinian, 268; prepares to invade North Africa, 231; recovers Temple treasure at Hippo Regius, 246; respect for enemy, 233
- Benjamin, Israel Joseph (Benjamin II), 63, 66, 69
- Benvenisti, Meron, 46
- Berlusconi, Prime Minister, 179, 187, 188
- Bernini, Gian Lorenzo, 170
- Bethlehem, 279
- Beth Shearim: ancient Jewish town, 108, 109–17; Aramaic inscription, 110; Besara, 110, 117; catacombs, 110–14; eagles, 115, 116; Gamaliel, Rabbi, 110; glassworks, 109; Judah Ha-Nassi, Rabbi, 110; Lion of Judah, 113; menorah, 113; Nike, 113; sarcophagi, 112–14; Sanhedrin, 109, 110, 114; synagogue, 117
- Black Eyed Peas, 297
- Blühmel, Friedrich, 132
- Boaz, 23
- Boniface, 245-46
- Book of Nahum, 80
- Boqeq, En, 88
- Borsippa, 26
- British Mandate, 290
- Brown, Dan, 42
- Bush, George, 176, 199, 283
- Butrint, 237, 242
- Byblos, 110
- Byzantium: letters, 42; origins, 251; recycling, 253–54
- Caesar, Julius: builds the Senate House, 175; expands the Circus Maximus, 200; Forum of, 176; Magna Carta of the Jews, 183; statue of, 159; statue of, in Constantinople, 256
- Caesarea: aqueducts, 35, 153; Byzantine Esplanade, 154; city, xii, 8, 284; Eusebius, 43; harbor of Sebastos, 6, 31, 138, 153, 154, 290; Herod's lighthouse, 8; Roman warehouses, 154; royal palace, 31; Temple of Augustus, 6

Cage, Nicolas, x, 17

Cairo Museum, xi

Calacte, Caecilius of, 184

Caligula, Emperor Gaius, 35, 140, 155, 170 candelabrum, *see* menorah

Capernaum, 116 carabinieri, 187–88

- Carmel, 8
- Carthage: Antonine Baths, 223, 226; Byrsa Hill, 223, 225, 234, 235–43; Byzantine esplanade, 239; Cathedral of St. Louis, 239; Circular (Military) Harbor, 225, 233, 241; La Malga water cisterns, 223; Misuas shipyards, 223; Mandracium, 233; nineteenth-century spoliation, 224; Odeon, 223; Ottoman customs, 227; prison (Ancon), 240; relocation of Temple treasure, 219; Roman theater,
- 226; Vandal palace, 234, 237-43
- Castor and Pollux statuary, 257
- Çelebi, Hizir Bey, 272
- Cestius Gallus, 143
- Chagall, Marc, 113
- Chaldeans, 180
- Chigi, Pope Alexander VII, 170
- Choniates, Niketas: statue of Helen of Troy in Constantinople, 261
- Chrestus, 181
- Chosroes I, King, 284
- Christ, True Cross of, 121, 281-82, 286
- Church of Scientology, 168
- Cicero: domination of Israel, 181; political power of Rome's Jews, 184
- Cinq Années en Orient, 66
- Circus Maximus: Arch of Titus, 198–99; chariot races, 201; Consualia festival, 200; expanded under Julius Caesar, 200; founded by King Tarquin, 200; model for Constantinople's hippodrome, 256; spina, 200; triumphs, 200–202
- Claudius, Emperor, 139, 181
- Clement of Alexandria, 133

Cleopatra of Egypt, 173

- Colosseum, Rome: Amphitheatrum Flavium, 13; architrave, 14; based on Theatre of Marcellus, 190; cost of building, 15, 101; *manubiae* (spoils), 15; masonry used for Basilica of St. Peter, 299; phantom inscription, 14, 15, 17
- Commodus, Emperor, 218
- Constans I, Emperor, 242
- Constantine I, Emperor: builds Church of the Holy Sepulchre, 281; founds Constantinople, 249–51; history of Rome, 43
- Constantinople: Baths of Zeuxippos, 254; capital of Byzantine Empire, 16, 231;

310 -

Index

Chalke (Bronze Gate), 274–75; Church of St. Irene, 274; Church of St. Polyeuktos, 250, 268–73; Church of St. Sophia, 253, 254, 260, 266, 272, 273, 275; Convent of Repentance, 267; Forum of, 252, 269, 270; Golden Gate, 252; Justinian's Palace, 275; the Mese, 252, 269; Milion, 260; Nika Revolt, 274; Ottoman, 70, 73; palace of Justinian, 252; Senate House, 274; Serpent Column, 261–62; silk production, 254; Theodosius's Column, 262

- Constantius II, Emperor, 219
- Copper Scroll, x, 69, 78-84, 92-97
- Corbu, Noel, 76
- Corneille, Pierre, 268
- corona Etrusca, 195
- Crassus, Governor of Judaea, 31
- Cross, Professor Frank, 81
- Crusaders, 42, 50
- Ctesiphon, 286
- Cyril of Jerusalem: on True Cross of Christ, 282
- Cyrila, Bishop, 228
- Cyrus of Persia, King, 25, 107
- Da Vinci Code, 42
- Damascus, 284, 288
- Daniel and the Lion's Den, 25
- Dark Ages, 237, 264
- David, City of, 49, 55, 58
- David, King, 24, 56, 68, 71
- Dayan, Moshe, 51, 63
- Dead Sea: economic base, 88-89; scrolls, geography, 69, 77-80, 84-85, 97
- Delphi, 10, 262
- Dilmun, 118
- Dio, Cassius: burning of Temple of Peace, 218
- Diocles, Gaius Appuleius, 201
- Diocletian, Emperor, 43, 256
- Diodorus Siculus, 10
- Dome of the Rock, x, 18, 46, 54, 62, 72, 73, 297, 298
- Domitian, Roman emperor, 15, 172, 182, 217
- Dor: archaeology, 8–9; architecture, 21; port city, 8, 15; shipwrecks, 9, 11
- Dracontius, 221, 223
- Dragobert II, King, 75
- dromones, 232
- Drusilla, Princess, 139
- Dura Europos, 116
- Ecole Biblique et Archéologique de Saint-Etienne, 71, 80, 85 Edom, 48, 138

- Egypt: Alexandria, 6, 125, 181; Aswan, 210; balsam, 89; Exodus, 47, 49; Lake Mareotis, 6; mines, 4; obelisks, 170, 171–72, 262; Sais, 170; Temple of Amon, 262
- Ein Gedi: Essenes, 81–82, 84–88, 91; Galen, 89; synagogue, 89
- Eisenberg, Jerome, 297
- Eleazor, Priest, 47
- Elijah, 134
- Elizabeth I, Queen, 42
- Ephesus, John of: Justinianic plague, 283
- Essenes: bank, 81; Bannus, 86; Ein Gedi, 88; monastic settlement, 84, 85, 86; personal possessions renounced, 86, 91; ritual purity, 86–87
- Ethiopia, 23
- Euagees, 230
- Eudocia, Empress, 280
- Eudoxia, Empress, 217
- Eugenius, Bishop, 228
- Euphrates, River, 118, 119
- Eusebius Pamphilius, Bishop of Caesarea, 43
- Exodus: God's protection of Israelites, 115; on manufacture of the menorah, 103; Table of the Divine Presence, 123–24
- Exodus, from Egypt, 20, 151
- Expositio Totius Mundi et Gentium, 214
- Ezekiel: face of God, 115–16

Fabricius, Lucius, 179

- fasces, 193-94
- Felix, Pope, 209
- Festus, 196
- Field of Mars, 167-73, 190-96
- Fifth Legion, 147
- Fine, Steven, 41
- Firatli, Nezih, 269
- Fiscus judaicus, 160
- Flaccus, Lucius Valerius, 184
- Flavian Dynasty: economics, 15;T. Flavius Petro, 155; T. Flavius Sabinus, 155; propaganda, 159–60, 199
- Flavius Josephus: Agrippa freed by Caligula, 35; Antiochus IV ransacks Jerusalem, 28–30; background, xi; Caligula demands pagan worship in Jerusalem, 140; causes of First Jewish Revolt, 139–40; construction of Temple of Peace, 205; death of Simon Ben Giora in Rome, 203–4; Gate of the Pomp, 176; Gessius Florus seizes Jerusalem's sacred money, 35–36, 140–41; golden eagle, 111; hyperbole, 11; Jesus son of Gamala denounces Jewish revolutionaries, 143; Judas Maccabeus restores the Second

311

Temple, 30; Mary of Bethezuba roasts child, 147; menorah, 104; outer surface of Temple, 33; Pompey violates the Temple, 31; Pontius Pilate, 35; prayer book burned at Beth-Horen, 140; as Roman informer, 145; Sabinus seizes Temple treasury, 35; Simon Ben Giora held at Caesarea, 154;Table of the Divine Presence, 124; Titus refuses to burn the Temple, 152; on Triumph of Vespasian and Titus, 174, 192–93, 200–202; Vespasian and Titus serve dinner at triumphal dinner, 176

Foster, Norman, 206 Frangipani, 43 Frazer, Sir James, 196

Gaiseric, King: atrocities against Catholic Church, 227–28; captures Eudoxia, 218; invades Rome, 216–18

Galati, statues, 208

Galba, Servius Sulpicius, 156

- Galilee, xi, 108, 109, 153
- Gamala, Jesus son of, 143
- Gamaliel, Rabbi, 110

Ganges, 119

- Ganymede of Leochares, 208
- Garden of Eden, 118
- Garmu, House of, 34, 126

Gaster, T. H., 97

Gaza, 45

- Gela, 10
- Gelimer, King: character, 230; flees into Numidia, 244; palace of Carthage, 237–43; paraded in Triumph of Constantinople, 250, 263–64; surrenders from Mt. Papua, 263

geniza, 82

- Germanicus, Aulus Vitellius, 156
- Gessius Florus, Procurator of Judaea, 35–36, 140–41
- Gilgamesh, King of Uruk, 118
- Giora, Simon Ben: capture, 3; death in Rome, 203–4; faction of, 142–43; paraded in Rome, 10; seizes imperial baggage, 143; sent severed hands, 145
- Gischala, John of: capture, 3; loots the Temple, 36; sent severed hands, 145

Golan Heights, 62

Golden Bough, 196

Golgotha, 281

- Goths, xii, 11, 209, 215
- Gounod, Charles, 268
- Granicus, Battle of, 188
- Greek fire, 232
- Gregory the Great, Pope, 202

Gulf War, 9, 176, 193 Gunthamund, King, 223 Gush Katif, 45 Haaretz, 48 Hadrian, 172, 181, 281 Hadrumetum, 156 Haifa, 8, 48 Halicarnassus, Dionysius of, 184 Hamas, 45, 280, 295 Hannibal, 269 Hanukkah, Festival of Lights, 117 Haram, 19 Haram al-Sharif, 40, 57, 60, 296 Harding, Lankester, 80 Hareuveni, David, 63, 66 Harrison, Martin, 269 270 Hasmonean dynasty, 31, 35, 88, 107, 142 Hawara, 46 Helena, 281 Helen of Troy, 261 Helena, Oueen, 148 Helios, 202 Heraclius, Emperor, 288 Hercules, 257, 261 Herod Agrippa, 35 Herod, King: builds the Temple of Jerusalem, 31-32; client king of Rome, 138; date plantations, 88-89; golden eagle on Temple, 112; harbor of Caesarea, 6, 283, 290 Herodium, 31 Herodotus, xiii Herzog, Isaac, 41 Hesse-Wartegg, Ernest, 224, 226 Hilderic, King, 230 Hilkiah, 26 Hippicus, 148 Hippodrome, of Constantinople: chariot rivalry, 255; founded by Severus, 255; kathisma (royal box), 256, 262-63; Serpent Column, 261-62; sphendone, 260; spina, 260, 261; statue collection, 257, 261; Theodosius's Column, 262; topography, 260-63 Hiram of Tyre, king, 22 Hirschfeld, Yizhar, 87-88 Hispania Tarraconensis, 156 Hispanus, Gnaeus Cornelius, 180 Hitler, Adolf, ix Hoamer, 230 Hodges, Richard, 237 Holme-next-the-sea, 120 Holv Grail, x

- Holy Land, 45, 265, 280, 282
- Holy Sepulchre, Church of: Anastasis, 281;

- 312 -

Chamber of Relics, 282; dedicated under Constantine, 281; restored after Persian Invasion, 288; Temple treasure, 281, 289

Humbert, Jean-Baptiste, 92

Huneric, King: atrocities against the Church, 229; toleration of Catholicism, 228

Honorius, 262

Hunzinger, Hunno, 80

Hussein of Jordan, King, 96

Hussein, Saddam, 8, 127

idolatry: in Deuteronomy, 111

Intifada, 59, 253, 297

Isaac, 4

Isis, 168-69

Israel: accusations against the Vatican, 39; Antiquities Authority (IAA), 43, 56, 57; Department of Culture, 44; Embassy, London, 43; Ministry of Education, 44

Israelites, 18, 20, 21, 47

Istanbul:Blue Mosque,260,263,275;Bosphorus, 251, 290; development of the dome, 254; Galatasaray, 249; Golden Horn, 249, 251; Saraçhane, 268, 272; Sea of Marmara, 209, 249, 251, 252, 275; Sehzade Camii (Mosque of the Prince), 272;Town Hall, 272; university, 252, 260, 270

Itinerary of Rabbi Benjamin of Tudela, 67

Jachin, 23

Jehoash, King, 298

Jeremiah, 25

Jericho, 31, 88

Jerusalem: Acra, 143, 148-49; Benjamin Mazar excavations, 150; captured by Antiochus IV Epiphanes, 28-30; Church of Eleona, 284; Church of Gethsemane, 284; Church of Holy Zion, 288; Church of the Ascension, 288; Church of St. John the Baptist, 284; City of David, 49, 55, 58; Convent of St. Melania, 284; David's Citadel, 150; destroyed by Nebuchadnezzar, 24; destroyed by Rome, 3-6; El Azariah, 52, 57; end-times, 40; Hezekiah's Tunnel, 72; Hill of Ophel, 56, 70, 142; golden eagle, 111; Jewish Quarter, 150; Kidron Valley, 52, 142; mikvaot, 150; Mount of Olives, 47; Nachman Avigad excavations, 150; Robinson's Arch, 150; Solomon's city, 24; restored by Judas Maccabeus, 30; restored by King Cyrus, 25; siege of Titus, 145-52; Temple Mount and Land of Israel Faithful Movement, 40, 44, 45, 47-49, 57-66; Third Temple, 41, 287, 298; Upper City, 140-41, 148; Virgin's Well, 71

Jerusalem Post, 9

Jesus, Son of Thebuthi, 6

Jewish Revolt, First: Acra fortress, 148, 149; Ananias, 142; Antonia fortress, 145-47; balsam, 90; Caligula demands pagan worship in Jerusalem, 140; causes of, xi, 138-43; defeat of, ix, 4, 144-48; commander Alexander, 32; Eleazor son of Simon, 142; Essenes, 87; factions, 36, 46, 141-43; Fifth Legion, 147; Flavius Josephus, xi, 145; Gessius Florus loots the Temple, 140-41; John of Gischala, 142; Mary of Bethezuba roasts child, 147; palace of Queen Helena burned, 148; poneroi revolutionaries, 142; Pontius Pilate violates Jerusalem, 139; Publius Petronius marches on Jerusalem, 140; revolutionaries denounced by Jesus son of Gamala, 143; Sicarii, 140; siege of Jerusalem by Titus, 145-52; Simon Ben Giora, 142; Temple of Jerusalem burned down, 151; Zealots, 142-43

Jewish Revolt, Second, 96, 133

Jewish Tax, 160

Jezreel Valley, 109

John VIII, Pope, 43

John-Paul II, Pope, 40, 189

Jordan, 31

Jordanian Department of Antiquities, 80

Joshua, son of Jehozadak, 32

Judaea, 23, 28, 32, 34, 77, 87, 143

Judaea Capta coins, 91

Judah, 22, 25, 48

Judah Ha-Nassi, Rabbi, 110

Judaism, 11, 20, 21, 31, 118

Juliana, Princess Anicia, 268–73, 276

Jupiter, 172, 193, 194

Jupiter Sabazius, 180-81

Justin I, Emperor, 267

Justinian I, Emperor: builds Church of St. Sophia, 273; Gelimer pays obeisance to, 263–64; history, xii; ignoble ancestry, 267; invasion of North Africa, 230–31; palace of, 274–75; plague of, 283; sends Temple treasure to Jerusalem, 276, 280

Justiniana Prima, 266

Juvelius, Valter, x, 18, 70-73, 122

Kabbalah, 168

Kasper, Cardinal Walter, 189

Katzav, Moshe, 39

Kfar Hasidim, 48

Kfar Menachem, 48

Khuzistan Chronicle: Jews violate Tomb of Christ, 287; True Cross of Christ, 286

Knights Templar, x, 50, 74, 76

Kristallnacht, 29 Kuhn, K. G., 79 Kuwait, 8

Lapeyre, Father, 237, 241 Laurus, 233 Lebanon, 22-23 Legends of the Jews: coming of the Messiah, 134; Tree of Life in Paradise, 118-19 Leonardo da Vinci, 74 Levite, 26 Liberalius, 151 Life of Brian, 141 Liverani, Paolo, 44 Lod, 284, 287 London, 13 London Illustrated News, 73 Louvre, xi Lucas, George, 18 Lusitania, 156 Luz, City of Almonds, 119 Lysippus: statue of Alexander the Great, 188 Maariv, 40 Maccabees, dynasty, 30 Maccabeus, Judas, 30, 108, 110 Machaerus, 31 Mackness, Robin, 74 Magi, 291, 294

Malalas, John: Constantinople's hippodrome, 255-56 Mansuetus, 228 Marcellinus, Ammianus, 201, 219 Marcellus, M. Claudius, 190 Margalothus, Matthias son of, 111 Mariamme, 148 Marissa (Cappadocia), 290 Mars, 167, 173 Martial, 201 Mary, daughter of Eleazor of Bethezuba, 147 Mary Queen of Scots, 42 Maximus, Petronius, 216-17, 220 Maximus, Valerius, 180 Mazar, Benjamin, 56, 150 Mazar, Eilat, 52, 55, 57 Megara, Byzas of, 251 Mehmed II, Sultan, 251 Mehmet, Prince, 272 menorah (candelabrum): in ancient art, 102,

106–8, 110, 114; on Arch of Titus, ix, 203; base, 105; in Beth Shearim, 113; on coins of Mattathias Antigonos, 107; decoration, 26; Egyptian inspiration, 105; ensign of Israel, 107–8; Hannukah, 106–8, 114;

history of, 16, 40, 101-8; legends, 26, 41; pagan decoration, 108; paraded in Rome, 10; plundered by Rome, 7, 26; prototype in Exodus, 103; seized by Antiochus IV Epiphanes, 29; seven-branched, 105-6, 117, 121; in Solomon's Temple, 104, 117; in St. John the Lateran, 41; symbolism, 120-22; Tabernacle, 103, 105, 117; thrown into River Tiber, 41; value, 297; in Vatican, 39-44, 122; in Zechariah, 106 Mesopotamia, 115, 118 Messene, 110 Messiah, 26, 134 Metellus, 188 Metzger, Yehuda, 40 mikva, 21, 87, 92, 150 Miletus, Isidorus of, 272 Milik, Józef, 79, 80, 96-97 Minerva, 13, 16, 242 Mishnah, 33, 34, 126 Mithredath, 25 Modestus, Patriarch, 287-91 Modi'in, 30 Mohammed, prophet, 53, 72, 289 Mons Porphyrites, 210 Moors, 243, 244, 263 Moses, 21, 22, 47, 103, 104, 111, 117, 119, 123, 130 - 31Mount Horeb, 119 Mount of Olives, 47, 284, 288 Mount Olympus, 173 Mount Sinai, 21, 25, 103, 104, 111, 130 Mussolini, Benito, ix, 182, 199 Myron, 9, 219

Nabataea, 88 Nablus, 46 Naples, 4 Napoleon Bonaparte, 28 Nazis, 30, 74, 140 National Treasure, film, x, 18 Neal, James, 19 Near East, 15, 32 Nebuchadnezzar, King: destruction of First Temple, x, 24, 25, 49, 107, 117, 123; loots Temple treasures, 18, 70 Necromancers, 19 Nero, Emperor: art collection, 208; Colossus, 202; commits suicide, 156; financial irregularities, 144, 159-60; great fire of Rome, 206; Jewish factions, 140; memory damned, 202; poetry, 155 Netanyahu, Benjamin, 46

New York, 18

314 -

Newton, Sir Isaac, 74

Nicholas V, Pope, 299

Nicomacus, 208

Nietzche, 179

Nike, 7, 113

Nile, 119

Noah's ark, x, 73

- North Africa: Byzantine invasion of Justinian, 230, 232; Hippo Regius, 244–45, 263; invasion of Emperor Leo, 230
- Numbers: on manufacture of the Temple trumpets, 131

Numidia, 244

obelisks: in Constantinople's hippodrome, 262; in Piazza della Minerva, 170; in Piazza della Rotonda, 171

Olybrius, Flavius Anicius, 269

Olympia, 10

Onias III, High Priest, 28

Ophir, 23

Ormsby, John, 239

Orpheus, 116

Osiris, 168

Ostia: menorah, 101; synagogue, 186

Otho, Marius Salvius, 156

Ottoman: architecture, 8; customs, 19, 226; government, 70, 290 Ovid, 184

Palace, of Solomon, 113 Palatine, Rome, 43

Palestine Exploration Fund, 71

Palestinians, 45, 46

Palmyra, 110

Pampinianus, 228

Pantheon, 172–73

Paradise, 26, 119

Parker, Captain Montague Brownslow, x, 70-73

Parker Expedition, 18, 67–74

Parthians, 31

Patriarchum, Rome, 43

Passover, 3, 34, 49, 128, 140, 142

Patton, Guy, 74

Paul V Borghese, Pope, 42, 43

Pelusium, 283

Pentecost, 34

Perón, Eva, 267

Persepolis, 10

Persia: Byzantine tribute, 230; captures True Cross of Christ, 286; invades Palestine, 284– 87, 289, 290; sacks Jerusalem, 285; threat to Byzantium, 257, 267

Persians, xii, xii, 25

Petahiah, 34

Petro, T. Flavius of Reate, 155

Petronius, 182

Pharisees, 86

Phasael, 148, 149

Pheidias, 9, 208

Pheretae, 143

Philo of Alexandria: menorah symbolism, 121; Table of the Divine Presence, 127–28

Phineas, 6

Phoenicians: Queen Dido, 236; tombs, 236-37

Pisa, 172

Pius XII, Pope, 41

Plato: on hidden treasure, 299

Pliny the Elder: Jericho, town of dates, 88; majesty of Flavian Rome, 159; Nero's art restored to the public, 208; perfume, 89; on Temple of Peace, 207, 208

Plutarch, 10

Polyeuktos, Church of, 250, 268–73; built using biblical royal cubit, 271; decoration, 269; martyr, 268, 269; Palatine Anthology, 270; Princess Anicia Juliana, 268–73; Temple treasure, 276

Polykleitos, 9, 208

Pollio, 208

Pompey the Great, 31, 108, 199

Pontius Pilate, 139

Poppaea, Empress, 184

Poseidon, 8, 11

Priory of Sion, 74

Proconnesus, 209

Procopius of Caesarea: background, xii; Belisarius demands moderation in battle, 233; Belisarius imprisoned, 268; Buildings, xii; capture of Vandal palace, Carthage, 234, 237; character of Justinian and Theodora, 267; on Gaiseric's sack of Rome, 216, 217-18; Gelimer paraded in Constantinople triumph, 263-64; justification for Byzantine invasion of North Africa, 231; plunder of Temple of Jupiter Capitolinus, 217-18; reasons for Vandal invasion, 215; Secret History, xii, 266; Temple treasure captured at Hippo Regius, 245; Temple treasure in Constantinople, 263; Temple treasure shipped to Jerusalem, 276; Theodora's poor background, 266; triumph of Belisarius in Constantinople, 250; Vandal love of luxury, 231-32; Vandal treasure at Tricamarum, 244; wall mosaics of Justinian's victories on Chalke Gate, 274

Protogenes of Caunus, 206 Ptolemais (Acre), 283 Ptolemy II Philadelphus, King, 125 Ptolemy VI, king of Egypt, 28, 29 Publius Petronius, 140 Putnam, Bill, 76

Qumran: "Cave 3," x, 69, 79, 80; 'Cave 4', 80; coins, 91; Copper Scroll, 78–83, 84, 92–97; Ein Feshkha, 89, 90; Essenes, 84–88; John Allegro, 79–83, 94; Józef Milik, 79, 80, 81, 96–97; manor house, 87, 88; mikvaot, 21, 87, 92; monastery, 84; Roland de Vaux, 80; "Roman" villa, 87, 92; scriptorium, 85, 87; wine press, 89; Zealots, 82

Raveh, Kurt, 9

- Ravenna, 254
- Remus, 202, 256
- Rennes-le-Château, x, 18, 69, 75-76, 122
- Republicans, 155
- Richard, King (the Lionheart), 231
- Robinson, Edward, 150
- Rogers, Mary Eliza, 19
- Rome: ancient xenophobia, 179-82; Arch of Titus (in Circus Maximus), 198-99; Arch of Titus (on Sacred Way), ix, xi, 203; Basilica of St. Peter, 299; Basilica Paulli, 207; Capitoline Hill, 166, 167, 191, 195, 198; Chapel of St. John the Lateran, 41, 68; Circus Flaminius, 176, 178, 185; Circus Maximus, 198-202, 255, 256; client kings of, 138-39; Colosseum, 13-15, 202, 206, 299; Colossus of Nero, 202; curia (Senate House), 175-76; Fabricius's Bridge, 179, 199; Field of Mars, 166-73, 176, 190-98; Forum, 10, 175, 176, 197, 202-4, 208; Gate of the Pomp (Triumphal Gate), 166, 176-77, 195-96, 197-98; great fire, 18, 160; Great Synagogue, 185; Madam Lucretia, 169; Mamertine Prison, 204; Minerva's Piglet, 170; Monument of Victor Emmanuel II, 169; Octavian's Walks, 174-76; Palatine, 43, 198, 201, 202, 208, 256; Pantheon, 172-73, 254; Patriarchum, 43; Porticus of Gaius and Lucius, 203; Porticus of Octavia, 188, 208; Precinct of the Harmonious Gods, 197, 204; River Tiber, 41, 78, 159, 165, 185, 199; rostra (Orator's Platform), 176, 203; Sacred Way, ix, 20, 202-4; Senate, 166, 174-76, 199; temple complex of Spes, Janus and Sospita, 191; Temple of Apollo Medicus Sosianus, 176, 190-91, 196; Temple of Bellona, 176, 190, 196; Temple of Isis, 166, 168-72; Temple of Jupiter Capitolinus, 10, 160, 166, 204, 217; Temple of Peace, 10, 17, 68, 165, 166, 205-10, 218-19; Theater of Balbus, 188; Theater of

Marcellus, 190, 195; Tower of the Winds, 42; Trajan's Forum, 32; Trastevere (Transtiberinum), 178, 179; triumph, 154, 166-73, 185, 192; Turris Chartularia, 43; Umbilicus Urbis (Navel of the City), 175-76, 204 Romulus, 68-69, 176, 202, 256 Rosh Hashanah, 130 Rothschild, Baron Edmond de, 72 Rufius Lampadius, 14 Ruini, Cardinal Camillo, 189 Sabazius, 180-81 Sabbath, 133, 181, 182, 183 Sabines, 155 Sabinus, 35, 155 Sabri, Sheikh Ikrima, 54 Sacred Treasure, Secret Power, 74 Sadducees, 86 Sahiri, 19 St. Catherine, Monastery of, 254 St. Theodosius, Monastery of, 280, 287, 290-95,300 Salamon, Albert, 76 Sallust, 204 Salomon, Gershon, 44, 58-66, 69 Sanhedrin, 109, 114 Saranda, 101 Sardis, 101 Saripheus, Judas son of, 111 Sasanians: capture True Cross, 121, 286 Saunière, Abbé Bérenger, x, 18, 75–76 Seleucid, Syrian dynasty, 28 Seneca, 182, 184 Septimius Severus, Emperor, 219 Seth, 168 Severan Marble Plan, 209-10 Shahrbaraz, General, 286 Shamshiel, 26 Sharon, Ariel, 44 Sharon Plain, 153 Shekel, taxation, 34 Sheshbazzar, 25 Shetreet, Shimon, 39 Shimur, Levite, 26 Shittim, valley of, 48 shofar, 130, 132 Showbread Table, see Table of the Divine Presence Shushar, 25 Sicarii, 140 Sidon, 110, 283 Simon, Eleazor Ben, 82, 142 Sinai, Wilderness of, 48, 106, 119 Shepherds of Arcady, 75

Six-Day War, 51, 54, 61

- Smithsonian, xi
- Solomon, King, 22-24, 26, 71, 113, 271, 273
- Sossius, Governor of Syria, 35, 199
- Spielberg, Steven, 18
- spolia opima, 191, 203
- SPQR, 199
- stibadium, 238
- Stölzel, Heinrich, 132
- Strabo: Field of Mars, 167
- Strategos, Antiochus: attack on Jericho, 287; sack of Jerusalem, 285
- Sudano, Angelo, 39
- Suetonius: Claudius legislates against Jews of Rome, 181
- Sukkot, 34, 127
- suovetaurilia, 175
- Syria, 15, 28, 30

Tabernacle, 21, 47-48

- Table of the Divine Presence: on Arch of Titus, ix, x, 122, 203; in Aristeas, 125–26; on coins of Simon Bar-Kokhba, 127; crafted by King Ptolemy II Philadelphus, 125; dimensions, 124; history, 16, 26, 123–28; in the Mishnah, 126; in Philo of Alexandria, 127–28; seized by Antiochus IV Epiphanes, 29–30; symbolism, 127–28; value, 297
- Tacitus, Publius Cornelius, 182
- Tappern, Bandsman, 131-32
- Tarantino, Quentin, 226
- Tarmal Galsin, King, 67
- Tarquin the Elder, King, 200
- Tel Aviv, 45
- Temple Mount: dimensions, 32; Dome of the Rock, 18, 298; Hadrian builds Temple of Venus, 181; Jehoash inscription, 297–98; Juvelius excavations, 122; Katemin Gate, 55; Parker Expedition excavations, 18, 69, 73; Revava Movement march, 45; Solomon's stables, 50, 72; Third Temple, 41, 47, 49, 60, 186, 287, 298; Tunnel Riots, 46; Western "Wailing" Wall, 46, 48
- Temple Mount and Land of Israel Faithful Movement, 39, 40, 44, 45, 47, 48, 58-66
- Temple of Jerusalem, Herod's: Antonia fortress, 54, 145, 147; Chamber of Utensils, 34; cloisters, 54; construction, 32–33; crown of Joshua, son of Jehozadak, 33; donations, 32–36; eagle, 33, 112; golden vine, 33; Holy of Holies, 4, 6, 32, 108; House of Garmu, 34; Hulda Gate, 50–51; looted by John of Gischala, 36; Lower Court, 32; Mercy Seat, 34; razed by Rome, 3–7, 16, 151; ritual purity.

34; *shofar* chests, 34; show bread, 34; taxation, 34; treasures in the Copper Scroll, 81–82; treasures of, x, 5–6, 9, 14–15, 20, 33–34; treasury seized by Gessius Florus, 35; treasury seized by Pontius Pilate, 35; treasury seized by Sabinus, 35; Yohanan ben Pinhas, 34

- Temple of Jerusalem, Solomon's: Ark of the Covenant, x, 18, 21; Boaz, 23; breastplate of judgment, 22; cherubim, 23; construction and decoration, 22–24; dedication, 132; destroyed by King Nebuchadnezzar, x, 18, 24, 25, 107, 117, 148; imitated by Church of St. Polyeuctos, 271; Jachin, 23; King Hiram of Tyre, 23; in *National Treasure*, x; red heifers, 48; restored by Cyrus of Persia, 25; Table of the Divine Presence, 123; treasures of, 21– 27, 68
- Temple of Peace, Rome: artwork, 208; burns down, 218; described by Josephus, 205; excavations, 210; Gallic rose beds, 210; Hall of the Marble Plan, 209–10; history, 165; library, 207
- Temple, Second, of Jerusalem: restored by Judas Maccabeus, 30, 107; treasury looted by Crassus, 31; violated by Pompey the Great, 31, 108
- Temple, Third, of Jerusalem, 41, 47, 49, 60, 186, 287, 298
- Ten Commandments, 111
- Theodora, Empress, 266-68
- Theodorus, Bishop of Petra: on Monastery of St. Theodosius, 291
- Theodosius, Saint, 290-91
- Theodosius II, Emperor: Column of, 262; doubles size of Constantinople, 251; forum of, 252, 269, 270; land walls, 257
- Theophanes Confessor: confirms Temple treasure in Constantinople, 264; immorality of Eudoxia, 217; relocation of Temple treasure to Carthage, 220
- Thrasamund, King, 223
- Thucydides, xii
- Tiberius Alexander, 157
- Tiberius, Emperor, 35
- tick-borne relapsing fever, 111
- Tigris, 119
- Titus, Emperor: builds triumphal arch in Circus Maximus, 198–99; captures Jerusalem, 144–52; celebrates triumph, ix, 10, 176; on Colosseum inscription, 14; First Jewish Revolt, 12, 15; menorah inscription, St. John the Lateran, 41; in triumph of Rome, 174–76, 200
- Tobias, sons of, 28, 29
- Tower of the Winds, 42

- 317 -

Tralles, Anthemius of, 272

- triumph, in Constantinople: Belisarius honored, 250, 264; route, 253–58; Temple treasure, 264, 276
- triumph, in Rome: Arch of Titus (in Circus Maximus), 198–99; Arch of Titus (on Sacred Way), 202–3; Circus Flaminius, 186; Circus Maximus, 198–202; Circus of Marcellus, 190; Colosseum, 202; cry of *triumpe*, 194; death of Simon Ben Giora, 203–4; decoration of floats and shows, 192, 202; dress and behavior of the *triumphator*, 194–95; Field of Mars, 166–73, 186, 190–98; history: 124, 154; Porticus of Octavia, 188; *rostra* (Orator's Platform), 176, 203; Sacred Way, 202–4; Temple of Peace, 205–10; Theater of Balbus, 188; Triumphal Gate, 195, 197
- Tree of Life, 118-21
- Treasure of Rennes-le-Château, 76
- Trumpets, silver: on Arch of Titus, ix, 133, 203; blown in Jewish festivals, 130; on coins of Simon Bar-Kokhba, 133; form described on Mount Sinai, 130–31; history, 16, 130–34; in *Legends of the Jews*, 134; origins, 130–33; in Paedagogues, 133; in Revelation, 134; seized by Antiochus IV Epiphanes, 29–30; in *Sibylline Oracles*, 133; sound, 132; of Tutankhamun, 131–32, 133; value, 297
- Tudela, Rabbi Benjamin Ben Jonah of, 63, 67
- Tunis, 213, 215–16, 222, 223, 224, 226, 242; Byrsa district, 223; see also Carthage
- Tunisia: Bulla Regia, 243; Byzacium, 232; Caputvada, 232; Grasse, 240; Hermione, 232; Tricamarum, 243
- Tuthmosis III, Pharaoh, 262
- Tyre, 110, 283, 285, 288

Underground Jerusalem, 73 UNESCO, 46, 58, 222, 242 University of Cincinnati, 41 University of Florence, 39

- Valens, Emperor, 270
- Valentinian II, Emperor, 262
- Valentinian III, Emperor, 216–18
- Vandals: culture of, 225; described by Procopius, xii; emigration from the Danube, 214–15; history, xii; invasion of Rome, 11, 216–18; love of luxury, 231–32; treasures found at Tricamarum, 243–44

Vatican: accused of imprisoning the Temple

treasure, 39–44, 69, 122; Angelo Sudano, 39;West Wing, 42; Basilica of St. Peter, 299; letter from Israel's minister of culture, 9; Paolo Liverani, 44; secret archive, 42–43

Vaux, Roland de, 80, 85, 90

Venus, 173, 281

- Vespasian, Emperor: builds Temple of Peace, 205; celebrates triumph, ix, 10, 122, 176, 200; coins of Peace, 158; declared emperor, 156; destiny fated, 159; destroys Jerusalem, 18; finances, 160; Flavian dynasty founder, 15, 144; Jewish treasure spent by, 101; Judaea Capta coins, 159; offends Nero, 155, 174; professional career, 155–61; pulls down Colossus of Nero, 202; restores Rome, 159– 60; returns Nero's art to the public, 208; tolerance of Jews, 183
- Victor of Vita: Vandal atrocities against Catholic Church, 227–29; Vandal devastation of North Africa, 222;

Vincent, Père Louis Hughes, 71, 73

Virgin Mary, 169

Visigoths, 74

- Vitruvius: on excellence of Rome's climate, 298
- Wakidi, al-: Arab conquest of Palestine, 289-90
- Waqf, Islamic, 50, 51-52, 55, 56, 57
- Ward-Perkins, Bryan, 215
- Warren, Charles, 71

West Bank: Beit Sahour, 289; Bethlehem, 279, 290, 295; Deir Dosi, 290; Hamas, 295; Mar Saba, 289; Monastery of St. Theodosius, 280, 287, 290–95, 300; Ubeidiya, 280, 290
Western Wall, Jerusalem, 46, 48, 50, 52, 296

Wood, John Edwin, 76

Year of the Four Emperors, 156 Yemen, 23 Yohanan ben Pinhas, 34 Yom Kippur, 130 Yousef, Hassan, 45

Zamzam Spring, Mecca, 51 Zacharias, Patriarch, 287, 289 Zealots, 4, 82, 142–43 Zechariah, 106 Zedekiah, 26 Zenodorus, 202 Zerubbabel, 32 Zeus, 257

- 318 —